ART NOUVEAU: AN ANNOTATED BIBLIOGRAPHY

ART & ARCHITECTURE BIBLIOGRAPHIES 4

This first volume contains the following sections:
Art Nouveau in General; Austria; Belgium; France.

ART NOUVEAU
an annotated bibliography

Richard Kempton

LOS ANGELES
HENNESSEY & INGALLS, INC.
1977

One thousand copies published by

Hennessey & Ingalls, Inc.
11833 Wilshire Boulevard
Los Angeles, California 90025
U.S.A.

Library of Congress Cataloging in Publication Data

Kempton, Richard
 Art Nouveau: an annotated bibliography

 (Art & architecture bibliographies; 4)
 CONTENTS: v. 1. General, Austria, Belgium & France.
 1. Art Nouveau—Bibliography. I. Title. II. Series
Z5936.N6K45 [N6465.A7] 016.709'04 77-3689
ISBN 0-912158-59-X

Manufactured in the United States of America
Designed by Laurence McGilvery

This bibliography
is dedicated to the memory of
the Belgian painter Maria Van Lent (1934-1965)
of Bornem in the province of
Oostvlaanderen

CONTENTS

ACKNOWLEDGEMENTS

THIS bibliography was originally the brainchild of William R.
Treese, Art Librarian at the University of California, Santa Bar-
bara, who commissioned me in 1970 to do a bibliography of Art
Nouveau holdings in the UCSB Library. The small booklet that
resulted from that assignment ultimately led to the present vol-
ume. I am very grateful to Mr. Treese for encouraging me in this
endeavour and for the help he and his staff have given me during
the past four years. I was also most fortunate in making the ac-
quaintance of Dr. Stephan Tschudi Madsen of Oslo, the author of
Sources of Art Nouveau, the definitive monograph on the subject,
when he was a visiting professor at UCSB in the Spring of 1973.
He gave me much encouragement and assistance in this project.

My main sources for research were the art libraries of UCSB
and UCLA. I would like to thank Mrs. Virginia Carlson Smith and
Mrs. Antonia Cosentino, both of whom aided me with the origi-
nal bibliography I did for the UCSB Library, and Mrs. Jean Moore
and her excellent and intelligent student staff at the UCLA Art
Library. I also owe a great debt of gratitude, as must every re-
searcher working in the United States, to the New York Public
Library and its capable and patient staff, particularly in the Art
& Architecture Division. The Inter-Library Loan Desk at UCSB
was instrumental in getting much material for me which I might
otherwise have not been able to include.

I would like to thank a number of individuals who were most
helpful in giving generously of their time and opening their libra-
ries to me: Dr. Maurice Bloch, Grunwald Center for the Graphic
Arts, UCLA; Mr. James G. Davis, Powell Library, UCLA; Dr. Her-
win Schaefer, School of Environmental Design Library, University
of California; Mary Schmidt, Fine Arts Library, and Mr. Adolf
Placzek, Avery Library, both of Columbia University; Elizabeth
Usher, Metropolitan Museum of Art Library; Sally Robertson of
Thackrey & Robertson (formerly The Poster Shop), San Francis-
co; and Mrs. Ada Polak of London.

Two grants from the Academic Senate of UCSB allowed me

several important weeks in Berkeley to consult the collections of the University of California Library.

Circumstances provided me with the good fortune of traveling to the Netherlands in the course of compiling this bibliography. I was able to consult many collections, both public and private, and I wish to thank the following persons: R.W.D. Oxenaar, Director of the Kröller-Müller Museum, Otterlo; Mrs. Bettina Spaanstra-Polak of Groningen; and Karel Citroen of Amsterdam. All of them gave most generously of their time, their friendship, and their personal knowledge of the Art Nouveau movement.

For permission to examine the closed collection of the Rijks-bureau voor Kunsthistorische Documentatie (RKD) in The Hague, I am grateful to Miss Anna Blankert, the institute's librarian. I would also like to thank Miss Martha Op de Coul and Mr. Van Dam of the R.K.D. for their generous help. I appreciate the help of Dr. H. Gerson, Director, and Miss W. Sikkens, Librarian, both of the Art History Institute at the University of Groningen, for permission and assistance in using their collection. Mr. J.M. Joosten of the Stedelijk Museum, Amsterdam, was very helpful in that museum's library and brought several important bibliographic matters to my attention.

Although this bibliography could not have been completed without the aid of the people and institutions mentioned above, I should like to emphasize that any errors in fact or in judgment are solely my responsibility. I hope that the work still remaining to be done on the second and third volumes will bring me into contact with other interested individuals and with more libraries, for the more cooperative a venture this bibliography is, the better record it can be of Art Nouveau publication.

INTRODUCTION

ART Nouveau marks the transition from nineteenth-century art to modern art. Its origins are found in those nineteenth-century English movements which rejected classical Historicism. Foremost among these were the Gothic Revival, the visionary art of William Blake and his followers, the Pre-Raphaelite school, and the Arts & Crafts movement of William Morris. The development of steel engineering for architectural construction in England and France influenced Art Nouveau artists, as did the French Rococo of the eighteenth century and Europe's discovery in the late nineteenth century of Japanese art.

Art Nouveau is generally considered to have started in 1893 with the Tassel House of Victor Horta in Brussels. As a European movement it really caught fire in 1897-98 when it swept France and Germany before spreading to other countries with varying degrees of success. By 1903 Art Nouveau had burned out as a dynamic, living movement. A long transition period into the Art Deco style of the 1920s began, particularly in Austria and France, so that it is difficult to fix the date when Art Nouveau ended. Much material dating between 1903 and 1910 has been included in this bibliography, either for stylistic reasons or for its value in the study of individual artists.

The excellent work of Madsen, Schmutzler, and others in establishing the origins of Art Nouveau made it easy to determine the early limits of the movement for the purposes of this bibliography. The Pre-Raphaelites, William Blake, the Gothic Revival, and other forerunners of Art Nouveau are not included, save for a few bibliographies.

The problem of determining the scope of this bibliography is very much the problem of defining Art Nouveau. If one wished to state a definition in a single sentence, I would suggest the following: "Art Nouveau is characterized by the *modern* use of the linear motif in design between 1893 and 1903 in Continental Europe." The burden of the definition falls upon the adjective "modern", which could easily be elaborated upon by many pages

of commentary. Art Nouveau was primarily a Continental movement which touched England and Scandinavia only slightly. Outside of Europe the only significant Art Nouveau activity occurred in the United States.

No two people would agree exactly on what Art Nouveau is or just who of the thousands of artists active around 1900 should be included within its limits; similarly, no two bibliographers would put together the same list of books and articles. Certain well-known artists frequently mentioned in connection with Art Nouveau are not listed in this bibliography, including Rodin, Gauguin, Bernard, Kandinsky, Kokoschka, Mendelsohn, Bonnard, Valloton, and Van Gogh; it should be noted that some stylistic elements in Rodin and Van Gogh could well be considered examples of Art Nouveau line. Other artists are reluctantly listed in the bibliography because the literature on Art Nouveau constantly mentions them and illustrates their work alongside that of Art Nouveau artists; these include Maurice Denis, Adolf Loos, William Morris, Edvard Munch, Henri de Toulouse-Lautrec, and Louis Sullivan. The bibliographies on these artists are limited to brief lists because the literature on most of them is too plentiful to include in full.

A proper definition of the end of Art Nouveau creates another problem in determining just what should be included in this bibliography. Art Nouveau ceased as a vital movement in 1903, but its artists carried on their work in many styles. Some, such as Gaudí and Guimard, continued to do excellent Art Nouveau work. Others, such as Van de Velde and Behrens, changed their style, but their later work can be said to reflect the spirit of the Art Nouveau movement. In both instances the post-1903 work is listed in this bibliography. Yet other artists, such as René Lalique and Josef Hoffmann, moved rapidly toward an Art Deco style after 1903 and became major figures in the Art Deco movement of the 1920s. Art Deco is not included in this bibliography because it is a distinct movement in its own right, and it is already confused far too often with Art Nouveau.

The most truly representative forms of Art Nouveau are the decorative arts, architectural ornament, the poster, and typography. It is highly debatable whether there is really an Art Nouveau architecture. Guimard, Gaudí, Endell, and Horta seem to be the proof of it, but the work of most other architects confuses the

issue. The practice has been to classify as Art Nouveau those transitional architects who bridge the two centuries. C.F.A. Voysey, H.P. Berlage, M.H. Baillie Scott, Louis Sullivan, and Adolf Loos were not Art Nouveau architects, although Voysey, Berlage, and Scott all did excellent decorative art work which was significant in the history of Art Nouveau.

Painting has little to do with Art Nouveau. What is often called Art Nouveau painting is more accurately Symbolist painting. Only a few general works on this school are cited in the bibliography. There is no clear-cut reason for grouping the Symbolists with the Art Nouveau movement, although some Symbolist painters, such as Klimt, Hodler, Khnopff, and Segantini, are included in the bibliography because they appear in the literature on Art Nouveau and were associated with the artists of the movement.

England is the ancestral homeland of Art Nouveau, but after a slow gestation period of a hundred years, the unwanted offspring was exiled to the Continent (aside from Beardsley and the Glasgow Four). What is sometimes called English Art Nouveau is actually the second generation of the Arts & Crafts movement, which parallels Art Nouveau, but in ways more ideological than stylistic. Crane, Ashbee, Mackmurdo, Voysey, Scott, and other representatives of this tradition have been included in the bibliography.

There are several distinct Art Nouveau movements. The style began in Belgium and spread quickly to France and Germany. In France it was best known as "Style 1900" or "Modern'Style", and in Germany it became known as "Jugendstil". It came late to Italy and was known there as "Stile Liberty" after the name of a famous London department store which promoted Art Nouveau textiles. In these four countries one finds the curvilinear line which is the best-known stylistic characteristic of the movement. The differences between German "Jugendstil" and Belgian "Art Nouveau" are less than those between "Jugendstil" and Austrian "Secessionstil". The Austrian style is more rectilinear than curvilinear in its use of line and bears close resemblance to the distinctive Art Nouveau of Scotland (The Glasgow Four). The Austrian Secession also greatly influenced Eastern Europe, especially Poland, Czechoslovakia, and Hungary. Art Nouveau in Spain is primarily the work of a few Catalan architects in Barcelona. In Holland and Scandinavia Art Nouveau seems closer to the Arts & Crafts concept. In the United States, where there was no organized movement, Art Nou-

veau was the work of a few individual artists and firms.

Scope

I propose to list some six thousand items in all, to be published in three volumes. An asterisk (*) represents a book which has not been seen personally by the bibliographer. At the present time we do not have a clear idea just how much has been written on Art Nouveau. It will take years of painstaking research in many European libraries to fully describe the total publication on the movement. I can only suggest the figure of six thousand as a beginning, a provisional working number which represents x percent of an unknown total. Volume 1 covers Art Nouveau in general, plus Austria, Belgium, and France. Volume 2 will be devoted to Germany, Great Britain, Italy, the Netherlands, Scandinavia, East Europe, Spain, and the United States. These first two volumes will include publications through 1971 (with some important later listings). A third, supplementary volume will index some early art journals not included in the first two volumes, such as *Kunst und Künstler, Kunst und Handwerk* of Munich, and *Art Journal;* it will also include additional theses and dissertations, books published during the period 1972-76, and other material which could not be located in time for the first two volumes.

A number of art journals from the turn of the century have been indexed (or analyzed) for the bibliography: *Art Décoratif, Art et Décoration, Revue des Arts Décoratifs, l'Art Moderne, The Studio, The Craftsman, Kunst und Kunsthandwerk* (Vienna), *Ver Sacrum* (except for vol. 3, a copy of which I was not able to locate), *Das Interieur, Hohe Warte, Moderne Bauformen, Zeitschrift für Bücherfreunde, Zeitschrift für Innendekoration, Kunstgewerbeblatt, Dekorative Kunst* (alias *Die Kunst*), *Deutsche Kunst und Dekoration, Pan, Arte Decorative,* and *Emporium.* These journals, many of them semi-official organs of Art Nouveau in their own countries, yield hundreds of articles; those in turn form the bulk of the bibliography. Indeed, this bibliography marks the first systematic attempt to list the relevant Art Nouveau periodical literature for the 1900 period. Nonetheless, a number of journals still remain to be indexed.

Although an annotated list of journals which specialized in Art Nouveau at the turn of the century is planned for volume 2 of this bibliography it would perhaps be better to discuss at this

point some of the complexities of the German journal *Dekorative Kunst,* published by F. Bruckmann in Munich, beginning in October, 1897. The first year was published in two volumes, Band 1 and Band 2. In October, 1898 a French version was brought out in Paris under the title *Art Décoratif.* Volume 1 of the French title is Band 3 of *Dekorative Kunst,* and volume 2 of *Art Décoratif* is Band 4 of *Dekorative Kunst.* There is some variation in illustration and text between the two versions of the periodical. The same articles are often written by Julius Meier-Graefe under two different pseudonyms, one for each journal. Volume 3 of *Art Décoratif* resembles Band 5 of *Dekorative Kunst,* and volume 4 of *Art Décoratif* is similar to Band 6 of *Dekorative Kunst.* Although both versions share the same illustrations in 1898-99, the second year of co-publication, the written content diverges until the point is reached in 1899-1900 when the two titles may be considered to be two different journals. Few libraries have both the French and German versions in the same location, and accurate comparison of them is difficult.

Even more complex is the confusion surrounding the subsequent titles of the German version. In October, 1899, a new journal appeared entitled *Die Kunst: Monatshefte für freie und angewandte Kunst.* Under this new title were incorporated two already existing periodicals, the monthly *Dekorative Kunst* and the semimonthly *Die Kunst für Alle* (24 issues per year). *Die Kunst für Alle* became the odd-numbered volumes 1-59 of *Die Kunst...,* with the secondary title *Freie Kunst: der "Kunst für Alle".* Similarly, *Dekorative Kunst* became the even-numbered volumes 2-60 of *Die Kunst...,* with the secondary title *Angewandte Kunst: der "Dekorativen Kunst".* Since each periodical continued to appear at its usual frequency, each pair of full, yearly volumes of *Die Kunst...* came out simultaneously, not consecutively as the numbering would appear to indicate. Volumes 1 and 2 of *Die Kunst...* both cover the full year October 1899–September 1900 and include, respectively, the twenty-four issues of the fifteenth year (Jahrgang) of the old *Die Kunst für Alle* and the twelve issues of the third year of the old *Dekorative Kunst;* the original volume numbering of *Dekorative Kunst* is *also* maintained under the new title, so that volume 2 of *Die Kunst...* may additionally be described as the fifth and sixth volumes (Bände) of *Dekorative Kunst.* As a final source of potential confusion, both of the original titles

were maintained separately, perhaps for the benefit of subscribers who wanted only one of the two journals. In 1929 *Dekorative Kunst* was superceded by *Das schöne Heim.* Since 1945 *Die Kunst...* has been titled *Die Kunst und das schöne Heim.*

Should this explanation seem overly complex, the reader is asked to bear in mind that these periodicals may be catalogued variously in different libraries, and citations to articles may vary widely. To take a single example, an article from the February 1900 issue of *Dekorative Kunst* might be cited in any of three ways by different authors using different resources: *Die Kunst...,* Band 2; *Dekorative Kunst,* Jahrgang 3; or *Dekorative Kunst,* Band Band 5.

The first two years of *Dekorative Kunst,* prior to its incorporation into *Die Kunst...,* are rather rare, but the later titles may be found in a number of libraries.

There is also a minor variation in *The Studio,* which began publication in London in April, 1893. Its American counterpart, *The International Studio,* began publication in March, 1897. The two journals are identical, save that the articles are issued one month later in *The International Studio.* Thus, any article published in *The Studio* for May, 1900, will be published intact in the June, 1900 issue of *The International Studio.* Articles published in *The Studio* prior to January, 1897, will not be found in *The International Studio.*

As criteria for inclusion, articles indexed had to be at least two pages in length or include at least three illustrations. A great deal of relevant information in these journals thus remains unindexed, such as articles too short for inclusion, brief notices, announcements, odd illustrations, and the like, all of which may be of great value to the serious researcher. Book reviews are not listed except for those occasional ones which are in themselves longer, independent articles.

Detailed descriptions of the journals themselves will be found at the end of volume 2. Citations for illustrations may not hold for every set of every journal. Binding practice at the beginning of the century was inconsistent and color plates in various journals were frequently bound out of sequence. Most bound sets in libraries date from that time.

There has been a steady increase in publication on Art Nouveau in recent years. There are indications that copiously illustrated

major studies will continue to be published on important artists who have been heretofore neglected. One may also expect more theses and dissertations. The variety of illustrations in the literature on Art Nouveau is astonishingly rich and rewarding, and one continually uncovers unfamiliar photographs of familiar subjects, even after months of research. In fact, the illustrations tend to display more variety than the texts themselves.

Arrangement

The bibliography is arranged in several sections, the first of which includes the general subject of Art Nouveau; the later ones cover individual countries. The general section and the national sections are further divided by form (i.e. architecture, posters, decorative arts, and the like). Within each country an alphabetical listing of individual artists follows the various media (it should be remembered that most Art Nouveau artists worked in more than one medium). Within each subdivision for a subject or artist, books and exhibition catalogs are listed in one alphabetical sequence, followed by periodical articles in a second alphabetical sequence.

Artists who lived in more than one country are difficult to assign to a particular one. Where an arbitrary decision has been made, the artist appears under the country where he did most of his Art Nouveau work. Thus, the Czech artist Alphonse Mucha is listed under France, Henry Van de Velde in his native Belgium, and, most difficult of all to decide, the Austrian architect Joseph Maria Olbrich is listed under Germany, where he was most active. Switzerland loses Eugène Grasset and Carlos Schwabe to France, Giovanni Segantini to Italy, and Hermann Obrist to Germany.

Another difficult question was just how many translations of a book to include. Where applicable this bibliography lists a book in its original language plus a translation in one other language, preferably English. This problem arises primarily with books published after 1960. The technical difficulties involved in listing all of the translations of a given book far outweigh the value of such an effort.

In recent years many books published in English are issued simultaneously in London and New York (or another American city) by two different publishers (both of which are noted in the bibliography), but both versions are absolutely identical.

Books, catalogs, and journal articles published after 1950 are

usually easy to find in most large academic and research libraries. The older material may be very difficult to locate. The American researcher may be forced to rely upon libraries in the Boston and New York areas and the European researcher on the older art libraries of a few countries.

ABBREVIATIONS & LIST OF PERIODICALS

Ja	January	ed.	edited, edition, editor
F	February	e.g.	exempli gratia (for example)
Mr	March	et al	et alia (and others)
Ap	April	etc.	et cetera (and so forth)
My	May	f., ff.	following (singular and plural)
Je	June	i.e.	id est (that is)
Jy	July	illus.	illustrated, illustration(s)
Ag	August	incl.	including
Se	September	Jrg.	Jahrgang (year)
O	October	N.F.	Neue Folge (new series)
N	November	no., nos.	number, numbers
D	December	n.s.	new series
		o.s.	old series
		p., pp.	page, pages

* indicates an item not personally
 seen by the bibliographer
Aufl. Auflage (edition)
Bd. Band (volume)
bibl. bibliography, bibliographical
c19-- copyright and year
col. color

pl., pls. plate, plates
port., ports. portrait, portraits
pseud. pseudonym
ser. series
v., vol., vols. volume, volumes
verb. verbessert (corrected)
verm. vermehrt (enlarged)

PERIODICALS

A dagger (†) indicates turn-of-the-century periodicals
that have been fully indexed for their Art Nouveau
contents. A double dagger (‡) indicates recent periodicals
that contain a substantial amount of material on Art
Nouveau; these have been fully indexed for their Art
Nouveau contents through 1971.

‡AMK	Alte und moderne Kunst
AV	Antichità Viva: rassegna d'arte
‡Apollo	Apollo: the magazine of the arts
†Arch Rec	The architectural record
Arch Rev	The architectural review
Arch d'Auj	L'Architecture d'aujourd'hui
Arch et U	Architecture et Urbanisme; *see* Emulation
Arch u W	Architektur und Wohnform; *see* Zeitschrift für Innendekoration
Archtt	L'Architettura: cronica e storia

Art Bull	The art bulletin
Art Fr	Art de France
†Art Dec	L'Art décoratif: revue de la vie artistique, ancienne et moderne
†Art & Dec	Art & (et) décoration
Art Int	Art international
Art J	Art journal
†Art Mod	L'Art moderne
†Arte Decor	L'Arte decorativa moderna
Arts Mag	Arts magazine
†Br Archw	Berliner Architekturwelt: Zeitschrift für Baukunst, Malerei, Plastik und Kunstgewerbe der Gegenwart
Burl	The Burlington magazine
‡CHVV	Cahiers Henry Van de Velde
Csbl	Casabella: rivista di urbanistica e disegno industriale
‡Cons des Arts	Connaissance des arts
Conss	The Connoisseur
†Cfm	The Craftsman
†Dek K	Dekorative Kunst
†DKD	Deutsche Kunst und Dekoration: illustrierte Monats-Hefte für moderne Malerei, Plastik, Architektur, Wohnungskunst u. Künstler
Domus	Domus: architettura, arredamento, arte
†Emp	Emporium: rivista mensile illustrata d'arte, letteratura, scienza e varieta
†Emul	Emulation
GBA	Gazette des Beaux Arts
†HW	Hohe Warte: illustrierte Halbmonatsschrift für die künstlerischen, geistigen und wirtschaftlichen Interessen der städtischen Kultur
IKZID	Illustrierte kunstgewerbliche Zeitschrift für Innen-Dekoration; *see* Zeitschrift für Innendekoration
‡IHA	L'Information d'histoire de l'art
†InnDek	Innen-Dekoration; *see* Zeitschrift für Innendekoration
†Intr	Das Interieur: Wiener Monatshefte für Wohnungsaustattung und angewandte Kunst
‡JGS	Journal of glass studies
Joventut	Joventut, periódich catalanista: art, ciencia, literatura
†Kunst	Die Kunst: monatshefte für freie und angewandte Kunst
‡KHM	Kunst in Hessen und am Mittelrhein
†KKhw	Kunst und Kunsthandwerk: Monatsschrift herausgegeben vom Oesterreichischen Museum fuer Kunst und Industrie
†Kgwb	Kunstgewerbeblatt
Kwk	Das Kunstwerk: eine Zeitschrift über alle Gebiete der bildenden Kunst
†MB	Moderne Bauformen: Monatshefte für Architektur und Raumkunst
Oeil	L'Oeil: revue d'art mensuelle

†Pan	Pan
†Plume	La Plume: littéraire, artistique, philosophique
Rep K	Repertorium für Kunstwissenschaft
†Rev Arts Dec	Revue des arts décoratifs
†Studio	The studio: an illustrated magazine of fine and applied arts
†VS	Ver Sacrum: Mitteilungen der Vereinigung Bildender Künstler Oesterreichs
Werk	Werk
†ZfB	Zeitschrift für Bücherfreunde: Monatshefte für Bibliophilie und verwandte Interessen
†ZfIn	Zeitschrift für Innendekoration

The supplementary list below includes those periodicals that are cited only once or twice in the bibliography.

Académie Royale des Sciences, des Lettres, et des Beaux-Arts de Belgique, Brussels. Classe des Beaux-Arts. Bulletin
American artist
Architects year book
Architectural design
Der Architekt
Archiv für deutsche Postgeschichte
Art and artists
Art news
Arts et métiers graphiques
Arts review
Association Henry Van de Velde. Bulletin
Aufbau
Bizarre
Carnegie magazine
Construction moderne
Contemporary review
Du Atlantis
L'Estampille
Forum
Gand artistique
Gebrauchsgraphik
Gesellschaft für vergleichende Kunstforschung in Wien. Mitteilungen
Goed wonen
Goya
Harvard Library bulletin
International Congress of the History of Art, 22nd, Budapest, 1969. Bulletin
Jardin des arts
K. Vlaamse Academie voor Wetenschappen, Letteren- en Schone Kunsten van België. Jaarboek
Kunstkultur

Maandblad voor beeldende kunsten
Magazine of art
La maison
Marsyas
Médecine de France
Mercure de France
Minotaure
Musées Royaux des Beaux-Arts de Belgique. Bulletin
Museums kunde
Nieuw vlaams tijdschrift
Österreichischen Galerie, Vienna. Mitteilungen
Revue d'art
Revue de littérature comparée
Revue du Louvre et des Musées de France
Rythme
Saarbrücker Hefte
Society of Architectural Historians. Journal
Studio international
Van nu en straks
Wallonia
Wallraf-Richartz Jahrbuch
World Review
Zodiac

ART NOUVEAU: AN ANNOTATED BIBLIOGRAPHY

ART NOUVEAU IN GENERAL

Art Nouveau books written since 1940
The basic monographs for studying the movement are Madsen, 1955 (item 17 in this bibliography), Pevsner, 1960 (19) and Schmutzler (25). Madsen, 1967 (16) and Selz (27) are general introductory texts. Several short, well-written introductions are those by Amaya (1), Barilli (2), and Pevsner, 1968 (20). Many of the books in this section have been translated into several languages.

1. Amaya, Mario. *Art Nouveau*. London: Studio; New York: Dutton, Dutton Vista pictureback 23, [1966]. 168 pp., illus., plates
Very good photographs. Reliable, short text on a general level.

*2a. Barilli, Renato. *Il Liberty*. Elite, le arti e gli stili in ogni tempo e passe. [Milano]: Frat. Fabbri, [c1966]. 157 pp., 67 col. illus.

2b. Barilli, Renato. *Art Nouveau*. London: Hamlyn; New York: Tudor, [1969, c1966]. 157 pp., 67 pls.
Translation of 2a. A well-written, short introductory essay. Beautiful photographs, particularly of the furniture.

3. Bini, Vittorio, and Trabuchelli, Angioletta. *L'Art Nouveau*. [Milano: G. de Silvestri], 1957. 123 pp., illus., bibl.
Surveys the rise and spread of Art Nouveau with emphasis on Italy. Small illustrations.

*4a. Cassou, Jean; Langui, Emile; and Pevsner, Nikolaus. *Les Sources du 20e siècle*. Paris: Editions des Deux Mondes, 1961. 365 pp., 400 illus., 52 col. pls.
See 4c for annotation.

*4b. Cassou, Jean; Langui, Emile; and Pevsner, Nikolaus. *The sources of modern art*. London: Thames & Hudson, [1962].

362 pp. illus., col. pls.
The British edition of 4a.

4c. Cassou, Jean; Langui, Emile; and Pevsner, Nikolaus. *Gateway to the twentieth century: art and culture in a changing world.* New York: McGraw, Hill, [1962]. 362 pp., 333 illus., 52 col. pls.
 Book based on the catalog *Les sources du XXe siècle* (63) of the exhibition held at the Musée National d'Art Moderne, Paris, in 1960. The catalog has more texts concerning Art Nouveau; however, see Pevsner text in present volume, pp. 229-60. Beautifully and copiously illustrated. Notes to illustrations, pp. 335-8. The U.S. edition of 4a.

*4d. Cassou, Jean; Langui, Emile; and Pevsner, Nikolaus. *Durchbruch zum 20. Jahrhundert: Kunst und Kultur der Jahrhundertwende.* München: G.D.W. Callwey, [1962]. 367 pp., 333 illus., 52 col. pls.
 German translation of 4a.

5. Champigneulle, Bernard. *L'Art Nouveau.* Paris: Somogy, [1972]. 287 pp., 257 illus. (part col.)
 A survey of the movement and its English antecedents. Excellent selection of illustrations.

6a. Cremona, Italo. *Il tempo dell'Art Nouveau, Modern'style, Sezession, Jugendstil, Arts and Crafts, Floreale, Liberty.* Per il tempo libero. [Firenze]: Vallechi, [1964]. 230 pp., 374 illus., 8 col. pls.
 A survey of Art Nouveau. Numerous black-and-white photographs. Biographical dictionary of artists, pp. 183-221.

6b. Cremona, Italo. *Die Zeit des Jugendstils.* München: Langen-Müller, [1964]. 215 pp. (incl. 197 illus.)
 German translation of 6a, but containing fewer illustrations. Biographical dictionary.

*7a. Delevoy, Robert L. *Dimensions du XXe siècle, 1900-1945.* Art, idées, histoire. Genève: Skira, [1965]. 236 pp., 60 illus., 60 col. pls.

7b. Delevoy, Robert L. *Dimensions of the 20th Century, 1900-1945*. [Geneva]: Skira, [1965]. 223 pp., illus., col. pls., bibl. Translation of 7a. A philosophical discussion of modern art, copiously illustrated with color plates. For Art Nouveau, see pp. 24-55.

8. Dingelstedt, Kurt. *Jugendstil in der angewandten Kunst: ein Brevier*. Braunschweig: Klinkhardt & Biermann, [1959]. 46 pp., 21 illus. (part col.)
A short survey of Art Nouveau with emphasis on Germany.

9. Hermand, Jost, ed. *Jugendstil*. Wege der Forschung 110. Darmstadt: Wissenschaftliche Buchgesellschaft, 1971. 507 pp., 41 illus.
A collection of eighteen important theoretical articles on Jugendstil dating from 1914 to 1964 and eleven articles on literary Jugendstil in Germany. Essays on art as follows: "Jugendstil und dekorativer Archaismus in der deutschen Malerei," by Richard Hamann; "Die entwicklungsgeschichtliche Bedeutung des Jugendstils," by Ernst Michalski; "Jugendstil. Begriff und Physiognomik", "Sinnlichkeit um die Jahrhundertwende", and "Zauberbann," by Dolf Sternberger; "Der Jugendstil," by Nikolaus Pevsner; "Jugendstil und neue Sachlichkeit" and "Die Frage einer Jugendstilmalerei" by Fritz Schmalenbach; "Umfang und Verdienste des 'Jugendstils'," by Peter Meyer; "Die Münchener Gruppe," by Friedrich Ahlers-Hestermann; "Der Jugendstil im deutschen Buch," by Walter Tiemann; "Vom 19. zum 20. Jahrhundert," by Hans Curjel; "Das Jugendstil-Ornament in der deutschen Buchkunst," by Maria Gräfin Lanckorońska; *"Pan:* Geschichte einer Zeitschrift," by Karl H. Salzmann; "Schrift im Jugendstil in Deutschland," by Roswitha Riegger-Baurmann; "Jugendstil," by Kurt Bauch; "Der Sinn des Art Nouveau," by Robert Schmutzler; "Kurzgefasster Rückblick auf den Jugendstil," by Jost Hermand. Reprinted from various journals and books.

10. Hofmann, Werner. *Grundlagen der modernen Kunst: eine Einführung in ihre symbolischen Formen*. Stuttgart: Alfred Kröner Verlag, Kröners Taschenausgabe 355, [1966]. 512 pp., 18 illus., 30 pls. (incl. 53 illus.), bibl.
See book index for appropriate citations.

11. Hofmann, Werner. *Turning points in twentieth-century art, 1890-1917.* Transl. by Charles Kessler. London: Allen Lane: New York: G. Braziller, [1969]. 286 pp., 155 illus., bibl. footnotes
 A survey of the period, which includes Art Nouveau and other transitional art movements.

12. Hope, Henry R. "The sources of Art Nouveau." Ph.D. dissertation, Harvard University, 1942. 350 pp., 230 illus., bibl., bibl. footnotes
 An important and monumental pioneer work dealing with the origins and early stages of Art Nouveau as it developed in Britain, France, and, especially, Belgium. Bibliography of ten pages. Available at some libraries on microfilm.

*13a. Hutter, Heribert. *Jugendstil.* Wien: Rosenbaum, [1965]. 56 pp., 20 col. pls.

13b. Hutter, Heribert. *Art Nouveau.* London: Methuen: New York: Crown, [1967]. 13 pp., 20 col. pls., bibl.
 Translation of 13a. Short essay, plus descriptions of the plates.

14. Huyghe, René, ed. *L'Art et le monde moderne.* Vol. 1:1880-1920. Paris: Larousse, [1970]. 391 pp., 1,202 illus. (part col.)
 A survey of modern art. See pp. 112-69 (illus. 335-556) and pp. 208-11. Includes some beautiful illustrations.

15. Lenning, Henry F. *The Art Nouveau.* The Hague: Martinus Nijhoff, 1951. 142 pp., 54 illus., bibl., bibl. footnotes
 This early monograph emphasizes Van de Velde and developments in France. Chapter on the expositions. Photographs from early journals. Although there are some errors, the book gives a good idea of the atmosphere in France at that time. Bibliography includes many journal articles from the 1900 period.

16. Madsen, Stephan Tschudi. *Art Nouveau.* . . London: Weidenfeld & Nicolson: New York: McGraw-Hill, World University Library, [1967]. 256 pp., 101 illus. (part col.), bibl., bibl. footnotes
 An authoritative introduction to the subject by a noted specialist. Attempts to define the style generally and as it appears in various art forms. Traces the historical rise and decline of the

movement. Many illustrations. Has been translated into
many languages.

17. Madsen, Stephan Tschudi. *Sources of Art Nouveau.* Oslo:
H. Aschehoug: New York: Wittenborn, [1956]. 488 pp., 264
illus., bibl.
 The definitive monograph on Art Nouveau and the point of
 departure for much that has been written since its publication.
 A survey of English and other nineteenth-century movements
 which led to Art Nouveau, as well as a survey of the movement
 itself. Numerous black-and-white illustrations. Extensive bibli-
 ography of older books, periodicals, and periodical articles.,
 pp. 451-70. Also available on microfilm: Ann Arbor, Mich.,
 University Microfilms, 1968. See nos. 78, 85, and 87 for re-
 views of this book.

18. Mráz, Bohumír, and Mrázovi, Marcela. *Secese.* [Praha]: Obe-
lisk, [1971]. 71, [16] pp., 24 pp. of col. illus., [64] pp. of pls. with
illus., bibl.
 Text in Czech. A general survey of Art Nouveau. Arranged by
 country with emphasis on Czechoslovakia (pls. 16-24; illus. 54-
 67; pp. 65-8).

19a. Pevsner, Nikolaus. *Pioneers of the modern movement from
William Morris to Walter Gropius.* London: Faber & Faber, [1936].
240 pp., illus.

19b. Pevsner, Nikolaus. *Pioneers of modern design from William
Morris to Walter Gropius.* Harmondsworth, Baltimore: Penguin,
(Pelican books A497) 1960 [c1936]. 255 pp., 147 illus., bibl.,
bibl. footnotes
 A pioneer work itself, the original edition (19a) was the first
 general monograph on Art Nouveau. Discusses the origins of
 and subsequent development of Art Nouveau and parallel con-
 temporary movements. The second edition (1949) has sharper
 illustrations than the third (1960). For the 1966 reprint a bib-
 liography of new literature has been added, pp. 241-2.

20. Pevsner, Nikolaus. *The sources of modern architecture and
design.* World of art series. London: Thames & Hudson: New York:

Praeger, [1968]. 216 pp. (incl. 198 illus.), bibl., bibl. footnotes
A short introductory essay on Art Nouveau and the transition
to modern architecture by a noted art historian. Text inter-
spersed with numerous photographs, mostly black-and-white.
Biographical notes, pp. 204-13.

21. Ponente, Nello. *The structures of the modern world, 1850-
1900.* [Transl. from the Italian.] [Geneva]: Skira: Cleveland:
World, [1956]. 210 pp., illus., col. pls.
A survey of nineteenth-century art touching briefly on Art
Nouveau. Excellent color photographs. A French-language edi-
tion was published simultaneously.

22a. Rheims, Maurice. *L'Art 1900, ou, le style Jules Verne.* Paris:
Arts et Métiers Graphiques, [1965]. 428 pp., 595 illus., 12 col. pls.
Book is arranged by art form (architecture, painting, and so
forth). Popular, short texts. Significant for its numerous illustra-
tions. All illustrations described individually, but on different
pages, making the book difficult to use. Index.

*22b. Rheims, Maurice. *The age of Art Nouveau.* London: Thames
& Hudson, [1966]. 450 pp., 595 illus., 12 col. pls.
The British edition of 22a.

22c. Rheims, Maurice. *The flowering of Art Nouveau.* New York:
Abrams, [1966]. 450 pp., 595 illus., 12 col. pls.
U.S. edition of 22a, in same format as French edition.

23a. Schaefer, Herwin. *Nineteenth century modern: the function-
al tradition in Victorian design.* New York: Praeger, [1970]. x,
211 pp., illus., bibl., bibl. footnotes
Reviews the development of applied arts since 1800, particu-
larly the non-artistic tradition in England. Does not view Art
Nouveau as innovative in functional design (pp. 163ff.).

*23b. Schaefer, Herwin. *Roots of modern design: functional tradi-
tion in the 19th century.* London: Studio Vista, 1970. xi, 211 pp.,
illus., bibl., bibl. footnotes
The British edition of 23a.

24. Schmalenbach, Fritz. *Kunsthistorische Studien.* Basel: The Author, 1941. 139 pp.
A collection of essays widely cited in bibliographies on Art Nouveau, because of the article "Jugendstil und neue Sachlichkeit," pp. 9-21. The problem of form and function and its origins in Jugendstil are discussed in the article, which originally appeared in *Das Werk* 24:129-34 (1937), and which was later reprinted in *Jugendstil*, ed. by Jost Hermand (9), pp. 65-77. Also of interest for the essays "Der Name 'Neue Sachlichkeit'," pp. 22-32, and "Grundlinien der Fruhexpressionismus," pp. 49-99, which discuss related movements.

25a. Schmutzler, Robert. *Art Nouveau—Jugendstil.* [Stuttgart]: Hatje, [1962]. 322 pp., 348 illus., 12 col. pls., bibl., bibl. footnotes.
A major monograph on the movement, perhaps second to Madsen's (17) in scope and depth. Emphasis is on the English proto-Art Nouveau (Blake, Pre-Raphaelites, and so forth). Blake's role is perhaps over-emphasized. Numerous illustrations. Bibliographic notes, pp. 281-6. Extensive bibliography, pp. 299-307. Notes to illustrations, pp. 308-17. Index. See 68 and 77 for reviews.

25b. Schmutzler, Robert. *Art Nouveau.* London: Thames & Hudson: New York: Abrams, [1964, c1962]. 322 pp., 348 illus., 12 col. pls., bibl., bibl. footnotes
Format follows the original German edition (25a). Major bibl.

26. Seling, Helmut, ed. *Jugendstil: der Weg ins 20. Jahrhundert.* Eingeleitet von Kurt Bauch. [Heidelberg]: Keysersche Verlagsbuchhandlung, [1959]. 459 pp., 356 illus. (incl. col. pls.), bibl.
An important collection of fifteen essays on various art forms of Art Nouveau, particularly in the decorative arts. General introductory essay by Kurt Bauch, and essays on other subjects as follows: architecture by Hans-Günther Sperlich; furniture by Klaus-Jürgen Sembach; painting by Hans H. Hofstätter; typography by Roswitha Baurmann; book design by Hans Platte; posters by Annemarie Hagner; sculpture by Berthold C. Hakkelsberger; porcelain by Erich Köllmann; glass by Hanns-Ulrich Haedeke; silverware and jewelry by Helmut Seling; tapestry by Gabriele Howaldt; carpets by Hans H. Hofstätter; theater deco-

ration by Gertrud Rudloff-Hille; aesthetic theory by Rudolf G. Köhler. Artists' biographies, pp. 430-46. Bibliographies are found after several of the essays, particularly on pp. 165-7, 211-14, and 304.

27. Selz, Peter, and Constantine, Mildred, eds. *Art Nouveau: art and design at the turn of the century.* New York: Museum of Modern Art, [1959]. 192 pp. [191] illus., bibl., bibl. footnotes
Four introductory essays on the movement: "Graphic design," by Alan M. Fern; "Painting and sculpture, prints and drawings," by Peter Selz; "Decorative arts," by Gerda Daniel; "Architecture," by Henry-Russell Hitchcock. Catalog to the museum's exhibition of 304 items with biographies of the artists (pp. 162-85). Important bibliography of 288 books and periodical articles by James Grady, p. 152ff. Many good illustrations. Reprinted by the Arno Press, New York, 1972. For reviews see 69 and 81.

28. Sternberger, Dolf. *Über den Jugendstil und andere Essays.* Hamburg: Claassen, [1956]. 253 pp.
Includes the title essay, pp. 11-28, which was also published in *Jugendstil*, edited by Jost Hermand (9), pp. 27-46.

29. Wallis, Mieczyslaw. *Secesja.* [Warszawa]: Arkady, 1967. 343 pp., 189 illus., 5 col. pls., bibl., bibl. footnotes
Comprehensive monograph on the Art Nouveau movement in general, including Russia, p. 129ff., and Poland, pp. 136-86. Text in Polish with a brief English summary (pp. 335-8). Valuable for numerous illustrations. Extensive bibliographic notes, pp. 292-317.

30. Warren, Geoffrey. *All color book of Art Nouveau.* [London]: Octopus Books, [1972]. 70 pp., 101 col. illus.
Beautiful color photographs of Art Nouveau art objects and architecture. Introduction, pp. 4-14.

ALSO SEE: 1442, 1581

General books written before 1940

31. Behrendt, Walter Curt. *Der Kampf um den Stil im Kunstge-
werbe und in der Architektur.* Stuttgart: Deutsche Verlags-Anstalt,
1920. 276 pp., 29 illus.
A comprehensive study of Art Nouveau decor and architecture
in the context of its historical development and the social and
practical problems it faced. Written in 1912 but delayed by the
war. Preface by Henry van de Velde.

32. Bénédite, Léonce. *Histoire des beaux-arts, 1800-1900.* Paris:
Flammarion, [1909]. 738 pp., illus.
Pages 613-714 cover Art Nouveau and parallel movements.

33. [Cazalis, Henri]. *L'Art Nouveau, son histoire, l'Art Nouveau
étranger à l'Exposition, l'Art Nouveau au point de vue social,* par
Jean Lahor [pseudonym]. Paris: Lemerre, 1901. 104 pp.
The rise and spread of Art Nouveau and its triumph at the Paris
Exposition of 1900. The author's hope for a people's art. No
illustrations. Copy at the Fogg Art Library, Harvard University.

34. Fred, W. [pseudonym of Alfred Wechsler]. *Modernes Kunst-
gewerbe: Essays.* Ueber Kunst der Neuzeit 6. Strassburg: Heitz,
1901. viii, 128 pp., bibl.
An early history of Art Nouveau and its origins. Includes Crane,
Ashbee, Baillie Scott, Van de Velde, Obrist, Gallé, Lalique, Tif-
fany, Wagner and Olbrich. No illustrations. Copy at the Avery
Library, Columbia University.

35. Graul, Richard, ed. *Die Krisis im Kunstgewerbe: Studien über
die Wege und Ziele der modernen Richtung.* Leipzig: S. Hirzel,
1901. viii, 237 pp.
Thirteen essays by various authors on the new art movements in
six countries and in six art forms. Includes essays on England by
Muthesius and on the 1900 Exposition by Fritz Schumacher. No
illustrations.

36. Haack, Friedrich. *Die Kunst des XIX. Jahrhunderts.* Grundriss
der Kunstgeschichte, von Wilhelm Lübke, Bd. 5. Esslingen a.N.:
Neff, 1913. 632 pp., illus., pls.

Fifteenth edition examined. Chapter 4, "Die Moderne," gives a general background. Will be cataloged under Wilhelm Lübke in most libraries as volume 5 of his *Grundriss der Kunstgeschichte.*

37. Haeckel, Ernst. *Kunstformen der Natur.* Leipzig, Wien: Verlag des Bibliographischen Instituts, [1899-1904]. Heft 1-10 [und Supplement Heft] 100 plates
 These illustrations of deep-sea life had great influence on Art Nouveau artists. Selections from this collection were published in 1914 and 1924.

*38. Kalas, Blanche (Truchon). *De la Tamise à la Spree, l'essor des industries d'art,* par B.E. Kalas. Quatre conférences faites à l'Académie Nationale de Reims. Reims: L. Michaud, 1905. 138 pp.
 An early account of the rise of Art Nouveau. Copy in the Bibliothèque Nationale, Paris.

39. *Magazine of Art.* "L'Art Nouveau, what is it and what's thought of it: a symposium." [London]. v. 28, (*or* n.s., vol. 2):209-13, 259-64, 324-7, 377-81 (Mr-Je 1904) 9 illus.
 An inquiry concerning Art Nouveau by F.S. Blizard and the reactions of thirty-seven English artists. The remarks are largely unfavorable and arch. Contributors include Crane, Voysey, and Alfred Gilbert.

40a. Meier-Graefe, Julius. *Entwicklungsgeschichte der modernen Stil: vergleichende Betrachtung der bildende Künste, als Beitrag zu einer neuen Aesthetik.* Stuttgart: Verlag Jul. Hoffmann, 1904. 3 vols. xi, 770 pp., 62 illus. in vols. 1-2; 208 pls. in vol. 3
 The first edition of Meier-Graefe's pioneer work in art history has the most expanded text of his *Fünftes Buch: Der Kampf um den Stil,* with sections on William Morris, English book design, and Beardsley and his circle (vol. 2, p. 581ff), as well as a section on Art Nouveau in Belgium, France, and Holland (vol. 2, p. 627ff) and in Austria and Germany (vol. 2, p. 677ff). These were omitted in the later German editions and in the English translations.

40b. Meier-Graefe, Julius. *Entwicklungsgeschichte der modernen Kunst.* Nach der dritten Auflage, neu herausgegeben von Benno

Reifenberg und Annemarie Meier-Graefe-Broch. München: R. Piper, Piper paperback, [1966]. 2 vols. 778 p., 24 illus., 46 pls.
This selection of chapters from an important work has none of the material on Art Nouveau. This edition is significant for the added material, which includes an introduction on Meier-Graefe (pp. 9-38) and the introductions to the four original German editions (1904, 1913, 1920, 1924), pp. 39-47. Appendixes at end of vol. 2.

40c. Meier-Graefe, Julius. *Modern art, being a contribution to a new system of aesthetics.* From the German by Florence Simmonds and George W. Chrystal. London: Heinemann; New York: Putnam, 1908. Vol. 2, ix, 337 pp., pls.
An English translation of 40a. Essays on Minne, Munch, Beardsley, and the movement in general (pp. 235-324). Reprinted in 1968 by the Arno Press, New York.

41. Michel, André. *Histoire de l'art.* Vol. 8, part 3. Paris: A. Colin, 1929. pp. 924-1256, illus., bibl.
Chapter 27, "La Renaissance des arts décoratifs à la fin du XXe siècle," par Paul Vitry, pp. 1205-28. Also see chapter 22 on Dutch and Belgian architecture by Vitry.

42. *Der Moderne Stil: eine internationale Rundschau über die besten Leistungen der auf gewerblichem Gebiete thätigen Kunstler unserer Zeit, mit besonderer Berücksichtigung des Auslandes.* Stuttgart: Julius Hoffmann, 1899-1905. 7 vols., illus.
Annual anthology of photographs of Art Nouveau decorative arts from all countries, especially France and England. Each volume is in folio format and contains about one hundred monochrome plates, with four to eight photographs per plate. No index. No text. Cited under Hoffmann in many bibliographies.

43. Mourey, Gabriel. *Les Arts de la vie et le règne de la laideur.* Paris: Ollendorf, [1899]. 132 pp.
Two essays commenting on the esthetic situation of the 1890s.

44. Muthesius, Hermann. *Kultur und Kunst.* 2. Aufl. Jena: Eugen Diedrichs, 1909. viii, 155 pp.
Five essays on general esthetic questions and on architecture. First published in 1904.

45. Muthesius, Hermann. *Kunstgewerbe und Architektur.* Jena: Eugen Diedrichs, 1907. 149 pp.
Five essays on the esthetics of architecture and the decorative arts. One chapter is on the English house.

46. Obrist, Hermann. *Neue Möglichkeiten in der bildende Kunst: Essays.* Leipzig: Diedrichs, 1903. 168 pp., 1 pl.
Seven essays written by the artist which deal with the esthetic problems of Art Nouveau. Copy at the Fogg Art Library, Harvard University.

47. Scheffler, Karl. *Eine Auswahl seiner Essays aus Kunst und Leben, 1905-1950.* Herausgegeben und kommentiert von Carl Georg Heise und Johannes Langner. Hamburg: Hauswedell, 1969. 187 pp.
Includes short essays on Van de Velde, Hodler, Osthaus, and Th. Th. Heine.

48. Waentig, Heinrich. *Wirtschaft und Kunst: eine Untersuchung über Geschichte und Theorie der modernen Kunstgewerbebewegung.* Jena: G. Fischer, 1909. v, 434 pp.
A history of the applied arts movement, tracing its rise in England and its diffusion in Europe and the United States.

49. Wenke, Friedrich Wilhelm. "Die Prinzipen des modernen Kunstgewerbes." Inaugural-Dissertation. Friedrich-Alexander-Universität Erlangen. Erlangen: Junge & Sohn, 1908. 80 pp., bibl., bibl. footnotes
Early dissertation on the development and principles of Art Nouveau. Traces the same historical development as the later literature. Bibliographic information, pp. 74-80. No illustrations. Copy in the New York Public Library.

General exhibitions held since 1952

50. Baden-Baden. Staatliche Kunsthalle. *Aus der Zeit um 1900.* Baden-Baden, 1958. Unpaged, 40 illus.
Exhibition catalog of 290 items listed on green paper in middle of catalog. Texts by Klaus Lankheit, Hans Gerhard Evers, Clemens Weiler, Hans A. Halbey, and H. Lanzke.

51. Berlin. Staatliche Museen. *Art Nouveau und Jugendstil: Kunstwerke aus dem Besitz der Staatlichen Museen Preussischer Kulturbesitz. Ausstellung in der Kunsthalle zu Kiel, 1970,* [und] *in den Staatlichen Museen Preussischer Kulturbesitz in Berlin, 1971.* Berlin, 1971. 97 pp., 101 illus. (part col.), bibl.

Exhibition catalog of 213 items from various countries. Contents, bottom of p. 10. Bibliography with each item. Biographies of the artists. Introductory essay by Ekhart Berckenhagen. Index. Cataloged by Library of Congress under Berckenhagen.

52. Berlin. Staatliche Museen. *Stilkunst um 1900 in Deutschland.* Berlin, 1972. 237 pp., illus., 8 col. pls. pls, 291 illus., bibl.

Exhibition catalog of 976 items, pp. 123-210. Includes painting, graphic art, and decorative art of all countries, despite the title of the catalog, but emphasis is on Germany. Texts by Hans Ebert, Willi Geismeier, Claude Keisch, Günther Schade, Rolf Karnahl, George Brühl, and Katharina Flügel-Lindenlaub (pp. 9-112). "Chronologie der Stilbewegung," by Claude Keisch, pp. 113-22. Note sections on periodicals, pp. 69-86 and 142-7. Bibl., pp. 212-37. List of illustrations in text, pp. [238-9]. No index.

53. Bremen. Kunsthalle. *Europäischer Jugendstil: Druckgraphik, Handzeichnungen und Aquarelle, Plakate, Illustrationen und Buchkunst um 1900 aus dem Besitz der Kunsthalle Bremen.* Bremen, 1965. 227 pp. (incl. 89 pls.), bibl.

Exhibition of 599 items owned by the Bremen museum. For arrangement of the catalog see pp. 39 and 121. Introduction and essay by Günther Busch (pp. 5-26); "Der Japonismus Bonnard, Vuillard und Lautrec," by Christian von Heusinger, pp. 27-31; "Stimmung und Gestimmtheit: Grundlagen der Kunst um 1900," by Henning Bock, pp. 35-8. Index, pp. 216-27.

54. Frankfurt am Main. Museum für Kunsthandwerk. *Jugendstil: Führer durch die Ausstellung.* Herausgegeben vom Mitteldeutschen Kunstgewerbeverein. Frankfurt a.M., 1955. 48 pp., 8 pls.

Exhibition catalog of 485 items. No contents page. Index. Short texts by Eo Graf zu Soms and Dolf Sternberger. One of the earliest exhibitions reflecting revived interest in Art Nouveau.

55. Grosvenor Gallery, London. *Art Nouveau...* London, 1965.

[12] pp., [8] pls.
 Exhibition of 393 items, including graphic and decorative arts.
 Two page essay by Martin Battersby. Exhibition reviewed in
 item 67.

56. Item number not used.

57. Michigan. University. Museum of Art. *Art Nouveau sampler.*
Ann Arbor [1962?]. Unpaged, [3] illus.
 Introduction by Miriam Levin and Robert Mode. Mimeograph
 catalog of seventy-three objects from all countries.

58. Munich. Haus der Kunst. *Secession: europäische Kunst um
die Jahrhundertwende.* München, 1964. 136 pp., 61 illus., 6 col.
pls.
 Comprehensive general exhibition of 1,236 objects. Essay,
 "Secession—Secessio plebis," pp. 1-19, by Siegfried Wichmann on
 the various Secession movements in Europe and in Japan. Cata-
 log is divided into two sections, "Malerei und Graphik," pp. 21-
 84, and "Plastik und Kunsthandwerk," pp. 85-136. Arranged
 alphabetically by artist within each section. Another essay by
 Wichmann, pp. 86-91.

59. New London, Conn. Lyman Allyn Museum. *Art Nouveau.*
Ed. by Jane Hayward. New London, Conn., 1963. 62 pp., 31 illus.
 Exhibition of 243 items. Introduction by Robert Koch.

NOTE: An Art Nouveau exhibition was held at Ostend, Belgium in
1967. For this event three distinct catalogs (60-2) were issued
which should not be confused with one another.

60. Ostend. Kursaal. *Europa 1900.* [Album]. Bruxelles: Editions
de la Connaissance, [1967]. Unpaged, 167 illus. (part col.)
 Cover title: *Europa 1900, Ostende.* Numerous photographs of
 Art Nouveau objects from various countries. No text. Exhibi-
 tion was held to honor Ostend's 700th anniversary.

61. Ostend. Kursaal. *Europa 1900...* Bruxelles: Editions de la
Connaissance, [1967]. 92 pp.
 Includes essays on Art Nouveau by Robert Guiette, Bruno Zevi,

François Mathey, G. Bott, Y. Oostens-Wittamer, as well as essays on cinema and photography. All texts in French. Catalog listing of 1,112 items, pp. 55-92. No table of contents. No illustrations.

62. Ostend. Musée des Beaux-Arts. *Europa 1900: peintures— dessins—sculptures—bijoux...* Bruxelles: Editions de la Connaissance, [1967]. 48 pp., pls. (77 illus.), 10 col. pls.

Essays by Emile Langui and Karel Citroen (on jewelry). Remainder of text is a catalog of 310 items, which include biographies of the artists.

63. Paris. Musée National d'Art Moderne. *Les Sources du XXe siècle: les arts en Europe de 1884 à 1914.* Paris, 1960. lviii, 443 pp., 83 illus., bibl.

Exhibition catalog of 1,587 items. Includes biography with each artist and bibliography with each item. All texts in French. No table of contents. Introductory text by Jean Cassou, pp. vii and xiii-xxvii; "Les Arts plastiques," by Giulio Carlo Argan, pp. xxix-xxxix; and "L'Architecture et les arts appliqués," by Nikolaus Pevsner, pp. xli-lvi. Catalog divided into two sections: "Arts plastiques," with brief texts by various authors, pp. 1-12, followed by alphabetical catalog of artists, pp. 13-254; and "Architecture et arts décoratifs," with texts on pp. 259-76 and alphabetical catalog of artists on pp. 277-410. Most Art Nouveau content is in the second section. There is no general index. Some of the texts were adapted for later publication as a book (4), but many pertinent to Art Nouveau were not included.

64. Piccadilly Gallery, London. *Art Nouveau: glass, objects, furniture, pictures, etc.* London, [1964]. 24 pp., 48 illus.

Catalog of 316 items. No text. Small black and white photographs.

65. Virginia Museum of Fine Arts, Richmond. *Art Nouveau: a loan exhibition at the Virginia Museum.* [Richmond, Va.], 1971. 39 pp., 16 pls. (part col.), bibl.

Exhibition catalog of 221 items, with a short essay by Frederick R. Brandt. Beautiful color photographs.

66. Zurich. Kunstgewerbemuseum. *Um 1900, Art Nouveau und*

Jugendstil: Kunst und Kunstgewerbe aus Europa und Amerika zur Zeit der Stilwende. 2. verb. Aufl. Zurich, 1952. 48 pp., 24 pls., bibl.

This pioneer exhibition of Art Nouveau heralded a revival of interest in the movement. The general essay by Hans Curjel was reprinted in *Jugendstil*, ed. by J. Hermand (9), pp. 123-44. See also item 71. Includes texts by Art Nouveau artists in the original languages.

Journal articles published since 1930

67. Amaya, Mario. "London galleries: some major aspects of Art Nouveau." *Apollo* 83:68-9 (Ja 1966). 6 illus.

An appreciation of the Art Nouveau collection of Martin Battersby on exhibit at the Grosvenor Gallery (see item 55).

68. "Art Nouveau: then and now..." *Print*, vol. 18, no. 6:16-23 (N-D 1964). 26 illus.

A short note on Schmutzler's book, *Art Nouveau* (25). Illustrations compare design motifs of the 1960s with the older Art Nouveau.

69. Collins, George R. "Some reflections on the Art Nouveau." *Art Int*, vol. 4, no. 7:63-72 (Se 1960). 23 illus.

An attempt to define Art Nouveau, written on the occasion of the exhibition at the Museum of Modern Art, New York (see item 27). "Supplementary note on the Art Nouveau exhibition," p. 71.

70. Cremona, Italo. "Discorso sullo Stile Liberty." *Sele Arte*, vol. 1, no. 3:15-22 (N-D 1952). 16 illus., 1 col. pl.

A brief survey of the Art Nouveau movement.

71. Curjel, Hans. "Um 1900." *Werk* 39:402-6 (D 1952). 36 illus. (pp. 381, 393-406)

Reprinted from the exhibition catalog of the Kunstgewerbemuseum in Zurich (66). Also see: "Zur Einführung," p. 381; "Worte der Pioniere," pp. 389-92, comprising quotations from Art Nouveau architects; and item 72 below.

72. Curjel, Hans. "Konfrontationen: Formensprache um 1900
und Gestaltungsmethoden des 20. Jahrhunderts." *Werk* 39:382-8
(D 1952). 16 illus.
 The 1890s viewed as a decade of transition to modern art. Inter-
 esting juxtapositions of Art Nouveau and modern motifs. Eng-
 lish and French summaries inserted in front of magazine.

73. Dali, Salvador. "De la beauté terrifiante et comestible de
l'architecture modern'style." *Minotaure* no. 3-4:68-76 (D 1933).
22 illus.
 An early, if bizarre, appreciation of the Art Nouveau style in
 which Dali celebrates its edibility. Reprinted in *Dali on modern
 art* (New York: Dial, 1957), pp. 31-45 (English text): pp. 113-
 27 (French text).

74. "Editorial—a fresh look at the Fin de Siècle." *Apollo* 83:2-9
(Ja 1966). 8 illus., 2 pls.
 Notes a new interest in art movements of the late nineteenth
 century. This issue was devoted to the 1890s.

75. Fitzgerald, D., and Fitzgerald, P.M. "Editorial, Art Nouveau."
World Review, n.s. no. 47:14-22 (Ja 1953). 6 illus., 11 illus. on 4
pls. (p. 32ff.)
 Introductory article to a special issue on Art Nouveau, listing
 five principles of the movement and an inventory of its rise in
 seven countries.

76. Grady, James. "Nature and the Art Nouveau." *Art Bull* 37:
187-92 (Se 1955). 8 illus.
 Nature is cited as a dominant influence in Art Nouveau.

77. Hoffmann, Edith. Review of *Art Nouveau*, by Robert Schmutz-
ler. *Burl* 110:225-6 (Ap 1968)
 This review of Schmutzler's book (25) is a survey of the move-
 ment in its own right.

78. Jacobus, John M. Jr. Review of *Sources of Art Nouveau...*,
by Stephan Tschudi Madsen. *Art Bull* 40:364-73 (D 1958)
 This extensive critique of Madsen's book (17) deals with the
 problem of defining Art Nouveau.

79. Köhler, Rudolf G. "Programmatische Künstlerschriften." In *Jugendstil, der Weg in 20. Jahrhundert*, ed. by Helmut Seling, pp. 403-29 (26)

Esthetic theory, with quotes from the work of Otto Wagner, Berlage, Van de Velde, Obrist, Endell, and Behrens.

80. "De kortstondige glorie van de gevoelige, vloeiende lijn." *Elegance* (Amsterdam) 23:84-8, 128-32 (Se 1966). 15 illus.

A general article on Art Nouveau in a Dutch women's magazine.

81. Kramer, Hilton. "The erotic style: reflections on the exhibition of 'Art Nouveau'." *Arts*, vol. 34, no. 10:22-6 (Se 1960). 16 illus.

This reaction to the 1959 exhibition at the Museum of Modern Art, New York, (see item 27) rejects Art Nouveau as art.

82. Lemaire, Claudine. "Le Style 1900: réalité ou mythe? A propos de l'exposition d'Ostende, 'Europe 1900'." *CHVV*, no. 9-10: 58-62 (1968). Bibl. footnotes

An essay which questions the unity of Art Nouveau as a style.

83. Madsen, Stephan Tschudi. "Il simbolismo dell'Art Nouveau." *Edilizia Moderna*, no. 86:31-5 [1965]. 16 illus.

On the mood and symbolism of Art Nouveau. Motifs of movement, flora, fauna, and woman.

*84. Meyer, Peter. "Umfang und Verdienste des 'Jugendstils'." *Werk* 24:134-70 (1937)

Reprinted in *Jugendstil*, ed. by Jost Hermand (9), pp. 78-86.

85. Pevsner, Nikolaus. "Beautiful and, if need be, useful." *Arch Rev* 122:297-9 (N 1957). 6 illus.

A response to Madsen's *Sources of Art Nouveau* (17), discussing the ambiguities of defining Art Nouveau.

86. Praz, Mario. "Art Nouveau." In *J.P. Hodin, European critic: essays by various hands... published as a tribute on his 60th birthday*, ed. by Walter Kern. London: Cory, Adams & Mackay, [1965]. pp. 50-8

A literary essay on the movement in general.

87. Rossi, Aldo. "A proposito di un recente studio sull'Art Nouveau." *Casabella Continuità*, no. 215:44-6 (Ap-My 1957). 8 illus.
A review of Madsen's *Sources of Art Nouveau* (17). English summary, p. xii; French, p. v.

88. Item number not used.

89. Schmutzler, Robert. "The English origins of Art Nouveau." *Arch Rev* 117:108-17 (F 1955). 33 illus., bibl. footnotes
A pioneer article on English stylistic influences on Art Nouveau, based on the author's thesis and foreshadowing his major book (25).

90. Sternberger, Dolf. "Jugendstil: Begriff und Physiognomik." *Neue Rundschau* 2:255-71 (1934)
On the major characteristics of the movement. Reprinted in *Jugendstil*, ed. by Jost Hermand (9), pp. 27-46.

*91. Sternberger, Dolf. "Zauberbann: anlässlich einer Jugendstil-Ausstellung im Zürcher Kunstgewerbemuseum." *Gegenwart*, no. 164 (Se 13, 1952)
On the magic atmosphere generated by Art Nouveau creations. Reprinted in the author's *Über den Jugendstil und andere Essays*, pp. 129-38 (28) and *Jugendstil*, ed. by Jost Hermand (9), pp. 145-55.

92. Thompson, Jan. "The role of woman in the iconography of Art Nouveau." *Art J* 31:158-67 (Winter 1971/72). 20 illus., bibl. footnotes
The social and esthetic background of the portrayal of woman by various Art Nouveau artists.

93. Waldberg, Patrick. "Modern Style." *Oeil*, no. 71:48-61, 90 (N 1960). 25 illus.
The atmosphere of Art Nouveau, particularly in Paris.

Journal articles published around 1900

94. Abels, Ludwig. "Interieur-Kunst." *Intr* 1:49-54 (1900)
The esthetics of interior design.

95. Berlepsch-Valendas, H.E. von. "Ansichten." *Kgwb,* N.F. 13: 125-43 (1902). 28 illus. (pp. 125-44)
Illustrated with examples of the author's work.

96. Bing, S. "L'Art Nouveau." *Arch Rec* 12:279-85 (Ag 1902). 6 illus.
Bing defines Art Nouveau and his relation to it.

97. Bing, S. "L'Art Nouveau." *Cfm* 5:1-15 (O 1903). 15 illus.
A defense and a survey of the movement by the man who gave it its name. Illustrated with examples of the "Art Nouveau Bing" group.

98. Bing, S. "Wohin treiben Wir?" *Dek K* 1:1-3, 68-71, 173-7 (1898)
An article in three installments on the English origins and the general principles of Art Nouveau.

99. Bode, Wilhelm. "Künstler im Kunsthandwerk." *Pan* 3:40-6, 112-20 (1897). 11 illus., 2 pls.
In two installments. See part 2, pp. 112-20, "Die Abteilung der Kleinkunst in den Internationalen Ausstellungen zu München und Dresden 1897."

100. Champier, Victor. "Les Expositions de 'l'Art Nouveau'." *Rev Arts Dec* 16:1-6 (1896)
The first exhibits in S. Bing's boutique.

101. Commichau, Felix. "Kritische Umschau..." *InnDek* 13:230-2 (Se 1902). 18 illus., 2 pls. (pp. 234-45, 248)
Includes the Wiener Secession (Hoffmann, Bauer), Turin (Behrens), and other expositions.

102. Croly, Herbert. "The New World and the new art." *Arch Rec* 12:135-53 (Je 1902) illus.
An analysis of Art Nouveau, citing the articles of Guimard (1610) and A. Charpentier (1466) in the same journal, and on the need for the movement in the United States.

103. Ernst, Otto. "Die Kunst und die Massen." *Pan* 2:309-12 (1896)

104. [Meier-Graefe, Julius]. "Moderne kunstgewerbliche Ausstellungen." *Dek K* Jrg. 1 (Bd. 1):28-37 (1898, Heft 1). 11 illus.
Architecture and interiors of various Art Nouveau exhibitions including Art Nouveau Bing by the architect Bonnier.

105. Grävell, A. "Die Grundlagen der künstigen Entwicklung des Stils in der dekorativen Kunst." *InnDek* 11:110-18 (Jy 1900)
A critic of the "new style".

106. Hamlin, A.D.F. "L'Art Nouveau: its origin and development." *Cfm* 3:129-43 (D 1902)
A critical article on the movement.

107. J. "L'Art industriel." *Art Dec* 1:253-6 (Mr 1899)
The esthetic and social problems of mass-produced art.

108. Jacques, G.M. "Les Limites du décor." *Art Dec* 3:141-4 (Ja 1900)
The relation between the art value of an object and its decorative value.

109. Jacques, G.M. "Paradoxes." *Art Dec* 9:2 pp. following p. 120 (Mr 1903)
A note on the esthetic principles of modern art.

110. Jacques, G.M. "Utopie?" *Art Dec* 2:185-9 (Ag 1899) 3 illus.
Esthetics, mechanization, and jewelry. Comment on remarks of Arsène Alexandre.

111. [Koch, Alexandre]. "Zu den Abbildungen dieses Heftes." *InnDek* 13:34-5 (Ja 1902). 26 illus. (pp. 14-15, 24-40), 1 col. pl.
Work of Valentin Mink, Van de Velde, J. Hoffmann, Plumet & Selmersheim, and a plate of Baillie Scott's *Haus einer Kunstfreundes.*

112. "Korrespondenzen." *Dek K* 1:42-53 (1898, Heft 1). 14 illus.
Art Nouveau activity in Berlin, Munich, Hamburg, Dresden, London, Glasgow, Amsterdam, and Brussels (by Van de Velde).
Motifs by Endell, pp. 14-15, 21.

113. Kühn, Paul. "Nicola Perscheid und die bildnis mässzige Photographie." *DKD* 15:147-65 (D 1903). 15 illus., 1 col. pl.
Includes portraits of Th. Th. Heine, Ernst Haeckel, and Van de Velde.

114. "Künstlerische Cultur." *Intr* 3:129-41 (1902)
The role of the artist in nineteenth-century culture, with reviews of books by Graul and Von Kunowsky.

115. Kurzwelly, Albrecht. "Die Pflanze in ihrer dekorativen Verwertung: Ausstellung im Leipziger Kunstgewerbemuseum." *Kgwb* N.F. 14:125-36 (1903). 21 illus. (pp. 125-44)

116. Locke, Josephine C. "Some impressions of l'Art Nouveau." *Cfm* 2:201-4 (Jy 1904)
A favorable impression of the movement.

117. Lux, Joseph Aug. "Die Anfänge der modernen Bewegung rund um Deutschland." *Kgwb*, N.F. 19:61-70 (1908)
On the Art Nouveau movement in general, with specific reference to *Pan.*

118. [Meier-Graefe, J.]. "Epigonen." *Dek K* Jrg. 2 (Bd. 4):129-31 (1899, Heft 10)
Early observation on the degeneration of Art Nouveau in France and Belgium. Also discusses Hankar (11 illus., pp. 162-7).

119a. [Meier-Graefe, J.] "Floral-Linear." *Dek K* Jrg. 2 (Bd. 4):169-72, 1899, Heft 11)
The floral versus linear (or abstract) argument in Art Nouveau, which involved Van de Velde. Illustrated with drawings of Richard Grimm (also see p. 208).

119b. Meier-Graefe, J. "Ornement floral, ornement linéaire." *Art Dec* 2:234-6 (Se 1899). 13 illus. (pp. 262-71)
A French translation of 119a signed by Meier-Graefe; illustrated by Van de Velde's work.

120. Mielke, Robert. "Ueber intime Kunst." *InnDek* 10:185-90 (D 1899)

121. Monod, François. "L'Art décoratif à l'Exposition Internationale de Milan." *Art & Dec* 20, supplément:1-3 (N 1900)

122. Muthesius, H. "Kunst und Maschine." *Dek K* Jrg. 5 (Bd. 9): 141-7 (Ja 1902); or *Kunst* Bd. 6:141-7 (Ja 1902)

123. Muthesius, H. "Neues Ornament und neue Kunst." *Dek K* Jrg. 4 (Bd. 8):349-66 (Je 1901); or *Kunst* Bd. 4:349-66 (Je 1901)
A critique of the Art Nouveau movement.

124. Muthesius, Hermann. "Die Weg und das Endziel des Kunstgewerbes." *Dek K* Jrg. 8 (Bd. 15):181-91 (F):230-8 (Mr 1905); or *Kunst* Bd. 12:181-91 (F); 230-8 (Mr 1905)
The role of decorative art in the new movement and its relationship to modern architecture.

125. [Photographic illustrations]. *DKD* 15:123-35 (N 1904) 26 illus.
No text. Includes interiors by Hoffmann, jewelry by Georg Kleeman, and metalware by Paul Haustein, Baillie Scott, and Riemerschmid.

126. Pietsch, Ludwig. "Das Hohenzollern-Kunstgewerbehaus-Berlin: aus Anlass seines 25 jährigen Bestehens." *DKD* 15:169-76 (D 1904). 61 illus. (pp. 169-208)
On the noted shop of Hermann Hirschwald. Includes interiors by Van de Velde, Patriz Huber, Hoffmann, and Kolo Moser, as well as art objects by many artists.

127. Plehn, A.L. "Einfach oder Primitiv?" *InnDek* 11:83, 86-7 (My); 103 (Je 1900)
A discussion of esthetic principles in design.

128. Pudor, Heinrich. "Thoughts upon modern industrial art." *Cfm* 6:507-10 (Ag 1904)

129. Ritter, William. "L'Art décoratif aux dernières expositions de Vienne." *Art & Dec* 4:33-42 (Ag 1898). 10 illus.
Painting, sculpture and ceramics. Includes the work of Segantini.

130. Sargent, Irene. "The plant in decoration." *Cfm* 4:239-47
(Jy 1903)
 A free translation of an article from *Art et Décoration* of May
 1903; expanded by the translator.

131. Sargent, Irene. " 'The wavy line'." *Cfm* 2:131-42 (Je 1902).
4 illus.
 A negative criticism of Art Nouveau.

132. Scheffler, Karl. "Eine Bilanz." *Dek K* Jrg. 6 (Bd. 12):243-56
(Ap 1903); or *Kunst* Bd. 8:243-56 (Ap 1903)

133. Scheffler, Karl. "Meditationen über das Ornament." *Dek K*
Jrg. 4 (Bd. 8):397-414 (Jy 1901); or *Kunst* Bd. 4:397-414 (Jy
1901)

134. Scheffler, Karl. "Notizen über die Farbe." *Dek K* Jrg. 4 (Bd.
7):183-96 (Ja 1901); or *Kunst* Bd. 4:183-96 (Ja 1901)
 The use of color by the "new movement" (p. 190ff.)

135. Scheffler, Karl. "Unsere Traditionen." *Dek K* Jrg. 3 (Bd. 6):
436-45 (Ag 1900); or *Kunst* Bd. 2:436-45 (Ag 1900)
 The relationship of the modern style to tradition.

136. Schopfer, Jean. "L'Art Nouveau: an argument and defence."
Cfm 4:229-38 (Jy 1903). 6 pls.
 A careful reply to the criticism of A.D.F. Hamlin (106).

137. Seidlitz, W. von. "Das moderne Kunstgewerbe und die Aus-
stellungen." *Pan* 4:45-50 (1899)

138. Soulier, Gustave. "La Plante et ses applications ornementales."
Art & Dec 1:187-9 (Je 1899). 3 illus., 1 col. pl.
 Also published in the *Revue des arts décoratifs* 20:93-6 (1900)

139. [Stickley, Gustav]. "Secession art in Europe: its growth,
meaning and failure." *Cfm* 13:36-49, incl. 6 pls. (O 1907)
 The editor of *Craftsman* on the failure of the Art Nouveau move-
ment.

140. X. "De l'étude documentaire de la plante." *Art & Dec* 18: 25-32 (Jy 1905). 8 illus., 1 col. pl.
Theoretical article on botanical motifs.

Paris. Exposition Universelle, 1900

141. Au Bon Marche, Paris. *Guide illustré du Bon Marché: l'Exposition et Paris au vingtième siècle.* [Paris]: P. Brodard, 1900. xviii, 382 pp., 175 illus., 9 col. maps.
A guide to the 1900 Exposition as well as a guide to Paris, published by the famous department store. Classification of exhibitions, pp. xv-xviii. First half of book deals with the Exposition. Index, pp. 163-6. No contents page. Maps of the Exposition.

*142. Champier, Victor. *Les Industries d'art à l'Exposition Universelle de 1900...* avec la collaboration de MM. Louis Aubry, L. Bénédite, [et al]. Paris: Bureaux de la Revue des Arts Décoratifs, 1902. 244 pp., 800 illus., 500 pls., folio format

143. Exposition Universelle, 1900. *The chefs-d'oeuvre.* Applied art by Victor Champier. Centennial and retrospective by André Saglio. Art and architecture by William Walton. Philadelphia: George Barrie, [1900-02]. 10 vols., illus., pls.
List of illustrations at the end of each volume. No contents pages or indexes. Volumes 1-8 are devoted to contemporary academic painting and art of earlier periods. Vol. 4 includes Klimt, Vol. 5, Mucha and Axel Gallen. Vol. 9, *The decorative arts*, is by Victor Champier. Although most illustrations are not Art Nouveau, the text deals with the movement with heavy emphasis on France. See particularly pp. 8ff., 43ff., 54ff., 72ff., and the chapter, "Characteristics of the modern style," p. 97ff. Vol. 10, *Architecture,* is by William Walton. Although only the Finland pavilion may be called Art Nouveau, the illustrations give a good idea of the 1900 Exposition.

*144. Germany. Reichscommissar für die Weltausstellung in Paris, 1900. *Amtlicher Katalog der Ausstellung des Deutschen Reichs.* [Berlin: Selbstverlag des Reichscommissariats, 1900?]. 440 pp., illus., maps
The official German catalog for the 1900 Exposition, which was

also published in English and French. Book was designed by Bernhard Pankok. Considered a major example of Jugendstil book design.

*145a. Lambert, Théodore, ed. *Le Meuble de style moderne à l'Exposition de 1900.* Paris: Charles Schmid, 1900. Folio, 40 pls.

145b. Lambert, Théodore, ed. *Die moderne Dekoration auf der Pariser Weltausstellung 1900...* Stuttgart: Jul. Hoffmann, [1900]. [4] pp., 40 pls. (incl. 180 illus.)
Forty loose plates with 4-page descriptive text in German. Folio format. An interesting collection of fine photographs rarely or never seen elsewhere. Primarily in Art Nouveau style. Countries emphasized are France, Austria, Germany, Holland, and Norway. Copy in the Rijksmuseum, Amsterdam.

146. Mandell, Richard D. *Paris 1900: the Great World's Fair.* [Toronto]: University of Toronto Press, [1967]. xv, 173 pp., pls. (39 illus.), bibl., bibl. footnotes
An introductory monograph on the Exposition Universelle of 1900, with an historical and social background to the fair. Important bibliography with essay, pp. 122-39, which can serve as a guide to further research.

147a. Marx, Roger. "Les Arts à l'Exposition Universelle de 1900: la décoration et les industries d'art." *Gazette des Beaux-Arts*, sér. 3, vol. 24:397-421 (N 1900); 563-76 (D 1900); vol. 25:53-88 (Ja 1901); 136-68 (F 1901) 88 illus., 10 pls.

147b. Marx, Roger. *La Décoration et les industries d'art à l'Exposition Universelle de 1900.* Paris: Ch. Delagrave, [1901]. vii, 130 pp., 97 illus., 26 pls.
A review of the architecture, interior decoration, and decorative arts at the 1900 Exposition, most of it in the Art Nouveau style. Profusely illustrated. Appendices, p. 119ff, with index and list of plates and illustrations.

148. Meier-Graefe, Julius, ed. *Die Weltausstellung in Paris 1900.* Paris, Leipzig: F. Krüger, 1900. 211 pp., [270] illus., 5 pls.
A comprehensive description of the 1900 Exposition. The nu-

merous illustrations give a good idea of the layout and extent of the Exposition. Most of the texts were written by Meier-Graefe. Chapter 6 is on the decorative arts at the fair. May be cataloged by some libraries as follows: Paris. Exposition Universelle, 1900.

149. Paris. Exposition Universelle, 1900. *L'Art à l'Exposition Universelle de 1900.* Paris: Librairie de l'Art Ancien et Moderne, 1900. 512 pp., illus., pls.
Primarily academic art, but includes some Art Nouveau.

149x. Malkowsky, Georg, ed. *Die Pariser Weltausstellung in Wort und Bild.* Berlin: Kirchnoff, 1900. xvi, 512 pp., illus.
A comprehensive treatment of the 1900 Exposition, with more than one hundred articles, all in German. Hundreds of black-and-white illustrations, quite a number of which are of Art Nouveau interest.

149y. Quantin, Albert. *L'Exposition du siècle.* Paris: Le Monde Moderne, 190—? xx, 367 pp., illus.
A general review of the 1900 Exposition, with emphasis on the French exhibits. Hundreds of black-and-white illustrations. Contents page at end of book. Two chapters on decorative arts, pp. 76-126.

150. "Architektur auf der Welt-Ausstellung." *InnDek* 11:95-102 (Je 1900)
The pavilions of the 1900 Exposition. No illustrations.

151. "Ausstellungskunst." *Dek K* Jrg. 3 (Bd. 6):454-6 (Ag 1900); or *Kunst* Bd. 2:454-6 (Ag 1900)
A critique of the Exposition.

152. Bans, Georges. "Exposition Universelle." *Art Dec* 4:6 (Ap 1900). 7 illus. (pp. 7, 37-40)
Primarily photographs.

153. Barthélemy, A. "L'Architecture nouvelle à l'Exposition." *Art & Dec* 8:12-20 (1900). 9 illus.
Includes the incredible Blue Pavilion of Dulong.

154. "L'Esposizione Mondiale di Parigi." *Emp* 12:241-54 (Se 1900). 18 illus.

155. Fred, W. [pseud. of Alfred Wechsler]. "Architektur und Aussendecoration auf der Pariser Weltausstellung." *KKhw* 3:290-309 (Jy 1900). 18 illus.

156. W. Fred. "Intérieurs und Möbel auf der Pariser Weltausstellung." *KKhw* 3:331-52 (Ag 1900). 22 illus.

157. W. Fred. "Kleine Nachrichten: Intérieurs und Möbel auf der Pariser Weltausstellung." *KKhw* 3:400-3 (Se 1900)

158. [Meier-Graefe, J.]. "Das Äussere der Weltausstellung." *Dek K* Jrg. 3 (Bd. 6):350-4 (Je 1900); or *Kunst* Bd. 2:350-4 (Je 1900) No illustrations.

159. Jacques, G.M. "L'Exposition Universelle." *Art Dec* 4:77-9 (My 1900)
An unfavorable review of the Exposition.

160. Jourdain, Frantz. "L'Architecture à l'Exposition Universelle: promenade à batons rompus." *Rev Arts Dec* 20:245-51, 326-32, 342-50 (1900). 21 illus.
The Finnish pavilion and work by Dulong and other French architects.

161. "Mittheilungen aus dem K.K. Österreichischen Museum." *KKhw* 4:371-2 (1901). 22 illus. (pp. 345-69)
Purchases by the museum from the 1900 Exposition.

162. Osborn, Max. "Das Ergebniss der Pariser Weltausstellung." *DKD* 7:1-27 (O 1900). 28 illus.
A review of the Exposition with illustrations of work, primarily by Olbrich and Riemerschmid.

163. Osborn, Max. "Die Innen-Dekoration auf der Welt-Ausstellung." *InnDek* 11:105-6 (Jy 1900). 15 illus., 2 pls. (pp. 106-20)

164. Osborn, Max. "Das Testament der Pariser Welt-Ausstellung." *DKD* 7:169-76 (Ja 1901)

165. Osborn, Max. "Von der Pariser Welt-Ausstellung 1900 (zu unseren Abbildungen)." *InnDek* 11:137, 142-3 (Se 1900). 10 illus., 1 pl. (pp. 138-52)
Architecture and furniture from the 1900 Exposition.

166. Pantini, Romualdo. "L'arte industriale a Parigi." *Emp* 13: 263-88 (Ap 1901). 60 illus.
Includes the "Art Nouveau Bing" pavilion and jewelry by Lalique.

167. Saunier, Charles. "Les Petites Constructions de l'Exposition." *Art Dec* 5:55-70 (N 1900). 13 illus. (pp. 54-65)
Pavilions of the 1900 Exposition.

168. G.S. [i.e. Gustave Soulier]. "Les Installations générales de l'Exposition." *Art & Dec* 9:156-65 (1901). 12 illus.
Buildings of the 1900 Exposition. Well illustrated.

169. Vilaregut, Salvador. "Un cop d'ull a la Exposicio." *Joventut* 1:444-6, 458-60 (Ag 23-30, 1900)
Text in Catalan.

ALSO SEE: 33, 35, 250, 304, 341-2, 344-5, 353, 362-3, 366, 379-80, 384, 391, 395, 398, 401-2, 419, 472-80, 803, 1113-18, 1183, 1210, 1263, 1286, 1293, 1305, 1311-12, 1317, 1323, 1346, 1365, 1378, 1388, 1436, 1438-40, 1444-7, 1450, 1522, 1630, 1660

Turin. Esposizione Internazionale d'Arte Decorativa Moderna, 1902.

170. Fratini, Francesca R., ed. *Torino 1902: polemiche in Italia sull' Arte Nuova.* "Nadar", richerche sull'arte contemporanea, 3. Torino: Martano, [1970]. 303 pp., 115 illus.
An anthology of 124 critical reviews of the Turin Exposition, written at the time of the fair, almost all of them by Italian critics. Foreign reviews are translated into Italian. Index of reviews, pp. 297-330. General notes on the fair, pp. 55-62. Illustrations take up the first fifty pages of the book and are small black-and-white reproductions of old photographs.

171. Koch, Alexander, ed. *L'Exposition Internationale des Arts Décoratifs Modernes à Turin 1902.* Texte par Georg Fuchs et F.H. Newbery. Darmstadt: A. Koch Librairie des Arts Décoratifs, [1903]. 340 pp., illus., 6 pls.

A major work consisting of nineteen essays on the various countries at the Exhibition, as well as the fair's general architecture. Richly illustrated with numerous photographs. This book was also published in German by the same publisher under the title *Internationale Ausstellung für moderne Kunst in Turin...* The essays in this book are probably the articles that appear in *Deutsche Kunst und Dekoration*, vols. 10 and 11 (1902-03).

172. Nacht, Leo, comp. *Turin 1902.* Berlin: E. Wasmuth, [1902]. 50 pls.

Two-page introduction by Nacht. Folio of photographs of the Turin Exposition.

173. Pica, Vittorio. *L'arte decorativa all'Esposizione di Torino del 1902.* Bergamo: Istituto Italiana d'Arti Grafiche, 1903. 388 pp., 454 illus., 5 col. pls.

A survey of the Turin Exposition, which is considered the climax and triumph of Art Nouveau. More important for the photographs which span the whole of Art Nouveau. Index to illustrations, pp. 385-8.

174. "Die Ausstellung in Turin 1902." *DKD* 9:297-8 (Mr 1902)

175. "Exposition Internationale des Arts Décoratifs à Turin." *Art Mod* 21:126 (Ap 7, 1901); 368 (N 3, 1901); 383 (N 17, 1901)

176. Fiérens-Gevaert, H. "L'Exposition de Turin." *Art Mod* 22: 249-51 (Jy 27, 1902); 257-9 (Ag 3, 1902)

177. Fred, W. [pseud. of Alfred Wechsler]. "Die Turiner Ausstellung: das Bild, die Bauten, der künstlerische Erfold." *Dek K* Jrg. 5 (Bd. 10):393-407 (Ag 1902) 40 illus. (pp. 393-419); or *Kunst* Bd. 6:393-407 (Ag 1902)

A preview of the 1902 Exposition, with separate sections on England and Scotland. Photographs of d'Aronco's buildings and the work of Mackintosh and other British artists.

178. W. Fred. "Die Turiner Ausstellung (Fortsetzung)..." *Dek K*
Jrg. 5 (Bd. 10):433-72 (Se 1902); or *Kunst* Bd. 6:433-72 (Se
1902). 55 illus.
Reports on the German, Austrian, Hungarian, French, Italian,
and Scandinavian sections. Copiously illustrated.

179. Koch, Alexander. "Erste Eindrücke von der Turiner Aus-
stellung." *DKD* 10:519-23 (Jy 1902). 1 illus.

180. Melani, Alfredo. "L'Art Nouveau, at Turin: an account of
the Exposition." *Arch Rec* 12:584-99 (N 1902) 9 illus.; 734-50
(D 1902). 14 illus.
Article in two installments on the organization of the fair and
on participating Italian and foreign artists.

181. Minkus, Fritz. "Die Erste Internationale Ausstellung für
Moderne Dekorative Kunst in Turin."*KKhw* 5:402-50 (1902). 44
illus.
Part 1, pp. 402-16, is on Austria. Part 2, pp. 416-50, is about
the other participating countries. Includes many interesting pho-
tographs.

182. Mussche, Paul. "Une Exposition d'art moderne à Turin en
1902." *Art Mod* 21:358-9 (O 27, 1901)

183. Plehn, A.L. "Erste Internationale Ausstellung für Moderne
Dekorative Kunst in Turin." *Kgwb*, N.F. 14:1-20 (1903). 7 illus.
(pp. 17-20) 1 col. pl.

184. Soulier, Gustave. "L'Exposition de Turin: 1. Les édifices."
Art Dec 8:186-90 (Ag 1902). 5 illus.
Buildings at the Turin Exposition.

185. G.S. [i.e. Gustave Soulier]. "L'Exposition Internationale
d'Art Décoratif Moderne à Turin." *Art Dec* 8:129-30 (Je 1902)

186. Thovez, Enrico. "The First International Exhibition of
Modern Decorative Art at Turin." *Studio* 26:44-7 (Je 1902)

187. Verneuil, M.P. "L'Exposition d'Art Décoratif Moderne à

Turin." *Art & Dec* 12:65-112 (1902). 56 illus., 7 pls.
Comprehensive review of the 1902 exhibition.

ALSO SEE: 101, 481-5, 804-5, 1207

Collecting Art Nouveau

188. Klamkin, Marian. *The collector's book of Art Nouveau.* Illustrated with photographs by Charles Klamkin. New York: Dodd, Mead, [1971]. 112 pp., [117] illus., 1 col. pl., bibl.
A general survey of the movement, with emphasis on collecting Art Nouveau objects.

189. Mebane, John. *The complete book of collecting Art Nouveau.* New York: Coward McCann, [1970]. 256 pp., [131] illus., bibl.
A different approach, that of the antique dealer. Emphasis on the minor applied arts, notably silverware, as well as pottery and glass. Two chapters deal with prices and collecting objects.

NOTE: Many books and articles on Tiffany and other American Art Nouveau glass are written from the viewpoint of the antique collector; they will be covered in volume 2 of this bibliography.

Oriental influence and Art Nouveau

190. Graul, Richard. *Ostasiatische Kunst und ihr Einfluss auf Europa.* Aus Natur und Geisteswelt..., 87. Leipzig: Teubner, 1906. 88 pp., 49 illus., 1 pl.
Chapter 3, "Der Einfluss Ostasiens auf das moderne Kunstgewerbe," p. 56ff. Small illustrations.

191. Dreger, Moriz. "Zur Wertschätzung der japanischen Kunst." *Ver Sacrum* 2, Heft 9:18-31 (1899), illus.
Japanese woodcuts, pp. 2-16.

192. Gonse, Louis. "L'Art japonais et son influence sur le goût européen." *Rev Arts Dec* 18:97-116 (1898). illus.

193. Hevesi, Ludwig. "Aus dem Wiener Kunstleben: eine Hokusai-Ausstellung." *KKhw* 4:134-6 (1901)

194. Lancaster, Clay. "Oriental contributions to Art Nouveau."
Art Bull 34:297-310 (D 1952). 22 illus., bibl. footnotes
The general development of the movement against a background
of Oriental influence.

195. Metzger, Max. "Die japanische Flächen-Dekoration als Vor-
bild für unsere moderne Kunstrichtung." *InnDek* 9:65-7 (Ap 1898).
illus.

196. Schur, Ernst. "Der Geist der japonischen Kunst." *VS* 2, Heft
4:5-20 (1899). illus.

197. "Was uns die japanische Kunst noch sein kann." *InnDek* 12:
131-3, 136 (Ag 1901)

Art Nouveau and the 1960s

198. Glaser, Hermann. *Jugend-Stil, Stil der Jugend: Thesen und
Aspekte.* [München]: Manz Verlag, [1971]. 130 pp., illus., fold-
out, bibl. footnotes
Five essays by Glaser, Dieter Baacke, Gert Heidenrach, Klaus
Peter Dencker, and Eberhard Roters which compare Art Nou-
veau with the pop movements of the 1960s.

199a. Madsen, Stephan Tschudi. "Neo-Art Nouveau and psyche-
delic art." *In:* International Congress of the History of Art, 22nd,
Budapest, 1969. *Bulletin*, pp. 329-33. 13 illus. (pp. 435-8, plates
389-92)
A comparison of the two art movements. Published in Budapest
in 1972.

199b. Madsen, Stephan Tschudi. "Neo-Art Nouveau og Psykede-
lisk Kunst." *Kunstkultur* 50:157-68 (1967). 12 illus.
In Norwegian.

200. Medeiros, Walter Patrick. "San Francisco rock concert post-
ers: imagery and meaning." M.A. thesis, Art History Department,
University of California, Berkeley, 1972. vi, 126 pp., (incl. 26 pls.,
part col.) bibl., bibl. footnotes
A firsthand account of the movement.

201. Walker, Cummings G., ed. *The great poster trip: art eureka.* [Palo Alto]: Coyne & Blanchard, 1968. 79 pp., 201 illus. (part col.)
 Illustrations of San Francisco rock concert posters. Texts, pp. 4-5, 75.

Bibliography in general
 Five continuing reference works index new journal articles and books on art. They are the *Art index* (202), *Artbibliographies modern* (203a), *Art design photo* (203b), *Répertoire international de la littérature de l'art* (203c), and the *Répertoire d'art et d'archéologie* (210), each of which index as many art magazines; the last four also index books. For effective, current coverage they are perhaps best used together. For older publications see the bibliographies in Madsen (17), Schmutzler (25), Grady (204), and the one by Grady in Selz (27). There are also many more specialized bibliographies which are noted throughout this book. See end of section for a list of references.

202. *Art index.* New York: H.W. Wilson Co., 1933– .
 A quarterly index to current art periodicals by the publishers of the *Reader's guide to periodical literature.* Coverage extends back to 1929. Cumulated both annually and triennially. Arrangement is alphabetical by subject and author. There has been an entry for Art Nouveau since Vol. 8 (1950-53). Especially strong for English-language journals; lists articles, book reviews, exhibition notices, and illustrations. Coverage of continental European journals is weaker. In addition to "Art Nouveau", entries will appear under the names of individual artists. List of journals indexed is at the front of each issue. Does not include *Alte und moderne Kunst, Information d'histoire de l'art, Cahiers Henry Van de Velde,* or *Kunst in Hessen und in Mittel-Rhein,* all of which are important current journals for Art Nouveau. Although incomplete it makes a good starting point for locating current articles. Easy to use.

203a. *Artbibliographies modern.* Santa Barbara, Calif.: American Bibliographical Center-Clio Press 1972– .
 An annual index and abstract of books and periodical articles which was begun in 1969 under the name *LOMA (Literature*

on modern art) by Alexander Davis. The name was changed
with volume 2, although it appears under both titles. In 1973
the format was changed with volume 4, number 1, to an easy-
to-read layout with numerous abstracts of both books and ar-
ticles. One must look up both the term "Art Nouveau" and spe-
cific artists. Shows great promise of becoming a valuable biblio-
graphic tool.

203b. *Art design photo 1972: annual bibliography of books, cata-
logues and articles on modern art, graphic design, photography,
art libraries,* by Alexander Davis. Hemel Hempstead, Herts, Eng.:
Alexander Davis Publications; distr. by Idea Books, London,
1973– .

An annual, unannotated bibliography of late nineteenth-century
and twentieth-century art, with emphasis on contemporary art.
Coverage is for the year previous to publication. The bibliogra-
phy is divided into separate alphabetical listings for artists and
subjects. Under subjects note: "Art decorative: Art Nouveau";
"Art decorative: Arts and Crafts Movement"; "Graphic design:
Posters"; and Vienna Secession". Although the subject headings
are unwieldy, the bibliography has a very accessible listing of
Art Nouveau items of interest. Articles on individual artists are
not listed in the general Art Nouveau subject section, but there
are cross-references from the individual artists to the general
Art Nouveau section. For each volume there is a general index.
Note that this bibliography does not index *Alte und moderne
Kunst, Cahiers Henry Van de Velde, Information d'histoire de
l'art,* or *Kunst in Hessen und am Mittelrhein.*

203c. *Répertoire international de la littérature de l'art. Interna-
tional repertory of the literature of art.* [Also known as *RILA*.]
[Williamstown, Mass]: College Art Association of America,
1975– .

An annotated bibliography of art history published twice a
year beginning in 1975. Each issue comes in two parts, *Abstracts*
and *Index*. Lists books, exhibition catalogs, and journal articles
in all languages. A list of journals appears at the beginning of
each issue of part two. Journals not indexed include *Alte und
moderne Kunst, Cahiers Henry Van de Velde, Information de
l'histoire de l'art,* and *Kunst in Hessen und am Mittelrhein.* The

bibliography is best approached by using the index. See particularly "Art Nouveau", "Jugendstil", "Sezession", "Posters", and the names of the individual artists. A demonstration issue was published in 1973. *RILA* shows promise of being a good bibliography, particularly in view of the abstracts provided with the majority of the items listed.

204. Grady, James. "A bibliography of the Art Nouveau." Society of Architectural Historians. *Journal*, vol. 14, no. 2:18-27 (My 1955)
An important early bibliography arranged alphabetically by country, with a list of periodicals (pp. 26-7). Useful for its complete description of each item. Longer than the same author's bibliography in Selz (27).

205. Kornfeld und Klipstein, Bern. *Jugendstil–Art Nouveau: Buchkunst um 1900, Plakate, Graphik, Glaser. Auktion in Bern... 22.-23. März 1968.* Zürich: L'Art Ancien; Bern: Kornfeld und Klipstein, 1968. 168 pp., illus., 27 pls., bibl.
A landmark catalog of 750 items, primarily books (nos. 164-682) and periodicals (nos. 683-750), as well as art objects, all of which are fully annotated. Includes many outstanding examples of Art Nouveau book publishing and decoration. Valuable bibliography for the art of the book at this period. Auction catalog no. 124 of Kornfeld & Klipstein.

206. *Kunst und Kunsthandwerk.* "Literatur des Kunstgewerbes." Wien: KK. Österreichisches Museums für Kunst und Industrie, 1898– .
Monthly column, usually of four pages, listing books and periodicals from all countries and all periods. One of the few bibliographical listings from this period. See annual tables of contents for pagination of each issue.

207. Lietzmann, Hilda. *Bibliographie zur Kunstgeschichte des 19. Jahrhunderts: Publikationen der Jahre 1940-1966.* Studien zur Kunst des neunzehnten Jahrhunderts, Bd. 4. München: Prestel Verlag, 1968. 234 pp., 7 illus.
Comprehensive bibliography of 4,431 items on nineteenth-century art. Arranged by subject: architecture, sculpture, painting, and decorative art; these are in turn subdivided by country,

then by artist. See contents, pp. 49-51. Author index only, at rear of book. Contains much information, but is difficult to use from an Art Nouveau point of interest. At the front of the book are three essays on nineteenth-century art.

208. Paris. Bibliothèque Forney. *Catalogue d'articles de périodiques: arts décoratifs et beaux-arts. Catalog of periodical articles: decorative and fine arts.* Boston: G.K. Hall, 1972. 4 vols.
The alphabetical subject catalog to periodical articles in a noted French library; printed in book format. See preliminary paging in volume 1. Preface in French and English. Particularly strong in French art and technical journals of the 1960s. Artists' names are a good starting point for using this bibliography.

209. Paris. Bibliothèque Forney. *Catalogue matières: arts décoratifs, beaux-arts, métiers, techniques.* Paris: Société des Amis de la Bibliothèque Forney, 1970-4. 4 vols.
Alphabetical subject catalog of books; in book format. See the term "Art Nouveau", pp. 483-5 in vol. 1. A list of subjects for cross-reference is given.

210. *Répertoire d'art et d'archéologie: de l'époque paléochrétienne à 1939.* Paris: Centre National de la Recherche Scientifique, 1910— .
Subtitle varies. An annually published bibliography of books and journal articles on art history which is quite comprehensive in scope but does not include many articles on Art Nouveau. Indexes for artists, authors, and geographic locations, making it easy to use for locating material on a specific artist. Most Art Nouveau material is located in the nineteenth-century section, which is divided into general, architecture, sculpture, painting and drawing, and decorative arts; each of these is subdivided by country (see contents). Some Art Nouveau artists are listed in the twentieth-century section, particularly in architecture and decorative arts. Most items include a brief annotation in French. This bibliography is particularly valuable for its coverage of East European publications, the titles of which are translated into French. Indexes *Alte und moderne Kunst* and *Information de l'histoire de l'art,* but not *Cahiers Henry Van de Velde* or *Kunst in Hessen und am Mittelrhein.* In 1973 the *Répertoire*

became a quarterly publication with annual indexes for authors, artists, and subjects. The organization of the bibliography was simplified so as to facilitate computer production of the publication.

211. S. "Zeitschriften." *VS* 1, Heft 2:24-6 (F 1898); Heft 4:23-4 (Ap 1898)
Comments on articles in other periodicals.

ALSO SEE: 12, 17, 25-7, 29, 268, 277, 405, 682a-b, 807, 836, 876b, 1589

Architecture in general
It is a hotly debated question as to whether there is an Art Nouveau architecture or not. There are, at least, Art Nouveau architectural decor and ornament in many turn-of-the-century buildings. Important standard works on the history of modern architecture which deal with Art Nouveau are Giedion (218) and Hitchcock (219a). Attention should also be called to the beautiful illustrations in Hofmann (221) and the notable collection of essays by Richards and Pevsner (227), as well as a bibliography by Sharp (248).

212. Behrendt, Walter Curt. *Modern building: its nature, problems, and forms.* New York: Harcourt, Brace, [1937]. 241 pp., illus., bibl.
For Art Nouveau see pp. 76-104.

213a. Benevolo, Leonardo. *Storia dell'architettura moderna.* Bari: Editori Laterza, 1960. 2 vols., 1,066 pp., 992 illus. (incl. plans), bibl.
For the Art Nouveau period see section 4, p. 341ff, particularly chapter 9, "L'Art Nouveau", pp. 353-416, in vol. 1. Bibliography in vol. 2, p. 1,033ff.

213b. Benevolo, Leonardo. *History of modern architecture.* London: Routledge & Kegan Paul; Cambridge, Mass.: M.I.T. Press, [1971, c1960] 2 vols., xxxiv, 868 pp., 1,066 illus. (incl. plans), bibl., bibl. footnotes
Particularly see "Art Nouveau", chapter 9 in vol. 1, pp. 262-319. Bibliography and essay, vol. 2, pp. 850-8, updated from the Ita-

lian edition. Bibliographic notes at end of text for each volume.
Index at end of vol. 2.

214. Bie, Oscar. *Die Wand und ihre Künstlerische Behandlung.*
Die Kunst: Sammlung illustrierter Monographien... Berlin: Bard,
Marquardt, [1904]. 117 pp., illus.
 The fourth chapter, "Moderne Wand", p. 82ff., deals in part
 with Art Nouveau architecture and interior design.

215. Brion-Guerry, Liliane. "L'Évolution des formes structurales
dans l'architecture des années 1910-1914." In *L'Année 1913: les
formes esthétiques de l'oeuvre d'art à la veille de la première guerre
mondiale.* Ed. par L. Brion-Guerry. Paris: Klincksieck, 1971, pp.
99-179
 Survey of the last year of Art Nouveau architecture in Europe
 and its relation to the newer architecture. Chronology, pp. 155-
 79.

216. Casteels, Maurice. *Die Sachlichkeit in der modernen Kunst.*
Paris, Leipzig: Henri Jonquières, [1930]. 123, xv pp., 144 pls.
 On functional modern architecture of the 1920s. Only inci-
 dentally on Art Nouveau. Foreword by Henry Van de Velde,
 pp. 7-10.

217. Fierens-Gevaert, Hippolyte. *Nouveaux essais sur l'art con-
temporaine.* Paris: Felix Alcan, 1903. ii, 213 pp.
 Essays by a Belgian art historian, notably the first two essays
 on modern architecture (particularly p. 45ff.). This book is
 mistakenly attributed to Paul Fierens in many bibliographies.

218. Giedion, Siegfried. *Space, time and architecture: the growth
of a new tradition.* Charles Eliot Norton lectures for 1938-1939.
5th ed. rev. and enl. Cambridge, Mass.: Harvard University Press,
1967 [c1941]. lvi, 897 pp., 531 illus., bibl. footnotes
 A classic survey of modern architecture. Part 4, p. 291ff., is
 on Art Nouveau architecture. A good, short survey.

219. Hitchcock, Henry-Russell. *Architecture: nineteenth and
twentieth centuries.* The Pelican History of Art, Z 15. 3rd rev. ed.
Harmondsworth, Baltimore: Penguin Books, [1968, c1958]. xxix,

520 pp., 57 illus., 196 pp., bibl. bibl. footnotes
Chapters 16, 17, 21, and 22 deal with Art Nouveau architec-
ture, with emphasis on Horta, Mackintosh, Gaudi, and Beh-
rens. In the second edition, published in 1963, chapters 16-18
and 20-1 cover Art Nouveau, as do plates 129-39a. The first
edition was published in 1958.

220. Hitchcock, Henry-Russell. *Modern architecture: Romanti-
cism and reintegration.* New York: Payson & Clarke, 1929. xvii,
252 pp., pls. (58 illus.), bibl.
A pioneer work on the history of modern architecture. Hostile
to Art Nouveau as a movement, but includes much on archi-
tects associated with it. See part 2, "The new tradition", pp. 77-
149. Index, p. 245ff. Bibliographical note, pp. 239-41. Re-
printed in 1970 by Hacker Art Books, New York.

*221a. Hofmann, Werner, and Kultermann, Udo. *Baukunst unserer
Zeit: die Entwicklung seit 1850.* Baukunst der Welt, Bd. 4. Essen:
Burkhard Verlag, 1969. 66 pp., 112 col. pls., bibl.
Original German edition of 221b.

221b. Hofmann, Werner, and Kultermann, Udo. *Modern architec-
ture in color.* London: Thames & Hudson; New York: Viking,
[1970, c1969]. 528 pp., 112 col. pls., plans, bibl.
A selection of 112 modern milestones in architecture, including
many Art Nouveau sites. A beautiful color plate and descrip-
tion for each building. Translation of 221a.

222. Joseph, David. *Geschichte der Baukunst vom Altertum bis
zur Neuzeit: ein Handbuch.* 2. Verb. und Verm. Auflage. Leipzig:
Baumgärtner, [1909]. 3 vols. in 4, illus.
For Art Nouveau architecture see the second book of vol. 3
(xlii, 863 pp., 879 illus. in 2 vols.). Contents page, however, is
in the first book of vol. 3, pp. ix-xii, followed by a list of illus-
trations. Arrangement is by country and includes much on Art
Nouveau. Numerous illustrations. Artist and location indexes
at end of second book of vol. 3.

223. *Moderne Städtebilder.* Berlin: E. Wasmuth, 1900-01. Abtei-
lungen 1-6, incl. 182 pls., plans, folio format

1. Neubauten in Brüssel. 37 pls. No text. Folio of photographs, mainly work by Hankar and Horta.
2. Neubauten in Holland (Amsterdam—Haag—Rotterdam) 37 pls., plans. No text. Folio of photographs. Includes work by Berlage.
*3. Neubauten in London. 35 pls.
4. Neubauten in Wien. 37 pls., plans. No text. Folio of photographs featuring work by Otto Wagner and Jul. Deininger.
5. Neubauten in München. 36 pls., plans. No text. Only a few photographs of Art Nouveau interest.
*6. Neubauten in Berlin. 40 pls.

*224. Muthesius, Hermann. *Architektonische Zeitbetrachtungen: ein Umblick an der Jahrhundertwende. Festrede geh. im Architekten-Verein zu Berlin zum Schinkelfeste am 13. März. 1900.* Berlin: W. Ernst, 1900. [22] pp.
Text of a speech. Reprinted from *Centralblatt der Bauverwaltung.*

225. Muthesius, Hermann. *Das moderne Landhaus und seine innere Ausstattung.* 2. verb., verm. Aufl. München: F. Bruckmann, 1905. xv pp., 320 illus.
Photographs of contemporary architecture of the period and interiors from Germany, Austria, England, and Finland, with a short introduction by the author.

226. Muthesius, Hermann. *Stilarchitektur und Baukunst: Wandlungen der Architektur im XIX. Jahrhundert und ihr heutiger Standpunkt.* Mülheim-Ruhr: K. Schimmelpfeng, 1902. 67 pp.
The relationship of the modern architecture of 1900 to that of the preceding century.

227. Richards, James M., and Pevsner, Nikolaus, eds. *The antirationalists.* [London]: Architectural Press, [1973]. 208 pp., 284 illus., bibl. footnotes
A major anthology of twenty articles on Art Nouveau, particularly on architecture. Fifteen of the articles appeared previously in the *Architectural Review* (see note facing p. 1). Wide coverage of countries. Architects include Guimard, Berenguer, Domenech i Montaner, Wagner, Ödön Lechner, Aladár Árkay, Mack-

murdo, Mackintosh, the Watts Chapel, and Poelzig. Numerous small black-and-white photographs. Bibliographical notes follow each chapter.

228. Scheffler, Karl. *Moderne Baukunst.* Leipzig: Zeitler, 1908 [c1907]. 190 pp., 24 pls.
Ten essays on technical and general questions in relation to Art Nouveau and parallel movements.

229. Sharp, Dennis. *Modern architecture and Expressionism.* [London]: Longmans; New York: Braziller, [1966]. 204 pp., illus., bibl.
A definitive monograph on Expressionist architecture which discusses its Art Nouveau origins, notably in Van de Velde and Behrens.

230. Voss, Hans. *Neunzehntes Jahrhundert: ein Umschau-Bild-sachbuch.* Herausgegeben von Harald Busch. Epochen der Architektur. Frankfurt a.M.: Umschau Verlag, [1969]. 233 pp., illus., bibl.
A history of nineteenth-century architecture describing major buildings with accompanying photographs. Last third of the book includes much Art Nouveau. "Literaturverzeichnis", pp. 22-3.

231. Vriend, J.J. *Nieuwere architectuur: beknopt overzicht van de historische ontwikkeling van de bouwkunst.* Amsterdam: Kosmos, [1935]. 139 pp., 234 illus.
Chapter 4 is on the Art Nouveau period.

232. Zevi, Bruno. *Storia dell'architettura moderna, dalle origine al 1950.* [Torino]: Einaudi, 1961. 787 pp., 147 illus., 76 pls., bibl.
Noted Italian history of modern architecture. Chapter 2 is on Art Nouveau. Extensive bibliography of more than a hundred pages. For Art Nouveau see pp. 573-93, 638-9.

233. Bruand, Yves. "L'Ambiguïté de l'Art Nouveau en architecture." *IHA* 9:118-24 (My-Je 1964) 4 illus., bibl. footnotes

234. Lange, Willy. "Zur künstlerischen Gestaltung des Gartens."
InnDek 14:45 (F 1903); 75, 78 (Mr 1903); 109-16 (Ap 1903)
8 illus.
Landscape gardening.

235. [Lux, Jos. Aug.]. "Das Wohnhaus." *HW* 2:134-9 (1906) 13
illus.
Illustrated with a series of drawings by Joseph Hoffmann, called
"Wohnhaus Hohe Warte" (pp. 134-46).

236. Mumford, Lewis. "The wavy line versus the cube." *Arch Rec*
135:111-16 (Ja 1964) 19 illus.
A discussion of weaknesses in both Art Nouveau and modern
architecture, in relation to an article written by the author in
1931.

237. Muret, Luciana Miotto. "Principaux courants de pensée de
la fin du 19e et du début du 20e siècle." *Arch d'Auj*, no. 158:6-17
(O 1971). 34 illus., bibl. footnotes
The main esthetic theories of 1890-1914 and their influence on
the architecture of the period. "Chronology" of modern archi-
tecture, p. 68ff.

238. Scheerbart, Paul. "Licht und Luft." *VS* 1, Heft 7:13-14
(Jy 1898)

239. Scheffler, K. "La Moulure dans l'art moderne." *Art Dec* 1:
206-7 (F 1899). 5 illus.
The disappearance of moulding in modern architecture. A dis-
cussion of Van de Velde's design, illustrated by his work (pp.
238-41).

240. Shand, P. Morton. "Scenario for a human drama." *Arch Rev*
76:9-16 (Jy 1934); 39-42 (Ag 1934); 83-6 (Se 1934); 131-4 (N 1934);
vol. 77:23-6 (Ja 1935). 51 illus.
An article in five parts. Parts 2-4 are a history of the modern
movement in reverse chronological order. Part 3 (p. 83ff.) is on
Peter Behrens. Part 4, "Van de Velde to Wagner", also deals
with Hoffmann and Loos. Part 5, "Glasgow Interlude", is about
C.R. Mackintosh.

241. "Unser Wettbewerb: Wohnhaus eines Kunstfreundes."
InnDek 12:111-13 (Jy 1901). 7 illus., 2 pls., plans (pp. 112-19)
The famous architecture competition of Alexander Koch.
Discussion and illustration of a German entry by Paul Zeroch
called "Und?"

242. "Unser Wettbewerb: Wohnhaus eines Kunstfreundes, 2."
InnDek 12:137 (Ag 1901). 12 illus., 2 pls., plans (pp. 132-42)
Contributions by architects Karl Müller, Hans Schlicht, and
Wilhelm Pipping (p. 138) to the famous architectural compe-
tition of Alexander Koch.

243. Villenoisy, F. de. "L'Architecture en fer et l'école française
contemporaine." *Rev Arts Dec* 16:7-15, 276-86, 325-31 (1896)
illus.
A series of three articles on iron construction in nineteenth-
century French architecture.

244. ["Wettbewerb: Wohnhaus eines Kunstfreundes. Illustra-
tions."] *InnDek* 12:168-75 (O? 1901). 9 illus., 1 pl., plans
The plans of two German firms for the Alexander Koch archi-
tectural competition: Rohmann & Edler; and Böhngen, Glaser,
& Hansen. Also a drawing by Valentin Mink (p. 182). No text.

245. "Zu unseren Illustrationen [Wettbewerbes für das Wohn-
haus eines Kunstfreundes]." *InnDek* 12:166 (Se 1901). 16 illus.,
3 pls., plans (pp. 148-63)
Contributions to the competition of Alexander Koch by four
Germans: Karl Späth, Emil Rockstroh, Oscar Wichtendahl, and
Arthur Biberfeld. Includes illustrations of some of their other
work.

246. "Zu unseren Illustrationen: Wettbewerbe der Innen-Dekora-
tion... 'Wohnhaus eines Kunstfreundes'." *InnDek* 12:196 (N 1901)
2 illus. (pp. 194-5)
Contributions of Chr. Seebach and W. Martin to the Koch com-
petition.

247. Zucker, Paul. "The paradox of architectural theories at the
beginning of the 'Modern Movement'." Society of Architectural

Historians. *Journal.* Vol. 10, no. 3:8-14 (O 1951). Bibl. footnotes
Part 3 (pp. 9-10) deals with Art Nouveau theories. Condensa-
tion of a contribution intended for the Festschrift *Essays in
honor of Hans Tietze...* (Paris: Gazette des Beaux Arts, [1958]),
but not published in it.

ALSO SEE: 20, 26-7, 41, 44-5, 124, 184, 225, 243, 450, 452, 454, 566-76,
 611-16, 624ff., 722, 767-92, 836-45, 867-74, 876-97, 939, 963ff., 1075a,
 1139-52, 1377, 1471-2, 1589-1620, 1623, 1651-2, 1698, 1700-1, 1704,
 1706, 1712, 1714, 1718, 1733, 1741, 1742ff., 1752-56, 1790

Architecture in general—Bibliography

248. Sharp, Dennis. *Sources of modern architecture.* Architec-
tural Association (London). Paper no. 2. New York: Wittenborn,
[1967]. 56 pp., ports.
 A comprehensive bibliography. See alphabetical "Biographical
bibliography", p. 9ff., which includes fifteen Art Nouveau archi-
tects. Also see "Art Nouveau", pp. 45-6.

Sculpture in general

249. Althof, Paul. "Dekorative Bronzen." *Intr* 1:33-40 (1900)
The esthetics of decorative statuary.

250. Detouche, Henry. "Les Bronzes d'art à l'Exposition Univer-
selle." *Art Dec* 4:189-97 (Ag 1900). 17 illus.
 Bronze art statuary at the 1900 Exposition. Kitsch.

251. Schumacher, Fritz. "Grabmalkunst." *Dek K* Jrg. 1 (Bd. 1):
129-33 (D 1897). 7 illus.
 Tombstones. Illustrated by the author's drawings.

ALSO SEE: 26-7, 577, 622, 760, 793, 846, 926-37, 1153-6, 1427, 1458,
 1467, 1667, 1734-40

Posters and Graphic Art in general
 The poster more than any other art form originates in and
is closely identified with Art Nouveau. Most books on the history
of the poster give much attention to the Art Nouveau period. Post-

er collecting was already a popular pastime in the 1890s. Good introductory books are those by Hillier (261) and Rickards (271). Attention should also be called to the magnificently illustrated book of Hofstätter (262), which is on Art Nouveau illustration in general.

252. *Les Affiches étrangères illustrées,* par MM. M. Bauwens, T. Hayashi, La Forgue, Meier-Graefe, J. Pennell. Paris: G. Boudet, 1897. 206 pp. (incl. 150 illus., 62 col. pls.)
An early major book on the poster in thick folio format with beautiful color reproductions. Limited edition of 1,050 copies. Contents and indexes of illustrations, p. 197ff. All texts in French. Chapters on Germany and Austria by J. Meier-Graefe, England by Joseph Pennell, Belgium by Maurice Bauwens, United States by La Forgue, and Japan by Tadamasa Hayashi. In many bibliographies this book is listed under Pennell or Bauwens or even the publisher Boudet as the author.

253. Alexandre, Arsène; Jaccaci, A.F.; Bunner, H.C.; and Spielmann, M.H. *The modern poster.* New York: Scribners, 1895. 117 pp., [70] illus.
Four essays on posters of the early 1890s: French, by Alexandre; Italian, by Jaccaci; American, by Bunner; and English, by Spielmann.

254. Barnicoat, John. *A concise history of posters: 1870-1970.* London: Thames & Hudson; New York: Abrams, [1972]. 288 pp., 273 illus. (part col.), bibl.
A survey history of the poster. Art Nouveau, pp. 29-71, including psychedelic posters.

255. Buchheim, Lothar Günther. *Jugendstilplakate.* Feldafing: Buchheim Verlag, [1969]. 95 pp., 71 col. pls.
Primarily colored illustrations, with a short essay.

256. Cologne. Wallraf-Richartz Museum. *Halbe Unschuld, Weiblichkeit um 1900: Europäische Graphik aus der Zeit des Jugendstils.* Köln 1972. 60 pp. 53 illus. (part col.) bibl.
Exhibition of 136 posters, prints, etc. illustrating the feminine motif in Art Nouveau. Short essays by Horst Keller, H.A. Peters, and Günther Busch. Short bibliography, p. 22.

257. *Estampe moderne: publication mensuelle contenant quatre estampes originales inédites en couleurs et en noir des principaux artistes modernes, français et étrangers.* Paris: Imprimerie Champenois, 1897-99. 2 vols., 50 col. pls. in each vol.

Monthly publication of four color posters each, bound in an annual volume. Alphabetical indexes by title and by artist at end of book (however the indexes do not aid in finding the print). Few Art Nouveau motifs, but includes work by Mucha and others. Tendency to low and derivative art, mostly executed for this publication. Emphasis on Belgian and French artists. Text accompanies each print. Edited by Ch. Masson and H. Piazza. Preface by Léonce Bénédite, vol. 1, pp. 5-9.

258. Hamburg. Museum für Kunst und Gewerbe. *Plakat Ausstellung.* Hamburg: 1896. 94 pp.

Pioneer exhibition catalog of 400 posters. Arrangement is alphabetical by country (see contents, p. 94). No illustrations. Includes "Vorwort", "Nachwort", and short texts scattered through the catalog.

259. Hamburg. Museum für Kunst und Gewerbe. *Plakat- und Buchkunst um 1900: Plakate, Gebrauchsgraphik, Illustrationen, Schriftkunst, Buchschmuck und Bucheindbände aus dem Sammlungen des Museums für Kunst und Gewerbe Hamburg.* Hamburg: 1963. 109 pp., 57 pls., bibl.

Exhibition catalog of 1,085 items. No contents page. Introductory texts by Liselotte Möller and H. Sp. [i.e. Heinz Spielmann], with shorter texts scattered through the book. Arrangement is by country. Index, pp. 108-9. Plates are black-and-white photographs. Lists of illustrations in Art Nouveau periodicals, pp. 28-30, 48, 80-5, 106.

260. Hiatt, Charles. *Picture posters.* London: Bell, 1895. 367 pp., illus.

Largely a discussion of contemporary (1895) posters. Many Art Nouveau artists. No index.

261. Hillier, Bevis. *Posters.* London: Weidenfeld & Nicolson; New York: Stein & Day, [1969]. 296 pp., illus., pls. (part col.), bibl.

A good introduction to the subject. Although general in scope,

most of the book covers the Art Nouveau period (pp. 32-233). Numerous illustrations.

262. Hofstätter, Hans H. *Jugendstil: Druckkunst.* Baden-Baden: Holle Verlag, [1968]. 295 pp., illus. (part col.), col. pls., bibl. Numerous outstanding illustrations. Book and periodical illustrations and posters, perhaps unequalled in scope. Also valuable for East European coverage. Arranged by country. General introduction, followed by short biographical sketches and bibliographies of many artists, not all of whom are necessarily Art Nouveau. Some of the artists included are: (France) Toulouse-Lautrec, Ranson, Chéret, de Feure, Henri Jossot, Mucha; (Britain, U.S.) Ricketts, Mackmurdo, Beardsley, Bradley, Crane, Jesse King; (Belgium) Van de Velde, Khnopff; (Holland) R.N. Roland Holst, Toorop, J. Thorn Prikker; (Scandinavia) Munch, Munthe, Gallen; (Germany) Leistikow, Eckmann, Ludwig von Hofmann, Behrens, E.R. Weiss, Fidus, Lilien, Lechter, F.H. Ehmcke, Vogeler, Hans Christiansen, Franz Stuck, Pankok, Th. Th. Heine, Bruno Paul, Fritz Endell; (Switzerland) Hodler, Kreidolf; (Italy) Antonio Rizzi, Adolphus de Carolis; (Austria) Klimt, J. Hoffmann, Emil Orlik, Carl Czeschka; and (Poland) Wyspianski.

263. Hutchison, Harold F. *The poster: an illustrated history from 1860.* A Studio book. London: Studio Vista; New York: Viking, [1968]. 216 pp., 218 illus., (part col.), bibl.
Art Nouveau posters from France, England and the United States are discussed, pp. 14-47. Light emphasis on Art Nouveau.

264. *Les Maîtres de l'affiche: publication mensuelle contenant la reproduction des grands artistes, français et étrangers.* Paris: Imprimerie Chaix, 1896-1900. 5 vols., 240 col. pls.
Five folio-sized volumes of 48 colored plates each, cumulated annually. Each volume has a brief preface by Roger Marx. Numbering for the 240 plates runs consecutively through the five volumes. Indexes at rear of each volume list plates numerically. Artist index also. Emphasis is on France, particularly Chéret.

265. Melvin, Andrew, ed. *Art Nouveau posters and designs.* [London]: Academy Editions, [1971]. Unpaged, 52 illus. (part col.)
Leading examples of posters and book illustrations from all countries. Each plate accompanied by a short text.

266. Metzl, Ervine. *The poster: its history and its art.* [New York]: Watson-Guptill, [1963]. 183 pp., illus., col. pls.
A general history of the poster. See chapters 4-7 (pp. 41-84). Numerous illustrations.

267. Müller-Brockmann, Josef, and Müller-Brockmann, Shizuko. *Geschichte des Plakates. Histoire de l'affiche. History of the poster.* Zürich: A B C Verlag, [1971]. 244 pp., 291 illus. (chiefly col.), bibl.
A well-illustrated general history of the poster, with texts in German, French, and English. See contents, pp. 6-7. Art Nouveau is treated on pp. 31-69.

268. New York. Museum of Modern Art. *Word and image: posters from the collection of the Museum of Modern Art.* Selected and edited by Mildred Constantine. Text by Alan M. Fern. Greenwich, Conn.: New York Graphic Society, [1968]. 160 pp., illus. (part col.), bibl.
Numerous illustrations. Art Nouveau, text, pp. 12-20; illustrations, pp. 25-45. Extensive bibliography by Bernard Karpel, pp. 141-55.

269. Penfield, Edward. *Posters in miniature.* London: John Lane; New York: R.H. Russell, 1896. Unpaged, illus.
Small format. Illustrations almost completely in black-and-white, chiefly of English and American posters. Two-page introduction by Penfield and one-page foreword by Percival Pollard.

270. Price, Charles Matlack. *Posters: a critical study of the development of poster designs in continental Europe, England and America.* New York: G.W. Bricka, 1913. xvi, 380 pp., 120 illus., 42 col. pls.
A general survey of the poster, primarily of developments in the 1890s. Emphasis on the United States. Chapter 2 is on Chéret. Full page illustrations comprise about half of the book. Index.

271. Rickards, Maurice. *Posters at the turn of the century.* London: Evelyn, Adams & Mackay; New York: Walker, [1968]. 70 pp., [32] pls. (part col.)
A short and well-written, well-illustrated introductory essay.

*272a. Rossi, Attilio. *I manifesti.* Elite: le arti e gli studi ogni tempo e paese, 40. Milano: Frat. Fabbri Editori, 1966. 157 pp., illus., pls.

272b. Rossi, Attilio. *Posters.* Cameo. London, New York: Paul Hamlyn, [1969, c1966]. 159 pp., 77 col. illus.
 Art Nouveau posters are discussed and illustrated between pp. 10-55. Translation of 272a.

273. Sponsel, Jean Louis. *Das moderne Plakat.* Dresden: G. Kühtmann, 1897. vii, 316 pp., 266 illus., 52 col. pls.
 A survey of 1890s posters, with separate chapters on France, Belgium, England, the United States, and Germany and Austria. Many fine color reproductions. Contents and index, pp. 309-16.

274. Vinkenoog, Simon. *On wings of colour.* [Bennekom, Holland]: Verkerke Reprodukties, [1970?]. 96 pp., illus. (part col.)
 Introduction by the Dutch poet Vinkenoog in Dutch, German, and English, pp. 2-10. Primarily illustrations (pp. 11-96). Art Nouveau, pp. 11-24.

275. Villani, Dino. *Storia del manifesto pubblicitario...* Milano: Omnia Editrice, [1964]. 399 pp., illus. (part col.)
 A general history of the poster. Pages 81-158 cover the Art Nouveau period. Numerous illustrations.

276. Walters, Thomas. *Art Nouveau graphics.* London: Academy Editions; New York: St. Martins Press, [1972, c1971]. 87 pp., illus. (part col.)
 Short introductory text, pp. 5-7. List of plates, pp. 10-11. Primarily illustrations, pp. 12-85.

277. Wember, Paul. *Die Jugend der Plakate, 1887-1917.* Krefeld: Scherpe, [1961]. 28, 342 pp., illus., bibl.
 Hundreds of small illustrations of posters from all countries (pp. 47-307). Brief introductory text. Biographical dictionary of the artists, pp. 313-26. Bibliography, pp. 333-8.

278. Wichmann, Siegfried. *Berghaus Jugendstil-Album.* [N.p.]:

Berghaus-Verlag, [1971?]. Unpaged, 38 col. pls.
 Folio of colored plates, some of which are Art Nouveau. Short
 introductory text in front of book. List of plates at rear of
 book.

279. Zurich. Kunstgewerbemuseum. *Meister der Plakatkunst:*
Ausstellung im Rahmen der Juni-Festwochen, Zürich. Wegleitung,
229. Zürich, 1959. Unpaged, illus.
 Exhibition catalog of 210 posters. Only posters through num-
 ber 67 are Art Nouveau. Foreword by Hans Fischli. Essay,
 "Zur Geschichte des Plakates," by Willy Rotzler in front of cat-
 alog.

280. Bans, Georges. "Concours: 'La Chasse illustrée'." *Art Dec*
4:81-2 (My 1900). 6 illus.
 Competition for a magazine cover design.

281. Forrer, Robert. "Alte und moderne Neujahrswünsche und
ihre künstlerische Wiedergeburt." *ZfB* 3:369-86 (Ja 1900). 35
illus. (part col.)
 Historical and contemporary (1900) New Year's greeting cards.

282. Gugitz, Gustav. "Das Plakat." *VS* 1, Heft 11:13-18 (N 1898).
8 illus. (pp. 12-23)

283. Jessen, Peter. "Die Kunst im Plakatwesen." *Kgwb* N.F. 7:
81-91 (1896). 8 illus. (part col.) 2 pls.

284. Koch, Robert. "The poster movement and 'Art Nouveau'."
GBA Sér. 6, vol. 50:285-96 (N 1957). 11 illus.
 A review of poster art until 1896.

285. Kurtz, Stephen. "Word and image." *Arts Mag* v. 42, no. 3:
43-7 (D 1967/Ja 1968). 15 illus.
 An observation on the poster exhibition "Word and Image" at
 the Museum of Modern Art, New York (268).

286. Maggioni, Aldo. "La 1a. [i.e., primiera] esposizione inter-
nationale di cartoline postali illustrate a Venezia." *Emp* 10:310-
24 (O 1899). 58 illus.

287. Mellerio, Andrea. "Il rinnovamento della stampa." *Emp* 5: 323-36 (My 1897). 24 illus., 1 pl.
The revival of graphic arts and illustration.

288. Michel, Wilhelm. "Künstlerische Plakate." *DKD* 19:493-501 (Mr 1907). 24 illus., 8 col. pls. (pp. 493-515ff.)

289. Pica, Vittorio. "Attraverso gli albi e le cartelle, 5: i cartelloni illustrati in America, in Inghilterra, in Belgio ed in Olanda." Sensazioni d'arte. *Emp* 5:99-125 (F 1897). 52 illus.
Posters from the United States, England, Belgium and Holland. Part 6 of the same series (*Emporium* 5:208-32, Mr 1897) deals with posters from Germany, Austria, Russia, Scandinavia, Spain and Italy. With 61 illustrations. See item 1174 for article on France.

290. Pica, Vittorio. "Taccuino dell'amatore di stampe..." [in 2 parts]. *Emp* 11:72-6 (Ja 1900), 11 illus.; 11:313-19 (Ap 1900), 20 illus.

291. Poppenberg, Felix. "Moderne Plakatkunst." *ZfB* 1:183-92 (Jy 1897). 11 col. illus., 1 col. pl.

292. Rath, Philipp. "Künstlerische Inseraten-Reklamen." *ZfB* 2: 506-19 (Mr 1899). 16 illus.
Advertising inserts from various countries.

293. Singer, Hans W. "Plakatkunst." *Pan* 1:329-36 (F-Mr 1896). 9 illus., 1 pl.

294. Uzanne, Octave. "Les Affiches étrangères." *Plume* no. 155: 409-25 (O 1, 1895). [93] illus.
Special issue of the magazine devoted to an early survey of the foreign poster, particularly in England, America, and Belgium. Lead article by Uzanne, with eight shorter articles on individual countries (pp. 426-41). Numerous black-and-white illustrations, pp. 409-61.

295-6. These item numbers not used.

ALSO SEE: 26, 200-1, 546, 578-82, 847-52, 869, 906-7, 911, 923, 1157-76, 1473-8, 1588, 1673-95, 1768-80

Painting in general (Symbolist painting)
Art Nouveau painting, to the extent it exists, is perhaps best classed with the Symbolist school of painting. It is questionable, however, whether Symbolist painting really is Art Nouveau. Only a few general works are listed here. Lucie-Smith (299) and Milner (300) are good introductions. Hofstätter (262, 297, 298) has written much on the subject. Individual Symbolist painters often cited in the literature on Art Nouveau are listed under their country.

297. Hofstätter, Hans H. *Geschichte der europäischen Jugendstilmalerei: ein Entwurf.* DuMont Dokumente: Kultur und Geschichte. Köln: M. DuMont Schauberg, [1963]. 271 pp., 48 illus., 51 pls., bibl., bibl. footnotes
A survey of Art Nouveau/Symbolist painting in Europe. Appendix, p. 252ff., includes notes, bibliography, lists of illustrations, and index. Many illustrations in black and white.

298. Hofstätter, Hans H. *Symbolismus und die Kunst der Jahrhundertwende.* DuMont Dokumente, Reihe 1.: Kunstgeschichte Deutung Dokumente. Köln: M. DuMont Schauberg, [1965]. 274 pp., 86 illus., 94 pls., bibl., bibl. footnotes
Symbolist painting and graphic work. Includes Art Nouveau material. Extensive treatment of the subject.

299. Lucie-Smith, Edward. *Symbolist art.* London: Thames & Hudson; New York: Praeger, [1972]. 216 pp., 185 illus. (part col.), bibl.
A general survey of symbolist painting and graphic art with emphasis on France. Includes Art Nouveau artists. Bibliography, p. 209.

300. Milner, John. *Symbolists and decadents.* London: Studio Vista; New York: Dutton, Studio Vista/Dutton pictureback. 1971. 160 pp., [119] illus., bibl. footnotes
Short general text. The numerous illustrations give a good idea of the scope of Symbolist painting.

301. Rasch, Wolfdietrich. "Fläche, Welle, Ornament: zur Deutung der nachimpressionistischen Malerei und des Jugendstils." In: *Festschrift Werner Hager,* pp. 136-60, [hrsg. von Günther Fiensch und Max Imdahl]. Recklinghausen: Bongers, [1966]
See illustrations 118-32. Bibliographical footnotes, pp. 159-60.

302. Klein, Rudolf. "Die Internationale Kunstausstellung in Düsseldorf." *DKD* 14:589-608 (Ag 1904). 19 illus.
Painters exhibited include Munch, Hodler, Segantini, and Khnopff.

303. Michalski, Ernst. "Die entwicklungsgeschichtliche Bedeutung des Jugendstils." *Rep K* 46:133-49 (1925). 7 illus.
Noted early article on stylization in Art Nouveau. Discusses theories of Eckmann, Van de Velde, and Japanese influences. Identifies Van Gogh with Art Nouveau. Reprinted in *Jugendstil,* ed. by Jost Hermand (9).

304. Pica, Vittorio. "La pittura all'Esposizione di Parigi, 6: il Belgio, l'Olanda, la Germania, l'Austria, la Svizzera, la Spagna, l'Italia ed il Giappone." *Emp* 13:243-62 (Ap 1901). 20 illus.
One in a series of articles on painting at the 1900 Exposition Universelle. Includes Hodler, Klimt, and Segantini.

305. Roh, Juliane. "Auf dem Wege zum Selbstausdruck der künstlerischen Mittel: zur Ausstellung 'Sezession, europäische Kunst der Jahrhundertwende', in München." *Kwk* vol. 18, no. 1-3: 72, 81 (Jy-Se 1964). 13 illus. (part col.), pp. 73-80
Some reflections on Art Nouveau painting and sculpture in relation to the Munich exhibition (58).

*306. Schmalenbach, Fritz. "Die Frage einer Jugendstilmalerei." Österreichischen Galerie, Vienna. *Mitteilungen* no. 54:53-68 (O 1966)
The problem of defining a Jugendstil school of painting, with particular reference to France and Germany. A revised version appears in *Jugendstil,* ed. by Jost Hermand (9). Originally published in the *Neue Zürcher Zeitung,* My 27, 1962.

307. Schumann, Paul. "Die Internationale Kunstausstellung zu

Dresden, 1901: graphische Kunst." *KKbw* 4:522-45 (1901)
No. 3 of three articles on this international exhibition. Includes
work of Orlik, Leistikow, and Th. Th. Heine among others. No
illustrations.

ALSO SEE: 26-7, 583-5, 673ff., 853-6, 898-919, 1118, 1177-82, 1429-31,
 1460

Decorative arts in general
 Decorative arts typify Art Nouveau at its best and at its
most characteristic. There is no confusing the Art Nouveau objet
d'art with work in other styles, as can occur with Art Nouveau
architecture and painting, the distinct existence of which is even
debatable. Because there are no major surveys devoted exclusively
to the decorative arts of the period, one must consult the general
books on Art Nouveau in the first section. Attention should be
called, however, to Schneck (349) and to the catalog of the Citro-
en collection in Darmstadt (310). An outline of this section follows:
 Decorative arts in general 308-32
 Carpets 333-6
 Ceramics 337-45
 Clocks 346
 Furniture 347-56
 Glass 357-66
 Jewelry and precious metals 367-84
 Leather 386
 Lighting fixtures 387-8
 Metalware 389-92
 Postage stamps 393
 Tapestries 394
 Textiles and embroidery 395-7
 Wallpapers 398-402
 Women's dress 403

308. Arnhem. Gemeentemuseum. *Collectie Citroen.* [Arnhem],
1959. Unpaged, illus., 2 col. pls.
 Catalog of 185 items from the noted collection of Art Nou-
veau jewelry and decorative art. Short text in Dutch by K.A.
Citroen. This exhibit was also held in Rotterdam at the Boy-
mans-Van Beuningen Museum.

309. Citroen, K.A. *Jugendstil Sammlung K.A. Citroen, Amster-dam.* [Darmstadt: Hessisches Landesmuseum, 1962]. 181 pp., illus. (part col.)
 Catalog of a noted Dutch collection (323 items), now at the Hessisches Landesmuseum. Each item illustrated.

310. Darmstadt, Hessisches Landesmuseum. *Kunsthandwerk um 1900: Jugendstil...* Bearbeitet von Gerhard Bott. Kataloge des Hessischen Landesmuseum, no. 1. Darmstadt: Eduard Roether Verlag, 1965. 411 pp., 451 illus. (incl. col. pls.)
 Beautifully illustrated catalog of the museum's important Art Nouveau holdings, including the noted K.A. Citroen collection. An exceptional catalog.

311. Essen. Museum Folkwang. *Jugendstil: Sammlung Citroen in Hessischen Landesmuseum, Darmstadt; Ausgewählte Neuer-werbungen der Sammlung Citroen, Amsterdam.* Essen, [1962]. 217 pp., 347 illus., bibl.
 Exhibition catalog of 347 items, all illustrated, from the Ci-troen collection. Introductory texts by Paul Vogt and K.A. Citroen. Arrangement is by type of object; no contents page. Bibliography, p. 6. Index of artists at rear of book.

312. Friling, Hermann. *Moderne Flachornamente, entwickelt aus dem Pflanzen- und Thierreich.* Berlin: Bruno Hessling, [1897-?]. 3 vols. in 2
 Three folios of twenty-four plates each with floral and animal motifs. Folio 1 is closer to Arts & Crafts than Art Nouveau. No text. No artist credits.

313. Mosel, Christel. *Kunsthandwerk im Umbruch: Jugendstil und Zwanziger Jahre.* Bildkataloge des Kestner-Museums, Han-nover, 11. Hannover: Kestner-Museum, 1971. viii, 178 pp., [268] illus., 12 col. pls., bibl.
 Exhibition catalog of 232 items, all of which are illustrated. Part 1, "Kunsthandwerk" (primarily glass and pottery), pp. 1-133; part 2 "Medaillen und Plaketten", pp. 135-70. Part 1 is completely Art Nouveau. Contents, p. 178. Arrangement in each part is alphabetical by country and then alphabetical by artist. Emphasis is on Germany and France. Biographies of

each artist. Bibliographical citation for each item. Bibliography, pp. 171-4. Indexes, pp. 175-7.

314. Künstlerhaus-Galerie, Wien. *Jugendstil—20er Jähre: Verkaufs-Ausstellung...* Wien, 1969. 41 pp., 163 pls. (part col.), bibl.
Sales catalog of 271 items, mostly Art Nouveau decorative art, and some Art Deco. 163 items illustrated. Unillustrated items listed on pp. 1-22. Biographies of artists, pp. 23-40. Bibliography, p. 41.

315. North Carolina. University. Ackland Art Center. *Arts of the Fin-de-Siècle: elegant objects and images.* Chapel Hill, N.C., 1966. 64 pp., 32 illus. (pp. 45-63)
Exhibition of 133 items, mainly glass and ceramics. Introduction by Mary Davis Hill.

316. Woeckel, Gerhard P. *Jugendstilsammlung Dr. Gerhard P. Woeckel, München.* Kassel: Staatliche Kunstsammlungen, 1968. Unpaged (approx. 200 pp.), 203 pls. (part col.)
Exhibition catalog of the Woeckel collection of 203 decorative art objects (all illustrated), mostly from France and Germany. Arrangement is by country, in alphabetical order. Bibliographical citation with each item. Index of artists and of manufacturers follows the catalog section. Short introductory texts by Erich Herzog and by Woeckel.

317. Brüning, A. "Ausstellung im Kunstgewerbemuseum." *Br Archw* 4:60-8 (1902). Abb. 80-93
Berlin exhibition of European Art Nouveau.

318. "L'Art image." *Art Dec* 8:343-8 (N 1902). 12 illus.
Art objects with animal and floral motifs. Includes artists of the Art Nouveau Bing group in Paris.

319. Fourcaud, L. de. "Les Arts décoratifs aux salons de 1896, [parts] 1-3: Le Champ-de-Mars. *Rev Arts Dec* 16:181-6, 213-32, 256-8 (1896). Illus., pls.
Part 1 covers foreign artists, part 2, French artists.

320. Hevesi, Ludwig. "Aus dem Wiener Kunstleben." *KKhw* 1:

59-70, 111-17, 181-9, 224-9, 254-7, 402ff. (1898). Illus.
Notes on newer art in general and on the Secession.

321. "Les Industries d'art." *Art Mod* 14:331-2 (O 21, 1894)
A general review.

322. "Kaiser Wilhelm-Museum zu Crefeld." *DKD* 1:140 (1897)
A note on the new museum and its notable Art Nouveau collection.

323. "München: das Kunstgewerbe im Glaspalast und in der Secession." Korrespondenzen. *Dek K* 3:7-8 (O 1899). 7 illus. (pp. 37-9)

324. "Das Kunstgewerbe auf der Berliner Kunstausstellung." *Br Archw* 1:225-8 (1899)

325. Nocq, Henri. "Une Enquête sur l'évolution des industries d'art." *Art Mod* 14:288-9, 326-7, 333-4, 341-3, 349-50, 366-7, 383-4 (Se 9–D 2, 1894)

326. Sargent, Irene. "A recent Arts & Crafts exhibition." *Cfm* 4:69-83 (My 1903). 11 pls.
An international exhibit with Art Nouveau motifs held in Syracuse, N.Y.

327. Scheffler, Karl. "Unterricht in Kunstgewerbe." *Dek K* 5: 365-84 (Jy 1902); or *Kunst* 6:365-84 (Jy 1902). 38 illus.
The problems of handcraft schools relative to the Jugendstil movement. Illustrated with work of Obrist, Kersten, Ferdinand Morawe (jewelry), Georg Klimt, and W.J. Stokvis.

328. Schliepmann, Hans. "Von alten und neuen Flach-Ornament." *DKD* 6:386-8 (My 1900); 431-6 (Je 1900); 547 (Ag 1900)

329. Spielmann, Heinz. "Kunst der spätern 19. und des 20. Jahrhunderts: Erwerbungen 1963 und 1964." Hamburger Kunstsammlungen. *Jahrbuch* 10:231-62 (1965). 36 illus., bibl. footnotes
Acquisitions of the Hamburg Museum für Kunst und Gewerbe, much of which is Art Nouveau.

330. Strzygowski, Jos. "Das Ornament." *HW* 4:363-6 (1908)

331. "Studio talk, Berlin." *Studio* 16:139 (Mr 1899). 3 illus.
(pp. 136-8)
Applied art at Hirschwald's Gallery in Berlin.

332. "Zu den Abbildungen auf Seite 312-328." *InnDek* 17:328
(N 1906). 19 illus.
Includes work by Georg Honald, Hoffmann, and McLachlan.

ALSO SEE: 27, 143b, 173, 450, 452, 547-56, 586-607, 624ff., 723ff., 857-
63, 1183-1260, 1271-7, 1362

Decorative arts in general—Carpets

333. Dreger, Moriz. "Drei neue Teppiche." *KKhw* 5:545-54
(1902). 3 col. pls. facing p. 554
Designs by Voysey and Eckmann.

334. Jacques, G.M. "Tapis." *Art Dec* 5:232-40 (Mr 1901). 12
illus.
Carpets designed by Mucha, Aubert, Lemmen, Eckmann, and
others.

335. Lemmen, Georges. "Moderne Teppiche." *Dek K* 1:97-105
(1898, Heft 3). 15 illus., 1 col. pl.
Includes work by Lemmen and Brangwyn.

336. Verneuil, M.P. "Le Tapis moderne." *Art & Dec* 13:41-52
(F 1903). 16 illus. (part col.)
Carpets from England (Liberty), France (Art Nouveau Bing),
and Austria (Ginzkey).

ALSO SEE: 26, 1019, 1414, 1440

Decorative arts in general—Ceramics

337. Berlin. Kunstgewerbemuseum (West Berlin). *Werke um
1900.* Von Wolfgang Scheffler. Berlin: Stiftung Preussischer Kul-
turbesitz, Staatliche Museen, [1966]. 217 pp., 275 illus. (part col.),
bibl.

Text, pp. 5-6. Mainly French and German ceramics, with some glass and furniture. Alphabetized index for works not illustrated (p. 190ff.).

338. Hillier, Bevis. *Pottery and porcelain, 1700-1914.* London: Weidenfeld & Nicolson; New York: Meredith, [1968]. 386 pp., 217 illus., 16 col. pls., bibl., bibl. footnotes
Chapter 14 is on Art Nouveau pottery.

339. Zurich. Kunstgewerbemuseum. *Europäische Keramik seit 1900: Ausstellung.* Zurich, 1955. 10 pp., 6 foldout illus.
Short text by W.R. [Willy Rotzler?]. Includes some Art Nouveau.

340. Borrmann, R. "Moderne Keramik." *Kgwb* N.F. 9:159-68; 173-84 (1898). 17 illus. (pp. 166-7, 174-83)

341. Falke, O. von. "Die Kunsttöpferei auf der Pariser Weltausstellung." *Kgwb* N.F. 12:83-96 (1901). 24 illus. (pp. 82-100)
Ceramics at the 1900 Exposition.

342. Leymaire, Camille. "La Céramique d'architecture à l'Exposition Universelle." *Rev Arts Dec* 21:33-40, 91-4 (1900). Illus.
Note on the Pavillon de l'Histoire de la Céramique.

343. Molinier, Emile. "Quelques mots sur l'exposition de céramique." *Art & Dec* 2:1-8 (Jy 1897). 14 illus.
Copenhagen and Sevres porcelain.

344. Sandier, Alex. "La Céramique à l'Exposition." *Art & Dec* 8:184-96 (1900) 32 illus., 1 col. pl.; 9:53-68 (F 1901) 33 illus.
Porcelain from all countries at the 1900 Exposition. The first article emphasizes Scandinavia, the second, France.

345. Saunier, Charles. "La Céramique architecturale à l'Exposition." *Art Dec* 5:97-101 (D 1900). 5 illus., 1 pl.

ALSO SEE: 26, 189, 1261-70a, 1338, 1452, 1455, 1488-92, 1504, 1513, 1516, 1624-5

Decorative arts in general—Clocks

346. Gerdeil, O. "La Pendule." *Art Dec* 8:27-32 (Ap 1902)
Art Nouveau clock designs.

Decorative arts in general—Furniture

347. Frey, Gilbert. *The modern chair: 1850 to today. Le Siège moderne de 1850 à aujourd'hui. Das moderne Sitzmöbel von 1850 bis heute.* Teufen, Switzl.: A. Niggli Verlag, [1970]. 187 pp., illus., bibl.
Pages 11-39 cover the period to 1914.

348. Madsen, Stephan Tschudi, and Hopstock, Carsten. *Stoler og stiler.* Oslo: H. Aschehoug, 1955. 195 pp., 123, xv illus.
Text in Norwegian on 'chairs and styles'. Traces changes in art style through chair design from antiquity to modern times. For Art Nouveau see pp. 137-52. Chronological tables, p. 193ff.

349. Schneck, Adolf G. *Neue Möbel von Jugendstil bis heute.* [München]: F. Bruckmann, [1962]. 159 pp. (chiefly illus.)
Largely on Art Nouveau furniture and its subsequent influence on modern furniture. The author is a German designer and emphasis is on Germany. Numerous photographs of Art Nouveau furniture (pp. 31-156).

350. [French prize competition.] *Dek K* Bd. 4:48 (Jrg. 2) (1899); or *Kunst* 4:48 (1899). 11 illus. (pp. 85-8)
Desk design competition. Entries from G. Lemmen, M. Dufrène, H. Sauvage, and L. Sparre.

351. Jacques, G.M. "Fantaisie pour piano." *Art Dec* 3:6-7 (O 1899). 3 illus. (pp. 36, 38; also 55 [N 1899])
Esthetics of piano design. Mentions examples by Voysey, Baillie Scott, and Riemerschmid.

352. L. "Ein französisches Urteil über das Fremdlänsche moderne Mobiliar in Paris 1900." *Kgwb* N.F. 12:233-7 (1901)
Comment on Lucien Magne's article in the *Revue des Arts Décoratifs* (1317).

353. Luthmer, F. "Möbel und Zimmereinrichtungen auf der Pariser Weltausstellung." *Kgwb* N.F. 12:148-56 (1901)

354. "Moderne Inneneinrichtungen." *Dek K* 5:353-61 (Jy 1902); or *Kunst* 6:353-61 (Jy 1902). 15 illus. (pp. 353-63)
Interiors from Germany, England, Russia, and Hungary.

355. Oerley, Robert. "Moderne Möbel." *Intr* 1:17-23 (1900)
The problem of modern furniture.

356. Salis, Cumgrano [pseud?]."Arbeitswohnungen." *Intr* 1: 65-8 (1900)
The problem of interior decoration for worker's homes.

ALSO SEE: 26, 473, 586-7, 603, 617, 640, 644, 648, 704, 740, 747, 752, 755, 758, 762, 946ff., 990, 1000, 1007-8, 1021, 1032, 1064, 1083, 1115, 1124, 1182-3, 1217, 1234, 1245, 1247, 1294-1332, 1381, 1406, 1408-10, 1437, 1439, 1447, 1510, 1523, 1558, 1587, 1592, 1597, 1646-9, 1658-61, 1699ff., 1747, 1752

Decorative arts in general—Glass

357. Galerie des Arts Décoratifs, S.A., Lausanne. *L'Art verrier à l'aube du XXe siècle.* Lausanne, 1973. 106 pp., illus., bibl.
Exhibition of 245 examples of European glass, notably Gallé and Daum Frères. See contents, p. 5. Includes biographies of the artists. Black-and-white photographs of most of the objects.

358. Haedeke, Hanns-Ulrich. "Glas." In *Jugendstil, der Weg ins 20. Jahrhundert,* ed. by Helmut Seling (26), pp. 325-40. 36 illus., 1 col. pl. (pp. 313-36), bibl.
A survey of Art Nouveau glass, with a detailed section on Gallé as well as one on Tiffany.

359. Hagen. Karl-Ernst-Osthaus Museum. *Glas des Jugendstil: Sammlung Hentrich.* Hagen, 1965. Unpaged, 10 col. pls.
Catalog of 120 items from a private collection. Introduction by Herta Hesse. "Glas des Jugendstils," by Henri Fettweis is a translation of his essay from the catalog *Art verrier 1865-1925* (Musées Royaux d'Art et d'Histoire, Brussels).

360. Munich. Museum Stuck-Villa. *Internationales Jugendstil-glas: Verformen moderner Kunst.* München, 1969. Unpaged, 201 illus. (incl. col. pls.)
Comprehensive exhibition of Art Nouveau glassware. Essay, "Neue Formen: Bemerkungen zur Typologie der Jugendstil-gläser," by Siegfried Wichmann. Followed by a glossary of technical terms in German entitled "Technologie". Numerous photographs.

361. Pazaurek, Gustav E. *Moderne Gläser.* Monographien des Kunstgewerbes. Leipzig: H. Seeman, [1901]. 133 pp., 199 illus., 4 col. pls.
A comprehensive survey on Art Nouveau glass. Chapter 10 is on Gallé and the Nancy school. Many illustrations.

362. Didron, Ed. "Les Vitraux à l'Exposition de 1900." *Rev Arts Dec* 20:269-77, 315-25 (1900). 16 illus., 1 pl.
Stained glass windows at the 1900 Exposition.

363. Fred, W. [pseud. of Alfred Wechsler]. "Glas und Keramik auf der Pariser Weltausstellung." *KKhw* 3:379-400 (Se 1900). 44 illus.

364. G. [i.e. J. Meier-Graefe]. "Farbige Glasfenster." *Dek K* 1: 160-73 (1898, Heft 4). 25 illus. (pp. 159-77, part col.)
Stained glass windows from various countries.

365. O'Neal, William B. "Three Art Nouveau glass makers." *JGS* 2:125-37 (1960). 11 illus., bibl. footnotes
On Tiffany, Lalique, and Gallé.

366. Saunier, Charles. "Le Vitrail." *Art Dec* 6:30-6 (Ap 1901). 14 illus. (pp. 29-37)
Stained glass windows at the 1900 Exposition.

ALSO SEE: 26, 189, 706, 725, 819, 962, 1119ff., 1128, 1268, 1333-8, 1374, 1525-56, 1632

Decorative arts in general—Jewelry and precious metals

367. Amersfoort, Neth. Zonnehof. *Sieraad 1900-1972: eerste triënnale onder auspiciën van de Amersfoortse Culturele Raad.* Amersfoort, 1972. [16] pls. (178 illus.)
 Exhibition of 178 pieces of jewelry, all illustrated. Introduction by Anne H. Mulder. "Art Nouveau en Art Deco," by K.A. Citroen. First forty illustrations are Art Nouveau. Bibliographical citations on the artists follow the plates. Chronology on jewelry at rear of book.

368. Holme, Charles, ed. *Modern design in jewellery and fans.* London: *Studio.* 1902. Variously paginated, [209] illus. (part col.)
 A collection of six essays on jewelry and fans: France by Gabriel Mourey; Britain by Aymer Vallance; Austria by W. Fred [i.e., Alfred Wechsler]; Germany by Chr. Ferdinand Morawe; Belgium by Fernand Khnopff; and Denmark by Georg Brochner. Primarily illustrations.

369. Koch, Alexander, ed. *Schmuck und Edelmetall-Arbeiten: eine Auswahl moderner Werke.* Koch's Monographien, 9. Darmstadt: Verlag Alexander Koch, [190-?]. 103 pp. (entirely illus.)
 Black-and-white photographs of jewelry and precious metalware from Germany, Austria, France, and England. Brief introduction by Koch. Subject and artist indexes.

370. Pforzheim. Schmuckmuseum. *Goldschmiedkunst des Jugendstils: Schmuck und Gerät um 1900.* Pforzheim, 1963. 28 pp., 34 pls.
 Exhibition catalog of Art Nouveau goldware, mainly jewelry. Includes biographies of the artists. Introductory essay by Ulla Stöver.

371. Belknap, Henry W. "Jewelry and enamels." *Cfm* 4:178-80 (Je 1903). 1 pl.

372. Citroen, K.A. "Renaissance in edel metaal." *Forum* (Amsterdam) 13:339-44 (Ja 1959). 14 illus., bibl., bibl. footnotes

373. Citroen, Karel. "Zierat der Jahrhundertwende." *KHM* 5: 39-69 (1965). Schriften der Hessischen Museen. 85 illus., bibl. footnotes

Art Nouveau jewelry. Arrangement is by country (p. 47ff.) with historical background.

374. "Goldschmiedekunst." *HW* 1:343-6 (1905). 7 illus. The goldsmith's art. Jewelry by Hoffmann and Moser. Part 2 of the article is by Alfred Lichtwark and appears in vol. 2:57-9 (1905) and vol. 3:53 (1906).

375. Lemaire, C. " 'Les Serres chaudes' ou l'Exposition du Bijou 1900: Bruxelles, Mai 1965." *CHVV* 5:20-4 (1965). 3 illus. Summary in Dutch, pp. 38-9. Review of exhibition described in item 1339.

376. Maillard, Léon. "Orfèvrerie, orfèvres." *Art Dec* 5:198-209 (F 1901). 21 illus. Decorative art objects in gold from various countries.

377. G. [i.e. J. Meier-Graefe]. "Schmuck." *Dek K* 3:1-2 (O 1899); or *Kunst* 2:1-2 (O 1899). 30 illus. (pp. 10-15)

378. Melville, Robert. "The soft jewellery of Art Nouveau." *Arch Rev* 131:320-5 (My 1962). 13 illus. Comments on the curvilinear line of Art Nouveau, as well as on the jewelry.

379. Minkus, Fritz. "Die Edelschmiedkunst auf der Pariser Weltausstellung." *KKhw* 4:109-32 (1901). 30 illus. Decorative metalware at the 1900 Exposition.

380. Minkus, Fritz. "Die Juwelierkunst auf der Pariser Weltausstellung." *KKhw* 3:485-503 (1900). 38 illus., 2 pls.

381. "Moderner Schmuck." *Dek K* 11:174-81 (F 1903); or *Kunst* 8:174-81 (F 1903). 68 illus., 1 col. pl. Jewelry from all countries.

382. Pudor, Heinrich. "Modern jewelry." *Cfm* 6:130-5 (My 1904)

With Irene Sargent's comment, "A comparison of critics, suggested by the comments of Dr. Pudor," pp. 135-41. Compares Wolfers and Lalique.

383. Rücklin, Prof. "Die moderne Schmuckkunst im Licht der Weltausstellung in St. Louis." *Kgwb* N.F. 16:146-60 (1905). 27 illus. (pp. 153-60)

384. Vitry, Paul. "L'Orfèvrerie à l'Exposition." *Art & Dec* 8: 161-76 (1900). 26 illus.
Goldware and silverware from various countries at the 1900 Exposition.

385. This item number not used.

ALSO SEE: 26, 62, 189, 308-11, 745, 1076-82, 1183, 1211, 1222-3, 1228, 1231, 1238-9, 1252, 1339-76, 1450, 1496, 1519-22, 1524, 1627-45, 1720, 1729, 1787-9

Decorative arts in general—Leather

386. Sedeyn, Emile. "Le Cuir." *Art Dec* 8:32-40 (Ap 1902). 19 illus.
Art Nouveau motifs in leatherwork.

ALSO SEE: 1184, 1401, 1499. Also see Bookbindings in the index.

Decorative arts in general—Lighting fixtures

387. G. [i.e. J. Meier-Graefe]. "Moderne Beleuchtungskörper." *Dek K* 1:4-14 (1898, Heft 1). 37 illus. (pp. 3-20)
Electric light fixtures, including work by Benson, Tiffany, and Eckmann.

388. T.T. "La Lampe." *Art Dec* 7:160-8 (Ja 1902). 16 illus.
Lamps by Dufrène and other artists.

Decorative arts in general—Metalware

389. "Beschläge und Griffe." *Dek K* 1:57-66 (1898, Heft 2).

24 illus. (pp. 57-71)
A survey of Art Nouveau decorative hardware for doors and furniture.

390. F. "Ueber altes und neues Zinngerät." *Kgwb* N.F. 7:165-71 (1896). 7 illus., 1 pl.
Includes Art Nouveau tinware and sculpture.

391. Fred, W. [pseud. of Alfred Wechsler]. "Bemerkungen über die Metallindustrien auf der Pariser Weltausstellung." *KKhw* 3: 427-39 (O 1900). 16 illus.

392. [Metallarbeiten: Illustrations.] *Dek K* Jrg. 2 (Bd. 4):177-85 (1899). 16 illus.
Metal work by Ashbee, Berlepsch-Valendas, and others. Texts, pp. 172-3.

ALSO SEE: 125, 864, 951, 1377-84

Decorative arts in general—Postage stamps

393. Asche, Kurt. "Art Nouveau. Jugendstil auf Briefmarken und Postkarten." *Archiv für Deutsche Postgeschichte* 1970, Heft 2. 41 illus. (part col.)
Art Nouveau influence on postage stamp design in various countries in the early twentieth century.

ALSO SEE: 544, 731, 737, 1689

Decorative arts in general—Tapestries

394. Howaldt, Gabriele. "Bildteppiche der Stilbewegung." *KHM* 4, entire issue, 1964. Schriften der Hessischen Museen, 153 pp., 71 illus., 1 col. pl., bibl., bibl. footnotes
Special issue devoted entirely to Art Nouveau tapestry. Published in Darmstadt by Eduard Roether Verlag. May be catalogued in some libraries as a monograph. Arrangement is by country. Black-and-white photographs follow each chapter. Bibliography, pp. 145-7.

ALSO SEE: 26, 396

Decorative arts in general—Textiles and embroidery

395. Bartesch, Hermine. "Die Kunststickerei auf der Pariser Weltausstellung." *Kgwb* N.F. 12:103-7 (1901)

396. [Lux, Jos. Aug.]. "Gewerbe und Stickereien, Vorhänge und Teppiche." *HW* 3:293-4 (1907). 4 illus.
 Illustrated by work of Margarete von Brauchitsch and Jutta Sicka.

397. Verneuil, M.P. "La Broderie." *Art & Dec* 17:147-60 (My 1905). 22 illus.
 Art Nouveau embroidery, including designs by Lalique.

ALSO SEE: 539, 548, 555, 599, 617, 724, 738, 756-7, 973, 1285-93, 1420, 1650, 1789

Decorative arts in general—Wallpapers

398. Havard, Henry. "Le Papier peint à l'Exposition Universelle de 1900." *Rev Arts Dec* 20:301-14 (1900). 12 illus.

399. Scheffler, Karl. "Dekorationsmalerei." *Dek K* Jrg. 1 (Bd. 1): 67-70 (1898). 4 illus.
 Patterned designs for wallpaper.

400. "Die Tapete." *Dek K* Jrg. 3 (Bd. 6):274-90 (Ap 1900); or *Kunst* Jrg. 2:274-90 (Ap 1900). 25 illus., 1 col. pl.
 Designs for wallpapers. Includes Eckmann, Leistikow, Behrens, and Pankok as well as foreign artists.

401. "Die Tapete auf der Welt-Ausstellung in Paris." *InnDek* 12: 7, 11-16 (Ja 1901)
 Wallpapers from various countries at the 1900 Exposition. No illustrations.

402. Verneuil, M.P. "Le Papier peint à l'Exposition." *Art & Dec* 8:83-90 (1900). 11 illus.
 Wallpaper designs at the 1900 Exposition from France, England, and Germany.

ALSO SEE: 759, 870, 957, 1060, 1062, 1188, 1208, 1222, 1494-5, 1576

Decorative arts in general—Women's dress

403. Velde, Maria Van de. "Sonderausstellung moderner Damen-kostüme." *Dek K* Jrg. 4 (Bd. 7):41-7 (N 1900); or *Kunst*, Bd. 4: 41-7 (N 1900). 4 illus.

An exhibition in Krefeld of women's dress. Includes work by Henry Van de Velde, whose wife wrote the article.

ALSO SEE: 539, 1068

Book design in general

404. Cave, Roderick. *The private press.* London: Faber & Faber; New York: Watson-Guptil, [1971]. 376 pp., 83 illus., 72 pls., bibl.

A survey of private presses in various countries. Chapters 11-14 and 23 cover William Morris and the Art Nouveau and Arts & Crafts printers influenced by him, giving a general review of the period. Bibliography, p. 347ff., is arranged by chapter.

405. Harvard University. Dept. of Printing and Graphic Arts, Houghton Library. *The turn of a century, 1885-1910: Art Nou-veau-Jugendstil books.* [Catalogue by Eleanor M. Garvey, Anne B. Smith, and Peter A. Wick]. [Cambridge, Mass.], 1970. 124 pp., illus., bibl.

Exhibition catalog of 142 items. Arrangement is by country. Short essay and bibliographic citations for each item. Introduction by Peter A. Wick, pp. 1-7. Many black-and-white illustrations and page vignettes. Indexes. No contents page. Important bibliography, pp. 115-17.

406. Holme, Charles, ed. *The art of the book: a review of some recent European and American work in typography, page decoration and binding.* London: "The Studio", 1914. 276 pp., illus., col. pls.

A collection of eight short articles on Britain, France, Austria, Hungary, Sweden, and America. Beautifully and abundantly illustrated with hundreds of illustrations, facsimile reproduc-

tions, and colored plates. Includes both Art Nouveau and somewhat later work.

407. Kautzsch, Rudolf, ed. *Die neue Buchkunst: Studien im In- und Ausland.* Weimar: Gesellschaft der Bibliophilen, 1902. [xii], 200 pp.
A collection of eight essays in German on book decoration; England by H.C. Mariller; America by Franz Blei; Denmark by Deneken; Netherlands by Pol du Mont; Germany and Otto Eckmann by H. Loubier; Sattler by Kühl; and Peter Behrens by Haupt. Foreword by the editor. Design and type by Behrens.

408. Bierbaum, Otto Julius. "Gedanken über Buchausstattung." *ZfB* 1:210-12 (Jy 1897)

409. Ebart, Egon. "Von der Münchener Buchausstellung." *ZfB* 3:277-8 (O 1899)

410. Th. G. [i.e. Theodor Goebel]. "Buchausstattung." Chronik. *ZfB* 5:83-5 (My 1901). 4 illus.
Includes a review of the German translation of Walter Crane's *Of the decorative illustration of books old and new* (434) and vignettes by Walter Tiemann.

411. Kautzsch, Rudolf. "Von der internationalen Ausstellung für neuzeitige Buchausstattung im Kaiser Wilhelm-Museum zu Krefeld." *ZfB* 3:158-63 (Je 1899)
Review of an international exhibition of book design.

412. Kersten, Paul. "Der künstlerische Bucheinband: Plaudereien eines Fachsmanns." *ZfB* 1:307-22 (Se 1897). Illus.

413. "München: Buchgewerbeausstellung in Glaspalast". Korrespondenzen. *Dek K* Jrg. 2 (Bd. 4):213 (1899)
Exhibition of book design from various countries.

414. Loubier, Jean. "Die Kunst im Buchdruck: Sonderausstellung im Königl. Kunstgewerbemuseum zu Berlin, [part] 2." *ZfB* 2:475-87 (F 1899). 12 illus.

This second article on a Berlin museum exhibition deals with modern book design and illustration.

415. Schliepmann, Hans. "Zu Ästhetik der Buchausstattung." *ZfB* 1:479-84 (D 1897)

416. Zobeltitz, Fedor von. "Moderne Buchausstattung." *ZfB* 1: 21-32 (Ap 1897). 14 illus.

ALSO SEE: 26, 40, 205, 608-9, 922b, 1392, 1397, 1402, 1404

Book design in general—Bookbinding

417. The Studio. *Modern bookbindings and their designers.* Special winter number, 1899-1900. [London, 1900]. 82 pp., [126] illus., 5 col. pls.
A copiously illustrated anthology of eight essays on bookbindings, featuring two long articles on Britain by Esther Wood and shorter essays on the United States by Edward F. Strange, France by Octave Uzanne, Holland by Gabriel Mourey, Belgium by Fernand Khnopff, and two articles on Scandinavia.

418. Uzanne, Octave. *L'Art dans la décoration extérieure des livres en France et à l'étrangère...* Paris: Société française d'éditions d'art, 1898. 272 pp., [274] illus., [132] pls.
Study of bookbindings and covers of the fin-de-siècle, most of which are Art Nouveau. Emphasis is on France and England. Numerous illustrations (listed at end of the book). 1,060 copies.

419. Bosquet, Em. "La Relieure étrangère à l'Exposition." *Art & Dec* 9:99-104 (1901). 8 illus.

420. Goebel, Theodor. "Moderne künstlerische Bucheinbände." *ZfB* 5:154-7 (Jy 1901). 9 illus.

421. Hevesi, Ludwig. "Die Ausstellung von Bucheinbänden und Vorsatzpapieren im Öesterreichischen Museum." *KKhw* 6:121-48 (1903). 32 illus. (pp. 122-53)
Includes work since 1890.

422. Kühl, Gustav. "Neue Bucheinbände." *Dek K* Jrg. 4 (Bd. 7): 123-6 (D 1900); or *Kunst* Bd. 4:123-6 (D 1900). 5 illus., 4 col. pls.
Primarily German and English work.

423. Meier-Graefe, J. "Some recent continental bookbindings." *Studio* 9:37-50 (O 1895). 29 illus.
French, Danish, and Finnish bookbindings.

424. Saunier, Charles. "La Relieure moderne." *Art Dec* 5:253-63 (Mr 1901). 20 illus.
Bookbindings from France, England, and Germany.

425. Schölermann, Wilhelm. "Neues vom Bucheinband des Auslandes." *ZfB* 4:106-8 (My-Je 1900)

426. [Lux, J.A.]. "Technik und Kunst des Bucheinbandes: was man von der Pflege des Buches wissen soll." *HW* 1:182-5 (1905)
On bookbinding. Illustrations of the work of Douglas Cockerell.

427. Uzanne, Octave. "Couvertures illustrées de publications étrangères." *Art & Dec* 5:33-42 (F 1899). 14 illus.
Book covers from Germany, England, and Belgium.

428. Zur Westen, Walter von. "Der künstlerische Buchumschlag, 3: Oesterreich, Schweiz, Italien, Holland, Belgien, Skandinavien, Russland, England. *ZfB* 3:249-72 (O 1899). 17 illus. (part col.)
See item 1404 for article on France and North America.

ALSO SEE: 406, 725, 973, 991, 1102, 1386-8, 1394-6, 1398-1401, 1403-4, 1728, 1730

Book design in general—Bookmarks

429. Forrer, R. "Mittelalterliche und neue Lesezeichen." *ZfB* 2: 57-62 (My 1898). 17 illus. (part col.) (pp. 57-65)
Bookmarks from medieval times and from circa 1900.

Book design in general—Bookplates (Ex-Libris)

430. Zur Westen, Walter von. *Exlibris (Bucheignerzeichen).*
Sammlung illustrierter Monographien, 4. Bielefeld: Velhagen &
Klasing, 1901. 103 pp., 164 illus., 6 col. pls.
 A general review of bookplates, concentrating on the 1890s
 and covering all countries. Index. Numerous illustrations.

431. "Ex-libris." *Joventut* 1:554 (O 11, 1900). 2 illus.
 On bookplates. Text in Catalan.

Book design in general—Endpapers

432. Bierbaum, Otto Julius. "Künstlerische Vorsatzpapiere."
Dek K Jrg. 2 (Bd. 3):111-29 (1898, Heft 3). 25 illus., 3 col. pls.
 A survey of endpapers, including work by Lemmen and E.R.
 Weiss.

433. Kersten, Paul. "Das Buntpapier und seine Verwendung, be-
sonders für Bucheinbande." *ZfB* 4:169-76 (Ag-Se 1900). 22 illus.
9 col. pls.
 A general article on endpapers by a noted bookbinder. Includes
 some designs of Eckmann.

ALSO SEE: 421, 922

Book design in general—Illustration

434. Crane, Walter. *Of the decorative illustration of books old
and new.* 2nd ed. London: Bell, 1901. 337 pp., illus.
 Chapter 4 is on book illustration in 1900. Many illustrations
 from contemporary English books. First published in 1896.
 Third edition in 1905. See 410 for review.

435. G.P. "Die Ausstellung von illustrierten Büchern in der Bre-
mer Kunsthalle." *ZfB* 4:338-40 (D 1900). 1 illus.
 An exhibit including many books of the 1890s.

ALSO SEE: 262, 743, 854-6, 1389, 1391, 1585, 1695

Book design in general—Typography

436a. Day, Kenneth, ed. *Book typography, 1815-1965, in Europe and the United States of America.* [Chicago]: University of Chicago Press, [1965]. xxiii, 401 pp., 192 pls.

A collection of nine essays on modern typography in seven West European countries and the U.S. See especially: "Books in Belgium," by Fernand Baudin (pp. 20-32, primarily on Van de Velde); "The Art of the book in Germany in the 19th and 20th centuries," by Georg Kurt Schauer (pp. 103-8 and following on E.R. Weiss); "150 years of book typography in The Netherlands," by G.W. Ovink (p. 248ff.); and "British book typography," by P.M. Handover (pp. 154-9). Also see index entries for Art Nouveau and for William Morris. An expanded translation of *Anderhalve eeuw boektypographie, 1815-1965,* Nijmegen, 1965.

*436b. Schauer, Georg Kurt, ed. *Internationale Buchkunst im 19. und 20. Jahrhundert.* Ravensburg: O. Maier, 1969. ix, 421 pp., illus.

German translation of *Anderhalve eeuw boektypographie, 1815-1965,* Nijmegen, 1965.

437. Menter, Theodore, ed. *Art Nouveau and early Art Deco type and design from the Roman Scherer catalogue.* New York: Dover, Dover pictorial archive series. [1972]. 87 pp. of illus.

Typographical ornaments reprinted from the 1908 catalog of Scherer, a type manufacturer in Lucerne, Switzerland. No text.

*438a. Larisch, Rudolf von. *Beispiele künstlerischer Schrift.* Wien: Schroll, 1900-26. 5 vols.

438b. "Beispiele künstlerischer Schrift, 2. Folge. Herausgegeben von Rudolf von Larisch..." *DKD* 11:86-7 (N 1902). 4 illus.

An illustrated review of the second volume of 438a.

439. Larisch, Rudolf von. "Aus dem Werke: *Beispiele künstlerischer Schrift.*" *DKD* 19:128-9 (N 1906). 5 illus.

440. Larisch, Rudolf von. "Beispiele künstlerischer Schrift."

DKD 7:53-64 (O 1900). 17 illus.

Examples of Art Nouveau typography designs, mostly by Austrian and German artists.

441. Schubring, P. "Die Kunst im Buchdruck." *Kgwb* N.F. 10: 181-90 (1899). 8 illus.

ALSO SEE: 26, 406, 1385, 1390, 1393, 1421a-c, 1564, 1781

AUSTRIA (SECESSION)

In Austria the Art Nouveau movement was known as the Secession style. The name was taken from the Vereinigung Bildender Künstler Oesterreichs "Secession" (items 486-533), an artists' group formed to protest the official academic art of the 1890s. The group promoted Art Nouveau from 1898 to 1903, when its leading members founded the Wiener Werkstätte (534-543). It is difficult to differentiate between books and articles on the Secession style in general and those specifically on the Secession organization (486-533). The history of each is inextricably intermingled with the other, and the assignment of books and articles to one section or the other of this bibliography is sometimes arbitrary. Among the major monographs on Austrian Art Nouveau are: Bahr (444) and Hevesi (449), both of which are collections of writings by two critics of the day (and may be hard to locate); Holme (450) and Waissenberger (456); Kossatz (578) and Mascha (579) on posters; Nebehay (680) and Novotny (682) on Gustav Klimt; and Geretsegger (769) and Lux (771) on Otto Wagner.

The Secession exhibition held in London in 1971 (487) stimulated a number of articles in English and European journals. Most material on the Secession movement is in German, but there is also a fair amount published in English.

The most important journals for a study of the movement are *Ver Sacrum*, the official organ of the Secession and a luxurious, beautifully designed magazine edited by the artists themselves (volume 3 could not be located for annotation in this bibliography); *Kunst und Kunsthandwerk*, the official journal of the Oesterreiches Museum für Kunst und Industrie, in Vienna; and *Hohe Warte*, an Austrian architectural journal published in Leipzig, Germany. An important present-day journal is *Alte und Moderne Kunst*, which is dedicated to Austrian art and art history and has published a number of articles on the Secession movement.

One major Austrian Art Nouveau artist, the architect Joseph Maria Olbrich, is listed under Germany (in volume 2). Early in his career he left Vienna for Darmstadt, where most of his Art Nou-

veau work was actually done, though the Secession building in Vienna is still his most famous single piece of architecture.

The Austrian Art Nouveau movement was a very compact one. It centered around the designers and architects of the Secession and, later, the Wiener Werkstätte under the leadership of the painter Gustav Klimt and the designers Moser and Hoffmann and under the spiritual leadership of Otto Wagner. These last three were professors, and their strong influence is readily seen in the work of their many pupils.

The movement was completely centered in Vienna, at that time the capital of the far-flung Austro-Hungarian Empire. Under Viennese influence the Secession style was cultivated in Hungary, Czechoslovakia, Poland, and Yugoslavia. Young artists from these countries trained under Wagner, Hoffmann, and others and then either practised in Vienna or returned to their homelands. See the section "Slavic and Eastern Europe" in volume 2.

General books and articles

442. Bahr, Hermann. *Essays.* Leipzig: Insel-Verlag, 1912. 255 pp.
A collection of essays on cultural subjects by a noted Austrian journalist. Includes "Otto Wagner: zum 60. Geburtstag," pp. 113-16.

443. Bahr, Hermann. *Das Hermann Bahr Buch: zum 19. Juli 1913.* Berlin: S. Fischer Verlag, [1913]. 318 pp., port.
A collection of Bahr's essays on various subjects, published on the occasion of his fiftieth birthday. For essays on the Secession see pp. 140-55.

444. Bahr, Hermann. *Secession.* 2. Aufl. [Wien]: Wiener Verlag, 1900. viii, 266 pp.
A collection of thirty-seven essays by a noted Austrian journalist, reprinted from four journals and dealing, for the most part, with the Secession movement in Austria. Index. Cover design by J.M. Olbrich. No illustrations.

445. Breicha, Otto, and Fritsch, Gerhard, eds. *Finale und Auftakt, Wien 1898-1914: Literatur, bildende Kunst, Musik.* Salzburg: Otto Müller Verlag, [1964]. 297 pp., illus., col. pls.

Anthology of texts from the turn of the century in Vienna.
The section on art, pp. 167-242, includes essays by Otto Wag-
ner, Hevesi, Hoffmann, and Loos. Indexes, p. 293ff. Sources
of texts, p. 293.

446. Darmstadt, Hessisches Landesmuseum. *Kunst in Wien um
1900: Malerei, Zeichnungen, Aquarelle, Druckgraphik, Plakate,
Buchkunst, Kunstgewerbe.* Darmstadt: 1966. 181 pp., [113]
illus. (part col.), bibl.
 Exhibition catalog of 361 examples of fine and applied arts.
 No contents page or index. Bibliographic citation for each item.
 Short texts by Franz Glück, pp. 3-6, and Gerhard Bott, p. 181.
 Reprint of a text by Hermann Bahr, pp. 7-13. Bibliography, pp.
 177-80.

447. Feuchtmüller, Rupert. *Kunst in Oesterreich, 1860-1918.*
Wien: Forum Verlag, [1964]. 130 pp., [10] illus., 100 pls. (black-
and-white), 25 col. pls., bibl.
 General survey. Includes the Wiener Secession and its immedi-
 ate historical background, pp. 29ff., 70ff., and 93-122. Numer-
 ous illustrations.

448. Hevesi, Ludwig. *Altkunst-Neukunst: Wien 1894-1908.* Wien:
Verlag Carl Konegen, 1909. 608 pp.
 118 articles from the Vienna press dealing with both older and
 modern art. For Art Nouveau see particularly the second section,
 "Neuwien," p. 206ff. No illustrations.

449. Hevesi, Ludwig. *Acht Jahre Sezession (März 1897-Juni 1905):
Kritik, Polemik, Chronik.* Wien: Verlagsbuchhandlung Carl Kone-
gen, 1906. xiii, 550 pp.
 A collection of more than one hundred essays and reviews on
 the Wiener Secession by the noted critic, reprinted from a num-
 ber of European newspapers and journals. Many essays on exhi-
 bitions of the Secession and on Klimt, as well as some on for-
 eign figures. Index. Binding and endpapers designed by Josef
 Hoffmann. No illustrations.

450. Holme, Charles, ed. *The art revival in Austria.* London: Stu-
dio, 1906. 44 pp., 221 illus. (incl. pls.)

Four essays on Austrian art, including two on the Secession, "The architectural revival in Austria", by Hugo Haberfeld, and "Modern decorative art in Austria", by A.S. Levetus. Photographs accompanying these two essays are particularly relevant. Work by Hoffmann, Moser, Prutscher, and Urban.

451. Holstein, Jürgen, Antiquariat, firm, booksellers, Frankfurt a.M. *Wien: Kunst und Kultur, 1870-1930.* Holstein Katalog, 40. Frankfurt a.M.: [1973?]. [29] pp., [8] illus., 5 pls.
A listing of 190 books in a sales catalog of a noted bookseller.

452. *Jung Wien, Ergebnisse aus der Wiener Kunstgewerbe-Schule: Entwürfe zu Architekturen und Flächen-Dekorationen junger Wiener Künstler.* Kochs Monographien, 12. Darmstadt: Alexander Koch, [1907?]. 71 pp. (chiefly illus., part col.)
Secession architecture and decorative and graphic arts by pupils of Hoffmann, Moser, Czeschka, and others. Richly illustrated. Introduction by J.A. Lux.

453. La Boetie (Gallery), New York. *Art and design in Vienna: 1900-1930.* New York: 1972. viii, 21 pp., 24 pls.
Exhibition catalog of 165 objects, including work of the Wiener Secession. Short text by R.J. Clark. Artists' signatures facing p. 1.

454. Lux, Joseph August. *Das moderne Wohnung und ihre Ausstattung.* Wien: Wiener Verlag, 1905. 174 pp., 173 illus., 8 col. pls.
Interior decoration by architects of the Secession, including Hoffmann. Arranged by type of room. Numerous illustrations.

455. Waissenberger, Robert. *Wien und die Kunst in unserem Jahrhundert.* Wien: Verlag für Jugend und Volk, [1965]. 119 pp., 48 pls. (part col.)
Chapter 2 is on the Secession, and chapter 4 is on the Wiener Werkstätte.

456. Waissenberger, Robert. *Die Wiener Secession.* Wien: Jugend und Volk, [1971]. 295 pp., 94 illus. (part col.), bibl., bibl. footnotes.
A beautiful book on the Secession from its beginnings to the

present day. Chapters 1-6 cover the Art Nouveau phase of the movement. Bibliography, pp. 231-2; notes, pp. 243-52.

457. *Wien um 1900: Ausstellung veranstaltet vom Kulturamt der Stadt Wien.* [Wien]: 1964. xxiii, 130 pp., 94 black-and-white pls., 16 col. pls.
Exhibition of 870 items held in three Viennese museums (Secession, Künstlerhaus, and Historisches Museum der Stadt Wien). Foreword by Hans Mandl. Introductions by Franz Glück and Fritz Novotny. Biographies, pp. 115-27; bibliography pp. 128-30. Numerous illustrations.

458. Abels, Ludwig. "Ein Wiener Kunst-Jahr." *DKD* 10:463-72 (Je 1902). 18 illus. (pp. 455-66)
Report on architecture and plastic and decorative arts in Vienna.

459. Abels, Ludwig. "Wiener Moderne." *Dek K* Jrg. 4 (Bd. 7): 89-118 (D 1900); or *Kunst* Bd. 4:89-118 (D 1900). 45 illus. (pp. 89-122)
A survey article with emphasis on Wagner. Also Olbrich, Hoffmann, and Leopold Bauer.

460. Bahr, H. "Der englische Stil." *VS* Jrg. 1, no. 7:3-4 (Jy 1898)
A warning on English influence in Austria.

461. *Deutsche Kunst und Dekoration.* [Illustrations.] *DKD* 23: 153-207 (D 1908). 94 illus.
No text. Photographs of interiors and decorative art by Hoffmann, C.O. Czeschka, and others.

462. Eisler, Georg. "Achievements of the Vienna Secession." *Apollo* 93:44-51 (Ja 1971). 12 illus., 1 col. pl.
A general review of the movement.

463. Gesche, Klaus. "Wiener Secession." *Oeil* no. 126:8-15, 47 (Je 1965). 13 illus. (part col.)
Introductory article on the Vienna Secession.

464. Hodin, J.P. "Seventy-five years of Vienna Secession." *Art & Artists* vol. 5, no. 11:20-25 (F 1971). 6 illus. (part col.)

A general review of the movement, both during the Art Nouveau period and afterwards.

465. Kossatz, Horst-Herbert. "The Vienna Secession and its early relations with Great Britain." *Studio International* 181:9-20 (Ja 1971). 33 illus. (part col.)
The relationship of early Austrian art to English art since 1851, leading to the founding of the Secession group. Also deals with Mackintosh's visit to Vienna. Illustrations include an unpublished letter of Mackintosh and color reproductions of paintings by Schiele reflecting Klimt's influence.

466. Levetus, A.S. "The Imperial Arts and Crafts School, Vienna." *Studio* 39:323-334 (Ja 1907). 28 illus.
Architectural design and decorative arts by students of Hoffmann, Moser, and others.

467. Lux, Jos. Aug. "Die Moderne in Wien." *DKD* 16:521-9 (Je 1905). 72 illus. (pp. 521-46)
Interiors, decorative art objects, bookbindings, and page decorations by Austrian artists.

468. Lux, Jos. Aug. "Moderne Kunst." *HW* 2:68-70 (1906). 4 illus.
Austrian artists.

469. Neuwirth, Walther Maria. "Die sieben heroischen Jahre der Wiener Moderne." *AMK* Jrg. 9 (no. 74):28-31 (My-Je 1964). 9 illus.
On the beginnings of the Secession movement.

470. Schölermann, Wilhelm. "Modern fine and applied art in Vienna." *Studio* 16:30-8 (F 1899). 17 illus.
On two Viennese exhibitions.

471. Zuckerkandl, B. "Wiener Geschmacklosigkeiten." *VS* vol. 1, no. 2:4-6 (F 1898)
On the lack of artistic taste in Vienna.

ALSO SEE: 40a, 145, 181, 320

Exposition Universelle, 1900, Paris—Austrian exhibits

472. Abels, Ludwig. "Die Kunstgewerbeausstellung der Secession." *Intr* 2:17-23 (1901). 14 illus.
The Secession exhibit at the 1900 Exhibition

473. Abels, Ludwig. "Wiener Tischlerarbeit auf der Pariser Weltausstellung." *Intr* 1:129, 132, 134, 137, 144 (Se 1900). Illus.
Secession table design at the 1900 Exposition. Illustrated with tables by Hoffmann, pp. 129-37 and 139-44 (17 illus.) and pls. 52-4. Also four illustrations of interiors by Hoffmann, pp. 123-5, and one by Olbrich, p. 128.

474. Folnesics, J. "Die Wiener Kunstgewerbeschule auf der Pariser Weltausstellung." *Dek K* Jrg. 4 (Bd. 7):9-16 (O 1900); or *Kunst* Bd. 4:9-16 (O 1900). 9 illus.

475. Gerdeil, O. "L'Autriche." *Art Dec* 4:157-65 (Jy 1900). 9 illus.
The Austrian pavilion at the 1900 Exposition including interiors by Olbrich and J. & J. Kohn.

476. Hevesi, Ludwig. "Die Kunstgewerbeschule auf der Pariser Weltausstellung." *KKhw* 3:112-22 (Mr 1900). 25 illus. (pp. 113-30)

477. M.G. [i.e. J. Meier-Graefe]. "Die dekorative Kunst in den Ausstellungspalästen der Esplanade des Invalides: 2. Oesterreich." *Dek K* Jrg. 3 (Bd. 6):390-400 (Jy 1900); or *Kunst* Bd. 2:390-400 (Jy 1900). 8 illus. (pp. 394-400)
Notably the interiors of J.M. Olbrich.

478. Mourey, Gabriel. "Round the Exhibition: 4. Austrian decorative art." *Studio* 21:112-23 (N 1900). 9 illus.
Favorable review of the Austrian pavilion at the 1900 Exposition.

479. Pliwa, Ernst. "Die oesterreichischen kunstgewerblichen Lehranstalten auf der Pariser Weltausstellung." *KKhw* 4:145-79 (1901). 26 illus. (pp. 146-67)

Includes Austrian medieval interiors and modern decorative arts from the K.K. Kunstgewerbeschule in Prague (E. Novak, C. Kloucek).

480. C.S. "Die Mietswohnung die Pariser Weltausstellung." *Intr* 1:113-15, 118-19, 122 (Ag 1900). 6 illus. (pp. 122-25, 128)
The Secession interior at the 1900 Exposition.

Esposizione Internazionale d'Arte Decorativa Moderna, Turin, 1902—Austrian exhibits

481. Turin. Esposizione internationale d'arte decorativa moderna, 1st, 1902. Sezione austriaca. *Catalogo della sezione austriaca.* Vienna: O. Maass, [1902]. 42 pp.
Exhibition catalog of the Austrian exhibit.

482. Fred, W. [pseud. of Alfred Wechsler]. "The International Exhibition of Decorative Art at Turin: the Austrian section." *Studio* 27:130-4 (N 1902). 8 illus.

483. Levetus, A.S. "Austrian section at the Turin Exhibition." *Studio* 26:47-52 (Je 1902). 15 illus. (pp. 44-52)

484. "Die österreichische Abteilung auf der Turiner Ausstellung." *DKD* 11:73-4 (N 1902). 12 illus. (pp. 73-85)
Includes architecture by Ludwig Baumann.

485. "Das österreichische Kunstgewerbe in London und Turin: Vorbericht." *KKhw* 5:180-90 (1902). 64 illus. (pp. 181-215)
Numerous illustrations of Art Nouveau motifs in the decorative arts.

Wiener Secession (Vereinigung Bildender Künstler Oesterreichs "Secession")

*486. Vereinigung Bildender Künstler Oesterreichs "Secession". *Katalog der I.-[XXI.]... Wien: 1898-1904. 21 Hefte
The catalogs of the first 21 expositions of the Secession. In various formats.

487. Vereinigung Bildender Künstler Oesterreichs "Secession".
*Vienna Secession, Art Nouveau to 1970; Royal Academy of Arts,
London...* [Vienna: Jugend und Volk, 1971]. 29 pp., 49 illus.,
6 col. pls.
 Exhibition catalog of 598 items. Consists of seven short essays.
 All texts in English. Emphasis is on the Art Nouveau phase of
 the continuing Austrian movement. Includes a list of "British
 works of art shown at The Secession from 1897 to 1914," pp.
 29-[30].

488. Altenberg, Peter. "Peter Altenberg's Katalog XII. Ausstel-
lung." *VS* Jrg. 5, Heft 2:29-44 [entire issue] (1902). 12 illus.
 Catalog of the twelfth Secession exhibition, designed by Josef
 Hoffmann.

489. Ankwicz von Kleehoven, Hans. "Die Anfänge der Wiener
Secession." *AMK* vol. 5, no. 6-7:6-10 (Je-Jy 1960). 11 illus., bibl.
footnotes
 On the historical and organizational origins of the Secession
 group.

490. "Aus der Zehnten Ausstellung der Vereinigung Bildender
Künstler Oesterreichs 'Secession'." *VS* Jrg. 4, Heft 9:155-66 (1901).
8 pls.
 Photographs of the Secession's tenth exhibition. No text.

491. Bahr, Hermann. "An die Secession: ein Brief..." *VS* Jrg. 1,
Heft 5:5 (My 1898)

492. Bahr, Hermann. "Ein Brief an die Secession: Darmstadt,
im Mai 1901." *VS* Jrg. 4, Heft 14:227-238.

493. Bahr, Hermann. "Vereinigung Bildender Künstler Oester-
reichs: Secession." *VS* Jrg. 1, Heft 1:8-13 (Ja 1898). Illus.

494. Bahr, Hermann. "Zur IX. Ausstellung." *VS* Jrg. 4, Heft 4:
71-85 (1901). 8 pls.
 On the ninth exhibition of the Secession.

495. "Die VIII. Ausstellung der Wiener 'Secession'." *Dek K* Jrg. 4

(Bd. 7):171-83 (F 1901); or *Kunst* Bd. 4:171-83 (F 1901). 22
illus. (pp. 170-85)
 Includes work of Mackintosh and Hoffmann. Also see pp. 187-9
 for four illustrations of work by the Glasgow Four.

496. Fred, W. [pseud. of Alfred Wechsler]. "Die Wiener Sezession:
VIII. Ausstellung." *InnDek* 12:26-39 (F 1901). 12 illus., 1 pl. (pp.
31-40)
 Secession exhibition. Work by Mackintosh and Ashbee as well
 as Hoffmann and other Austrian artists.

497. Hautmann, Peter & Klara. "The house of the Vienna Seces-
sion movement." *Studio* 181:168-9 (Ap 1971). 5 illus.
 On the construction of the Olbrich edifice.

498. Hevesi, Ludwig. "Die erste Ausstellung der Vereinigung Bild-
ender Künstler Oesterreichs." *VS* Jrg. 1, Heft 5-6:1-4 (My 1898).
79 illus. (pp. 6-60)
 A special issue for the group's international exhibition. Primar-
 ily illustrations.

499. Hevesi, Ludwig. "Secession (Aus dem Wiener Kunstleben)."
KKhw 2:160-5 (Ap 1899). 3 illus.

500. Hevesi, Ludwig. "Ausstellung der Secession (Aus dem
Wiener Kunstleben)." *KKhw* 2:452-6 (D 1899)

501. Hevesi, Ludwig. "Secession (Aus dem Wiener Kunstleben)."
KKhw 3:145-9 (Mr 1900)

502. Hevesi, Ludwig. "Secession (Aus dem Wiener Kunstleben)."
KKhw 3:467-73 (N 1900)

503. Hevesi, Ludwig. "Secession (Aus dem Wiener Kunstleben)."
KKhw 4:38-42 (1901)

504. Hevesi, Ludwig. "Secession (Aus dem Wiener Kunstleben)."
KKhw 4:185 (1901)
 The tenth exhibition of the Secession.

505. Hevesi, Ludwig. "Secession (Aus dem Wiener Kunstleben)."
KKhw 4:548-50 (1901)
The twelfth exhibition of the Secession.

506. Hevesi, Ludwig. "Secession (Aus dem Wiener Kunstleben)."
KKhw 5:96-8 (1902)
The thirteenth exhibition of the Secession.

507. Hevesi, Ludwig. "Secession (Aus dem Wiener Kunstleben)."
KKhw 5:617-21 (1902)
The fifteenth exhibition of the Secession.

508. Hevesi, Ludwig. "Sezession (Aus dem Wiener Kunstleben)."
KKhw 6:101-3 (1903)
The sixteenth exhibition of the Secession.

509. Hevesi, Ludwig. "Sezession (Aus dem Wiener Kunstleben)."
KKhw 6:167 (1903)
The seventeenth exhibition of the Secession.

510. Hevesi, Ludwig. "Sezession (Aus dem Wiener Kunstleben)."
KKhw 6:533-4 (1903)

511. Hevesi, Ludwig. "Die Wiener Secession und ihr *Ver Sacrum.*"
Kgwb N.F. 10:141-53 (1899). 13 illus.

512. Hevesi, Ludwig. "Zwei Jahre Sezession." *VS* Jrg. 2, Heft 7:
3-12 (1899)

513. Levetus, A.S. "The exhibition of the Vienna Secession."
Studio 25:267-75 (My 1902). 10 illus.
Includes rooms arranged by Kolo Moser.

514. A.S.L. [i.e. A.S. Levetus]. "Studio-talk: Vienna." *Studio*
25:136-7 (Mr 1902). 4 illus. (pp. 135-8)

515. A.S.L. [i.e. A.S. Levetus]. "Studio-talk: Vienna." *Studio*
26:141-3 (Jy 1902). 3 illus.
Exhibition rooms of the Secession.

516. [Levetus, A.S.?]. "Studio-talk: Vienna." *Studio* 28:54-8
(F 1903). 4 illus.
The Winter 1903 Secession exhibition, designed by Bauer and
Moser.

517. A.S.L. [i.e. A.S. Levetus]. "Studio-talk: Vienna." *Studio*
29:135-40 (Jy 1903). 5 illus.
Includes a note on the Secession exhibition.

518. Lux, Joseph August. "XIV. Kunst-Ausstellung der Verein-
igung Bildender Künstler Oesterreich's Secession 1902: Klingers
Beethoven und die moderne Raum-Kunst." *DKD* 10:475-82 (Jy
1902). 40 illus. (pp. 475-518)
The fourteenth Secession exhibition, featuring Max Klinger's
statue of Beethoven, paintings by Klimt, and architecture by
Hoffmann.

519. J.A.L. [i.e. Jos. Aug. Lux]. "Secession: XVII. Ausstellung
…" *Intr* 4:81-95 (1903). Illus.

*520. Matulla, O. "Die Wiener Sezession: Gründing und Entwick-
lung." Gesellschaft für vergleichende Kunstforschung in Wien.
Mitteilungen 15:85-9 (1962-63)

521. "Mittheilungen der Vereinigung Bildender Künstler Oester-
reichs." *VS* Jrg. 1, Heft 3:23-4 (Mr 1898)
Also see Heft 4:30 (Ap), Heft 8:24 (Ag), Heft 10:28 (O), and
Heft 11:24 (N 1898). Short notices on the Secession group.

522. Mrazek, Wilhelm. "To every era its art." *Conss* 176:16-18
(Ja 1971). 5 illus.
A general note on the Secession and the Wiener Werkstätte.
Followed by "The Vienna Secession: dialogue with England,"
p. 19 (2 illus.)

523. Pevsner, Nikolaus. "Secession." *Arch Rev* 149:73-4 (F 1971).
4 illus.
The Secession building of architect Joseph Olbrich.

524. V.S. "Zeichnungen aus der Mappe, die dem Architekten

J.M. Olbrich von seinem Freunden zur Erinnerung an den Bau
des Secessionsgebäudes überreicht wurde." *VS* Jrg. 4, Heft 3:49-
56 (1901). Illus.

525. V.S. "D. Haus d. Secession." *VS* Jrg. 2, Heft 1:6-7 (1899).
4 illus.
 Olbrich's new Secession building. Photographs, pp. 4, 13, 19,
 30.

526. Schölermann, Wilhelm. "Wiener Brief." *DKD* 4:359-77 (My
1899)
 Activities of the Wiener Secession.

527. Schölermann, Wilhelm. "Wiener Kunstbericht." *DKD* 2:319-
22 (Je 1898)
 The first exhibition of the Wiener Secession.

528. *Ver Sacrum.* [XIII. Ausstellung.] *VS* Jrg. 5, Heft 6:95-106
(1902) [entire issue]. Illus.
 Photographs of the thirteenth Secession exhibition, which was
 designed by Moser (see pp. 95, 106). No text.

529. *Ver Sacrum.* [XIV. Ausstellung der Vereinigung...Secession.]
VS Jrg. 5, Heft 11:165-76 (1902) [entire issue]. Illus.
 Photographs of the fourteenth Secession exhibition, which was
 designed by Joseph Hoffmann. Includes a Klimt mural.

530. *Ver Sacrum.* [XIV. Ausstellung der Vereinigung...Secession.]
VS Jrg. 5, Heft 12:177-92 (1902) [entire issue]. Illus.
 Photographs of work exhibited in the fourteenth Secession ex-
 hibition.

531. *Ver Sacrum.* [Secession 15. Ausstellung...] *VS* Jrg. 5, Hefte
22, 23:315-38 (1902) [two entire issues]. 25 illus.
 Photographs of the fifteenth Secession exhibition, which was
 designed by Leopold Bauer and others. No text.

532. *Ver Sacrum.* [Photographs of the Haus der Secession.] *VS*
Jrg. 2, Heft 4:2, 15, 21, 28 (4 pls.)
 The Secession building of architect Joseph Olbrich.

533. Whitford, Frank. "Ends and beginnings: Viennese art at
the turn of the century." *Studio International* 181:21-3 (Ja 1971).
6 illus.
 Evaluates the role of the Vienna Secession in Austrian modern
 art.

ALSO SEE: 101, 320, 449, 455-6, 462-5, 469, 680, 687, 723, 914

Wiener Werkstätte

534. Eisler, Max. *Oesterreichische Werkkultur.* Herausgegeben
vom Oesterreichischen Werkbund. Wien: Anton Schroll, 1916.
262 pp., illus.
 Chiefly photographs of architecture and decorative art by mem-
 bers of the group, notably Hoffmann and Wagner, pp. 71-236
 and preceding pages. Most work illustrated is after 1910 and is
 not Art Nouveau. The text deals with the Werkbund's artistic
 ideals.

535. Galerie St. Etienne, New York. *Wiener Werkstaette.* New
York: 1966. 32 pp., [38] illus.
 Exhibition of fifty-six items, all post-Art Nouveau. Text, p. 3.

536. Vienna. Oesterreiches Museum für Angewandte Kunst.
Die Wiener Werkstätte: modernes Kunsthandwerk von 1903-1932.
Wien: 1967. 100 pp., 80 pls., bibl.
 Exhibition of 563 items from the studios of the Vienna Werk-
 stätte. Essay by Wilhelm Mrazek, pp. 10-24. Monograms of the
 artists, pp. 25-7. Bibliography, pp. 28-30. Biographies of the
 artists, pp. 31-3. Features the work of Josef Hoffmann.

537. Ankwicz-Kleehoven, Hans. "Die Wiener Werkstätte." *AMK*
vol. 12 (no. 92):20-7 (My-Je 1967). 19 illus.
 Decorative arts, largely from the 1920s.

538. Baum, Julius. "Wiener Werkstätte." *DKD* 19:443, 452-3,
456 (Mr 1907). 68 illus. (pp. 443-90)
 Includes work by Hoffmann and Moser.

539. Blei, Franz. "Die Wiener Werkstätte." *DKD* 19:37-45 (O

1906). 69 illus. (pp. 37-88)
Work by Hoffmann, Moser, Czeschka, and Klimt. Includes women's dresses designed by Klimt.

540. C.H. "A Vienna/In Vienna." *Domus* no. 453:[53-5] (Ag 1967). 8 illus.
Notice on the Vienna exhibition (536). Texts in Italian and English.

541. A.S.L. [i.e. A.S. Levetus]. "Studio-talk: Vienna." *Studio* 37:169-76 (Mr 1906). 4 illus. (pp. 166, 169-72)
Wiener Werkstätte exhibition rooms.

542. Mrazek, Wilhelm. "Die Wiedergeburt des Kunsthandwerks und die Wiener Werkstätte." *AMK* vol. 9 (no. 74):38-42 (My-Je 1964). 11 illus.
On the principles of the Wiener Werkstätte.

543. "Wiener Werkstätte..." *DKD* 22:75-114 (My 1908). 87 illus.
No text. Photographs of interiors and decorative art by Hoffmann, Moser, and others.

ALSO SEE: 455, 522, 634, 636, 723

Kunstschau (Vienna), 1908

544. Kuzmany, Karl M. "Kunstschau Wien 1908." *Dek K* Jrg. 11 (Bd. 22):513-36 (Se 1908); or *Kunst* Bd. 18:513-36 (Se 1908). 60 illus. (pp. 513-52)
Includes architecture and interiors by Hoffmann, paintings by Klimt, and postage stamp designs by Moser.

545. A.S.L. [i.e. A.S. Levetus]. "Studio-talk: Vienna." *Studio* 44:308-14 (Se 1908). 7 illus.
The "Kunstschau" exhibition, designed by Hoffmann.

546. Lux, Joseph Aug. "Kunstschau-Wien 1908." *DKD* 23:33-61 (O 1908). 60 illus. (pp. 33-77)
Includes architecture by Hoffmann and an exhibition of posters.

ALSO SEE: 641, 649, 697

Oesterreiches Museum für Kunst und Industrie, Vienna

547. Fred. W. [pseud. of Alfred Wechsler]. "Die Winter-Ausstellung im Oesterreichischen Museum." *InnDek* 12:41-4 (F 1901). 4 illus., 1 pl.
Includes a chimney by Van de Velde.

548. Hevesi, Ludwig. "Die Ausstellung der K.K. Kunstgewerblichen Fachschulen im Oesterreichischen Museum." *KKhw* 4:220-40 (1901). 50 illus. (pp. 218-52)
Exhibition of decorative work from Austrian trade schools. Art Nouveau motifs in embroidery, textiles, and decorative arts.

549. Hevesi, Ludwig. "Die Winterausstellung im Oesterreichischen Museum." *KKhw* 2:1-22 (Ja 1899). 39 illus., 2 pls.

550. Hevesi, Ludwig. "Die Winterausstellung im Oesterreichischen Museum." *KKhw* 3:1-33 (Ja 1900). 7 illus., 2 pls. (pp. 1-42)

551. Hevesi, Ludwig. "Die Winterausstellung im Oesterreichischen Museum." *KKhw* 5:1-19 (1902). 48 illus. (pp. 1-31)

552. Leisching, Eduard. "Die Ausstellung der K.K. Kunstgewerbeschule in Prag und der Kunstgewerbeschule der K.K. Oesterreichischen Museums." *KKhw* 4:274-96 (1901). 46 illus. (pp. 271-307)
Exhibition of decorative art work of students of the Prague and Vienna craft schools. Interesting illustrations.

553. Leisching, Ed. "Die Ausstellung der Kunstgewerbeschule des K.K. Oesterreichischen Museums." *KKhw* 6:173-96 (1903). 27 illus.
Exhibition of student work in the decorative arts. Includes students of Hoffmann and Moser.

554. Minkus, Fritz. "K.K. Oesterreichisches Museum für Kunst

und Industrie in Wien: die dritte Winterausstellung und die Konkurrenz aus dem Hoftiteltaxfond." *Kgwb* N.F. 11:122-30 (1900). 9 illus.

555. Minkus, Fritz. "Die Winterausstellung im Oesterreichischen Museum." *KKhw* 4:1-25 (1901). 37 illus., 1 pl. (pp. 1-32)
Includes Art Nouveau pottery, textiles, and wall decor.

556. "Die Winterausstellung in Oesterreichischen Museum." *KKhw* 6:1-16 (1903). 49 illus. (pp. 1-25)

Klagenfurt. Kärntnerische Kunstgewerbliche Ausstellung, 1903

557. "Erste Kärntnerische kunstgewerbliche Ausstellung in Klagenfurt 1903." *KKhw* 6:529-31 (1903). 12 illus. (pp. 522-31)
Features sculpture by F. Gornik.

558. "Die kunstgewerblichen Ausstellungen in Aussig und Klagenfurt." *Intr* 4:218, 221 (1903). 18 illus. (pp. 209-22)
Two decorative arts exhibitions. Notably work of Prutscher (pp. 209-210).

St. Louis. World Fair, 1904—Austrian exhibits

559. Creutz, Max. "Die Weltausstellung in St. Louis 1904 (Forsetzung): der Oesterreichische Pavillion." *Dek K* Jrg. 8 (Bd. 15): 125-8 (D 1904); or *Kunst* Bd. 12:125-8 (D 1904). 7 illus.

560. [Levetus, A.S.?]. "Studio-talk: Vienna." *Studio* 35:248-54 (Ag 1905). 5 illus.
The Austrian pavilion at the St. Louis fair.

Miscellaneous exhibitions

561. "Die Ausstellung der Arbeiten aus den Fachkursen in Salzburg 1903." *KKhw* 6:473-86 (1903). 38 illus. (pp. 460-88)

562. Haenel, Erich. "Das Kunstgewerbe auf der Düsseldorfer Kunstausstellung." *Dek K* Jrg. 6 (Bd. 11):25-35 (O 1902); or *Kunst* Bd. 8:25-35 (O 1902). 17 illus. (pp. 25-38)
Emphasis is on Austrian art, including Hoffmann and others.

563. Minkus, Fritz. "Die oesterreichische kunstgewerbliche Aus-
stellung in London." *KKhw* 5:361-75 (1902). 20 illus. (pp. 362-75)

564. V.S. "Die Jubiläums-Ausstellung in Wien 1898." *VS* Jrg. 1,
Heft 10:2 (O 1898). 15 illus. (pp. 2-4, 9-10, 15-16, 21)

565. Schölermann, W. "Ausstellungwesen." *VS* Jrg. 1, Heft 2:19-
23 (F 1898). Illus.
Exhibition notices. Also Heft 4 (Ap), p. 22.

Architecture in Austria

566. *Aufbau.* "Um 1900." Wien: Stadtbauamt, 1964. Illus.
Special issue of *Der Aufbau: Fachschrift für Planen, Bauen und
Wohnen,* Jrg. 19, Heft 4-5, April-Mai 1964 (pp. 143-201). In-
cludes articles by Kittl, Feuerstein (636) and Achleitner (570).
Church buildings, pp. 153-6 (27 illus.) and homes (Wohnbau),
pp. 157-64 (52 illus.), both by "Arbeitsgruppe 4" (Wilhelm
Holzbauer, Friedrich Kurrent, and Johannes Spalt). Article,
"Das Looshaus," by Hermann Czech and Wolfgang Mistelbauer,
pp. 172-6 (15 illus.); also "Groszstadt Wien—Stadtebau der Jahr-
hundertwende," by Sokratis Dimitriou, pp. 188-200 (26 illus.)

567. Rome. Galleria Nazionale d'Arte Moderna. *L'Archittetura
a Vienna intorno al 1900.* [Roma?]: De Luca Editore. 1971. 33
pp., 400 illus. (71 pls.), bibl.
Exhibition on Viennese architecture. Introduction by Palma
Bucarelli, pp. 5-6. Chronologies of the individual architects, pp.
10-15. Texts translated from German, pp. 16-32, are on the
various types of edifices (churches, villas, and so forth). Cata-
log edited by Maria Marchetti. Bibliography, p. 33. Illustrations
are small, dark black-and-white photographs of buildings and
plans.

568. Uhl, Ottokar. *Moderne Architektur in Wien von Otto Wag-
ner bis Heute.* Wien: Schroll Verlag [1966]. 130 pp., 80 illus.,
bibl.
The second section (p. 15ff.) is about Secession architects. Bib-
liography, notably pp. 26-7, 125. Biographical-bibliographic
dictionary, p. 107ff.

569. L.A. [i.e. Ludwig Abels]. "Wiener Ausstellungswesen."
Intr 2:81-6 (1901). 28 illus. (pp. 80-96)
Problems of organizing exhibitions. Accompanied by photographs of interiors by Franz Krásny, Sigmund Járay, Prutscher & Puchinger, and others.

570. Achleitner, Friedrich. "Die Wiener Architektur um 1900."
Aufbau 19:144-52 (Ap-My 1964). 25 illus.
Mainly work by Wagner and Hoffmann. Chronological chart of the important buildings, p. 152.

571. [Lux, Jos. Aug.]. "Der Architektenkongress 1908." *HW* 4: 209-11 (1908)

572. [Lux, Jos. Aug.]. "Ein Garten aus Rosen und Lorbeer."
HW 2:280-2 (1906). 3 illus.
Illustrated by A. Holub. Six other illustrations by Holub, pp. 290-2.

573. Lux, Jos. Aug. "Sommer- und Ferienhäuser (zum Preisausschreiben der 'Woche')." *HW* 3:215 (1907). Illus. (pp. 216-23)
Country homes by Austrian and German architects (Max Graumüller, Adolf Holub, Konrad Reich, Franz Brantzky).

574. "Moderne Kinder-Spiele-und Arbeits Zimmer." *InnDek* 14: 181-8 (Jy 1903) 8 illus.; 14:197 (Ag 1903). 5 illus. (pp. 199-203)
Interior drawings, including competition for a children's room by Austrian and German architects such as Franz Safonith and Richard Müller. Also see drawings, pp. 230-6.

575. K.H.O. "Unser Wettbewerb um 'Entwurfe zu einem Kinderschlafzimmer'." *InnDek* 15:227-33 (Se 1904). 18 illus. (pp. 228-38)
Competition for a child's bedroom by Austrian and German artists.

576. Schölermann, Wilhelm. "Neuere Wiener Architektur." *DKD* 3:197-216 (F 1899). 22 illus. (pp. 197-219)
Emphasis on the work of Joseph Olbrich.

ALSO SEE: 225, 450, 452, 454, 611-16 (Bauer), 624ff. (Hoffmann), 722, 767-92 (Wagner)

Sculpture in Austria

577. A.S.L. [i.e. A.S. Levetus]. "Studio-talk:Vienna." *Studio* 24:139-40 (N 1901). 6 illus. (pp. 140-2)
Decorative sculpture work.

ALSO SEE: 622, 760, 793

Posters in Austria

578. Kossatz, Horst Herbert. *Ornamentale Plakatkunst Wiener Jugendstil, 1897 bis 1914.* [Salzburg]: Residenz Verlag, [1970]. 183 pp., illus.
Short text. Beautiful reproductions of Austrian posters from the collection of the Albertina Museum, Vienna. Includes thirty-four posters in portfolio.

579. Mascha, Ottokar. *Oesterreichische Plakatkunst.* Wien: J. Löwy, [1914]. 124 pp., 176 illus., 21 col. pls.
An historical survey of Austrian and Czech posters, primarily from the Art Nouveau period. Beautiful color plates and numerous illustrations. Folio size format.

580. Grossmann, Bruno. "Wiener Plakate." *Dek K* Jrg. 3 (Bd. 5): 134-5 (Ja 1900); or *Kunst* Bd. 2:134-5 (Ja 1900) 9 illus. & 1 col. pl. (pp. 149-52)

581. Kossatz, Horst Herbert. "Unbekannte Wiener Reklame-Plakate: Aus der Plakatsammlung der Oesterreichischen Museums für Angewandte Kunst." *AMK* Jrg. 13 (Heft 100):28-35 (Se-O 1968). 21 illus., bibl. footnotes
Mainly Austrian Art Nouveau posters.

582. R. "Nos illustrations [Affiches viennoises]." *Art Dec* 3: 179 (Ja 1900). 9 illus. (pp. 161-3)
Posters by Auchentaller, Moser, and Roller.

ALSO SEE: 252, 273, 546

Painting and drawing in Austria

583. Hague. Gemeente Museum voor Moderne Kunst. *Ostenrijksche schilderijen en kunstnijverheid, 1900-1927: catalogus.* Den Haag: 1927. 46 pp., 21 illus.
 Short texts by J.F.B. Kalff and Hans Tietze (the second in German). 105 paintings and drawings, plus decorative arts. Includes Klimt and Hoffmann.

584. "Kalender für das Jahr 1901." *VS* Jrg. 4, Heft 1 (1901) [entire issue]. Illus.
 The famous gold-leaf twelve-month calendar, which includes Klimt's "Januar".

585. *Ver Sacrum.* [Drawings.] *VS* Jrg. 1, Heft 7 (Jy 1898) [entire issue]. Illus.
 Drawings by Olbrich, Hoffmann, and Joseph Auchentaller, among others.

ALSO SEE: 673ff. (Klimt)

Decorative arts in Austria

586. Abels, Ludwig. "Die Jahresausstellung der Wiener Kunstgewerbeschule." *Intr* 2:177-88 (1901). 53 illus. (pp. 167-92)
 Student exhibitions from the craft schools, mainly furniture and interiors.

587. L.A. [i.e. Ludwig Abels]. "Tischlermöbel." *Intr* 3:33-7 (1902). 22 illus. (pp. 33-48)
 Tables and other furniture designed by Josef Niedermoser and Max Benirschke.

588. Abels, Ludwig. "Vom Wiener Kunstgewerbe 1901-1902." *Kgwb* N.F. 13:205-14 (1902). 40 illus. (pp. 210-24)

589. Abels, Ludwig. "Wiener Brief." *Dek K* Jrg. 5 (Bd. 9):69-73, 77 (N 1901); or *Kunst* Bd. 6:69-73, 77 (N 1901). 12 illus. (pp. 66-73)
 Austrian decorative art.

590. "Ausländische Urteil über Wiener Interieurs." *Intr* 1:153
(O 1900); 1:161-3 (N 1900)
 Foreign reactions to Secession interiors.

591. Breuer, Robert. "Zur Revision des Japanismus." *DKD* 18:
445-8 (Ap 1906). 14 illus. (pp. 444-53)
 Japanese influence on Austrian decorative arts. Includes work
 by H.O. Miethke and fans by Kolo Moser.

592. Degen, Kurt. "Oesterreichischer Jugendstil." *AMK* Jrg. 8
(no. 66):40-1 (Ja-F 1963). 5 illus.
 A note on Austrian work in the K.A. Citroen collection.

593. [Evers, Henri]. "Ausländische Urteile über Wiener Interi-
eurs." *Intr* 2:26-32, 64 (1901)
 Foreign press comments on Secession interiors.

594. Fischel, Hartwig. "Das Wiener Interieur von einst und jetzt."
Intr 1:97, 100-6, 112 (Jy 1900). 20 illus.
 Principles of the new decorative movement in Vienna.

595. Folnesics, J. "Das moderne Wiener Kunstgewerbe." *DKD*
5:253-88 (Mr 1900). 37 illus. (pp. 253-75, 292ff.)
 Followed by an article on Viennese sculpture and painting by
 Wilhelm Schölermann, pp. 288-93 (11 illus.).

596. Folnesics, J. "Das Wiener Interieur." *Intr* 1:3-6 (1900)

597. Folnesics, J. "Wiener Kunstgewerbeverein." *Dek K* Jrg. 5
(Bd. 9):132-9 (Ja 1902); or *Kunst* Bd. 6:132-9 (Ja 1902). 9 illus.
(pp. 130-5)
 Furniture and interiors.

598. *Das Interieur.* [Various photographs and plates of drawings
by a number of architects.] *Intr* 1:40, 45, 105, 110-11, 156; also
pls. 3-4, 10-11, 14, 43, 48-9, 55, 62ff. (1900)
 No texts.

599. "Kunst und Kunst-Handwerk." *DKD* 6:346 (Ap 1900). 4
illus. (pp. 346-8)
 Competition for a textile design.

600. Levetus, A.S. "The craft schools of Austria." *Studio* 35: 201-19 (Ag 1905). 31 illus.
Late Art Nouveau decorative work of Austrian students.

601. "Neues vom Wiener Kunstgewerbe." *InnDek* 12:143, 145-6 (Ag 1901)

602. Riotor, L. "Les Dentelles de l'Ecole des Arts et Métiers de Vienne." *Art Dec* 5:32-8 (O 1900). 6 illus.
Lace from the Kunstgewerbeschule, Vienna.

603. Schliepmann, Hans. "Billige geschmackvolle Wohnungs-Einrichtungen: einige Worte zum Wettbewerbe der *Innen-Dekoration.*" *InnDek* 14:13-15 (Ja 1903). Illus., pls.
Competition for furniture design, sponsored by the magazine. Followed by itemized costs, descriptions, and illustrations of work by Hans Schlechta, Otto Wytrlik, and Wilhelm Schmidt (pp. 16-23, 28, 46-56, 70-1, 75-6, 80-3 (Ja-Mr 1903). Includes color plates.

604. Schölermann, Wilhelm. "Kunstgewerbliches aus Wien." *DKD* 3:218-24 (F 1899). Illus.

605. Schölermann, Wilhelm. "Die 'Wiener Richtung' in der Innerraum-Ausstattung: ein Rückblick und Ausblick." *InnDek* 16:19-28, 35-40 (Ja 1905)

606. Verneuil, M.P. "L'Enseignement des arts décoratifs à Vienne." *Art & Dec* 11:143-64 (My 1902). 50 illus., 1 pl.
The work of students of Hoffmann and Moser, among others.

607. Zuckerkandl, B. "Der Dilettantismus die neue Volkskunst." *VS* Jrg. 1, Heft 7:5-8 (Jy 1898)

ALSO SEE: 450, 452, 547-56, 624-69 (Hoffmann), 723-39 (Moser)

Book design in Austria

608. Waissenberger, Robert. *Buchkunst aus Wien.* Wien: Verlag für Jugend und Volk, [1966]. 53 pp., 15 pls. (part col.)

A review of twentieth-century book illustration in Austria. Emphasis on Secession artists in first half of the book. Beautifully illustrated, in small format. List of artists, p. 53ff.

609. "Eilf Lieder." *VS* Jrg. 4, Heft 24:409-30 (1901) [entire issue]. 20 pls.
Sheet music designed by Hoffmann, Böhm, Moser, König, and others. No text.

ALSO SEE: 406

INDIVIDUAL ARTISTS

J.M. Auchentaller

610. Auchentaller, J.M. "Zeichnungen und Entwürfe." *VS* Jrg. 4, Heft 8:137-52 (1901). 20 illus., 2 col. pls.
Special issue. Drawings and art objects by the artist. No text.

ALSO SEE: 582, 585

Leopold Bauer

*611. Feldegg, Ferdinand von. *Leopold Bauer, der Künstler und sein Werk.* Wien: A. Schroll, 1918. viii, 67 pp., 93 illus., 63 pls., plans
Monograph on the artist in folio format. Cataloged by Library of Congress under: Fellner von Feldegg, Ferdinand.

612. *Das Interieur.* [Work of Leopold Bauer: illustrations] *Intr* 1:145, 170-1 pls. 57-9, 66
No text.

613. Kuzmany, Karl M. "Leopold Bauer: seine Absichten und seine Werke." *Dek K* Jrg. 8 (Bd. 15):89-112 (D 1904); or *Kunst* Bd. 12:89-112 (D 1904). 24 illus.

614. Lux, Joseph August. "Familien-Landhauser von Leopold

Bauer, Wien." *DKD* 12:493-505 (Ag 1903). 11 illus. (pp. 497-504)

615. J.A.L. [i.e. Joseph August Lux]. "Wohnhaus in Brunn: erbaut von Arch. Leopold Bauer." *Intr* 4:185-200 (1903). 19 illus.
 A house in Brno, rebuilt by the architect.

616. Servaes, Franz. "Leopold Bauer." *MB* 6:1-4 (1907). 35 illus., col. pls. 1-4, plans (pp. 1-35)

ALSO SEE: 101, 459, 513, 516, 531, 668, 767

Max Benirschke

617. Lux, Joseph August. "Max Benirschke." *Dek K* Jrg. 6 (Bd. 12):471-6 (Se 1903); or *Kunst* Bd. 8:471-6 (Se 1903). 14 illus.
 Furniture and textile design by a student of Hoffmann.

ALSO SEE: 587, 630

Carl Otto Czeschka

618. Ankwicz von Kleehoven, Hans. "Carl Otto Czeschka." *AMK* Jrg. 6 (no. 47):14-17 (Jy 1961). 6 illus.

ALSO SEE: 262, 452, 461, 539

Hubert Gessner

619. Lux, Joseph August. "The 'Arbeiterheim', or Workman's Home, Vienna." *Studio* 30:150-3 (N 1903). 5 illus. (pp. 150-4)
 By the architect Hubert Gessner, a pupil of Wagner.

Ernst von Gotthilf

620. *Das Interieur.* [Interior architecture.] *Intr* 3:2, 3, 23 (1902). 3 illus.
 Interior architecture by Ernst von Gotthilf. Three photographs. No text.

E. Griebel

621. *Das Interieur.* [Sketches.] *Intr* 2: pls. 12, 13 (1901)
Two interior sketches by E. Griebel. No text.

Gustav Gurschner

622. Graetz-Windisch, Franz. "Leben und Werk des Bildhauers
Gustav Gurschner." *AMK* Jrg. 11 (no. 87):34-9 (Jy-Ag 1966). 15
illus.
An Austrian sculptor, some of whose work is Art Nouveau.

Rudolf Hammel

623. Hevesi, Ludwig. "Aus dem Wiener Kunstleben—Entwürfe
von Rudolf Hammel." *KKhw* 2:266-8 (Jy 1899). 12 illus. (pp.
266-73)

ALSO SEE: 757

Josef Hoffmann
 Josef (or Joseph) Hoffmann, active as designer and archi-
tect, is probably the most representative artist of the Wiener Se-
cession. Although there is a wealth of information published on
him there is, surprisingly, still no major monograph on this im-
portant figure. For a starting point one could consult Sekler (628),
Veronesi (629), and Girardi (637).

624. Hoffmann. Josef. *Josef Hoffmann.* [With an introduction
by] Armand Weiser. Genf: Verlag "Meister der Baukunst", 1930.
xviii pp., 59 pls., port.
Largely photographs of work by the architect from the 1920s.
The four page text by Weiser is in German, French, and Eng-
lish.

625. *Josef Hoffmann zum sechzigsten Geburtstage, 15. Dezem-
ber 1930.* Hrsg. vom Österreichischen Werkbund. [Ein Festschrift
mit Beiträgen von E.G. Asplund et al.] Wien: "Almanach der
Dame", [1930]. 75 pp., illus., port.
Special publication of the Viennese magazine *Almanach der
Dame.* Copy in Columbia University Library.

626. Kleiner, Leopold. *Josef Hoffmann...* Neue Werkkunst. Berlin: Hübsch Verlag, [1927]. xxi pp., 90 pls.
Primarily photographs of the architect's interiors and exteriors, with a brief text by the author.

627. Rochowanski, Leopold Wolfgang. *Josef Hoffmann: eine Studie geschrieben zur seinem 80. Geburtstag.* Wien: Verlag der Oesterreichischen Staatsdruckerei, [1950]. 67 pp., 11 illus., port.
A brief biographical sketch of the artist. Drawings and bookbinding by Hoffmann.

628a. Sekler, Edward F. "The Stoclet House by Josef Hoffmann." In: *Essays in the history of architecture presented to Rudolf Wittkower.* [London]: Phaidon, 1967. Pp. 228-44, pls. 26-36, 48 illus., bibl. footnotes
Essay on Hoffmann's chef-d'oeuvre in Brussels. Numerous photographs. Much bibliographical information in the footnotes.

628b. Sekler, Edward F. "Das Palais Stoclet in Brüssel." *AMK* Jrg. 15 (no. 113):32-43 (N-D 1970). 33 illus., bibl. footnotes
German version of 628a.

629. Veronesi, Giulia. *Josef Hoffmann.* Architetti del movimento moderno, 17. Milano: Il Balcone, 1956. 147 pp., [48] illus., bibl.
Booklet. Italian text. Short essay on the architect, pp. 7-36. Biography, pp. 38-40. List of major works, pp. 41-51. Bibliography, pp. 52-4. The rest of the book is devoted to the illustrations.

630. L.A. [i.e. Ludwig Abels]. "Clausur-Arbeiten." *Intr* 3:161-7 (1902). 8 illus.
The work of Hoffmann's graduating students, i.e. Max Benirschke. See plates 81-9, 97-8.

631. Ankwicz von Kleehoven, Hans. "Josef Hoffmann: das Palais Stoclet in Brüssel." *AMK* Jrg. 6 (no. 42):7-11 (Ja? 1961). 11 illus.

632. *Art Décoratif.* "Nos illustrations." *Art Dec* 2:8 (Ap 1899). 7 illus. (pp. 36-8)

633. Bredt, E.W. "Klagen der Künstler..." *DKD* 18:421-44 (Ap 1906). 21 illus., plans
Photographs of the Pürkersdorf Sanatarium by Hoffmann. Also photographs of interiors by Hoffmann, pp. 454-60.

634. *Deutsche Kunst und Dekoration.* [Illustrations.] *DKD* 20: 328-40 (Se 1907). 19 illus.
Photographs of work by Hoffmann and Otto Prutscher for the Wiener Werkstätte. No text.

635. Dreger, Moriz. "Die Schule Hoffmann an der K.K. Kunstgewerbeschule in Wien." *Intr* 2:1-8 (1901). 34 illus. (pp. 1-6)
Handcrafts by students of Hoffmann.

636. Feuerstein, Günther. "Josef Hoffmann und die Wiener Werkstätte." *Aufbau* 19:177-87 (Ap-My 1964). 18 illus.

637. Girardi, Vittoria. "Josef Hoffmann maestro dimenticato (eredità dell'ottocento)." *Archtt* 2:432-41 (O 1956). 47 illus.
Architecture done after 1903.

638. "Grabmäler: Entwürfe von Prof. Joseph Hoffmann." *HW* 2:6-7 (1905). 5 illus.
Tombs by Hoffmann.

639. Hevesi, Ludwig. "Aus dem Wiener Kunstleben—Joseph Hoffmann." *KKhw* 2:403-7 (N 1899). 18 illus. (pp. 392-410)

640. Hoffmann, Josef. "Einfache Möbel." *Intr* 2:193-205 (1901). 18 illus. (pp. 193-208)
A statement of esthetic principles. Illustrations of the artist's sketches for furniture.

641. *Hohe Warte.* [Kunstschau Wien 1908.] *HW* 4:215-21 (1908). 7 pls.
Photographs of the building designed by Hoffmann. No text.

642. *Innen-Dekoration.* [Photographs.] *InnDek* 16:47-57 (F 1905). 15 illus.
Interiors of the Biach residence, Vienna, by Hoffmann and Franz Messner. No text.

643. *Das Interieur.* "Josef Hoffmann." *Intr* 1:24-7 (1900). 6 illus.
Photographs of work by Hoffmann. Other work of the artist
illustrated in vol. 1, pp. 33, 50-1, 53, 57, 80, 146-51, and pls.
2-4, 7-8, 19, 32. No text.

644. *Das Interieur.* "19 Abbildungen von Hoffmann'schen Interi-
eurs und Möbeln." *Intr* 1:129-44 (Se 1900), 19 illus.; 1:146-51
(O 1900). 13 illus.
Photographs of Hoffmann interiors and furniture. No text.

645. *Das Interieur.* [Sketches for interiors.] *Intr* 2:pls. 85-92
(1901)
No text.

646. *Das Interieur.* [Illustrations of Hoffmann's work.] *Intr* 4:1-
8, 11, 32, 50-3, 90, 151-84 (1903). Illus.
Includes Villenkolonie "Hohe Warte", pp. 151-84. No text.

647. "Josef Hoffmann: primo ricordo." *Archt* 2:362-5 (Se 1956).
18 illus., plans
The Stoclet Palace in Brussels.

648. "Joseph Hoffmann: Ausstellung in der Secession—Einfache
Möbel." Dek K Jrg. 2 (Bd. 4):5-6 (1899). 9 illus. (pp. 36-8)
Furniture for Secession exhibits.

649. Kammerer, Marcel. "Die Architektur der 'Kunstschau'."
MB 7:361-2 (1908). 62 illus. (pp. 362-408), col. pls. 55-61
A special issue on the "Kunstschau" exhibition building by
Hoffmann, with contributions by many other artists. Also in-
cludes projects by Otto Wagner.

650. Khnopff, Fernand. "Josef Hoffmann—architect and deco-
rator." *Studio* 22:261-7 (My 1901). 10 illus.

651. Kossatz, Horst Herbert. "Josef Hoffmann, Adolf Loos und
die Wiener Kunst der Jahrhundertwende." *AMK* Jrg. 15 (no. 113):
2-3 (N-D 1970). 2 ports.

652. A.L. [i.e. A.S. Levetus]. "Ein Wiener Architekt." *Dek K*

Jrg. 1 (Bd. 2):227 (1898). 9 illus. (pp. 203-8)
 On Josef Hoffmann.

653. Levetus, A.S. "A Brussels mansion designed by Prof. Josef
Hoffmann of Vienna." *Studio* 61:189 (Ap 1914). 8 illus. (pp.
189-96)
 Primarily photographs. More complete version in *Moderne Bau-
formen,* vol. 13, no. 1 (1914), which was not located for in-
clusion in this bibliography.

654. Levetus, A.S. "Professor Hoffmann's artist colony, Vienna."
Studio 32:125-32 (Jy 1904). 9 illus. (pp. 124-30)
 Architecture by Hoffmann at the Hohe Warte estates.

655. [Lux, Joseph August]. "Denkmalideen." *HW* 2:287-9
(1906). 11 illus.
 Monument designs by Hoffmann.

656. Lux, Joseph August. "Innen-Kunst von Prof. Joseph Hoff-
mann, Wien." *InnDek* 13:129-32 (My 1902). 29 illus. (pp. 130-52)

657. Lux, Joseph August. "Josef Hoffmann, Koloman Moser."
DKD 15:1-14 (O 1904). 85 illus. (pp. 1-46)
 Interiors, decorative art, and jewelry, primarily by Hoffmann.
 Copiously illustrated.

658. J.A.L. [i.e. Joseph August Lux]. "Neue Entwürfe." *Intr* 4:
105-17 (1903). 36 illus. (pp. 97-120)
 Drawings and photographs of work by students of Hoffmann.

659. [Lux, Joseph August]. "Sanatorium." *HW* 1:406-7 (1905).
6 illus.
 The Pürkersdorf Sanatorium of Hoffmann.

660. Lux, Joseph August. "Villenkolonie Hohe Warte, erbaut
von Prof. Joseph Hoffmann." *Intr* 4:121-84 (1903). 66 illus.,
plans.
 Numerous photographs of the Hennenberg house (pp. 125-52)
and the Spitzer house (pp. 153-84), both by Hoffmann.

661. Mang, Karl, and Mang, Eva. "Das Haus auf der Bergerhöhe—
eine frühe Arbeit von Josef Hoffmann." *AMK* Jrg. 15 (no. 113):
29-31 (N-D 1970). 6 illus.
An Art Nouveau villa by Hoffmann (1899).

662. Pica, Agnoldomenico. "Il centenario di Hoffmann e di Loos."
Domus no. 492:1-7 (N 1970). 32 illus.
A comparison of the two architects' careers. Text in Italian and
English. French and German summaries in the pink inserts af-
ter the issue title page.

663. Sekler, Eduard F. "Art Nouveau Bergerhöhe." *Arch Rev* 149:
75-6 (F 1971). 4 illus., bibl. footnotes
An early villa by Hoffmann.

664. Strachwitz, Artur, Graf. "Ein Wiener Haus in Brüssel." *AMK*
Jrg. 7 (no. 60-1):22-5 (Jy-Ag 1962). 10 illus.
The Palais Stoclet in Brussels.

665. Verneuil, M.P. "Quelques intérieurs à Vienne par Joseph
Hoffmann." *Art & Dec* 16:61-70 (Ag 1904). 10 illus.
Interiors of four homes.

666. "Wiener Werkstätte: Josef Hoffmann, Kolo Moser." *DKD*
17:149-51 (D 1905). 88 illus. (pp. 149-92)
Post-Art Nouveau work by the two artists. Each artist's work
is identified by a stylized monogram.

667. Windisch-Graetz; Franz. "Das Jagdhaus Hochreith: zur Stil-
analyse der Räume von Josef Hoffmann." *AMK* Jrg. 12 (no. 92):
28-32 (My-Je 1967). 13 illus., bibl. footnotes
A villa constructed in 1906.

668. *Ver Sacrum.* [Architecture.] *VS* [Jrg. 5 or 6?], Heft 21 (1902).
Illus.
This issue contains photographs of architecture and drawings
by Leopold Bauer and Hoffmann.

669. Zuckerkandl, Berta. "Josef Hoffmann." *Dek K* Jrg. 7 (Bd.
13):1-17 (O 1903); or *Kunst* Bd. 10:1-17 (O 1903). 30 illus. (pp.
2-29)

ALSO SEE: 101, 111, 125-6, 235, 240, 262, 332, 374, 449-50, 454, 459, 461, 473, 488, 495-6, 518, 529, 534, 536, 538-9, 543-6, 562, 570, 583, 585, 680, 696, 708, 1339. Also see the Index.

Emil Hoppe

670. Giusti Baculo, Adriana. "Tra Otto Wagner e Sant'Elia: gli studi architettonici di Emil Hoppe." *Archtt* 15:552-6 (D 1969). 12 illus.
Architectural sketches by a student of Otto Wagner. Summary in four languages.

Sepp Hubatsch

671. Schachel, Roland L. "Ein Ensemble des Jugendstils: die Reihenhaussiedlung von Sepp Hubatsch in Brunn am Gebirge, Niederösterreich." *AMK* Jrg. 16 (no. 118):25-30 (Se-O 1971). 11 illus.
A row of houses in Art Nouveau motif in an Austrian provincial city.

Hermann Kirchmayr

672. Berlepsch-Valendas. "Hermann Kirchmayr, Silz (Tyrol)." *InnDek* 13:69-74 (Mr 1902). 32 illus. (pp. 70-87)

Gustav Klimt

Only a few of the many items on Klimt can be cited here. The most comprehensive bibliography is that of Johannes Dobai in Novotny (682), which lists hundreds of citations, including those from the daily press. The major monographs on Klimt are Nebehay (680), Novotny (682), and to a lesser extent W. Hofmann (678). The Guggenheim exhibition (685) is a comparative study of Klimt and Schiele.

*673. Bahr, Hermann, ed. *Gegen Klimt*. Vorwort von Hermann Bahr... [Wien: J. Eisenstein, 1903]. 76 pp.
A collection of negative criticisms on Klimt from contemporary newspapers, with commentary by Bahr. Copy in Columbia University Library.

674. Bahr, Hermann. *Rede über Klimt.* [Wien]: Wiener Verlag, [1901]. 25 pp.
> A speech on the artist by a noted art journalist of the day. Notes, pp. 14-25.

675. Darmstadt. Mathildenhohe Ausstellungshalle. *3. [i.e. dritte] International der Zeichnung: Sonderausstellung Gustav Klimt, Henri Matisse.* Darmstadt: 1970. 164 pp., 198 illus.
> Introductory text by Otto Breicha and Rudolf Leopold. Deals with Klimt through p. 107. Mostly illustrations of his drawings. Cataloged by Library of Congress under Klimt.

676. Eisler, Max. *Gustav Klimt.* Wien: Oesterr. Staatsdruckerei, 1920. 53 pp., 31 pls. (part col.)
> Short biographical monograph on the artist. The same publisher brought out an English language edition in 1921.

677. Galerie St. Etienne, New York. *Gustav Klimt; April 1959.* New York: 1959. Unpaged, 14 illus. (part col.)
> Small gallery exhibition of Klimt paintings. Includes essay of three pages by Otto Kallir.

678a. Hofmann, Werner. *Gustav Klimt.* Greenwich, Conn.: New York Graphic Society, [1971]; London: Studio Vista, 1972. 60 pp., 82 pls. (part col.), xv pls., 45 illus., port., bibl., bibl. footnotes
> English translation of the following item.

678b. Hofmann, Werner. *Gustav Klimt und die Wiener Jahrhundertwende.* Oesterreicher des 20. Jahrhunderts. Salzburg: Verlag Galerie Welz, [1970]. 180 pp. (incl. xv, 82 pls., part col.), 45 illus., port., bibl., bibl. footnotes
> Klimt and his artistic background in Vienna (pp. 7-50). Notes, pp. 51-6. Bibliography, pp. 179-80. Large, oversquare book.

679. Marlborough Fine Art, Ltd., London. *Gustav Klimt: paintings and drawings.* London: 1965. 15 pp., 24 illus., 1 col. pl., bibl.
> Catalog of fifty-two drawings and paintings. Essay, "Gustav Klimt—a Viennese painter between bourgeois late Romanticism and revolutionary Expressionism," by Wolfgang Fischer, pp. 2-3.

680. Nebehay, Christian M., ed. *Gustav Klimt: Dokumentation.*
Wien: Galerie Christian M. Nebehay, 1969. 543 pp., 640 illus.
(part col.), 15 col. pls., bibl. footnotes
 Comprehensive texts and documentation on Klimt's life and
 artistic career. Extensive coverage of the Secession exhibitions
 and Klimt's participation in them. Much information on Hoff-
 mann, Moser, and Roller. Many citations from the critical lit-
 erature of the period by Hevesi and others. Copiously illustrat-
 ed with reproductions of art work and photographs.

*681. Nebehay, Christian M. *Gustav Klimt: 150 bedeutende Zeich-
nungen.* Wien: 1962. Unpaged, illus.
 Exhibition catalog of Klimt drawings and monograms.

*682a. Novotny, Fritz, and Dobai, Johannes. *Gustav Klimt.* Hrsg.
von Friedrich Welz. Salzburg: Verlag Galerie Welz, [1967]. 423
pp., illus., pls., bibl. Illustrations (pp. 95-110, 275-423). "Oeuvre-
katalog der Gemälde," pp. 273-376. Bibliography, pp. 393-406.

682b. Novotny, Fritz. *Gustav Klimt, with a catalogue raisonné of
his paintings.* Transl. from the German... London: Thames & Hud-
son; New York: Praeger, 1968. 424 pp., 304 illus., 145 pls., bibl.
 The standard work on Klimt. Comprehensive and exhaustive
 bibliography by J. Dobai, pp. 397-410. Numerous color plates.
 Complete catalog of the artist's work by Johannes Dobai, pp.
 275-376.

*683. Pirchan, Emil. *Gustav Klimt, ein Künstler aus Wien.* Wien:
Wallishausser, [1942]. 226 pp., 38 illus., 140 pls. (part col.), bibl.

684. Pirchan, Emil. *Gustav Klimt.* Wien: Bergland Verlag, [1956].
55 pp., pls. (incl. 155 illus. and 12 col. pls.), port.
 Short monograph on the artist (pp. 13-42). Foreword by A.
 Grünberg (pp. 5-12). List of paintings, pp. 50-6. Numerous il-
 lustrations. Folio format.

685. Solomon R. Guggenheim Museum, New York. *Gustav
Klimt and Egon Schiele.* New York: [1965]. 119 pp., [101] illus.
(part col.), ports., bibl.
 Exhibition catalog of 158 paintings and drawings by the two

artists. Introductory texts by Thomas M. Messer, pp. 7-12.
"Gustav Klimt—Art Nouveau painter," by Johannes Dobai, pp.
20-5. "Egon Schiele—Paintings," by James T. Demetrion, pp.
63-7. "Egon Schiele—Drawings," by Alessandra Comini, pp.
107-10. Chronology: Klimt, pp. 17-19, Schiele, pp. 59-61. Bibliography: Klimt, pp. 54-5, Schiele, pp. 118-19. Bibliographical
citations also given for each painting in the catalog sections.

686a. Strobl, Alice. *Gustav Klimt: Zeichnungen und Gemälde.*
Salzburg: Welz, [1962]. 88 pp., illus.
Mostly illustrations, in small format.

686b. Strobl, Alice. *Gustav Klimt: twenty-five drawings...* Albertina publications, 1. Graz: Akademische Druck-und Verlagsanstalt, 1964. 14 pp., 25 illus.
Large folio of twenty-five beautifully mounted Klimt drawings,
with texts by Alice Strobl. List of Klimt exhibitions, 1918-
1964. Also published in German by the same publisher: *Gustav
Klimt: 25 Zeichnungen.*

686c. Strobl, Alice. *Gustav Klimt: Zeichnungen und Gemälde.*
3. erw. Auflage. Salzburg: Verlag Welz Galerie [1968, c1962]. 16
pp., 55 pls.
Short introductory text, pp. 5-14. Chronology, pp. 15-16.
Plates are black-and-white illustrations of the artist's drawings.

687. Vereinigung Bildender Künstler "Wiener Secession". *Kollektiv-Ausstellung Gustav Klimt.* 18. Ausstellung der Vereinigung...
[Wien: 1903]. 71 pp. (chiefly illus.)
Secession exhibition catalogue of eighty works, with illustrations of eighteen paintings and ten drawings.

688. Breicha, Otto. "Gustav Klimt und die neue Wiener Malerei
seiner Zeit." *AMK* Jrg. 9 (no. 74):32-7 (My-Je 1964). 10 illus.
Klimt's influence on younger Austrian painters.

689. Dobai, Johannes. "Das Bildnis Margaret Stonborough-Wittgenstein von Gustav Klimt." *AMK* Jrg. 5 (no. 8):8-11 (Ag 1960).
6 illus., bibl. footnotes
On a portrait by the artist.

690. "Gustav Klimt." *VS* Jrg. 1, Heft 3:1 (Mr 1898). 35 illus.
(pp. 1-24)
Entire issue illustrated by Klimt.

691. Haerdtl, Carmela. "Fra Klimt e Schiele. Mostra a Vienna
per il Cinquantenario." *Domus* no. 467:55-6 (O 1968). 2 illus.,
2 ports.
Exhibitions on the fiftieth anniversary of the two painters'
deaths. Comparison of their careers.

692. Hertlein, Edgar. "Frühe Zeichnungen von Egon Schiele..."
AMK Jrg. 12 (no. 95):32-41 (N-D 1967). 22 illus.
Discusses Schiele's relationship to Klimt.

693. Hevesi, Ludwig. "Klimts 'Philosophie' (Aus dem Wiener
Kunstleben)." *KKbw* 3:177-8 (Ap 1900)

694. Klimt, Gustav. "Bewegungs-Studien zur 'Medecin'... Dek-
kenbild für die Aula der Universität in Wien." *VS* Jrg. 4, Heft 6
(1901). 16 pls.
Drawings for the mural. No text.

695. Köller, Ernst. "Apotheose der Sinne: Gustav Klimt zum 100.
Geburtstag." *AMK* Jrg. 7 (no. 62-3):6-11 (Se-O 1962). 16 illus.

696. A.S.L. [i.e. A.S. Levetus]. "Studio-talk:Vienna." *Studio* 32:
348-54 (Se 1904). 4 illus.
Klimt and Hodler exhibits arranged by Moser and Hoffmann.

697. Lux, Joseph August. "Kunstschau: die Ausstellung der
Klimt-Gruppe." *HW* 4:180-2 (1908)

698. E.S. "Gustav Klimt..." *Cons des Arts* no. 194:102-7 (Ap
1968). 7 illus. (part col.)
Includes beautiful color illustrations.

699. Seifertová-Korecká, Hana. "Ein Frühwerk von Gustav Klimt—
der Theatervorhang in Reichenberg (Liberec)." *AMK* Jrg. 12 (no.
94):23-8 (Se-O 1967). 9 illus.
An early (1883) theater curtain by the artist.

700. Stöhr, Ernst. "Die Malerei unserer Zeit: ueber das Decken-gemälde 'Die Medecin' von Gustav Klimt." *VS* Jrg. 4, Heft 9:157-8, 163-4 (1901)

701. *Ver Sacrum.* [Gustav Klimt Studien.] *VS* Jrg. 5, Heft 10: 158-64 (1902). 8 illus.
Eight pencil drawings. No text.

702. Werner, Alfred. "Gustav Klimt, father of Austria's Art Nou-veau." *American Artist* vol. 32, no. 4:46-52, 78-81 (Ap 1968). 14 illus., port.
Introductory article on the artist.

703. Zuckerkandl, B. "Gustav Klimt's Decken-Gemälde." *DKD* 22:69-70 (My 1908). 2 illus. (preceding p. 69)

ALSO SEE: 143a, 262, 304, 449, 518, 529, 539, 544, 583-4

Jacob und Josef Kohn

704. "Zu unseren Illustrationen: Firma Jacob & Josef Kohn." *InnDek* 12:103 (Je 1901). 3 illus. (pp. 102-3)
Drawings for furniture by a Secession firm.

ALSO SEE: 475

Heinrich Leffler

705. "Atelier-Nachrichten: Heinrich Leffler." *DKD* 3:225-6 (F 1899). 7 illus. (pp. 224-32)
Decorative work of a Viennese artist.

Lötz-Witwe Factory, Bohemia

706. Munich. Stuck-Villa. *Loetz Austria: irisierende Farbgläser des Jugendstils.* [München: Stuck-Jugendstil-Verein, 1972]. Un-paged, 14 illus., 2 col. pls.
Exhibition of 143 glass objects (primarily vases) of the Lötz-Witwe factory in Bohemia, mostly from one French collection. Includes brief texts and signature illustrations.

Adolf Loos

　　Loos, an important transitional architect in the development of modern architecture, can hardly be said to be Art Nouveau, especially in the face of his famous dictum, "Ornament is crime." However, Loos was rescued from obscurity, along with many fellow Viennese architects, during the new revival of interest in Art Nouveau. He is therefore included in the bibliography, which will only list some dozen books. The major monograph is Münz (718). Some of Loos' later clients were the Dadaist Tristan Tzara and Josephine Baker.

*707. *Adolf Loos zum 60. Geburtstag am 10. Dezember 1930.*
[Beiträge von Peter Altenberg et al.] [Wien: R. Lanyi], 1930. 67 pp., port.
　　Festschrift for the architect. In some bibliographies the publisher R. Lanyi is given as the author.

708.　*Alte und Moderne Kunst.* "Loos, Hoffmann, 1870-1970."
AMK Heft 113 (N-D 1970). 58 pp., illus., bibl. footnotes
　　Special issue of a noted Austrian art journal on the two architects. The longer articles on Hoffmann have been separately indexed. Also includes shorter articles on the relationship of the two architects.

709.　*Casabella Continuità.* "Adolf Loos." *Casabella Continuità*
no. 233 [special issue] (N 1959). 56, xii pp., illus., plans, bibl.
　　Numerous photographs. Texts in Italian, with translation summaries (French, English, and German).

710.　Girardi, Vittoria. "Adolf Loos, pioniere protestante (1870-1933)." *Archtt* 11:56-64, 126-34, 200-4, 270-4, 340-4, 410-14, 480-4, 548-54 (My-D 1965); issues nos. 115-22. 157 illus., bibl.
　　A series of eight articles on the architect. Text in Italian, with summaries in English, French, German, and Spanish for each installment. Numerous black-and-white photographs. Bibliography and list of projects, p. 554.

711.　Glück, Franz. *Adolf Loos.* Les artistes nouveaux. Paris: G. Crès, [1931]. 15 pp., 32 pls.

712. Kubinszky, Mihály. *Adolf Loos.* Berlin: Henschelverlag
Kunst und Gesellschaft, 1970. 34 pp., 39 illus.

*713. Loos, Adolf. *Adolf Loos: das Werk des Architekten.* Hrsg.
von Heinrich Kulka. Neues Bauen in Der Welt, Bd. 4. Wien: A.
Schroll, 1931. 43 pp., pls., plans (270 illus.)
 Festschrift for the architect on his sixtieth birthday. Kulka is
 given as the author in many bibliographies. Cataloged under
 Loos in Library of Congress.

714. Loos, Adolf. *Sämtliche Schriften.* In 2 Bänden. Bd. 1: Ins
Leere gesprochen (1897-1900); Trotzdem (1900-1930). Herausg.
von Franz Glück. Wien: Herold, [1962]. 470 pp., port.
 A collection of the architect's essays. Volume 2 does not appear
 to have been published to date.

715. Loos, Elsie Altmann. *Adolf Loos der Mensch.* Wien: Verlag
Herold, [1968]. 191 pp.
 An anecdotal biography of the architect by his wife.

716. Marilaun, Karl. *Adolf Loos.* Die Wiedergabe, 1. Reihe, 5. Bd.
Wien: WILA, 1922. 44 pp., port.
 Short essay on the architect. No illustrations.

717. Münz, Ludwig. *Adolf Loos.* Architetti del movimento mo-
derno, 16. Milano: Il Balcone 1956. 153 pp., 50 illus. (incl. plans),
bibl.
 Small format book. Text in Italian. Bibliography, pp. 50-5. Pho-
 tographs of the architect's work, pp. 58-153.

*718a. Münz, Ludwig. *Der Architekt Adolf Loos: Darstellung
seines Schaffens nach Werkgruppen.* Wien: A. Schroll, [1964]. 200
pp., illus.

718b. Münz, Ludwig. *Adolf Loos, pioneer of modern architecture.*
New York: Praeger; London: Thames & Hudson, [1966, c1964].
234 pp., 243 illus., bibl.
 The major monograph on Loos' work. Numerous illustrations.
 "Chronological catalogue of projects," pp. 200-13, including
 bibliographic citations. Introduction by Nikolaus Pevsner and
 three short texts by Loos.

719. "Notizen: Adolf Loos." *Intr* 1:94 (1901). 2 illus. (pp. 95-6)

720. Loos, Adolf. "Die Potemkin'sche Stadt." *VS* Jrg. 1, Heft 7:15-17 (Jy 1898)
On the architectural esthetics of nineteenth-century Vienna.

721. Loos, Adolf. "Unseren jungen Architekten." *VS* Jrg. 1, Heft 7:19-21 (Jy 1898)

ALSO SEE: 240, 651, 662

Emmanuel Margold

722. L.D. "Emmanuel Margold—Wien." *DKD* 23:146 (N 1908). 18 illus. (pp. 141-52)
Architectural illustrations.

Koloman (Kolo) Moser
Moser is one of the leading designers and teachers of the Secession movement. A major monograph on the artist has been published since this volume was compiled: Fenz, Werner, *Kolo Moser: internationaler Jugendstil und Wiener Secession* (Salzburg: Residenz Verlag, [1976]).

723. Graz. Neue Galerie. *Koloman Moser 1868-1918: Gemälde, Graphik.* Graz: 1969. Unpaged, illus., [15] pls. (part col.)
Exhibition catalog by Werner Fenz. 225 objects. Seven-page essay on Moser's relation to the Wiener Secession and the Wiener Werkstätte. Chronology.

724. Moser, Koloman. *Flächenschmack.* Die Quelle, 3. Wien, Liepzig: Martin Gerlach, [1902]. 30 col. pls.
A small folio of sixty very beautiful pattern designs by the artist on thirty loose plates. No text.

725. L.A. [i.e. Ludwig Abels]. "Koloman Moser." *Dek K* Jrg. 4 (Bd. 7):227-32 (Ap 1901); or *Kunst* Bd. 4:227-32 (Ap 1901). 16 illus. (pp. 227-34)
Glassware and bookbindings designed by the artist.

726. "Atelier-Nachrichten: Koloman Moser." *DKD* 5:297 (Mr 1900)

727. *Art Décoratif.* "Nos illustrations." *Art Dec* 2:147 (Jy 1899). 16 illus. (pp. 147-8, 170-3)
Work by Koloman Moser.

728. *Dekorative Kunst.* [Koloman Moser.] *Dek K* Jrg. 2 (Bd. 4): 158-61 (1899). 10 illus.
Illustrations of the artist's work. No text.

729. *Deutsche Kunst und Dekoration.* "Koloman Moser." *DKD* 21:167-77 (D 1907). 41 illus. (pp. 167-205)
Stained-glass windows in the Pflege-Kirche of Otto Wagner, by Koloman Moser.

730. Fenz, Werner. "Kolo Moser und die Zeitschrift *Ver Sacrum.*" *AMK* Jrg. 15 (no. 108):28-32 (Ja-F 1970). 9 illus.

731. [Moser, Kolo. Die neuen Oesterreichischen Postmarken...] *HW* 4:174-5 (1908). 18 illus.
Austrian postage stamps designed by the artist. No text.

732. *Innen-Dekoration.* [Photographs.] *InnDek* 16:179-88 (Jy 1905). 11 illus.
Two interiors, by Moser and Hoffmann. No text.

733. *Das Interieur.* [Koloman Moser.] *Intr* 4:9-13, 35-48, 87, 94-5 (1905). Illus.
Illustrations of the artist's work. No text. Also work by Moser's students, pp. 99, 101.

734. "Kunstverglasungen." *DKD* 15:89 (O 1904). 3 illus.
Stained glass windows by Kolo Moser.

735. Levetus, A.S. "An Austrian decorative artist—Koloman Moser." *Studio* 33:111-17 (N 1904). 15 illus.

736. A.S. [i.e. A.S. Levetus]. "Studio-talk: Vienna." *Studio* 39: 174, 177-8 (N 1905). 5 illus.
Theater designs and miniatures by Kolo Moser.

737. "Die Neuen Oesterreich: Post-Wertzeichen." *DKD* 22:274 (Jy 1908). 17 illus.
Austrian postage stamps designed by Kolo Moser.

738. Verneuil, M.P. "Etoffes et tapis de Koloman Moser." *Art & Dec* 12:113-16 (1902). 9 illus., 1 col. pl.
Fabric designs by the artist.

739. Zuckerkandl, Berta. "Koloman Moser." *Dek K* Jrg. 7 (Bd. 14):329-44 (Je 1904); or *Kunst* Bd. 10:329-44 (Je 1904). 38 illus. (pp. 329-57)

ALSO SEE: 126, 374, 450, 513, 516, 528, 538-9, 543-4, 582, 591, 609, 657, 666, 680, 696, 819. Also see the Index.

Robert Oerley

740. Oerley, Robert. "Wie ein modernes Möbel entsteht." *Intr* 1:177-88 (D 1900). Illus.
Theoretical article on furniture design.

ALSO SEE: 355, 767

Hans Ofner

741. Lux, Joseph August. "Architekt Hans Ofner—Wien." *InnDek* 17:41-9 (F 1906). 44 illus. (pp. 50-64)
Interiors and decorative arts, showing the influence of Mackintosh.

Joseph Maria Olbrich
See Germany in volume 2 of this work.

ALSO SEE (in Austrian section): 34, 162, 444, 459, 473, 475, 477, 497, 523-5, 532, 576, 585, 1115

Emil Orlik

742. Orlik, Emil. *Emil Orlik, Wege eines Zeichners und Graphikers.* Notizen zu den "Kleinen Aufsätzen" Emil Orliks, von Friedrich

W. Pauli. Mit einem Beitrag von Walter R. Habicht. [Darmstadt]:
J.G. Bläschke Verlag, [1972]. 288 pp. (chiefly illus.), 2 illus., [111]
pls. (part col.), port., bibl.
 Primarily illustrations of the artist's post-Art Nouveau period
 drawings. Texts scattered throughout book. Bibliography, pp.
 278-9.

743. Leisching, Julius. "Emil Orlik als Buchkünstler." *ZfB* 4:153-7
(Jy 1900). 9 illus.

744. Singer, Hans W. "Emil Orlik—Wien." *DKD* 15:370-9 (Mr
1905). 22 illus. (pp. 369-81)

ALSO SEE: 262, 307

Max Peinlich

745. "The sculptured jewelry of an Austrian artist and craftsman."
Cfm 9:838 (Mr 1906). 4 illus.
 Jewelry by Max Peinlich.

Josef Plecnik

746. Pozzetto, Marco. *Joze Plecnik e la scuola di Otto Wagner.*
Torino: Albra Editrice, [1968]. 171 pp., 116 illus., elevations,
plans, bibl.
 Detailed monograph on a Yugoslav student of Wagner, who
 was active in Vienna. Comprehensive bibliography, pp. 144-65.

747. Lux, Joseph August. "Josef Plecnik." *Intr* 4:26-7 (1903).
2 illus.
 Also illustrations of his furniture, pp. 70-4.

748. V.S. "Gutenberg-Denkmal." *VS* Jrg. 1, Heft 2:2-3 (F 1898).
3 illus.
 A monument by Plecnik.

Victor Postelberg

749. [Postelberg, Victor. Vorzimmer.] *Intr* 3:100-1 (1902). 2 illus.
 Two photographs of an antechamber. No text.

Hans Prutscher

750. "Eine moderne Wiener Laden-Ausstattung." *InnDek* 15: 245 (O 1904). 3 illus. (pp. 246-7)
The Milek tailor shop in Vienna, by Hans Prutscher.

Otto Prutscher

751. *Das Interieur.* [Work by Otto Prutscher and Hans Vollmer.] *Intr* 1:pls. 33-9 (1900)
Interiors and furniture. No text. Furniture by Vollmer, vol. 1, pp. 113-19 (Ag 1900). 13 illus. Photographs. No text. Also see plate 51. For other work by Prutscher in vol. 1 see pp. 4, 10-12, 44, 48, 123, 151, 153-5, and plate 14.

752. *Das Interieur.* [Otto Prutscher.] *Intr* 3:10, 12, 16, 28, 110-12, 138-9 (1902). Illus.
Photographs of the artist's furniture. No text.

753. Levetus, A.S. "Otto Prutscher, a young Viennese designer of interiors." *Studio* 37:33-41 (F 1906). 14 illus.

754. J.A.L. [i.e. Joseph August Lux]. "Architekt Otto Prutscher—Wien." *InnDek* 17:93-5 (Ap 1906). 43 illus. (pp. 94-120)
Together with "Zu den Abbildungen aus dem Hause Josef Trier—Darmstadt," p. 111, with work by Prutscher. Some Art Nouveau design, notably in the tea pavilion.

755. J.A.L. [i.e. Joseph August Lux]. "Interieurs alt und neu." *Intr* 4:234-6, 245-6 (1903). 18 illus. (pp. 232-42)
Includes drawings and photographs of furniture by Otto Prutscher.

ALSO SEE: 450, 558, 634

Erwin Puchinger

756. A.S.L. [i.e. A.S. Levetus]. "Studio-talk: Vienna." *Studio* 29:227-8 (Ag 1903). 6 illus. (pp. 225-7)
Embroidery work by Erwin Puchinger.

Alfred Roller

757. "Moderne Leiningewerbe." *KKhw*:404-6 (1901). 8 illus.
(pp. 396-403)
 Textile designs by Alfred Roller and Rudolf Hammel.

ALSO SEE: 582, 680

Hans Schlechta

758. *Das Interieur.* [Hans Schlechta.] *Intr* 2:113-26 (1901). 30
illus., pls. 45-52 (part col.)
 Interiors, furniture, and the like. No text.

ALSO SEE: 603

Otto Schönthal

759. Schönthal, Otto. "Entwürf zu Flächen-Dekorationen."
DKD 16:744-9 (Se 1905). 11 illus. (part col.)
 Wallpaper designs by a Viennese architect. No text.

Hans Schwathe

760. Folnesics, Joseph. "Hans Schwathe." *KKhw* 5:265-73
(1902). 12 illus.
 Includes Art Nouveau figurines by an Austrian sculptor.

Richard Seifert

761. "Ein modernes Wiener Kaffeehaus." *Intr* 3:49-56 (1902).
6 illus.
 The Café Ronacher, Vienna, by Richard Seifert. Also see the
 four illustrations for Café Eiles, Vienna, by Adolf Tremmel. No
 text.

Adolf Tremmel

SEE: 761

Rudolf Tropsch

762. L.A. [i.e. Ludwig Abels]. "Einige Arbeiten von Rudolf Tropsch." *Intr* 2:129-44 (1901). 27 illus., pls. 53-60 (col.)
Designs for and photographs of furniture and interiors by a Secession artist. Beautiful color plates of the artist's work.

Joseph (Josef) Urban
Only a few articles are cited here for this architect who quickly moved on from the Art Nouveau style.

763. Abels, Ludwig. "Joseph Urban." *Intr* 3:81-91 (1902). 40 illus. (pp. 73-96, 99, 106-9, 114-21)
Illustrated with photographs of the architect's Wiener Hagenbundes, the Goltz Villa, Ranzoni house, and Wähner house. Also see plates 40-8 for a Viennese beer cellar.

764. Schölermann, Wilhelm. "Der Wiener Rathaus-Keller." *Inn-Dek* 10:69-71 (My 1899). 17 illus. (pp. 72-84)
Designed by Josef Urban.

765. Urban, Josef. "Damensalon für das Schloss des Grafen Karl Eszterházy in St. Abraham bei Dioszegh (Ungarn)." *Intr* 1:29-32 (1900). 9 illus., pl. 47
Two more illustrations, pp. 52-3. Other work illustrated by Urban, pp. 46-7, 60, 96, 126; plates 1, 15, 24, 60-1.

ALSO SEE: 450

Hans Vollmer

SEE: 751, 1645

John Jack Vrieslander

766. *Deutsche Kunst und Dekoration.* [John Jack Vrieslander.] *DKD* 15:47-8 (O 1904). 2 illus.
Two drawings by the artist. No text.

Otto Wagner

The architect Otto Wagner was both a forerunner of the Vienna Secession and a participant in it. He was important as an architect and as a teacher and polemecist of architecture. His students included Hoffmann and Olbrich, as well as a number of East European architects. The major monographs are Geretsegger (769) and Lux (771). Wagner's own writings are extensive (775-781) and some attempt has been made in the following section to bring order to the bibliographical chaos of Wagner's books.

767. Baculo, Adriana Giusti. *Otto Wagner: dall'architettura di stile allo stile utile.* [Napoli]: Edizioni Scientifiche Italiane, [1970]. 293 pp., 199 illus., bibl.

The lengthy Italian text treats of the cultural and historical background of Wagner's Vienna, of his written work, and of his architecture. An anthology of six texts, including five translated from German (Lux, Dagobert Frey, Bauer, Oerley, and Tietze, p. 223ff.). Contents, pp. 291-3. Bibliography, pp. 281-89. Illustrations are primarily black-and-white photographs.

768. Darmstadt. Hessisches Landesmuseum. *Otto Wagner: das Werk des Wiener Architekten, 1841-1918.* Darmstadt: 1963. Unpaged, illus., bibl.

Text by Otto A. Graf. Second section, "Katalog", contains numerous plans, photographs, and drawings. Short bibliography.

769a. Geretsegger, Heinz; Peintner, Max; and Pichler, Walter. *Otto Wagner, 1841-1918: unbegrenzte Groszstadt, Beginn der modernen Architektur.* Salzburg: Residenz Verlag, [1964]. 275 pp., 295 illus. (part col.), plans, bibl.

Format similar to the English translation (769b).

769b. Geretsegger, Heinz; Peintner, Max; and Pichler, Walter. *Otto Wagner, 1841-1918: the expanding city, the beginning of modern architecture.* Introduction by Richard Neutra. New York: Praeger; London: Pall Mall, [1970, c1964]. 276 pp., 294 illus. (part col.), plans, bibl.

A definitive pictorial survey of Wagner's work, divided into eight sections by type of building (pp. 46-240). Text includes biographical sketch and a discussion of Wagner's work and its

implications. Map of Vienna locating Wagner's buildings, pp.
242-3. Chronological table, pp. 244-52. Extensive bibliography,
pp. 264-70.

770. Graf, Otto Antonia. *Die vergessene Wagnerschule.* Schriften
des Museums des 20. Jahrhunderts 3. Wien: Verlag Jugend & Volk,
[1969]. 39 pp., 128 illus., bibl.
 A monograph on the career of Otto Wagner as professor of arch-
itecture. Numerous illustrations of work by his students, as well
as historically related work. Short bibliography, p. 29.

771. Lux, Josef August. *Otto Wagner: eine Monographie.* Mün-
chen: Delphin-Verlag, [c1914]. 167 pp., 120 illus. (incl. plates)
 An enthusiastic account of the architect's career, his revolu-
tionary achievements, and his influence. Many fine old photo-
graphs, plans and drawings. List of Wagner's students, pp. 162-4.

772. Ostwald, Hans. *Otto Wagner: ein Beitrag zum Verständnis
seines baukünstlerischen Schaffens.* Baden: Verlag Buchdruck
AG, 1948. 118 pp., 23 illus., bibl., bibl. footnotes
 Doctoral thesis (Zurich) on the architect's work. Rich source
of bibliographical information.

773. Pirchan, Emil. *Otto Wagner, der grosse Baukünstler.* Oester-
reich-Reihe, Bd. 13. Wien: Bergland Verlag, [1956]. 30 pp., 30
pls., port., bibl.
 Short essay on the architect. Plates are small black-and-white
photographs. Chronological lists of architectural works, pp.
29-31.

774. Tietze, Hans. *Otto Wagner.* Wien: Rikola Verlag, 1922. 16
pp., 16 pls.

775a. Wagner, Otto. *Die Baukunst unserer Zeit: dem Baukunst-
jünger ein Führer auf diesem Kunstgebiete.* 4. Aufl. Wien: A.
Schroll, 1914. 138 pp., 138 illus.
 The fourth edition of Wagner's *Moderne Architektur* (775b)
under a different title. The architect's exposition of his esthet-
ic and social principles. Includes the introductions to all four
editions. One small photograph per page.

*775b. Wagner, Otto. *Moderne Architektur: seinen Schülern ein Führer auf diesem Kunstgebiete.* 3. Aufl. Wien: A. Schroll, 1902. 188 pp., illus.

A first edition was published in 1896 (101 pp.) and a second edition in 1899 (120 pp.)

776. Wagner, Otto. *Einige Skizzen, Projekte und ausgeführte Bauwerke.* Wien: A. Schroll, 1892-1922. 4 vols., illus.

Mainly reproductions of plans, elevations, and drawings for competitions and projected buildings, as well as some photographs of completed works. Some of the illustrations can be found in Lux's monograph (771). Vol. 1 covers earlier work before 1890 and was issued in a second edition in 1897. All of the volumes are in folio-size format. Vol. 2 was published in 1897. Vol. 3 (or Band 3) was published in 10 Hefte, 1899-1906. Vol. 4 (or Band 4) was published in 10 Hefte, 1910-1922.

*777. Wagner, Otto. *Die Gross-Stadt, eine Studie über diese.* Wien: A. Schroll, [1911]. 23 pp., 1 illus., 2 pls.

Published in folio format.

778. Wagner, Otto. *Die Qualität des Baukünstlers: aus der eigenen Werkstatt; Vortragszyklus im Wiener Volksbildungsverein.* Leipzig, Wien: Hugo Heller, 1912. 50 pp.

A short speech by Wagner on the esthetics of architecture. An example of fine printing.

*779a. Wagner, Otto. "Aus der Wagnerschule." *Der Architekt: Wiener Monatshefte für Bauwesen und decorative Kunst.* Supplement Heft [1] Jahrgang 1897. Wien: A. Schroll, 1897. 20 pp., illus., folio

*779b. Wagner, Otto. "Aus der Wagnerschule." *Der Architekt...* Supplement Heft, 2. Wien: A. Schroll, [1898]. 20 pp., illus., folio

*779c. Wagner, Otto. "Aus der Wagnerschule." Redaktor, Alois Ludwig. *Der Architekt...* Supplement Heft, 5. Wien: A. Schroll, [1900]. 20 pp., illus., folio

*779d. Wagner, Otto. "Aus der Wagnerschule." Redaktor, Paul

Roller. *Der Architekt...* Supplement Heft, 6. Wien: A. Schroll, 1901. 44 pp., illus., 2 col. pls., folio

779e. Wagner, Otto. "Wagner-Schule 1901." Redaktor, Paul Roller. *Der Architekt...* Supplement Heft, 7. Wien: A. Schroll, 1902. 16 pp., 45 col. pl., folio
Primarily illustrations. Folio of architectural and decorative work in early Secession style by Wagner's students.

*779f. Wagner, Otto. *Wagner-Schule 1902.* Wien, Leipzig: Baumgärtner, [1903]. 81 pp., illus.
Cataloged by Library of Congress under title.

780a. Wagner, Otto. *Wagnerschule 1902/03 und 1903/04: Projekte, Studien und Skizzen aus der Spezialschule für Architektur des Oberbaurat Otto Wagner.* [Redaktion: Karl Maria Kerndle.] Leipzig: Baumgärtner, 1905. 79 pp. (chiefly illus., plans), folio
Folio of architectural projects of Wagner's students.

780b. Wagner, Otto. *Wagnerschule: Projekte, Studien und Skizzen aus der Spezialschule für Architektur des Oberbaurat Otto Wagner; Arbeiten aus den Jahren 1905/06 und 1906/07.* Nebst einem Anhange. Leipzig: Baumgärtner, 1910. iv, 87 pp. (chiefly illus., plans), folio
Architectural projects of Wagner's students. Cataloged by the University of California under: Vienna. Akademie der Bildende Künste. Spezialschule für Architektur.

*781. Wagner, Otto. *Zur Kunstförderung: ein Mahnwort.* Wien: F. Kosmack, [1909]. 105 pp.

782. Dreger, Moriz. "Die neue Bauschule (Ausstellung der Schüler Otto Wagners)." *VS* Jrg. 2, Heft 8:17, 20, 22-4 (1899)

783. Girardi, Vittoria. "Commento a Otto Wagner (Eredità dell' ottocento)." *Archtt* 4:118-23, 192-7, 264-9, 332-7, 408-13, 482-5, 550-5 (Je-D 1958); issues nos. 32-8. [96] illus., 2 col. pls., [9] plans
A survey of the architect's career in seven installments. Text in Italian, with brief summaries in English, French, German, and Spanish at the beginning of each installment. Chronology and publications of Wagner, p. 555. Numerous photographs.

784. "Die Haltestalle Karlsplatz in Wien." *Werk* 56:443 (Jy 1969). 2 illus.
An edifice by Wagner.

785. Hevesi, Ludwig. "Aus dem Wiener Kunstleben—eine moderne Kirche." *KKhw* 2:450-2 (D 1899). 3 illus.
Design for a Kirche für Währing by Wagner.

786. Kuzmany, Karl M. "Ein Kirchenbau von Otto Wagner." *Dek K* Jrg. 11 (Bd. 21):106-14 (D 1907); or *Kunst* Bd. 18:106-14 (D 1907). 8 illus. (pp. 105-13)
The Am Steinhof church in Vienna.

787. Planiscig, Leone. "Problemi d'architettura moderna: Otto Wagner." *Emp* 32:102-15 (Ag 1910). 13 illus.

788. V.S. "Der Hofpavillon der Wiener Stadtbahn." *VS* Jrg. 2, Heft 8:3-13 (1899). 12 illus., plan
The main station of the Vienna transit system, designed by Wagner. Nicely illustrated.

789. Wagner, Otto. "Der VIII. Internationale Architekten-Kongress in Wien 1908: Eröffnungsrede des Präsidenten Oberbaurat Otto Wagner." *HW* 4:177-8 (1908)

790. Wagner, Otto. "Der Architekt und sein Werdegang: fünf Fragen beantwortet von... Wagner, am Londoner Kongress 1906." *HW* 4:49-50, 53 (1908)

791. "Die Wiener Jubiläums-Ausstellung." *Dek K* Jrg. 1 (Bd. 2): 235-6 (1898). 13 illus. (pp. 256-68)
Work of Otto Wagner and his pupils.

792. "Zehn Jahre moderner Baukunst (zum zehnjährigen Jubiläum der Wagner-Schule)." *HW* 1:371-2 (1905)

ALSO SEE: 34, 223, 227, 240, 442, 459, 534, 568, 570, 649, 729. Also see the Index.

Franz Zelezny

793. Abels, Ludwig. "Franz Zelezny." *Intr* 1:81-6 (1900). 26
illus. (pp. 81-94)
 A sculptor in wood, some of whose work was Art Nouveau.
 Other illustrations in this volume are on pp. 3, 23, 28, 47, 50,
 106, 122, 124-5, 156, 162-6, 172

BELGIUM (ART NOUVEAU)

BELGIUM was the birthplace of Art Nouveau, which is generally agreed to have begun with the Maison Tassel of Victor Horta in 1893. An awareness of Belgian art history of the 1890s is basic to the understanding of the movement as a whole. The center of activity was Brussels, with Liège serving as a secondary center. Although there was no organized Art Nouveau movement in Belgium, the style was represented by a number of independent artists, some of whom were associated with the two avant-garde art groups "Le Groupe des Vingts" (806-13) and "La Libre Esthétique" (814-35). The most important Belgian periodicals for the movement were *L'Art Moderne,* a weekly bulletin of literature, art, and music, and *L'Emulation,* an architectural journal (volumes of the latter prior to 1900 were not available for annotation and inclusion in this bibliography). The *Cahiers Henry Van de Velde* (967b), a current journal, publishes articles about other Belgian Art Nouveau artists as well as Van de Velde.

Leading monographs on Art Nouveau in Belgium are: Mme. Maus (795); the Vingtists exhibition catalog of 1962 (807); Borsi (836) and the Musée des Arts Décoratifs, Paris catalog (840), both on architecture (for a guide to Brussels architecture see 838); Oostens-Wittamer (849) for posters; Legrand (853) for painting; Borsi (876) on Victor Horta; and Hammacher (975), Hüter (777), and the Brussels-Otterlo catalog (966) on Van de Velde.

Belgium is sharply split today into French and Flemish language zones. This division was not as evident in 1900, and most of the major figures, such as Horta, Van de Velde, and Minne, were Flemings who had moved to Brussels and spoke and wrote French. Flemish, which is a collection of Belgian dialects of the Dutch language, is formally referred to as *Nederlands* in the areas in which it is spoken. This bibliography will follow the conventional usage in English-speaking countries by identifying the language as Flemish in the section on Belgium and Dutch in the section on the Netherlands, in volume 2.

Belgian Art Nouveau in general

794. Fierens, Paul. *L'Art en Belgique du Moyen-Age à nos jours.* Bruxelles: Renaissance du Livre, 1939. 545 pp., illus., bibl. footnotes

Some sections between pp. 506 and 526 give a survey of the Belgian movement. Numerous illustrations. Good for nineteenth-century art.

795. Maus, Mme. Madeleine Octave. *Trente années de lutte pour l'art, 1884-1914.* Bruxelles; Librairie L'Oiseau Bleu, 1926. 508 pp., illus., 40 pls., port.

A year-by-year account of the exhibitions of "Les XX." (Salon de Vingts) and "La Libre Esthétique", by the widow of Octave Maus, founder of the two groups. Includes lists of exhibiting artists, music programs, and descriptive programs for each year. A basic source for information on the arts in Belgium of this period. Also includes many foreign artists, musicians and writers. Octave Maus is frequently listed erroneously in bibliographies as the author.

796. Tervuren. Musée Royale de l'Afrique Centrale. *Tervueren 1897.* Tervuren, Belgium: [1967]. 103 pp., 35 pls., bibl.

By M. Luwel and M. Bruneel-Hye de Cron. Exhibition commemorating the seventieth anniversary of the 1897 African, or Congo, exhibition, which was decorated in Art Nouveau motif by four Belgian artists. One essay in Flemish on the history of the exhibition and one in French, "L'Exposition de Tervuren et l'Art Nouveau." Bibliographies, pp. 42-3 and 82-8.

797. Vanzype, Gustave. *L'Art belge du XIXe siècle à l'Exposition Jubilaire du Cercle Artistique et Littéraire à Bruxelles en 1922.* Bruxelles, Paris: G. Van Oest, 1923. 146 pp., 102 pls.

Treats exclusively of nineteenth-century styles. Khnopff's early period is discussed. Portrait of Philippe Wolfers by Fr. van Holder (facing p. 125).

798. Cantel, Roberto. "Le grandi esposizioni internationali: L'Esposizione di Bruxelles." *Emp* 6:224-35 (Se 1897). 28 illus.

The Tervuren Colonial Exposition of 1897.

799. Champier, Victor. "L'Exposition Universelle de Bruxelles: l'art et l'industrie en Belgique." *Rev Arts Dec* 17:353-62 (1897). 13 illus., 1 pl.
 The Tervuren Exposition. A second article on the French exhibits appears on pp. 385-94 (13 illus., 3 pls.).

800. Maeyer, Charles de. "L'Art Nouveau en Belgique." *In* Paris. Musée National d'Art Moderne. *Les Sources du XX. Siècle*, pp. 263-5. (63)

801. Pierron, Sander. "L'Exposition du Cercle 'Pour l'Art' à Bruxelles." *Rev Arts Dec* 19:77-83 (1899). 9 illus.
 Includes jewelry by Philippe Wolfers.

802. "Zu unseren Illustrationen." *InnDek* 11:87-8 (My 1900). 5 illus. (pp. 78-80)
 Drawings by Armand van Waesberghe and furniture and stained glass by Léon Bochoms of Verviers.

ALSO SEE: 12, 40a, 118, 1092

Tervuren, 1897. Colonial Exposition
 Also known as the Exposition de Bruxelles, 1897.

SEE: 796, 798-9, 846, 858, 908, 1065

Exposition Universelle, 1900, Paris—Belgian exhibits

803. "La Section Belge des Beaux-Arts à l'Exposition de Paris en 1900." *Art Mod* 18:207 (Je 26, 1898)

Esposizione Internazionale d'Arte Decorativa Moderna, Torino, 1902—Belgian exhibits

804. Fuchs, Georg. "Die belgische Abteilung auf der Turiner Ausstellung." *DKD* 11:147-9 (D 1902). 15 illus. (pp. 147-60)

805. Thovez, Enrico. "The Turin Exhibition: the Belgian section." *Studio* 27:279-82 (Ja 1903). 7 illus.

Les XX. (Le Groupe des Vingt)

An influential group of twenty artists, most of them Belgian, which organized important international exhibitions between 1884 and 1893. Its membership included people later identified with Art Nouveau.

806. Brussels. Musées Royaux des Beaux-Arts de Belgique. Art Moderne. *Evocation des "XX." et de "La Libre Esthétique".* Bruxelles: 1966. [42] pp., [15] illus., bibl.

Small exhibition catalog of fifty-eight items about two Belgian avant-garde art circles of the 1890s. Not to be confused with the following item.

807. Brussels. Musées Royaux des Beaux-Arts de Belgique. Art Moderne. *Le Groupe des XX. et son temps.* [Bruxelles]: 1962. 148 pp., 45 pls., bibl.

Important exhibition catalog. Text by F.C. Legrand, pp. 17-35. Alphabetically arranged catalog of sixty-four artists, pp. 39-129. Includes biographies. Bibliography, pp. 137-46.

808. "Les Arts décoratifs au Salon des XX." *Art Mod* 13:65-6 (F 26, 1893)

Praises new work by Van de Velde and Lemmen.

809. Cachin, Françoise. "Des XX. à l'Europe." *Art Fr* 3:367-73 (1963). 5 illus., bibl. footnotes

810. "L'Exposition des XX." *Art Mod* 10:25-7 (Ja 26, 1890)

811. Laughton, Bruce. "The British and American contribution to 'Les XX.', 1884-93." *Apollo* 86:372-9 (N 1969). 9 illus., bibl. footnotes

A detailed account of the participation of Whistler and other British and American artists in the pioneer Belgian group. Includes a catalogue raisonné of works exhibited (pp. 376-9).

812. "Le Salon des XX.: Les Vingtistes." *Art Mod* 13:81-2 (Mr 12, 1893)

Belgian artists exhibiting in the group.

813. "Les XX., dix années de campagne: un peu de statistique."
Art Mod 13:115-17 (Ap 9, 1893)
 Lists of exhibitors with the Vingtistes group during the ten
 years of its existence. Also see pp. 107-8 in the preceeding issue
 (Ap 2) for information on 1893.

813x. Warmoes, Jean. "Les XX. et la littérature." *CHVV* no. 7:
19-42 (1966). 7 illus., bibl. footnotes
 Relations between the Vingtistes group and French and Belgian
 writers. Includes material on Khnopff.

ALSO SEE: 795, 925, 1061, 1074, 1771

"La Libre Esthétique"
 "La Libre Esthétique" succeeded the "Group des Vingts" in
1894. It held major exhibitions of international scope in Brussels,
thus furthering the development of Art Nouveau.

814. "Die Ausstellung der 'Libre Esthétique'." *Dek K* Jrg. 2 (Bd.
4):3-5 (1899). 35 illus. (pp. 24-35)

815. "Clôture de la 'Libre Esthétique'." *Art Mod* 20:105-6 (Ap
1, 1900)

816. Combaz, Gisbert. "Les Arts décoratifs au Salon de La Libre
Esthétique." *Art Mod* 17:97-101 (Mr 28, 1897). 10 illus.

817. Combaz, Gisbert. "Les Arts décoratifs à La Libre Esthétique
à Bruxelles." *Rev Arts Dec* 18:60-1 (1898). 1 illus.

818a. Desfagnes, Jeanne. "La Septième Exposition de la 'Libre
Esthétique'." *Art Dec* 4:45-61 (My 1900). 29 illus., 1 pl.
 Includes graphic work by Delville and Toorop, glass by Powell,
 and bindings by Paul Kersten.

818b. Desfagnes, Jeanne. "Die siebente Ausstellung der Libre
Esthétique in Brüssel." *Dek K* Jrg. 3 (Bd. 6):319-28 (My 1900);
or *Kunst* Bd. 2:319-28 (My 1900). 36 illus. (pp. 321-36), 1 pl.

819. Gerdeil, O. "La Libre Esthétique: huitième exposition."

Art Dec 6:80-2 (My 1901). 13 illus. (pp. 80-4)
Includes glass by Kolo Moser.

820. " 'La Libre Esthétique'." *Art Mod* 13:379-80 (N 26, 1893)
Announcing the beginning of the new group. List of members.

821. " 'La Libre Esthétique'." *Art Mod* 15:65-6, 73-6, 81-2, 89-91, 105-7 (Mr 3-Ap 7, 1895). Illus.
First season of the group. Two Beardsley illustrations, pp. 74-5.

822. Maus, Octave. "Les Industries d'art au Salon de la Libre Esthétique." *Art & Dec* 1:44-8 (F 1897). 7 illus.

823. Maus, Octave. "Les Industries d'art au Salon de la Libre Esthétique." *Art & Dec* 5:97-103 (Ap 1899). 13 illus.
International decorative art show in Brussels. Includes work by Minne, Behrens, and Combaz.

824. Maus, Octave. "Le Salon de la Libre Esthétique." *Art & Dec* 3:97-104 (Ap 1898). 12 illus.

825. Meier-Graefe, J. "Exposition de la Libre Esthétique." *Art Dec* 2:5-7 (Ap 1899). 36 illus. (pp. 17, 24-35)
Comprehensive exhibit of Belgian art.

826. Nocq, Henri. "L'Exposition de la 'Libre Esthétique'." *Rev Arts Dec* 16:141-8 (1896)
Includes work by Serrurier-Bovy and Van de Velde.

827. Nocq, Henri. "L'Exposition de la Libre Esthétique à Bruxelles." *Rev Arts Dec* 15:379-81 (1894/95)
Includes a notice on Serrurier-Bovy.

828. Pierron, Sander. "L'Exposition de l'etranger: les expositions du Cercle 'Pour L'Art' et de 'La Libre Esthétique', à Bruxelles." *Rev Arts Dec* 21:122-8 (1901). 12 illus.
Includes jewelry by Wolfers.

829. Pierron, Sander. "L'Exposition de la 'Libre Esthétique'." *Rev Arts Dec* 19:106-13 (1899). 16 illus.

830. "La Presse et La Libre Esthétique." *Art Mod* 20:137 (Ap 29); 20:154 (My 13, 1900); 21:132 (Ap 14); 21:150 (Ap 28, 1901); 22:132-3 (Ap 13, 1902); 22:189 (Je 1, 1902)

A series of press citations on the group over a period of three years.

831. "Le Salon de la Libre Esthétique." *Art Mod* 16:65-7, 73-5, 89-91, 99-101 (Mr 1-Mr 29, 1896)

The last of these four installments includes a note on Thorn-Prikker.

832. "Le Salon de la Libre Esthétique..." *Art Mod* 18:99-101 (Mr 27, 1898)

The last of four installments.

833. "Le Salon de la Libre Esthétique: l'art appliqué." *Art Mod* 14:84-6 (Mr 18, 1894)

834. "Le Salon de la Libre Esthétique: quelques dessinateurs." *Art Mod* 14:73-5 (Mr 11, 1894). Illus.

Includes work by English artists.

835. Verhaeren, Emile. "La Libre Esthétique." *Art Mod* 21:81-3 (Mr 17, 1901)

ALSO SEE: 795, 806, 892, 925, 937, 1015, 1771

Architecture in Belgium

836. Borsi, Franco, and Wieser, H. *Bruxelles, capitale de l'Art Nouveau...* [Roma]: C. Colombo, [1971]. 408 pp. (pp. 123-408, photographs), illus., col. pls., plans, bibl.

Comprehensive monograph on Belgian Art Nouveau architects, including Horta, Hankar, Van de Velde, and many minor figures. Chapter 4 on Serrurier-Bovy. Profusely illustrated. Bibliography, pp. 117-20 and also following the chronology for each architect described (p. 122ff.). Descriptions of illustrations and index in fold-out at rear of book.

837. Brussels. Ecole Nationale Supérieure d'Architecture et des

Arts Visuels. *Bruxelles 1900, capitale de l'Art Nouveau...* Bruxelles: 1971. 167 pp., 106 pls., 3 col. pls., plans
 Exhibition catalog in French, Flemish, and English. Texts by Delevoy and Wieser. Numerous photographs of Art Nouveau façades and interiors.

838. *Bruxelles, guide d'architecture. Brussels, guide to architecture.* Edité par le Ministère de la Culture Française à l'initiative de la Société Belge des Urbanistes et Architectes Modernistes. Bruxelles: Imprimerie Laconti, [1972]. 93 pp., illus.
 Bilingual guide to 296 architectural sites in Brussels. Introduction by Grégoire Wathelet. Sixty-six buildings listed for the period 1890-1914, pp. 24-37. Also see index of architects ("auteurs"), pp. 19-22, especially for post-1914 buildings by Art Nouveau architects. Small photographs of most buildings mentioned. Large locational map of Brussels inside of back cover.

839. *L'Oeil.* "Pionniers du XXème siècle." *Oeil* no. 194 (F 1971). 47 illus. (part col.)
 Special issue of *Oeil* on the artists featured in the exhibition held at the Musée des Arts Décoratifs, Paris (840). Articles by Alain Blondel and Yves Plantin on Guimard (1596), and by François Loyer on Van de Velde (1012) and Horta (887). Well illustrated.

840. Paris. Musée des Arts Décoratifs. *Pionniers du XXe siècle: Guimard, Horta, Van de Velde.* Paris: 1971. 221 pp., 63 illus., 3 ports., bibl.
 Catalog of an exhibition of 275 items honoring the three architects. No table of contents. Texts: "1900," by Jean Prouvé, pp. 6-7; "Pertes et profits de l'Art Nouveau," pp. 8-9, "Victor Horta," pp. 18-25, and "Henry van de Velde," pp. 68-77, all by Robert Delevoy; "Hector Guimard," by Yvonne Brunhammer, pp. 124-9. Emphasis is on architecture. Bibliographies are found at the end of the book. Bibliographic citation with each item.

841. Frigerio, Simone. "Guimard, Horta, Van de Velde: l'Exposition 'Pionniers du 20e siècle', Musée des Arts Décoratifs, Paris..."

Arch d'Auj no. 155:xv-xvii (Ap 1971). 5 illus.
Notice on the exhibition (840).

842. Gállego, Julián. "Los 'pioneros' del diseño industrial (Crónica de Paris)." *Goya* no. 102:410-12 (My 1971). 4 illus.
Notice on the exhibition at the Musée des Arts Décoratifs, Paris (840).

843. Lenning, Henry F. "The movement in Europe: Van de Velde, Horta and Guimard." *World Review* n.s. no. 47:33-8 (Ja 1953)

844. Maus, Octave. "Architecture moderne." *Art Mod* 20:85-6 (Mr 18); 93-5 (Mr 25, 1900)
Two articles on Belgian Art Nouveau architecture.

845. "Petite chronique: l'architecture 'nouveau style...'" *Art Mod* 20:47 (F 11, 1900)

ALSO SEE: 41, 867-74 (Hankar), 876-97 (Horta), 939, 963ff. (Van de Velde), 1075a, 1141, 1377

Sculpture in Belgium

846. Maus, Octave. "La Sculpture en ivoire à l'Exposition de Bruxelles." *Art & Dec* 2:129-33 (N 1897). 7 illus.
Belgian ivory sculpture at the Tervuren Colonial Exposition.

ALSO SEE: 926-37 (Minne)

Posters in Belgium

847. Demeure de Beaumont, Alexandre. *L'Affiche belge: essai critique...* L'Affiche illustré, 1. Toulouse: Chez l'auteur, 1897. 95, xxiii pp., album (pls.), bibl.
A contemporary account of 1890s Belgian posters, most of which are Art Nouveau. Numerous illustrations in sepia tint. Text followed by album of drawings. Bibliographic essay, p. xix ff.

848. Chateau de Fraiture-en-Condroz. *Les Affiches de la Belle*

Epoque: exposition. Fraiture-en-Condroz, Belgium: 1961. 114 pp., 32 pls., bibl.

Exhibition of 329 posters of the Wittamer-De Camps collection, Brussels. Introductory texts by François Mathey and Yolande Wittamer. Bibliography, pp. 14-15. Arrangement is alphabetical by artist, with some biographies. Includes both Belgian and foreign posters. Indexes.

849. Oostens-Wittamer, Yolande. *La Belle Epoque: Belgian posters, watercolors and drawings from the collection of L. Wittamer-De Camps...* [New York]: Grossman, [1970]. 93 pp., 136 illus. (part col.), bibl. footnotes

Large format exhibition catalog of an outstanding collection of Belgian Art Nouveau posters. Introduction by author, pp. 9-11. Arrangement is alphabetical by artist and includes biographies. Among the artists featured are Emile Berchmans, Gisbert Combaz, Adolphe Crespin, Lemmen, Privat Livemont, Victor Mignot, Armand Rassenfosse, and Théo van Rysselberghe, as well as some better known Belgian artists identified with other art movements. Arrangement is alphabetical by artist. Copiously illustrated. Bibliographical footnotes, pp. 92-3.

850. "A la Maison d'Art: exposition d'affiches françaises et belges." *Art Mod* 16:157 (My 17, 1896)

An exhibit of contemporary posters, including work by Théo van Rysselberghe.

851. "A Louvain: exposition internationale d'affiches." *Art Mod* 18:304 (Se 18, 1898)

852. Pica, Vittorio. "Attraverso gli albi e le cartelle (Sensazioni d'arte) VII: Donnay, Berchmans, Rassenfosse, Maréchal." *Emp* 6: 361-84 (N 1897). 50 illus.

Graphic art work by four Belgian artists.

ALSO SEE: 252, 257, 273, 869, 905-7, 911, 923

Painting and illustration in Belgium

853. Legrand, Francine-Claire. *Le Symbolisme en Belgique.*

Belgique, Arts du temps. Bruxelles: Laconti, [1971]. 277 pp., 139 illus., 20 col. pls., bibl., bibl. footnotes
 A survey of Symbolist painting in Belgium and its general background. Separate sections on Khnopff, Jean Delville, and on Art Nouveau (p. 207ff.). Biographies of the artists, p. 252ff.

854. Item number not used.

855. I.D. "Teatro drammatico contemporaneo: *Starkadd* di Alfred Hegenscheidt." *Emp* 9:183-94 (Se 1899). 9 illus., port.
 Article on a Flemish dramatist, illustrated by vignettes from Dutch and Belgian artists.

856. Meier-Graefe, J. "Die moderne Illustrationskunst in Belgien, 2: die Neueren. *ZfB* 1:505-19 (Ja 1898). 24 illus.

Decorative arts in Belgium

857. Fierens-Gevaert, H. "L'Art décoratif belge à l'Exposition de Milan." *Art Mod* 26:229 (Jy 29); 26:310-11 (Se 30, 1906)
 The Belgian exhibit was housed in a gallery designed by Horta.

858. "Les Industries d'art à l'Exposition de Bruxelles." *Art Mod* 17:126, 263-5 (1897)

859. Maus, Octave. "The Art Movement: decorative art in Belgium." *Magazine of Art* (London) 24:271-7 (1901). 8 illus.

860. G. [i.e. J. Meier-Graefe]. "Belgische Innendekoration." *Dek K* Jrg. 1 (Bd. 1):199-206 (F 1898). 9 illus.
 Includes work by Serrurier-Bovy and Van de Velde.

861. Schmidkunz, Hans. "Belgische Tafelkunst." *Kgwb* N.F. 17: 143-4 (1906). 9 illus.
 Includes work of the Val St. Lambert firm and of Otto Wiskemann.

862. Schmidkunz, Hans. "Innen-Dekoration auf der Weltausstellung Lüttich." *InnDek* 16:216-26 (Se 1905)
 Belgian exhibits at the 1905 World Fair in Liège.

863. Thiébault-Sisson. "L'Art décoratif en Belgique..." *Art & Dec* 1:17-23 (My 1897). 9 illus.
Includes work of Horta and embroidered screens by De Rudder.

INDIVIDUAL ARTISTS

Mme. E. Beetz

864. J. [i.e. J. Meier-Graefe?]. "Nos illustrations." *Art Dec* 3: 179 (Ja 1900). 5 illus. (pp. 159-60)
Metalwork by Mme. E. Beetz.

Marie Closset

865. R. "Nos illustrations." *Art Dec* 3:8 (O 1899). 4 illus. (p. 31)
Embroidery by Marie Closset, a young Belgian artist.

A. Willy Finch

866. Lemmen, George. "A.W. Finch: peintre, graveur, céramiste." *Art Dec* 2:231-4 (Se 1899). 10 illus. (pp. 272-6)
Belgian ceramicist living in Finland.

ALSO SEE: 922b

Paul Hankar

*867. Conrady, Charles, and Thibaut, Raymond. *Paul Hankar.* Bruxelles: Editions Tekhne, Revue de la Cité, 1923. 12 pp., pl.
Cited in Grady (204).

868. Maeyer, Charles de. *Paul Hankar.* Monographies de l'art belge. Bruxelles: Meddens, [1963]. 16 pp., 28 pls., port., bibl.
Short biographical sketch, with photographs of the architect's work. Bibliography, pp. 14-15. Also published in Flemish.

869. "MM. Crespin, Duyck et Hankar." *Art Mod* 16:44 (F 9, 1896)

Exhibition of decorative art and posters at the Cercle Artisti-
que by three artists.

870. Maus, Octave & Soulier, Gustave. "L'Art décoratif en Bel-
gique: MM. Paul Hankar et Adolphe Crespin." *Art Dec* 1:89-96
(Mr 1897). 8 illus.
 Architecture by Hankar and wallpaper designs by Crespin.

871. Maus, Octave. "Habitations modernes, Paul Hankar." *Art
Mod* 20:229-31 (Jy 22, 1900)
 Description of the architect's principal works.

872. "Monument funéraire à Paul Hankar, architecte." *Emul* 26:
32 (1901)

873. "Necrologie: Paul Hankar." *Art Mod* 20:22 (Ja 20, 1901)

874. "Necrologie: Paul Hankar, architecte." *Emul* 26:6-8 (1901).
3 illus.

ALSO SEE: 118, 223, 836, 907

Georges Hobé

875. Bénédite, Léonce. "Un Bâtisseur belge: Georges Hobé." *Art
& Dec* 9:89-98 (1901). 11 illus., 3 plans
 Arts & Crafts style architecture by a figure identified with Bel-
gian Art Nouveau.

Victor Horta
 Although Horta launched Art Nouveau as a movement with
the house he built in the rue Turin in Brussels in 1893, he aban-
doned this style in the earliest years of the twentieth century. Ex-
cluded from this bibliography are articles on his later works as
well as his own subsequent writings, which have no bearing on
Art Nouveau. The major monograph is Borsi & Portoghesi (876).
Also see the articles by Girardi (885) and Madsen (888).

*876a. Borsi, Franco, and Portoghesi, Paolo. *Victor Horta*. Prefa-
zione di Jean Delhaye. Roma: Edizioni del Tritone, 1969. 192

pp., illus., 219 pls.
Original edition of the following item.

876b. Borsi, Franco, and Portoghesi, Paolo. *Victor Horta...* Bruxelles: Marc Vokaer, [1970]. 196 pp., text illus., 168 & 413 illus. on hors-texte pls., 18 col. pls., plans, bibl., bibl. footnotes
The major work on Horta. A discussion of his work and its relation to modern art. Chronology, p. 185ff. Extensive bibliography, which includes newpaper articles, by Suzanne Henrion-Giele, pp. 193-6. Preface by Jean Delhaye, pp. 9-11. Richly illustrated with hundreds of photographs. Table of contents follows the title page.

877. Brussels. Musée Horta. *Victor Horta, son musée.* Saint-Gilles, Bruxelles: [1971?]. 38 pp., 64 illus. (incl. plans) (part col.)
Texts on the museum and the artist, as well as some unpublished texts by Horta. Many photographs and plans in reduced size. Chronological lists of Horta's work, pp. 35-7.

878. Delevoy, Robert L. *Victor Horta.* Monographies de l'art belge. Bruxelles: Elsevier, [1958]. 12 pp., 28 illus., 3 plans, bibl.
A brief sketch of the architect's career. Also published in Flemish.

879. Delhaye, Jean. *Victor Horta.* [Bruxelles]: Administration Communale de Saint-Gilles, [1964?]. 36 pp., [50] illus., plans
Photographs of Horta buildings and a short text on the architect.

880. Delhaye, J., and Puttermans, P. "L'Oeuvre de Victor Horta; numéro spéciale..." *Rythme* no. 39 (Ap 1964). xii, 40 pp., illus., plans
A collection of nineteen articles on Horta's principal buildings and on the position he occupies in the history of architecture. Richly illustrated. Also published separately as a reprint.

881. Conrady, Charles. "Victor Horta." *La Cité* (Bruxelles) 1: 217-19 (My 1920)
An appeal for post-war reconstruction, which discusses Horta's work.

882. Delhaye, Jean. "Victor Horta et la Maison du Peuple de Bruxelles." *CHVV* no. 9-10:5-57 (1968). 74 illus., 6 plans
 Detailed account of a Horta chef d'oeuvre which was demolished in 1968.

883. Fierens-Gevaert, H. "Architecture moderne." *Art Mod* 23: 255 (Jy 19, 1903)
 On a department store ("L'Innovation"?) by Horta.

884. Girardi, Vittoria. "L'Hotel Van de Velde a Bruxelles: architetto Victor Horta." *Archtt* 10:842-6 (Ap 1965). 7 illus.
 Private residence by Horta. No precise explanation is given for the Van de Velde name. Summaries in English, French, German, and Spanish.

885. Girardi, Vittoria [i.e. Architetti associati & Vittoria Girardi]: "Letture di Victor Horta." Eredità dell'Ottocento. *Archtt* 3:334-9, 408-11, 478-83, 548-55, 622-5, 698-701, 766-71, 836-41 (Se 1957–Ap 1958) (Issues nos. 23-30). 135 illus., 1 plan
 A review of the architect's work in eight installments. Text in Italian, with summaries in four languages. Numerous photographs. The most extensive work on Horta at the time of its publication. The first six installments deal with one or several major works (i.e., no. 1 is on the Hotel Tassel, no. 4, the Maison du Peuple, and no. 5, the Hotel Solvay). The last two installments deal with Horta's later work. A chronology is included with the last installment.

886. Kaufmann, Edgar. "Victor Horta." *Architects Year Book* 8:124-36 (1957). 14 illus.
 A description of three buildings by Horta. Chronological list of works, pp. 135-6.

887. Loyer, François. "L'Espage d'Horta." *Oeil* no. 194:14-19 (F 1971). 14 illus. (part col.)
 On the Hotel Solvay of Victor Horta.

888. Madsen, Stephan Tschudi. "Horta: works and style of Victor Horta before 1900." *Arch Rev* 118:388-92 (D 1955). 15 illus., bibl. footnotes

An important article on the genesis of the architect's Art Nouveau style. Footnote 10 describes Horta's early publications (1888-89), which are not of Art Nouveau interest.

889. Maus, Octave. "Architecture moderne." *Art Mod* 20:85-6 (Mr 18, 1900); 20:93-5 (Mr 25, 1900)
On the new Belgian architectural style of Horta. Part 2 describes a house by Octave Van Rysselberghe with decor by Van de Velde.

890. Maus, Octave. "Habitations modernes." *Art Mod* 20:221-3 (Jy 15, 1900)
A description of Horta's architectural work.

891a. G. [i.e. J. Meier-Graefe]. "V. Horta." *Dek K* Jrg. 3 (Bd. 5): 206-9 (F 1900); or *Kunst* Bd. 2:206-9 (F 1900). 6 illus.

891b. Jacques, G.M. [i.e. J. Meier-Graefe?]. "Deux façades de Horta." *Art Dec* 3:209-13 (F 1900). 4 illus.
Includes the Maison Tassel.

892. Nocq, Henry. "Courrier de l'étranger: l'exposition de la 'Libre Esthétique'." *Rev Arts Dec* 17:123-4 (1897)
Observations on Horta.

893. Pierron, Sander. "L'Évolution de l'architecture en Belgique: M. Victor Horta." *Rev Arts Dec* 19:273-90 (1899). 20 illus., 2 pls.

894. Puttermans, Pierre. "L'Héritage de Victor Horta." Académie Royale des Sciences, des Lettres et des Beaux-Arts de Belgique, Brussels. Classe des Beaux-Arts. *Bulletin* 50:271-92 (1968). 9 illus., bibl. footnotes
A review of the architect's career and of his historical reputation.

895. Sedeyn, Emile. "Victor Horta." *Art Dec* 7:230-42 (Mr 1902) 11 illus.

896. Thiébault-Sisson. "L'Art décoratif en Belgique, un novateur: Victor Horta." *Art & Dec* 1:11-18 (Ja 1897). 13 illus., 2 plans

897. Vinson, R.J. "Le Testament d'Horta." *Cons des Arts* no.
212:124-9 (O 1969). 13 col. illus.
The architect's home, now the Horta Museum.

ALSO SEE: 219a, 223, 836, 839-43, 857, 863, 1141

Fernand Khnopff

898a. Dumont-Wilden. Louis. *Fernand Khnopff.* Bruxelles: G.
Van Oest, 1907. 78 pp., [29] illus., [32] pls., port., bibl.
Monograph on the Symbolist painter. Deals with his life, thought,
and work. Numerous illustrations.

898b. Dumont-Wilden, Louis. "L'esthétique de Fernand Khnopff."
Art Mod 26:387-8 (D 9, 1906); 26:395-6 (D 16, 1906)
Part of the author's then unpublished monograph.

899. Eemans, Nestor. *Fernand Khnopff.* Monographien over
belgische kunst. Antwerpen: De Sikkel, [1950]. 15 pp., 24 pls.,
1 col. pl., port., bibl.
Short biographical sketch of the artist. Published simultaneously
in French.

900. Bahr, Hermann. "Fernand Khnopff." *VS* Jrg. 1, Heft 12:
3-4 (D 1898). 24 illus. (pp. 1-24)
Special issue on Khnopff. Includes the translation of a puppet
play by Maeterlinck, with illustrations by Khnopff.

901. Fiérens-Gevaert, H. "Fernand Khnopff." *Art & Dec* 4:116-
24 (O 1898). 8 illus., 1 pl.

902. Houyoux, Rose, et Sulzberger, Suzanne. "Fernand Khnopff
et Eugène Delacroix." *GBA* sér. 6, vol. 64:183-6 (Se 1964). 1 illus.,
bibl. footnotes
English summary, p. 185.

903. Khnopff, Fernand. "L'Eau-forte et la pointe-seche." *Art
Mod* 20:164-5 (My 12, 1901); 20:180-2 (My 26, 1901)
Technical article on the modes of artistic expression.

904. Khnopff, Fernand. "François Maréchal, a Liège etcher."
Studio 20:102-7 (Jy 1900). 4 illus.
 Review of the work of a realist etcher.

905. Khnopff, Fernand. "Some artists at Liège." *Studio* 13:178-
85 (Ap 1898). 8 illus., 1 col. pl.
 Includes posters by Armand Rassenfosse and an interior by
 Serrurier-Bovy.

906. F.K. [i.e. Fernand Khnopff]. "Studio-talk: Brussels." *Studio*
8:118-19 (Jy 1896). 6 illus. (pp. 116-21)
 Includes interiors by Serrurier-Bovy and Belgian posters.

907. F.K. [i.e. Fernand Khnopff]. "Studio-talk: Brussels." *Studio*
8:177-8 (Ag 1896). 3 illus.
 Includes Belgian posters and the Ixelles storefront by Hankar.

908. F.K. [i.e. Fernand Khnopff]. "Studio-talk: Brussels." *Studio*
11:200-3 (Ag 1897). 5 illus.
 A review of the Colonial Exhibition at Tervuren.

909. F.K. [i.e. Fernand Khnopff]. "Studio-talk: Brussels." *Studio*
15:134-7 (N 1898). 5 illus.
 Brief notices on three Belgian exhibits. Five photographs of
 work by Wolfers.

910. F.K. [i.e. Fernand Khnopff]. "Studio-talk: Brussels." *Studio*
16:134-5, 139 (Mr 1899). 6 illus.

911. Koch, Robert. "A poster by Fernand Khnopff." *Marsyas:
studies in the history of art.* Vol. 6:72-4 (1950-53). 1 pl. (4 illus.)
facing p. 71, bibl. footnotes

912. Laillet, Hélène. "The home of an artist: M. Fernand Khnopff's
villa at Brussels." *Studio* 57:201-7 (D 1912). 8 illus.

913. Legrand, Francine-Claire. "Fernand Khnopff—perfect Sym-
bolist." *Apollo* 85:278-87 (Ap 1967). 14 illus., bibl. footnotes
 Discussion of Khnopff's mode of work and of life, as well as
 foreign and Belgian literary and artistic influences on him.

914. "Nos artistes à l'étranger." *Art Mod* 18:192 (Je 12, 1898)
An exhibition of Khnopff at the Vienna Secession.

915. Pica, Vittorio. "Artisti contemporanei: Fernand Khnopff."
Emp 16:170-88 (Se 1902). 23 illus., port.

916. "Silhouette d'artistes—Fernand Khnopff." *Art Mod* 6:281-2
(Se 5, 1886); 6:289-90 (Se 12, 1886); 6:321-3 (O 10, 1886)
A series of three articles on the artist. A fourth one was appar-
ently planned but not published.

917. Sparrow, W. Shaw. "English art and M. Fernand Khnopff."
Studio 2:202-7 (Mr 1894). 10 illus.

918. "Studio-talk: London." *Studio* 38:156 (Jy 1906). 1 illus.,
1 col. pl.
Exhibit of paintings by Khnopff in London.

919. Waldschmidt, Wolfram. "Das Heim eines Symbolisten."
Dek K Jrg. 9 (Bd. 17):158-66 (Ja 1906); or *Kunst* Bd. 14:158-
66 (Ja 1906). 9 illus.
The home of Fernand Khnopff.

ALSO SEE: 262, 302, 797, 813x, 853

Georges Lemmen

920. Nyns, Marcel. *Georges Lemmen.* Monographies de l'art belge.
Anvers: De Sikkel, [1954]. 16 pp., 25 pls. (part col.), bibl.
A brief sketch of the artist's life which deals mainly with his
career as a neo-impressionist painter.

921. Destrée, O.G. "Die Schmuckkünstler Belgiens: Georges Lem-
men." *Dek K* Jrg. 1 (Bd. 1):105-11 (D 1897). 21 illus. (pp. 105-15)
Designs, including end papers, by the artist.

922a. Gerdeil, O. "Georges Lemmen." *Art Dec* 2:229-31 (Se 1899).
46 illus. (pp. 232-3, 237-61)

922b. "Georges Lemmen." *Dek K* Jrg. 2 (Bd. 4):209-11 (1899).

44 illus. (pp. 209, 212-13, 216-41)
> Many illustrations of the artist's designs for textiles and book decoration. Also includes illustrations of pottery by A.W. Finch (pp. 252-6).

ALSO SEE: 334-5, 350, 432, 808, 849, 866, 984, 1300

Privat Livemont

923. Maus, Octave. "Privat Livemont." *Art & Dec* 7:55-61 (1900). 11 illus.
> Posters by the artist.

ALSO SEE: 849

Octave Maus

924. Chartrain-Hebbelinck, Marie-Jeanne. "Les lettres de Paul Signac à Octave Maus." Musées Royaux des Beaux-Arts de Belgique. *Bulletin* 18, no. 1-2:52-102 (1969). 21 illus., 3 pls., bibl. footnotes
> Includes index of names in the letters, pp. 96-102.

925. Legrand, F.-C. "Octave Maus, Secrétaire des XX (1884-1893), Directeur de 'La Libre Esthétique'..." Musées Royaux des Beaux-Arts de Belgique. *Bulletin* 15, no. 1-2:11-16 (1966)
> Short article in both Flemish and French. Followed by James Ensor's letters to Maus (pp. 17-54) and Théo Van Rysselberghe's letters to Maus, introduced and annotated by M.-J. Chartrain-Hebbelinck (pp. 55-112). Flemish summaries, pp. 113-18. Index of names cited in the letters, pp. 119-30.

ALSO SEE: 795

George Minne

926. Brussels. Musées Royaux des Beaux-Arts. Musée Moderne. *Constantin Meunier, George Minne; dessins et sculptures.* Bruxelles: 1969. [45] pp., [14] illus., bibl.
> Exhibition of ninety-four sculptures and drawings by the two

artists. Preface by Ph. Roberts-Jones and introduction by Pierre Baudson (13 pp.). Last page of the bibliography lists articles and books on Minne.

927.　Galerie Georges Giroux, Brussels. *L'Oeuvre de George Minne: sculptures et dessins.* Bruxelles: 1929.　31 pp., [17] illus.
Exhibition of 202 sculptures and drawings. Introductory essay by Leo van Puyvelde, pp. 5-9.

928.　Puyvelde, Leo van. *George Minne.* Collection Les Contemporains. Bruxelles: Editions des "Cahiers de Belgique", [1930]. 85, vii pp., 142 pls., port.
The major monograph on the sculptor. Catalogue raisonné, pp. 75-85, with indexes at rear of the book. Extensively and well illustrated. Contents at end of book. Limited edition of 1,000 copies.

929.　Ridder, André de. *George Minne.* Monographies de l'art belge. Anvers: De Sikkel, [1947].　16 pp., 28 pls., port., bibl.
Brief biographical essay.

930.　Chabot, G. "Maurice Maeterlinck et George Minne." *Gand Artistique* (Ghent) 2:58-61 (Mr 1923). 14 illus.
On the long friendship between the artist and the writer.

931.　Chabot, G. "Les Sculptures de George Minne." *Gand Artistique* (Ghent) 3:5-14 (Ja 1924). 8 illus.
A compassionate portrait of the artist and a description of his career.

932.　*Dekorative Kunst.* "George Minne." *Dek K* Jrg. 4 (Bd. 7): 190-3 (F 1901); or *Kunst* Bd. 4:190-3 (F 1901). 5 illus.
Illustrations only, no text.

933.　Fierens-Gevaert, H. "George Minne." *Art Moderne* 22:377-9 (N 16, 1902)
A visit to the artist's home in Forest (Brussels).

934.　Fiérens-Gevaert, H. "George Minne." *Art & Dec* 10:108-12 (1901). 6 illus.

935. "George Minne." *VS* Jrg. 4, Heft 2:27-46 (1901). 13 illus.

936. Meier-Graefe, J. "Das plastische Ornament." *Pan* 4:257-64 (1898). 11 illus.
 An article on sculpture which concentrates on Minne.

937. "La Salon de 'La Libre Esthétique': George Minne." *Art Mod* 19:81-2 (Mr 12, 1899)
 Exhibition of Minne's fountain.

ALSO SEE: 40c, 823

Alfons Peerboom

938. Schoepp und Vorsteher. *Neue Kunstverglasungen für die Praxis.* Elberfeld: [191-?]. 43 col. pls. in 2 vol.
 Two folios illustrating stained glass windows. No text. Vol. 1 contains the work of Alfons Peerboom. Copy at the New York Public Library.

Antoine Pompe

939. *Antoine Pompe et l'effort moderne en Belgique 1890-1940.* [Bruxelles]: Editions du Musée d'Ixelles, 1969. 190 pp., illus. 2 col. pls., bibl.
 Comprehensive exhibition of modern Belgian architecture. See pp. 38-45 and many of the biographies, pp. 98-182. A list of Belgian architectural journals is given, pp. 184-5. Numerous illustrations.

Armand Rassenfosse.

940. Delchevalerie, Charles. "Armand Rassenfosse." *Art Mod* 22:269 (Ag 10, 1902)

ALSO SEE: 849, 852, 905

Théo Van Rysselberghe

Van Rysselberghe was a neo-impressionist painter like Georges Lemmen, and, like him, also did significant work in the area of Art

Nouveau book decoration and typographical ornament. His brother
Octave Van Rysselberghe was an Art Nouveau architect in Brussels,
for whom no significant information has been located for inclu-
sion in this bibliography.

941. Fierens, Paul. *Théo Van Rysselberghe.* Avec une étude de
Maurice Denis. Bruxelles: Editions de la Connaissance, 1937. 31
pp., 48 pls., port., bibl.
 Emphasis is on the artist's neo-impressionist paintings. Text,
 "L'Homme et l'oeuvre," by Denis, pp. 5-10. Bibliography, p.
 32. Plates are black-and-white photographs of paintings by the
 artist.

942. Maret, François. *Théo Van Rysselberghe.* Monographies de
l'art belge. Anvers: De Sikkel, [1948]. 16 pp., 24 pls., 1 col. pl.,
port., bibl.
 The artist's career as a neo-impressionist painter. Published si-
 multaneously in Flemish.

943. Pogu, Guy. *Théo Van Rysselberghe, sa vie.* [Paris?]: Pre-
miers Eléments, [1963]. iii, 29 pp., 13 illus.
 Short biography of the artist with quotations from his corre-
 spondence.

944. Leclère, Tristan. "Ateliers d'artistes: Théo Van Rysselberghe."
Plume no. 333:299-301 (Mr 1, 1903). 1 illus.

945. *Ver Sacrum.* [Théo Van Rysselberghe.] *VS* Jrg. 2, Heft 11
(1899). 21 illus.
 Special issue on Théo Van Rysselberghe. Short article by Emile
 Verhaeren, translated in German. Numerous illustrations.

ALSO SEE: 849-50, 925

Gustave Serrurier-Bovy
 There is as yet no monograph on the Liège furniture designer
Gustave Serrurier-Bovy, but attention should be called to a biblio-
graphy by François (950) and two articles by Watelet (961) and
Delvoy-Serrurier (*948). Gustave Serrurier added his wife's name
to his own late in life, and both the simple and compound forms
are used in the literature of the period.

946. *Dekorative Kunst.* [Two photographs.] *Dek K* Jrg. 2 (Bd. 4):190-1 (1899). 2 illus.
 Two rooms designed by the artist.

947. "L'Education de l'architecte." *Art Mod* 22:380-1 (N 16, 1902)
 Summary of an article by Serrurier-Bovy which appeared in *La Meuse* (Liège), vol. 47 (1902). It attacks the renewed use in architecture of motifs from classical antiquity.

*948. Delvoy-Serrurier, A. "L'Architecte décorateur liégeois Gustave Serrurier." *Vie Wallonne* vol. 43 (no. 327):161-92 (1969). 7 illus.

949. Félice, Roger de. "Le Sentiment architectural dans l'ameublement." *Art Dec* 12:191-200 (N 1904). 15 illus., 1 col. pl.
 Furniture by Serrurier-Bovy.

950. François, Pierre. "Gustave Serrurier-Bovy: essai de bibliographie." *CHVV* no. 6:27-9 (1965); no. 7:46 (1966)
 Bibliography on the artist in two installments.

951. Karageorgevitch, Prince B. "L'Emploi du métal dans l'ameublement." *Art Dec* 14:181-8 (N 1905). 13 illus.
 Metalware designed by the artist.

952. O.M. [i.e. Octave Maus]. "Necrologie: Gustave Serrurier." *Art Mod* 30:382 (N 27, 1910)
 Obituary.

953. "Ouvrages de dames." *Art Dec* 11:138-44 (Ap 1904). 15 illus., 2 pls.
 Embroidery work designed by Serrurier-Bovy.

954. R. "Nos illustrations." *Art Dec* 2:191-2 (Ag 1899). 2 illus. (pp. 206-7)
 Work by Serrurier-Bovy.

955. Riotor, Léon. "L'Art décoratif au Salon de l'Automobile." *Art Dec* 16:220-36 (D 1906). 16 illus.

Exhibition stands at an automobile show by Serrurier-Bovy
and by French artists.

956. Soulier, Gustave. "Une Installation de chateau." *Art Dec*
8:74-84 (My 1902). 10 illus.
A French home with furniture by Serrurier-Bovy.

957. Soulier, Gustave. "Les Papiers décorés de G. Serrurier." *Art
Dec* 8:9-16 (Ap 1902). 15 illus.
Wallpapers designed by Serrurier-Bovy.

958. Soulier, Gustave. "Serrurier-Bovy." *Art & Dec* 4:78-85 (Se
1898). 8 illus., 1 pl.

959. Velde, Henry van de. "G. Serrurier-Bovy, Lüttich." *InnDek*
13:41-7 (F 1902). 30 illus. (pp. 42-68)

960. Velde, Henry van de. "Un Ingénieur-décorateur liégeois,
M.G. Serrurier-Bovy." *Wallonia* (Liège) 10:285-96 (D 1902). 5 pls.

961. Watelet, J.G. "Le Décorateur liégeois Gustave Serrurier-
Bovy, 1858-1910." *CHVV* no. 11:5-29 (1970). 14 illus., bibl. foot-
notes
A survey of the artist's career.

ALSO SEE: 826-7, 836, 860, 905-6, 1102, 1306, 1324, 1327

Val St. Lambert
This was an important Belgian glassworks around the turn
of the century and is still in existence.

962a. Velde, Henry van de. "Les cristaux du Val St. Lambert."
Art Dec 1:106-7 (D 1898). 17 illus., 1 col. pl. (pp. 129-34, 138-
40)

962b. Velde, Henry van de. "Die Krystallglasserei Val St. Lambert."
Dek K Jrg. 2 (Bd. 3):99-100 (1899). 15 illus., 1 col. pl. (pp. 100,
121-6, 130, 132)

ALSO SEE: 861

Henry Van de Velde

Van de Velde worked in Belgium and Germany, as well as in Holland and France. All aspects of his work are covered in this part of the bibliography with cross-references to Belgium from other countries as appropriate. The entries have been divided between two sections, the first listing books, exhibition catalogs, and periodical articles about the artist (963-1040), the second, books and periodical articles written by the artist himself (1041-74). His name appears in library catalogs and bibliographies of many countries variously as: Velde, Henry Van de; and Van de Velde, Henry. There is no good bibliography of books and articles about Van de Velde, but there are good bibliographies dealing with the complex problem of his own writings. See Hammacher (975), Resseguier (979), and the Brussels-Otterlo exhibition catalog (966).

Because of the length of this section attention will be called to a few of the titles. The *Cahiers Henry Van de Velde* (967b) specializes in research on the artist and his Belgian contemporaries. Van de Velde was the art editor of *Van Nu en Straks* (984), the first Flemish literary magazine. The major modern monographs are Hammacher (975), Hüter (977), and the Brussels-Otterlo exhibition catalog (966). Another important catalog is that of the Kunstgewerbemuseum, Zurich (987). An older biography is that by Osthaus (978). Von Rüden (980) studies Van de Velde's influence on abstract painting. Several articles cover current research (989, 1003, 1004). Attention should also be called to articles by Lemaire (1010) and Pevsner (1020).

963. Avermaete, Roger. *Henry Van de Velde, pionier van een nieuwe stijl.* K. Vlaamse Academie voor Wetenschappen, Letteren- en Schone Kunsten van België. Klasse der Schone Kunsten. Mededelingen 25, no. 2. Brussel: Palais der Academiën, 1963. 11 pp.
> On the artist's crusade against nineteenth-century esthetics and in favor of the creation of a new style. Summary in French, pp. 10-11.

964. Avermaete, Roger. *Kanttekeningen bij het werk van A.M. Hammacher, "De wereld van Henry Van de Velde."* K. Vlaamse Academie voor Wetenschappen, Letteren- en Schone Kunsten van België. Klasse der Schone Kunsten. Jrg. 29, no. 2. Brussel:

Palais der Academiën, 1967. 19 pp., 7 illus.

Describes several points in Van de Velde's Belgian career after 1926, which Hammacher had not mentioned in his monograph (975).

965. Brussels. L'Ecuyer. *Exposition Henry Van de Velde 1863-1957.* Bruxelles: 1970. 108 pp., illus., col. pls.

Exhibition catalog of 195 items. Primarily illustrations. Includes several short texts on the artist. The deluxe edition of 250 copies also has a set of fifteen mounted lithographs of ornamental motifs.

966. Brussels. Palais des Beaux-Arts. *Henry Van de Velde 1863-1957.* Bruxelles. 1963. 115 pp., [22] illus. (incl. plans), [55] pls., ports., bibl., bibl. footnotes

Exhibition commemorating the hundredth anniversary of the artist's birth. Published in Brussels simultaneously in French and Flemish and in a slightly differing version by the Kröller-Müller Museum in Otterlo, Netherlands. Preface by Emile Langui. Three essays by Robert L. Delevoy, pp. 11-45, with shorter essays by R. Verwilghen, L. Lebeer, Fernand Baudin, and Marie Risselin. Exhibition catalog of 320 items (pp. 63-100). Bibliography of the artist's publications by Marcel Van Doren, pp. 101-6. Chronology, pp. 107-11.

967a. Association Henry Van de Velde. *Bulletin.* Bruxelles. nos. 1-4, 1961-63.

This periodical was the forerunner of the *Cahiers Henry Van de Velde,* which starts its numbering with no. 5, 1965 (967b). The *Bulletin* contains neither articles nor illustrations, only short notices on the association's activities. Also published in Flemish as *Tijdingen* of the Henry Van de Velde Genootschap.

967b. *Cahiers Henry Van de Velde.* Bruxelles: Association Henry Van de Velde, 1965- no. 5-

An irregular (usually annual) journal which deals with various aspects of Van de Velde's life and career and those of other Art Nouveau figures, particularly Belgian artists. Began publication in 1965 with issue number 5, continuing from the association's *Bulletin.* "Chronique" is a regular column dealing with

museum exhibitions of interest. Bibliographical information appears regularly, as well as news on the association's activities. Blue pages in the second half of each issue contain translations, usually from French into Flemish. Individual articles from the *Cahiers* are listed and annotated in an appropriate place in the bibliography.

968. *Casabella Continuità.* "Numero dedicato ad Henry Van de Velde." *Csbl* no. 237, Mr 1960. x, 56 pp., [103] illus., plans, bibl. Special issue on Van de Velde as an architect, with a leading article, "Henry Van de Velde, o dell'evoluzione," by E.N. Rogers, pp. 3-9. French, English, and German translations appear as a supplement to this issue. Also includes three texts by Van de Velde translated into Italian. Numerous photographs. Bibliography, p. 10.

969. Casteels, Maurice. *Henry Van de Velde.* Bruxelles: Edition des Cahiers de Belgique, [1932]. [12] pp., 29 illus. A brief sketch of the artist's career and thought. Photographs of post-Art Nouveau work only.

970. Deventer, S. Van. *Henry Van de Velde, 1863-1957: Persönlichkeit und Werk. Ansprache von S. Van Deventer aus Anlass der Eröffnung der Ausstellung Henry Van de Velde; im Karl-Ernst-Osthaus-Museum, Hagen, 6. September 1958.* Hagen i/W. 1958. 12 pp. Speech delivered upon the opening of a Van de Velde exhibition.

*971. *Gedenkboek Henry Van de Velde.* Samengesteld door Drs. Jean Van de Voort. Gent, 1933. Special issue of a Flemish art journal on the occasion of the artist's seventieth birthday. Published as vol. 4, nos. 10-12 of *Kunst: maandblad voor oude en jonge kunst.* Listed in many bibliographies under Voort, Jean van de.

972. Ghent. Rijksuniversiteit. Centrale Bibliotheek. *Tekeningen van Henry Van de Velde: catalogus van de tentoonstelling.* Gent, 1972. 31 pp., 2 illus. Catalog reproduced from typewritten manuscript. Exhibit of

thirty-six drawings. Two essays by Johan Werner Van den Bossche, "Henry Van de Velde en het leefmilieu," pp. 1-13 and "De tekeningen van Henry Van de Velde," pp. 14-23.

973. Hagen. Karl-Ernst-Osthaus Museum. *Henry Van de Velde: Gebrauchsgraphik, Buchgestaltung, Textilentwurf.* Hagen: 1963. [18] pp., [14] illus.
Catalog for an exhibition of 103 items of bookbinding, graphic art, and clothing by the Belgian artist. Introductory essay by Herta Hesse.

974. Hagen. Karl-Ernst-Osthaus Museum. *Der junge Van de Velde und sein Kreis, 1883-1893.* Hagen i/W.: 1959. [39] pp., illus., bibl.
Exhibition catalog of Van de Velde's early career as a painter, as well as the Belgian and foreign artists who influenced him. Text by Herta Hesse-Frielinghaus.

975. Hammacher, Abraham M. *Le Monde de Henry Van de Velde.* Anvers; Fonds Mercator; Paris: Hachette, 1967. 353 pp., [178] illus. (part col., incl. pls.), bibl.
Comprehensive monograph on the artist, valuable for illustrations and appendixes, though written in a somewhat inflated style. Also published by the Fonds Mercator in Dutch under the title *De wereld van Henry Van de Velde* and in German as *Die Welt Henry Van de Veldes.* Numerous beautiful plates and illustrations, listed on pp. 345-8. Appendixes, p. 327ff., prefaced by a note, "L'oeuvre peint et dessiné de Henry Van de Velde," by Erika Billeter, pp. 319-26. Catalogue raisonné of paintings and drawings, pp. 327-36. Chronologies of the artist's life, pp. 112-16, and 214-16, and another chronology of Art Nouveau (insert at rear of book). Bibliography of Van de Velde's published work by Caludine Lemaire, pp. 337-41, perhaps the most extensive published. Followed by a bibliography of books on the author.

976. "Hommage au maître-architecte Henry Van de Velde à l'occasion de son soixante-dixième anniversaire." *La Cité*, vol. 11, no. 5-6 Ap-My 1933. 43 pp. (entire issue), illus., plans, port., bibl.
A Festschrift special issue of *La Cité* which includes tributes from twelve artists, biographical table (p. 11), bibliography

(p. 12), an unsigned article, "Le théâtre dans l'oeuvre de Henry Van de Velde," pp. 13-18, and descriptions of Van de Velde's later architectural work, p. 19ff.

977. Hüter, Karl-Heinz. *Henry Van de Velde: sein Werk bis zum Ende seiner Tätigkeit in Deutschland.* Schriften zur Kunstgeschichte, Heft 9. Berlin: Akademie-Verlag, 1967. 286 pp., 264 illus., port., bibl., bibl. footnotes
 A thorough monograph on Van de Velde's early work in Belgium and his architecture in Germany until 1914. Sections on his career and on his applied art, architecture, and theory. Appendixes follow p. 253. Bibliography, pp. 270-3. Numerous illustrations, primarily black-and-white photographs, and plans.

978. Osthaus, Karl Ernst. *Van de Velde: Leben und Schaffen des Künstlers.* Hagen i/W.: Folkwang-Verlag, 1920. 152 pp., [134] pls., [7] plans, port.
 A biography of the artist by one of his friends. Numerous photographs.

979. Rességuier, Clemens. *Die Schriften Henry Van de Veldes.* New York: Delphic Press, 1955. 106 pp., bibl.
 The author's published dissertation from the University of Zurich, which discusses the artist's esthetic conceptions and describes the artist's books and journal articles. Bibliography of Van de Velde's published work through 1949.

980. Rüden, Egon von. *Van de Velde, Kandinsky, Hölzel: typologische Studien zur Entstehung der gegenstandslosen Malerei.* Wuppertal: A. Henn, [1971]. 85 pp., 29 pls., bibl.
 Comparative study of three painters with reference to the rise of abstract painting. Van de Velde, pp. 7-8, 19-30.

*981a. Scheffler, Karl. *Henry Van de Velde: 4* [i.e., vier] *Essays.* Leipzig: Insel-Verlag, 1913. 100 pp.

981b. Scheffler, Karl. "Hommage à Henry Van de Velde." *CHVV* no. 11:31-7 (1970)
 French translation of one of the author's four essays published in 1913.

982. Teirlinck, Herman. *Henry Van de Velde.* Monographies de l'art belge. Bruxelles: Elseviers, [1959]. 17 pp., 24 illus., bibl.
A short sketch of the artist's career by a noted Flemish novelist. Concentrates on the later work. Published simultaneously in Flemish and in French translation.

983a. Teirlinck, Herman. "De leer van Henry Van de Velde." In his *Ode aan mijn hand: tijdgeestige oefeningen.* Pp. 30-6, Brussel: A. Manteau, c1933
On Van de Velde's esthetics. Subsequently reprinted.

*983b. Teirlinck, Herman. *Ode à ma main.* Bruxelles: Edition des Artistes, 1967. 95 pp.
French translation of *Ode aan mijn hand* (983a).

984. *Van Nu en Straks.* Brussel: ser. 1, no. 1-10, 1892-95; ser. 2, v. 1-5, 1896-1901 (all published)
Flemish literary journal influenced by William Morris' typographic ideals. The first year (ser. 1) includes page decorations by Van de Velde and Georges Lemmen, as well as foreign artists. Van de Velde also did page ornaments for the new series, particularly vol. 1. Complete set at the Boston Public Library.

985. Weimar. Kunsthalle. *Henry Van de Velde, Weimar, 1902-1915.* Weimar: 1963. 54 pp., 16 illus., port.
Exhibition catalog of 179 items (pp. 23-54) on the artist's Weimar years. Essay, "Henry Van de Velde und Weimar," by Karl-Heinz Hüter, pp. 5-9. Chronology, pp. 11-16. Selection from Van de Velde's *Geschichte meines Leben* (1047a), pp. 17-20. Introduction by Dr. Scheidig, pp. 3-4.

986. Winter, F.G. *Erziehung durch Gestalt: Vortrag auf der Jahrestagung der Henry Van de Velde-Gesellschaft, "Henry Van de Velde und die Kunsterziehung," am 21. Oktober 1962 im Karl-Ernst-Osthaus-Museum im Hagen.* Hagen, 1962. [13] pp.
Text of a speech.

987. Zurich. Kunstgewerbemuseum. *Henry Van de Velde, 1863-1957: Persönlichkeit und Werk.* Zürich: 1958. 83 pp., 36 illus., plan

Memorial exhibition on the artist. Foreword by Hans Fischli and Willy Rotzler. Essay by Hans Curjel, pp. 7-19. "Stimmen der Zeitgenossen" quotes from various contemporary writers, p. 21ff. Good black-and-white photographs, pp. 45-72.

988. "A la Libre Esthétique." *Art Mod* 14:76 (Mr 11, 1894)
Review of a lecture by Van de Velde against painting and sculpture.

989. "Archives Henry Van de Velde de la Bibliothèque Royale, Bruxelles." *CHVV* no. 8:31-2 (1967)
A descriptive classification of manuscripts of Van de Velde in the Royal Library of Belgium.

990. *Art Décoratif.* [Photographs.] *Art Dec* 1:147-50 (D 1898). 6 illus.
Photographs of furniture by the artist at the Berlin gallery of Keller & Reiner. No text.

991. *Art Décoratif.* [Photographs.] *Art Dec* 3:89, 92 (1900). 3 illus.
Illustrations of bookbindings by the artist.

992. Blijstra, R. "Henry Van de Velde." *Tijdschrift voor Architecture en Beeldende Kunst* vol. 31, no. 10:226-31 (My 1964). 14 illus., port.
A summary of the artist's work and character.

993. Bodenhausen, Eberhard, Freiherr von. "Niederländische Kunst, Belgien und Holland: Van de Velde, Meunier, Israels. *Pan* 3:121-2 (1897). 2 illus.
The first of the three articles deals with Van de Velde.

994. E.v.B. [i.e. Eberhard von Bodenhausen]. "Notizen zu Van de Velde's neuesten Schöpfungen." *InnDek* 14:247-8 (O 1903). 28 illus. (pp. 242-64)
Recent work by the artist.

995. Bodenhausen, Eberhard, Freiherr von. "Van de Velde und die Eisen-Konstruktion." *InnDek* 14:237-46 (O 1903)

996. Bouillon, Jean Paul. "Notes de lecture: A.M. Hammacher, *Le Monde de Henri Van de Velde…*" *IHA* 14:187-92 (Se-O 1969). 5 illus., bibl. footnotes
A review of the French edition of Hammacher's monograph (975).

997. Braun, Hélène Thomas. "Henry Van de Velde et William Morris, première rencontre: le socialisme ruskinien et l'influence anglaise à Bruxelles." *CHVV* no. 8:21-7 (1967). Bibl. footnotes

998. "La Commemoration du centenaire de la naissance de Henry Van de Velde." *La Maison* 19:138 (My 1963). Port.
On the two Belgian observations of the artist's centennial.

999. Curjel, Hans. "L'Architecte Henry Van de Velde." *Zodiac, Rivista internazionale d'architettura contemporanea* 2:183-7 (1958). 9 illus., port.
A review of the architect's career. Text in French. No English translation.

1000. *Dekorative Kunst.* [Photographs.] *Dek K* Jrg. 2 (Bd. 4):242-51 (1899). 13 illus.
Photographs of furniture and light fixtures by Van de Velde. Text, p. 214.

1001. "Der Fächer." *HW* 2:80 (1905)
Report on a lecture given by Van de Velde.

1002a. "Henry Van de Velde." *Art Dec* 1:2-8 (O 1898). [76] illus., 5 col. pls. (pp. 9-44)

1002b. "Henry Van de Velde." *Dek K* Jrg. 2 (Bd. 3):2-8 (1899). 78 illus., 3 col. pls. (pp. 9-43)
Special issue on Van de Velde. A general article on the artist's esthetic principles, followed by numerous illustrations.

1003. Hesse, Herta. "Die Henry-Van de Velde-Gesellschaft (Unter besonderer Berücksichtigung der Van de Velde-Archive)." *Kunstchronik* 15:89-92 (1962)
Brief description of the group and its initiative in organizing the Van de Velde archives in Brussels.

1004. Hesse-Frielinghaus, Herta. "Die Museumbauten Henry Van de Veldes und ihre Vorgeschichte." *Museums Kunde* 1964, no. 1:1-23. 18 illus., bibl. footnotes

1005. Hoffmann, E. "Henry Van de Velde exhibition at Otterlo." *Burl* 106:301-2 (Je 1964)
A brief account of the artist's life and significance.

1006. A.J. "Professor Henry Van de Velde." *InnDek* 17:82 (Mr 1906). 26 illus. (pp. 76-88)
Recent work by the artist in Weimar, in many art forms.

1007. "K.E. Osthaus' Museum 'Folkwang'—Hagen i.W." *DKD* 13:146-9 (N 1903). 5 illus.
Furniture and interiors in the Osthaus (or Folkwang) Museum by Van de Velde.

1008. F.K. [i.e. Fernand Khnopff]. "Studio-talk: Brussels." *Studio* 18:207 (D 1899). 4 illus.
Furniture by Van de Velde.

1009. "Das Landhaus Dr. Leurings in Wittebrug." *Dek K* Jrg. 8 (Bd. 15):177-80; or *Kunst* Bd. 12:177-80 (Ja 1905). 12 illus. (pp. 177-89)
A house built by Van de Velde in Scheveningen (The Hague), Holland.

1010. Lemaire, Claudine. "August Vermeylen en Henry Van de Velde: voorgeschiedenis van het tijdschrift *Van Nu en Straks.* *Archives et Bibliothèques de Belgique* vol. 36, no. 1:84-96 (1965)
A note on Van de Velde's association with the Flemish periodical (984), with a lengthy passage in French on the 1890s from the unpublished Brussels manuscript of his memoirs.

1011. "Un Livre: *Six chansons...*". *Art Mod* 16:11 (Ja 12, 1896)
Review of a book by the poet Max Elskamp, which was printed by Van de Velde.

1012. Loyer, François. "Henry Van de Velde et son foyer." *Oeil* no. 194:8-13 (F 1971). 17 illus.
On "Bloemenwerf", the artist's first home in Brussels.

1013. O.M. [i.e. Octave Maus]. "Henry Van de Velde." *Art Mod*
30:260-1 (Ag 14, 1910)

1014. Maus, Octave. "Le Monument F. de Mérode." *Art & Dec*
5:57 (F 1899). 1 illus.
A monument designed by Van de Velde.

1015. Maus, Octave. "Le Salon de la Libre Esthétique à Bruxelles."
Rev Arts Dec 20:173-6 (1900). 4 illus.
Features work by Van de Velde.

1016. G.M. [i.e. Gabriel Mourey]. "Studio-talk: Paris." *Studio*
7:180 (Ap 1900). 1 illus. (p. 179)
A mantelpiece by Van de Velde, with panel paintings by Albert
Besnard.

1017. Osborn, Max. "Haby's Frisier-Salon von H. Van de Velde."
InnDek 12:166 (Se 1901). 2 illus. (pp. 164-5)

1018. Osborn, Max. "Henry Van de Velde, Brüssel." *InnDek* 11:
1-11 (Ja 1900). 33 illus., 2 pls. (pp. 2-23)

1019. Osborn, Max. "Die Van de Velde Ausstellung in Berlin."
DKD 8:340-8 (Ap 1901). 9 illus. (pp. 340-5)
Includes carpet designs by the artist.

1020. Pevsner, Nikolaus. "Gropius and Van de Velde." *Arch Rev*
133:165-8 (Mr 1963). 5 illus.
Suggests some ideological affinities between the two artists and
between the ideals of the Bauhaus and Art Nouveau.

1021. Plehn, A.L. "Van de Velde und die Berliner Tischlerei."
Kgwb N.F. 11:183-93 (1900)
Van de Velde's furniture for German manufacture.

1022. "Prof. Henry Van de Velde's Kunstgewerbliches Seminar
in Weimar." *InnDek* 13:278-9 (N 1902)

1023. Röling, Wiek. "Henry Van de Velde, 1863-1957: naar aan-
leiding van een tentoonstelling in 'zijn' museum Kröller-Müller."

Goed Wonen no. 5:10-11 (My 1964). 3 illus., port.
On the 1964 Otterlo exhibition (966).

1024. E.N.R. [i.e. Ernesto N. Rogers]. "Omaggio a Henry Van de Velde." *Casabella continuità* no. 217:6 (1957). 1 illus., port.
Obituary. English summary, p. viii. Also in French.

1025. A.R. [i.e. Adolf Rosenberg?]. "Dekoration und Kunstgewerbe." *Br Archw* 2:417-20 (1900). 4 illus. (pp. 405-8)
The Havana store in Berlin, designed by Van de Velde.

1026. Rosenhagen, Hans. " 'Folkwang' Museum für Kunst und Wissenschaft in Hagen i.W." *Dek K* Jrg. 6 (Bd. 11):1-16 (O 1902); or *Kunst*, Bd. 8:1-16 (O 1902). 21 illus. (pp. 1-20)
A new German museum, with interior architecture by Van de Velde.

1027. W.S. "Studio-talk: Weimar." *Studio* 41:71-3 (Je 1907). 4 illus.
The Gutbier gallery, Dresden, by Van de Velde.

1028. Scheffler, Karl. "Korrespondenzen-Berlin." *Dek K* Jrg. 2 (Bd. 3):192 (1899). 5 illus. (pp. 222-5)
Art salon of Bruno and Paul Cassirer in Berlin, designed by Van de Velde.

1029. Scheffler, Karl. "Ein moderne Laden von Van de Velde." *Dek K* Jrg. 4 (Bd. 8):486-8 (Se 1901); or *Kunst* Bd. 4:486-8 (Se 1901). 2 illus. (pp. 489-90)
The Haby salon in Berlin.

1030. Scheffler, Karl. "Van de Velde's neue Arbeiten." *Dek K* Jrg. 4 (Bd. 7):119, 122-3 (D 1900); or *Kunst* Bd. 4:119, 122-3 (D 1900)

1031. Schrijver, Elka. "Henry Van de Velde, 1863-1957." *Apollo* 81:110-15 (F 1965). 10 illus.
An appreciation of Van de Velde on the occasion of his centennial.

1032. Sembach, Klaus Jürgen. "Einige frühe Möbel Henry Van de Veldes." *CHVV* 7:14-18 (1966). 2 illus.
French translation, pp. 51-3.

1033. Smet, A. de. "In Memorium Henry Van de Velde..."
K. Vlaamse Academie voor Wetenschappen, Letteren- en Schone Kunsten van België. *Jaarboek* 19:209-13 (1957). 2 ports.
A review of the artist's career and influence.

1034. Sosset, Léon Louis. "L'Oeuvre de Henry Van de Velde."
Jardin des Arts no. 109:60-8 (D 1963). 17 illus.
A short sketch of the artist's 94-year lifespan.

1035. H. St. "Henry Van de Veldes Ornamente für Schmiedeeiserne Bogenlampemaste." *Dek K* Jrg. 9 (Bd. 18):332-3 (My 1906); or *Kunst* Bd. 14:332-3 (My 1906). 1 illus.

1036. Teirlinck, Herman. "Zoek de mens, Henry Van de Velde (1863-1957)." *Nieuw Vlaams Tijdschrift* 11:1186-92 (1957)

1037. "Van de Velde und die moderne Zimmer-Einrichtung."
Dek K Jrg. 2 (Bd. 3):19-23 (O? 1899)

1038. "Van de Velde's Programm." *InnDek* 12:106-8 (Je 1901)

1039. M.P. [i.e. M.P. Verneuil]. "Un Intérieur moderne." *Art & Dec* 1:62 (F 1897). 1 illus.
Henry Van de Velde's home in Uccle (Bloemenwerf).

1040. Wigny, P. "Le Monde de Henry Van de Velde." *La Maison* 23:104-5 (Ap 1967)
Extracts from a speech on the occasion of the publication of Hammacher's monograph (975).

ALSO SEE: 15, 34, 47, 111, 113, 119, 126, 229, 239-40, 262, 303, 403, 547, 808, 826, 836, 839-43, 860, 889, 1655

The writings of Henry Van de Velde
Fortunately, a great deal of bibliographic research has been done on Van de Velde's extensive writings. See the bibliographies

by Claudine Lemaire in Hammacher (975), perhaps the most complete one done, and the one by Marcel Van Doren in the Brussels-Otterlo catalog (966), as well as the thesis by Resseguier (979). Van de Velde wrote in French, but the major editions of his work were translations into German in the period 1900-1914. These German editions are fairly easy to find, whereas the French editions of his work, published in Belgium in the 1890s and after the First World War, are often bibliographic rarities, perhaps unavailable outside of Belgium. Although his autobiography was written in French, it has only been published in German and Italian translations (1047); an interesting passage has also been translated into English (1047c). The autobiography and an anthology of his writing edited by Curjel, *Zum neuen Stil* (1058), are probably the most easily obtainable books by Van de Velde. Much of what he wrote after 1920 does not deal with Art Nouveau.

1041. Velde, Henry Van de. *Amo.* Leipzig: Insel Verlag, Insel-Bücherei, no. 3 [1912]. 25 pp.

 A prose-poem in credo form by the artist about natural and artistic objects which he loves (p. 14ff.), preceded by a short essay. An earlier edition published in Leipzig by Friedrich Richter in 1909 has been reprinted by the Henry Van de Velde-Gesellschaft, Hagen, 1963.

*1042. Velde, Henry Van de. *Cours d'art, d'industrie et d'ornementation.* Bruxelles: H. Lamertin, [1895?]. 19 pp.

 Course taught at the extension of the University of Brussels in the academic year, 1894-95. Cited in Grady, 1955 (204).

1043a. Velde, Henry Van de. *Die drei Sünden wider die Schönheit.* Europäische Bibliothek, 5. Zürich: Rascher Verlag, 1918. 90 pp.

 German translation of *La triple offense à la beauté*, a lecture series given in Berne in 1917-18 in French. French text published in *Pages de doctrine* (1050a).

*1043b. Velde, Henry Van de. *De drievoudige smaad aan de schoonheid.* Bibliofielenvereeniging "Tijl" [N.p.]: Frank Van den Wyngaert, 1931. 54 pp.

 Flemish translation of *La triple offense à la beauté*. Limited

edition of 85. Another edition in Flemish was published by De Nederlandse Boekhandel, Antwerp, 1931.

1044. Velde, Henry Van de. *Essays.* Leipzig: Insel Verlag, 1910. 183 pp.
A collection of seven essays on esthetic topics: "Die Belebung des Stoffes als Prinzip der Schönheit," "Die Linie," "Vernunft-gemässe Schönheit," "Volkskunst," "Kunst und Industrie," "Der Facher," and "Kulturpolitik."

1045. Velde, Henry Van de. *Les Formules de la beauté architec-tonique moderne; ce livre contient et résume des essays, se rappor-tant au "Style nouveau," parus dans l'intervalle des années 1902 à 1912.* [Weimar: Privately printed, 1917]. 90 pp.
Essays in a finely printed, limited edition of 300 copies pub-lished privately during the war. Includes "Amo" (see 1041). Reprinted by L'Equerre, Brussels, in 1923 under the cover ti-tle *Les formules d'une esthétique moderne.* Flemish translation: *Formules van een moderne esthetik,* Antwerpen, De Sikkel, 1928.

1046. Velde, Henry Van de. *Les Fondements du Style Moderne.* Bruxelles: "Scarabée d'Or", 1933. 8 pp.
Limited edition of fifty copies published on the occasion of the artist's seventieth birthday. Short essay on esthetic princi-ples. Example of fine printing in sans-serif type. Oblong for-mat.

1047a. Velde, Henry Van de. *Geschichte meines Lebens.* Heraus-gegeben und übertragen von Hans Curjel. München: R. Piper Ver-lag, [1962]. 544 pp., 137 illus., port., bibl.
The German translation of a previously unpublished French manuscript of the author's autobiography. Note by the transla-tor, pp. 461-74. Notes, pp. 475-513. Bibliography, pp. 514-19.

1047b. Velde, Henry Van de. *La mia vita.* A cura di Hans Curjel... La cultura. Saggi di arte e di letteraturà, 2. [Milano]: Il Saggiatore, [1966, c1962]. 537 pp., bibl.
The Italian translation of Hans Curjel's German edition of Van de Velde's unpublished manuscript. Appendixes, p. 463ff., in-clude postscript, notes, bibliography, and index.

1047c. Velde, Henry Van de. "Extracts from his memoirs 1891-
1901." *Arch Rev* 112:143-55 (Se 1952). 15 illus.
An English translation of an important and interesting section
of the artist's autobiography. With an introduction by P. Mor-
ton Shand, pp. 143-5.

1048. Velde, Henry Van de. *Kunstgewerbliche Laienpredigten.*
Leipzig: H. Seeman, [1902]. 195 pp.
Four essays on esthetic principles: "Wie ich mir freie Bahn
Schuf," "Eine Predigt an die Jugend," "William Morris," and
"Prinzipielle Erklärungen." Translated from the French. The
original title of the first essay is "Déblaiement d'art," Bruxelles,
1894. The essay on Morris is a translation of "William Morris,
artisan et socialiste," Bruxelles, 1898.

1049. Velde, Henry Van de. *Le Nouveau: son apport à l'archi-
tecture et aux industries d'art.* Bruxelles: Amis de l'Institut Supé-
rieur des Arts Décoratifs, [1929]. 37 pp.
A defense of Art Nouveau against the charge that it is only a
search for novelty. Limited edition of 310 copies.

*1050a. Velde, Henry Van de. *Pages de doctrine.* Cahiers d'archi-
tecture et d'urbanisme. Bruxelles: Imprimerie Van Doorshaer,
1942
A collection of four essays: "La triple offense à la beauté,"
"Le nouveau: pourquoi toujours du nouveau?," "Devant l'archi-
tecture," and "L'architecture d'aujourd'hui en regard de celle
du passé." Published in a limited edition of 840 copies. Cited
in Resseguier (979).

1050b. Velde, Henry Van de. *Leerstellingen op zoek naar een be-
stendige schoonheid.* Antwerpen: De Nederlandsche Boekhandel,
[1944]. 114 pp.
Flemish translation of *Pages de doctrine* (1050a).

1051. Velde, Henry Van de. *De poetische vorming van Max Els-
kamp...* De seizoenen, no. 39. Antwerpen: De Nederlandsche
Boekhandel, 1943. 83 pp., port.
A biographical sketch of a Belgian poet who was a close friend
of the artist and a collaborator on fine printing in the 1890s.

Citations from their correspondence are in French with Flemish translations, pp. 65-84. Foreword by Lode Zielens. An earlier French edition was published in Brussels in 1933.

1052. Velde, Henry Van de. *Die Renaissance im modernen Kunstgewerbe.* Berlin: Bruno u. Paul Cassirer, 1901. 147 pp., bibl. footnotes
A collection of seven essays by the artist: "Geschichte der Renaissance im modernen Kunstgewerbe," pp. 7-67; "Die Englische und die festländische Renaissance im Kunstgewerbe," pp. 68-82; "Das Ornament als Symbol," pp. 83-96; "Das neue Ornament," pp. 97-108; "Die Rolle der Ingenieure in der modernen Architektur," pp. 109-23; "Die Ausschaltung der Phantasie als ornamentales Mittel," pp. 124-30; "Die Neugeburt des Kunstgewerbes und die soziale Bewegung," pp. 131-48. Ornaments for chapter headings by the artist.

1053a. Velde, Henry Van de. *Le Style moderne: contribution de la France.* Paris: Librairie des Arts Décoratifs, [1925]. [15] pp., 64 pls. (part col.)
Deals with French Moderne architecture of the 1920s. Has nothing to do with Art Nouveau. Primarily photographs.

1053b. Velde, Henry Van de. *Der neue Stil in Frankreich.* Berlin: Verlag Ernst Wasmuth, 1925. 63 pls. (part col.)
German translation of *Le style moderne* (1053a).

1054. Velde, Henry Van de. *Le Théâtre de l'Exposition du "Werkbund" à Cologne, 1914, et la scène tripartite.* Anvers: J.E. Buschmann, 1925. 24 pp., [18] illus. (incl. plans)
A polemic championing the tri-partite stage as used by the artist in his 1914 Werkbund theater in Cologne and forming part of an ongoing debate with Auguste Perret concerning the latter's 1925 design for a theater.

1055. Velde, Henry Van de. *Vie et mort de la colonne.* [Bruxelles]: Les Editions du Scarabée d'Or, [1942]. 19 pp.
A short history of the column in architecture from classical antiquity until its degeneration in the nineteenth century. Limited edition of 250. Fine printing on parchment in a small size.

1056. Velde, Henry Van de. *Le Voie sacrée*. [Bruxelles?: Les Editions du "Scarabée d'Or"], 1933. 21 pp.
A short personal review by the artist of his career and his esthetic theories. Example of fine printing in sans-serif type and oblong format.

1057. Velde, Henry Van de. *Vom neuen Stil*. Der Laienpredigten, Teil 2. Leipzig: Insel-Verlag, 1907. 101 pp.
Four essays on modern art and its relationship to the past including "Die veränderten Grundlagen des Kunstgewerbes seit der französischen Revolution," "Das Streben nach einem Stil," "Der neue Gedankenfolge für einen Vortrag."

1058a. Velde, Henry Van de. *Zum neuen Stil: aus seinen Schriften*. Ausgewählt und eingeleitet von Hans Curjel. München: Piper, [1955]. 255 pp., 16 illus., bibl.
Twenty-six essays by Van de Velde, selected by Hans Curjel, who also wrote the introduction to the book. Chronologically arranged, and selected to give an idea of the artist's wide-ranging interests.

*1058b. Velde, Henry Van de. *Per il nuovo stile*. A cura di Hans Curjel. I Gabbiani, 36. Milano: Il Saggiatore, 1966. 253 pp.
Italian translation of *Zum neuen Stil* (1058a).

1059. Velde, Henry Van de. "Allgemeine Bemerkungen zu einer Synthese der Kunst." *Pan* 5:261-70 (1899). 2 illus.

1060. Velde, Henry Van de. "Artistic wallpapers." *Art Mod* 13:193-5 (Je 18); 13:202-4 (Je 25, 1893)
An article championing the wallpapers of the English Arts & Crafts movement and its implications for decorative art. Also published in *Emulation*, vol. 18:150-1 (1893). Text in French.

1061. Velde, Henry Van de. "Du paysan en peinture." *Art Mod* 11:60-2 (F 22, 1891)
Extracts from a lecture at the Salon des XX.

1062. Velde, Henry Van de. "Essex & Co's. Westminster wallpapers." *Art Mod* 14:254-5 (Jy 12, 1894). 5 illus.

A favorable review of the English firm's floral wallpaper designs.

1063. Velde, Henry Van de. "Formes." *CHVV* no. 6:17-21 (1966). 1 illus.
French translation of an article appearing in the Swiss journal *Werk* in August, 1949.

1064. Velde, Henry Van de. "Ein Kapitel über Entwurf und Bau moderner Möbel." *Pan* 3:260-4 (1897). 8 illus.
The artist discusses his furniture construction.

1065. Velde, Henry Van de. "Die Kolonial-Ausstellung Tervueren." *Dek K* Jrg. 1 (Bd. 1):38-41 (O 1897). 5 illus.

1066. Velde, Henry Van de. "Der moderne Stil in Frankreich." *Form* no. 7:9-10 (1959)
German translation of a French text (possibly 1053a), in a special issue of the magazine on the 1920s art form.

1067. Velde, Henry Van de. "Das Museum 'Folkwang' in Hagen." *InnDek* 13:249-57 (O); 13:273-7 (N 1902). 52 illus. (pp. 250-92)
Article in two parts on the museum designed by the author. Numerous photographs of the museum and of work by Van de Velde for the Dusseldorf exposition.

1068. Velde, Henry Van de. "Das neue Kunst-Prinzip in der modernen Frauenkleidung." *DKD* 10:363-71 (My 1902). 24 illus. (pp. 364-86)
Jugendstil design in women's dress by Van de Velde and other artists.

1069. Velde, Henry Van de. "Première prédication d'art." *Art Mod* 13:420 (D 31, 1893); 14:20-3 (Ja 21, 1894); 14:27 (Ja 28, 1894)
On the role of art and the artist in contemporary society. Three lectures given in Antwerp.

1070. Velde, Henry Van de. "Pro Domo." *Dek K* Jrg. 10 (Bd. 19): 49-53 (N 1906); or *Kunst* Bd. 16:49-53 (N 1906). 28 illus. (pp. 49-64)

The author's defense of a museum entrance which he designed in Dresden, with murals by Ludwig von Hofmann. Article is followed by photographs of decorative work by Van de Velde.

1071. Velde, Henry Van de. "Variatïen en gevolgtrekkingen." *Van Nu en Straks,* new series 1:60-4 (Ja 1896)
Aphorisms on art. Translated from the French.

1072a. Velde, Henry Van de. "Die veränderten Grundlagen des Kunstgewerbes seit der französischen Revolution." *HW* 4:273-6 (1908)
An extract from his essay "Der neue Stil".

1072b. Velde, Henry Van de. *Der neue Stil: Vortrag gehalten in der Versammlung des Verbandes der Thüringer Gewerbevereine zu Weimar.* Weimar: C. Steinert, 1907. 144 pp.

1072c. Lux, Joseph August. *Der neue Stil* von Henry Van de Velde." *HW* 4:302-4 (1908)
Book review.

1073. Velde, Henry Van de. "Die verstandesmässigen und fol-gerechten Konstruktions-Prinzipien." *InnDek* 13:101-8 (Ap 1902). 35 illus. (pp. 102-28)
Principles for a new architecture, illustrated with examples from the author and from German architects, particularly Rie-merschmid.

1074. Velde, Henry Van de. "De XX." *Van Nu en Straks* 1, no. 2:20-2 (1893?)
Short article in Flemish on the group "Les Vingts".

ALSO SEE (other writings by Van de Velde): 31, 79, 112, 216, 959-60, 962a-b, 1010

A. Van Waesberghe

1075a. *Art Décoratif.* [Photographs.] *Art Dec* 2:209, 214-17 (1899). 10 illus.
Work by a Brussels architect. No text.

1075b. *Dekorative Kunst.* [Photographs.] *Dek K* Jrg. 2 (Bd. 4): 167, 193, 198-201 (1899). 13 illus.
　　No text.

ALSO SEE: 802

Philippe Wolfers

1076. Wolfers, Marcel. *Philippe Wolfers, précurseur de l'Art Nouveau.* Introduction de François Maret. Monographies de l'Art belge. Bruxelles: Editions Meddens, [1965]. 20 pp., 19 pls. (part col.), port., bibl.
　　A short monograph on the artist by his son. Perhaps the chief source of information on Wolfers. Also published in Flemish.

1077. Biermann, Georg. "Schmuckarbeiten von Philippe Wolfers in Brüssel." *Kgwb* N.F. 17:53-6 (1906). 15 illus. (pp. 50-6)

1078. F.K. [i.e. Fernand Khnopff]. "Studio-talk: Brussels." *Studio* 22:285 (My 1901). 3 illus. (pp. 284-5)
　　Jewelry by Wolfers.

1079. F.K. [i.e. Fernand Khnopff]. "Studio-talk: Brussels." *Studio* 25:290ff. (My 1902). 4 illus. (pp. 290, 293)
　　Jewelry.

1080. F.K. [i.e. Fernand Khnopff]. "Studio-talk: Brussels." *Studio* 29:71 (Je 1903). 2 illus.
　　Jewelry.

1081. Pica, Vittorio. "Philippe Wolfers." Artisti contemporanei. *Emp* 27:2-23 (Ja 1908). 22 illus., 1 pl., port.

1082. Pierron, Sander. "Philippe Wolfers." *Rev Arts Dec* 20:153-60 (1900) 11 illus., 1 pl.; 20:225-32 (1900) 9 illus., 1 pl.

ALSO SEE: 382, 797, 801, 828, 909, 1087, 1339, 1350, 1358, 1362

FRANCE (MODERN STYLE *or* STYLE 1900)

In France Art Nouveau is more commonly known as "Style 1900" or "Modern Style," the English name deriving from its foreign origin. "Art Nouveau" itself was the name of a boutique in Paris owned by a German named S. Bing, where the movement had its start in France as an organized effort. The period is known as "La Belle Epoque," the French equivalent of the "Gay Nineties." Little has been published on French Art Nouveau in book form, and many of the existing publications are now-rare, turn-of-the-century folios of photographs and designs. There is, however, a large periodical literature available, most of it from two magazines with almost identical names, *L'Art Décoratif* and *Art et Décoration.* They served as semi-official journals for the movement. Between them they yield hundreds of articles on Art Nouveau, particularly in its French heyday, the period 1897-1903. After that a heavier, less distinctly Art Nouveau form came into being, foreshadowing the Art Deco style of the 1920s. Most of the Art Nouveau designers worked in this new style, and it is often difficult to decide just what is and is not Art Nouveau after 1903.

Some monographs on French Art Nouveau are: Battersby (1083, 1084), Guerrand (1090), Mourey (1095), Waldberg (1099), Emery's architectural guide (1140), Abdy on posters (1157), the Museum of Modern art catalog on Guimard (1592), and Jiri Mucha on his father Alphonse Mucha (1676-9).

French Art Nouveau in general

1083. Battersby, Martin. *Art Nouveau.* [Feltham, Eng.]: P. Hamlyn, [1969]. 40 pp., 7 illus., 54 col. pls.
 Beautiful color photographs of furniture and bric-a-brac with a detailed description of each item. Comprehensive introduction, pp. 7-25.

1084. Battersby, Martin. *The world of Art Nouveau.* London: Arlington; New York: Funk & Wagnalls, [1969, c1968]. 183 pp.,

illus., pls., bibl.

A popular account of Art Nouveau and the fin-de-siècle culture in France. Establishes Loie Fuller's relation to Art Nouveau.

*1085a. Bayard, Jean Emile. *El estilo moderno*. Paris: Garnier Hermanos, 1919. 367 pp.

A Spanish-language edition of the French book (1085b), although published in Paris; this edition cited in most bibliographies.

1085b. Bayard, Jean Emile. *Le Style Moderne*. L'Art de reconnaître les styles. Paris: Garnier, [1919]. 374 pp., 170 illus.

An essay on French Art Nouveau from a strongly French point of view. Poorly written. Illustrations are numerous and unusual, but of poor quality. The Spanish translation is the edition usually cited in bibliographies (1085a).

1086. Caron, Claude. *Le Style 1900*. Marabout Flash. [Verviers, Belgium]: Gerard, [1968]. 154 pp., illus.

A brief and very general introduction to French Art Nouveau listing various types of furniture, crafts, and public works.

1087. *Documents d'atelier: art décoratif moderne*. Bibliothèque de la Revue des Arts Décoratifs, publiée sous la direction de Victor Champier. Paris: Librairie de la Revue des Arts Décoratifs, 1898-99. 2 vols. (each 60 col. pls.)

Mainly illustrations of decorative art, furniture, and some architecture by French artists; also includes work by the Belgian jeweler Ph. Wolfers. Preface by Gustave Larroumet in vol. 1. List of plates at the front of each volume. Many bibliographies give Victor Champier, the editor of the series, as the author of this work.

1088. Escholier, Raymond. *Le Nouveau Paris: la vie artistique de la cité moderne*. Préface de Gustave Geffroy. Ed. rev. et aug. Paris: Nilsson, [190-?]. 260 pp., [138] illus.

A review of the arts in Paris at the end of the nineteenth century. Includes much on Art Nouveau. Contents, pp. 239-41, before the "Conclusion".

1089. Fondation Paul Ricard, Paris. *L'Art et la vie en France à la Belle Epoque.* [Paris]: Bendor, 1971. Unpaged, illus.
Exhibition of 301 items, mostly paintings and sculptures. Divided into three sections, each with a short introductory text. Index of artists at rear of book.

1090. Guerrand, Roger-H. *L'Art Nouveau en Europe.* Précédé de " 'Le Modern Style' d'ou je suis," par Aragon. [Paris]: Plon, [1965]: xxxi, 241 pp., [81] illus.
A general survey of the movement with emphasis on the esthetic orientation of its major figures. The preface by a noted French writer is a personal memoir of the period's art.

1091. *L'Histoire générale de l'art française de la Révolution à nos jours.* Tome 3: L'Art décoratif, par Gabriel Mourey. Paris: Librairie de France, 1925. Illus.
A survey of major French artists and expositions. See pp. 176-267. Many illustrations.

1092. Marx, Roger. *L'Art social.* Paris: Charpentier, 1913. 312 pp.
Essays by a French critic on the social ideals of Art Nouveau. Includes essays on Gallé, Chéret, Lalique, and the Belgian movement.

1093. Marx, Roger. *La Décoration et l'art industriel à l'Exposition Universelle de 1889; conférence faite au congrès de la Société Centrale des Architectes Français...* Paris: Librairies-Imprimeries Réunis, 1890. 60 pp., 30 illus.
Includes work by Gallé, Chéret, and Tiffany.

1094. Mathey, François. "L'Art Nouveau à Paris." *In* Paris. Musée de l'Art Moderne, *Les sources du XX. siècle,* pp. 266-78 (63).

1095. Mourey, Gabriel. *Essai sur l'art décoratif français moderne.* 4. ed. Paris: Ollendorf, 1921. 197 pp., [24] pls.
A plea for a modern decorative art movement in France as well as a defence of Art Nouveau and Art Deco. Chapter 2 on Art Nouveau and pp. 95-105 on S. Bing are particularly relevant.

1096. Rheims, Maurice. *L'Objet 1900.* [Paris]: Arts et Métiers Graphiques, [1964]. 157 pp., 101 col. pls.
 A popularized survey of the French fin de siècle. Beautiful color photographs of both Art Nouveau and kitsch. Illustrations are identified only in the text.

1097a. Vachon, Maurice. *Pour la défense de nos industries d'art: l'instruction artistique des ouvriers en France, en Angleterre, en Allemagne et en Autriche.* Paris: A. Lahine, 1899. 287 pp.
 An official French government survey of art schools, expositions, and craft organizations in Europe, in response to foreign competition in the arts.

1097b. J. "Chronique." *Art Dec* 3:93-6 (N 1899)
 Review of the preceding item.

1098. Vidalenc, Georges. *William Morris.* Paris: F. Alcan, 1920. 166 pp.
 Chapter 6 touches on Morris' influence in France.

*1099a. Waldberg, Patrick. *Eros Modern Style.* Bibliothèque internationale d'érotologie. Paris: J.J. Pauvert, 1964. 237 pp., illus.

1099b. Waldberg, Patrick. *Eros in "La Belle Epoque".* New York: Grove, [1969]. 191 pp., 263 illus., bibl. footnotes
 Translation of the preceding item. An introduction to popular art, Art Nouveau, and erotic art in Paris of the 1890s. Numerous black-and-white illustrations and photographs.

1100. Bouyer, Raymond. *"L'Image." Art & Dec* 3:26-9 (Ja 1898). 7 illus.
 A review of the French art journal *L'Image.*

1101. Charpentier, Fr. Th. "Musée des Arts Décoratifs de Nancy dit de 'L'Ecole de Nancy': nouvelles acquisitions." *Revue du Louvre et des Musées de France* 18:385-92 (1968, no. 6). 6 illus., bibl. footnotes
 Discusses six Art Nouveau additions to the Nancy museum's collection, but not all are from the Nancy school.

1102. H.F. [i.e. Henri Frantz]. "Studio-talk: Paris." *Studio* 30: 258-60 (D 1903). 8 illus. (pp. 257-60)
Includes work by Serrurier-Bovy, Lachenal, and Roche, and bookbindings by Mère and Waldraff.

1103. Genuys, Ch. "A propos de l'Art Nouveau: soyons Français!" *Rev Arts Dec* 17:1-6 (1897)
A French reaction to the foreign origins of Art Nouveau.

1104. Genuys, Ch. "Avant-propos: l'orientation de l'art moderne." *Rev Arts Dec* 21:1-5 (Ja 1901)

1105. Jacques, G.M., [i.e. J. Meier-Graefe]. "L'Art appliqué et l'architecture aux salons." *Art Dec* 2:99-102 (Je 1899). 27 illus. (pp. 112-19)
Various aspects of French Art Nouveau.

1106. Melville, Robert. "Popular Art Nouveau." *Arch Rev* 136: 353-6 (N 1964). 11 illus.
A review of the exhibition of the Martin Battersby collection at the Brighton Museum.

1107. G.M. [i.e. Gabriel Mourey]. "Studio-talk: Paris." *Studio* 17:190-2 (Ag 1899). 11 illus. (pp. 191-6)
Recent French work.

1108. Saunier, Charles. "Origines du mouvement actuel." L'ornement qui passe. *Plume* no. 288:233-5 (Ap 15, 1901)

1109. "Studio-talk: Paris." *Studio* 14:138-43 (Jy 1898). 4 illus.
Includes notices on Gallé, Delaherche, and Plumet & Selmersheim.

1110. Uhry, Edmond. "Au Salon de l'Automobile." *Art Dec* 15: 77-80 (F 1906). 4 illus.
Art Nouveau exhibition stands at the Automobile show.

1111. Vaizey, Marina. "Robert Walker collection, part 1." *Conss* 178:16-26 (Se 1971). 18 illus. (part col.) bibl. footnotes
A private collection of Art Nouveau, primarily French, and in-

cluding work by Gallé and Guimard. Part 2 was evidently never published.

1112. Weyl, Fernand. "Reflections." *Art Dec* 1:1-4 (O 1899)
The dangers of excess in French Art Nouveau.

ALSO SEE: 12, 15, 40a, 42, 118, 145

Paris. Exposition Universelle, 1900—French exhibits

1113. Folnesics, Custos J. "Das französische Interieur auf der Pariser Weltausstellung." *Intr* 1:145-7, 150-2 (O 1900)
A favorable review of the French exhibits at the fair.

1114. Gallé, Emile. "Le Pavillion de l'Union Centrale des Arts Décoratifs à l'Exposition Universelle." *Rev Arts Dec* 20:217-24 (1900). 7 illus.
The artist's impression of a part of the 1900 fair.

1115. Genuys, Ch. "Exposition Universelle de 1900: les essais d'art moderne dans la décoration intérieure." *Rev Arts Dec* 20: 252-6 (1900). 5 illus., 1 pl.; 20:285-90 (1900). 8 illus.
In two parts. The second part includes furniture by Gallé, Guimard, and Olbrich.

1116. Jourdain, Frantz. "En vue de l'Exposition de 1900: le 2ème concours ouvert par l'Union Centrale des Arts Décoratifs." *Rev Arts Dec* 19:114-21 (1899). 8 illus.
Competitions for the 1900 fair.

1117. Ternisien: …"Le troisième concours ouvert par l'Union Centrale des Arts Décoratifs; rapport du secrétaire." *Rev Arts Dec* 20:149-52 (1900). 4 illus.

1118. Thomas, Albert. "La peinture décorative à l'Exposition." *Art Dec* 5:45-55 (N 1900). 11 illus., 2 pls. (pp. 46-53)
Includes work by Aubert, P.M. Ruty, and Chéret.

ALSO SEE: 149y, 1113-18, 1183, 1263, 1286, 1305, 1311-12, 1317, 1323, 1346, 1365, 1378, 1388, 1436, 1438-40, 1444-7, 1450, 1522, 1630, 1660

Nancy school (Ecole de Nancy)

Nancy, the provincial capital of Lorraine, was the second center of Art Nouveau in France after Paris. The Ecole de Nancy was only formally organized in 1900 after a long, formative period. Emile Gallé was the recognized leader and most important figure of this school, which included Majorelle, Daum Frères, Lachenal, Victor Prouvé, and the architect Emile André. Nancy was also an important early center for bookbinding. Only general articles on Nancy are listed below. Further articles will be found under the names of the individual artists. Also see the note for Emile Gallé.

1119. Charpentier, Thérèse. "L'Ecole de Nancy." *In* Paris. Musée de l'Art Moderne, *Les sources du XX. siècle*, p. 269 (63).

1120. Hallays, André. *Nancy.* 3. ed., rev. Les Villes d'art célèbres. Paris: H. Laurens, 1920. 105 pp., 64 pls., bibl.
 A general history of art in the city. For Art Nouveau see pp. 98-102, pls. 60-4.

1121. Belville, Eugène. "Daum, Lachenal, Majorelle à la Galerie Georges Petit." *Art Dec* 11:33-40 (Ja 1904). 12 illus.

1122. Champier, Victor. "Les Cadeaux offerts à l'escadre russe." *Rev Arts Dec* 14:129-35 (1893-94). 4 illus.
 Official gifts from the Lorraine region to the Russian fleet. Work of Gallé et al.

1123. Charpentier, Françoise-Thérèse. "L'Ecole de Nancy et le renouveau de l'art décoratif en France." *Medecine de France* no. 154:17-32 (Jy 1964). 40 illus.
 A review of Art Nouveau activity in Nancy with strong emphasis on Gallé.

1124. Duret-Robert, François. "Art 1900, l'Ecole de Nancy, 1: meubles et sièges." Encyclopédie CdA, Ecole de Nancy, leaves [1, 2]. *Cons des Arts* no. 223:101-4, 130 (Se 1970). 24 illus.
 A revue of work by Nancy furniture makers, including Gallé and Majorelle. Illustrations are very small, primarily black-and-white photographs.

1125. Einvaux, Roger C. d'. "L'Exposition d'art décoratif lorrain à Nancy." *Art Dec* 13:97-104 (F 1905). 10 illus.
 Includes work by Gallé, Majorelle, and Daum Frères.

1126. Frantz, Henri. "Emile Gallé and the decorative artists of Nancy." *Studio* 28:108-17 (Mr 1903). 12 illus., 1 col. pl.
 Description of Gallé's glasswork in the historical context of the Nancy school.

*1127. Hofmann, H.D. "Nancy, ein Zentrum des Jugendstils (Art Nouveau)." *Saarbrücker Hefte* 24:67-77 (1966)

1128. "Die Krystallkünstler Nancys." *Dek K* Jrg. 2 (Bd. 3):100-2 (D 1898). 8 illus. (pp. 126-30), 2 col. pls. (facing pp. 128, 136)
 Glass by Gallé and Daum Frères.

1129. Leroy, Maxime. "L'Ecole de Nancy au Pavillon de Marsan." *Art Dec* 9:176-82 (My 1903). 8 illus.
 Includes work by Majorelle, Gallé, and Daum Frères.

1130. Metken, Günter. "L'Ecole de Nancy." *Kwk* vol. 18, no. 5: 19-20 (N 1964). 4 illus. (pp. 21-2)
 Introductory article in German.

1131. E.N. "Studio-talk: Nancy." *Studio* 35:161-5 (Jy 1905). 3 illus.
 News on the Nancy school.

1132. Nicolas, Emile. "L'Ecole de Nancy et ses concours." *Art Dec* 16:191-4 (N 1906). 9 illus.
 Competitions of the Nancy art group.

1133. Nicolas, Emile. "Un Grand Magasin moderne." *Art Dec* 21: 143-53 (Ap 1909). 13 illus.
 Nancy department store by Weissenburger, architect. Majorelle did some of the interiors.

1134. *La Plume.* [Special issue on Lorraine and the Ecole de Nancy.] *Plume* no. 157:481-502 (N 1, 1895). Illus.
 Includes article by Ténib (1138).

1135. Rais, Jules. "L'Ecole de Nancy et son exposition au Musée des Arts Décoratifs." *Art & Dec* 13:129-38 (Ap 1903). 12 illus., plan
 Parisian exhibition of work by the Nancy school.

1136. Saunier, Charles. "L'Exposition lorraine à l'Union Centrale des Arts Décoratifs." *Plume* no. 336:465-8 (Ap 15, 1903)
 Paris exhibition of Gallé and the Nancy school.

1137. Smalldon, John. "Art Nouveau at Nancy." Special collections, 2. *Arts Review* 23:407 (Jy 3, 1971). 1 illus.
 Short review of the Nancy school and a visit to the Musée de l'Ecole de Nancy.

1138. Ténib, Charles. "Le Nouvel Art décoratif et l'Ecole lorrain." *Plume* no. 157:481-6 (N 1, 1895). Illus.
 Emile Gallé and artists of the Nancy school.

ALSO SEE: 361, 1144, 1187, 1337, 1372, 1394, 1547, 1587. Also see the Index

Architecture in France

1139. Basdevant, Denise. *L'Architecture française des origines à nos jours...* Bibliothèque des guides bleus. [Paris]: Hachette, [1971]. 414 pp., 374 illus., 24 pls., bibl.
 For Art Nouveau see "La Genèse de l'architecture moderne," by Gérald Gassiot-Talabot and Marc Gaillard, pp. 296-304 (illus. 237-42, pl. 21).

1140. Emery, Marc. *Un Siècle d'architecture moderne en France, 1850-1950.* [Paris]: Horizons de France, [1971]. 145 pp., illus., bibl.
 Directory of modern buildings in France, arranged alphabetically by architect, with locational maps of sites for Paris and Nancy. See André, Garnier, Guimard, and Perret, among others.

1141. Hennig-Schefold, Monica. *Struktur und Dekoration: Architekturtendenzen in Paris und Brüssel im späten 19. Jahrhundert.* [Winterthur: Werk-Verlag, 1969]. 95 pp., 147 illus., bibl.

Chiefly about metal construction in French and Belgian Art Nouveau architecture. Includes Horta and Guimard. Primarily photographs.

*1142. Lambert, Théodore. *Nouvelles constructions: maisons de rapport; plans, façades, coupes (loggias, bow-window, avant-corps).* Dessinées et rélévés de Th. Lambert. *His* Nouveau éléments d'architecture, 4e séries. Paris: C. Schmid, [1901]. 2 leaves, 48 pp., folio

1143. Lambert, Théodore. *Nouvelles constructions avec bow-window, loggias, tourelles, avant-corps.* Rélévés et dessinées par Th. Lambert... *His* Nouveaux éléments d'architecture, 2e séries. Paris: C. Schmid, [1899]. 2 pp., 48 pls., folio

1144. Charpentier, Thérèse. "L'Architecture '1900' et le milieu nancéien." *IHA* 5:138-46 (N-D 1960). 5 illus., bibl. footnotes
Art Nouveau architecture in Nancy.

1145. Chastel, André & Gloton Jean Jacques. "L'Architecture en France autour de 1900." *IHA* 3:128-41 (N-D 1958). 4 illus., bibl. footnotes

1146. Choay, Françoise. "Techniciens et architectes autour de 1900." *Art Fr* 3:311-20 (1963). 16 illus., bibl. footnotes

1147. Desbruères, Michel. "Maisons 1900 de Paris." *Bizarre* (Paris) 27:2-35 (1963). 43 illus.
On the Castel Béranger of Guimard and buildings by Jules Lavirotte and Charles Klein.

1148. Gardelle, Camille. "Moderne Kunst in der französischen Architektur: das Pariser Haus." *Dek K* 1:177-84 (Ja 1898). 7 illus. Includes work by Charles Plumet and A. de Baudot. Pt. 2, "Der Architekt Louis Bonnier," pp. 215-21 (F 1898), with 11 illus.

1149. Hennig-Schefold, Monica. "Eisen-Glas-Architektur und Jugendstil in Paris." *Werk* 54:205-10 (Ap 1967). 13 illus.
Article covers part of the author's book (1141). French and English summaries at front of April issue (blue pages).

1150. Jourdain, Frantz. "L'Architecture aux salons de 1902."
Art & Dec 11:188-96 (Je 1902). 9 illus., plan
Includes Majorelle's house in Nancy by Henri Sauvage.

1151. Magne, L. "L'Architecture moderne." *Art Dec* 3:45-53
(F 1898). 12 illus.; 3:73-80 (Mr 1898). 10 illus.
Part 1 includes Labrouste and Viollet-Le-Duc.

1152. Schopfer, Jean. "A new French method of cement con-
struction." *Arch Rec* 12:270-8 (Ag 1902). 6 illus.; 12:375-9 (Se
1902). 10 illus.

ALSO SEE: 243, 1377, 1471-2, 1589-1620 (Guimard), 1623, 1651-2, 1698,
1700-1, 1704, 1706, 1712, 1714, 1718, 1733, 1741, 1742ff. (Sauvage),
1752-6, 1790

Sculpture in France

1153. Anet, Claude. "Loïe Fuller in French sculpture." *Arch
Rec* 13:270-8 (Mr 1903). 7 illus.
Primarily illustrations.

1154. Magne, Lucien. "Concours de sculpture donné par la Ré-
union des Fabricants de Bronze." *Art & Dec* 15:34-6 (Ja 1903).
5 illus.

1155. Musey-Grévin [i.e. J. Meier-Graefe?]. "A travers la sculp-
ture." *Art Dec* 5:249-53 (Mr 1901). 7 illus.
Includes the *Jeu de l'écharpe* by A. Léonard, manufactured at
the Servrès works.

1156. Thomas, Albert. "Petits bronzes d'art." *Art Dec* 5:181-9
(F 1901). 14 illus., 2 pls.
Art Nouveau figurines.

ALSO SEE: 1427, 1458, 1467, 1667, 1734-40 (Roche)

Posters in France

1157. Abdy, Jane. *The French poster: Chéret to Capiello.* Lon-

don: Studio Vista; [New York]: Potter, [1969]. 176 pp., illus.,
bibl.
 Chiefly illustrations, some in color. Short general text on French
 Art Nouveau posters in the context of their social environment.

1158. Berlin. Staatliche Museen. *Französischen Plakate des*
19. Jahrhunderts in der Kunstbibliothek Berlin. Berlin: Gebr.
Mann Verlag, [1968]. 44 pp., 32 pls., 7 loose posters, bibl.
 Text in German by Christina Thon. Exclusively on the French
 Art Nouveau poster. Good bibliography, pp. 42-4.

1159. Galerie Wolfgang Ketterer, München. *2. Auktion, Sonder-*
katalog: Jugendstil, Exlibris, Plakate. München, [1969]. 23 pp.,
illus.
 Auction catalog, mainly of French posters.

1160. Laver, James. *XIXth century French posters.* Preface by
Henry Davray. London: Nicholson & Watson, [1944]. vi, 18 pp.,
4 col. pls., 21 pls.
 Text by Davray, "When Paris streets sang and danced."

*1161a. Maindron, Ernest. *Les Affiches illustrées.* Ouvrage orné
de 20 chromolithographies par Jules Chéret et de nombreuses re-
productions en noir et en couleur d'après les documents originaux.
Paris: H. Laurette, 1886. x, 100 pp., illus., pls. (part col.)

1161b. Maindron, Ernest. "Les Affiches illustrées." *GBA* sér. 2,
vol. 30:419-33 (N 1884); 30:535-47 (D 1884). 12 illus., 2 col. pls.
 Historical background of the French poster. Emphasis on Ché-
 ret. Reprinted in book form in 1886 (1161a).

1162. Maindron, Ernest. *"Les Affiches illustrées (1886-1895).*
Paris: G. Baudet, 1896. 251 pp., 102 illus. (part col.), 64 col. pls.
 A comprehensive monograph on French posters of the period
 with emphasis on Chéret and only incidental mention of Mucha.
 Limited edition of 1,025 copies. Copiously illustrated. Catalog
 of Chéret's poster work, pp. 193-242 (882 items). Contents to
 this catalog, pp. 243-4. Indexes to illustrations and texts, pp.
 243-51.

1163. Paris. Bibliothèque des Arts Décoratifs. *Cent ans d'affiches: "La Belle Epoque"*. Paris, 1964. 98 pp., [109] illus., bibl.

Catalog of an exhibition of 369 posters held in a section of the Louvre to celebrate the hundredth anniversary of the UCAD (Union Centrale des Arts Décoratifs). Black-and-white photographs. Index of artists, p. 97ff.

*1164a. Schardt, Hermann, ed. *Paris 1900: Französische Plakatkunst; 72 farbige Handlithographien aus der Sammlung der Folkwangschule...* [Stuttgart]: C. Belser, [1968]. 184 pp., 72 col. pls.

Same format as the English-language edition (1164b). Cataloged by Library of Congress under: Essen. Folkwangschule für Gestaltung.

1164b. Schardt, Hermann, ed. *Paris 1900: masterworks of French poster art*. London: Thames & Hudson; New York: Putnam, [1970]. 184 pp. (incl. 72 col. pls.)

Short introductory text and large, beautifully reproduced color plates of French posters from the collection of the Folkwangschule für Gestaltung in Essen. Emphasis on Chéret. Artist's biographies pp. 180-2. Cataloged by Library of Congress under: Essen. Folkwangschule für Gestaltung.

1165. Smithsonian Institution. Traveling Exhibition Service. *The avant-garde in theatre and art: French playbills of the 1890s*. Washington, D.C., [1972]. 32 pp., [31] illus., bibl.

Exhibition catalog of seventy-six playbills with biographies of the artists, pp. 13-29. Introduction by Alan M. Fern, pp. 1-2. Essay, "The Avant-Garde in theatre and art," by Daryl R. Rubenstein, pp. 3-12. The artwork is primarily by Nabi artists for the Theatre Libre, the Theatre de l'Oeuvre, and the Theatre Antoine and has little to do with Art Nouveau.

1166. "Affiches illustrées." *Art Mod* 11:302-3 (Se 20, 1891)

1167. "Album trimestriel illustré des affiches et estampes...La Plume." *Plume* 12:112ff. (separately numbered pp. 1-32) (1900)

Thirty-two pages of posters sold by the magazine.

1168. Bouchot, Henry. "Propos sur l'affiche." *Art & Dec* 3:115-

20 (Ap 1898). 10 illus. (pp. 121-2)
 French poster art.

1169. Goldwater, Robert J. " 'L'Affiche moderne': a revival of poster art after 1880." *GBA* sér. 6, vol. 22:173-82 (D 1942). 11 illus.
 Traces the development of the modern poster in France, notably with Chéret and Grasset.

1170. Grasset, E. "Concours pour une affiche." *Art & Dec* 23: 206-8 (Je 1908). 7 illus.
 Competition for a poster for the sponsoring magazine.

1171. Hiatt, Charles T.J. "The collecting of posters: a new field for connoisseurs." *Studio* 1:61-4 (1893). 5 illus.
 The work of Chéret and other French poster artists.

1172. L.M. [i.e. Léon Maillard]. "Les Affiches illustrées." *Plume* no. 162:43-51 (Ja 15, 1896). 13 illus. (pp. 43-53)

1173. Mourey, Gabriel. "Some French illustrated theatre programmes." *Studio* 10:237-43 (My 1897). 10 illus.
 Designs by French poster artists.

1174. Pica, Vittorio. "Attraverso gli albi e le cartelle, 4: i cartelloni illustrate in Francia." Sensazioni d'arte. *Emp* 4:371-90 (N 1896). 51 illus.
 See item 289 for other articles in same series.

1175. Soulier, Gustave. "Nos concours: une affiche pour *L'Art et Décoration.*" *Art & Dec* 5:58-64 (F 1899). 14 illus.

1176. Verneuil, M.P. "Quelques affiches." *Art & Dec* 20:164-72 (N 1906). 11 illus.
 Posters by French artists.

ALSO SEE: 253, 257, 264, 273, 1473-8 (Chéret), 1588, 1673-95 (Mucha), 1768-80 (Toulouse-Lautrec)

Painting in France

*1177a. Chassé, Charles. *Les Nabis et leur temps.* Lausanne: La Bibliothèque des Arts, [1960]. 186 pp., 54 pls. (part col.), bibl.

1177b. Chassé, Charles. *The Nabis and their period.* New York: Praeger; London: Lund Humphries, [1969]. 136 pp., 54 pls. (part col.), bibl.
 Comprehensive monograph on the post-impressionist school, sometimes considered Art Nouveau, whose membership included Maurice Denis. Biographies, pp. 121-4. Bibliographies, pp. 125-30, which also list exhibitions. This English translation is updated from the original French edition (1177a).

*1178a. Jullian, Philippe. *Esthètes et magiciens: l'art fin-de-siècle.* Paris: Perrin, [1969]. 347 pp., illus.

1178b. Jullian, Philippe. "Nostalgies fin de siècle." *GBA* 74:161-74 (Se 1969). 13 illus.
 An excerpt from the author's *Esthètes et magiciens* (1178a) on Symbolist painting. English summary, p. 174.

1178c. Jullian, Philippe. *Dreamers of decadence: Symbolist painters of the 1890s.* London: Pall Mall; New York: Praeger, [1971]. 272 pp., 149 illus. (incl. plates)
 A study of Art Nouveau and other Symbolist schools of painting in relationship to the wider cultural milieu of the 1890s. Translation of the author's *Esthètes et magiciens* (1178a).

1179. *Das Kunstwerk: eine Zeitschrift über alle Gebiete der bildenden Kunst.* "Um die Jahrhundertwende." Jrg. 6, Heft 3 (entire issue). 1952. 61 pp., illus.
 Special issue on French painting of 1900, but not specifically on Art Nouveau. Article on Toulouse-Lautrec, "Die Muse des fin de siècle und ihr Porträtist," by Leopold Zahn. Also includes articles on Edouard Vuillard, Paul Serusier, and Berthe Morisot.

1180. Rookmaaker, Henderik Roelof. *Synthetist art theories: genesis and nature of the ideas on art of Gauguin and his circle.* Amsterdam: Swets & Zeitlinger, 1959. xi, 284 pp., bibl., bibl. footnotes

Art theories in late nineteenth-century France, including Symbolism and Synthetism. A 78-page booklet of notes and translations for use with this book has also been published. Not directly concerned with Art Nouveau.

1181. Bacou, Roseline. "Décors d'appartements au temps des Nabis." *Art Fr* 4:190-205 (1964). 8 illus., 3 col. pls., bibl. footnotes

1182. Rambosson, Ivanhoe. "Hohe und angewandte Kunst in den Pariser Salons." *DKD* 13:97-107 (N 1903). 15 illus.
 Mostly paintings, but also includes furniture designed by E. Gaillard and others.

ALSO SEE: 299, 1429-31

Decorative art in France (General)

1183. Geffroy, Gustave. *Les Industries artistiques françaises et étrangères à l'Exposition Universelle de 1900.* Paris: Librairie Centrale des Beaux-Arts, [1902]. [63] pp., [33] illus., 100 pls. (part col.)
 Folio of one hundred loose plates of beautiful photographs with text, pp. 1-55, by Geffroy, in unbound gatherings. Emphasis is heavily on France. Lists of textual matter, plates, and illustrations, pp. [57-63] (between the text and the plates). Plates show many unusual examples of Art Nouveau and other contemporary design, including furniture, decorative art, interiors, and jewelry. Originally issued in ten fascicules, 1900-02.

1184. Belville, Eugène. "Le Cuir ciselé et repoussé à la main." *Art & Dec* 10:183-90 (1901). 14 illus.
 Art Nouveau designs for hand-tooled leather.

1185. Belville, Eugène. "Les Objets d'art au Salon (Société Nationale)." *Art Dec* 13:242-54 (Je 1905). 23 illus.

1186. Belville, Eugène. "La Société des Artistes Décorateurs au Pavillon du Marsan." *Art Dec* 19:1-16 (Ja 1908). 22 illus.
 Late Art Nouveau decorative arts. Includes work by Eugène Gaillard.

1187. Bousquet, Ch. du. "Le Salon des arts décoratifs français à l'Exposition de Bruxelles." *Art Dec* 23:121-44 (Ap 1910). 35 illus.
Very late Art Nouveau design. Exhibitors include Th. Lambert, P. Selmersheim, Ecole de Nancy, Follot, and Dufrène.

1188. Bramson, J. "Papiers peints." *Art Dec* 9:90-7 (Mr 1903). 13 illus.
Art Nouveau and floral motif wallpapers.

1189. Champier, Victor. "Les Arts fraternels au Salon du Champ-de-Mars." *Rev Arts Dec* 12:5-16 (1891-92). 7 illus.

1190. Couty, Edmé. "La Marqueterie." *Art & Dec* 4:104-15 (O 1898). 10 illus.
Wood panelling. Includes work by Majorelle.

1191. "Decorative art in the Salon du Champs de Mars." *Studio* 11:36-47 (Je 1897). 11 illus.
Generally negative review of a French Art Nouveau salon, with praise for some artists.

1192. "Eclairage éléctrique." *Art Dec* 9:78-80 (F 1903). 5 illus.
Electric lamps.

1193. Félice, R. de. "L'Art appliqué au Salon d'Automne." *Art Dec* 10:233-40 (D 1903). 12 illus.

1194. Félice, Roger de. "L'Art appliqué au Salon d'Automne." *Art Dec* 12:213-21 (D 1904). 13 illus.

1195. Félice, Roger de. "L'Art appliqué au Salon d'Automne." *Art Dec* 16:177-85 (N 1906). 8 illus.

1196. Félice, Roger de. "L'Art appliqué aux salons." *Art Dec* 17:161-86 (My 1907). 32 illus., 1 pl.

1197. Félice, Roger de. "L'Art décoratif au Salon (Société Nationale)." *Art Dec* 15:217-24 (Je 1906). 14 illus.; 16:33-40 (Jy 1906). 13 illus.

1198. Félice, Roger de. "Les Arts appliqués au Salon d'Automne."
Art Dec 14:209-19 (D 1905). Illus.

1199. Félice, R. de. "La Société des Artistes Décorateurs: deuxi-
ème exposition." *Art Dec* 16:201-12 (D 1906). 14 illus., 3 pls.
 Includes work of E. Gaillard, Majorelle, and Landry.

1200. Fourcaud, L. de. "Les Arts décoratifs au Salon de 1899."
Rev Arts Dec 19:161-72; 19:247-57; 19:291-300; 19:321-34
(1899). Illus., pls.
 Represents parts 1, 3, 4, and 5 in a series of articles. Numerous
 illustrations.

1201. Fourcaud, L. de. "Les Arts décoratifs aux salons." *Rev
Arts Dec* 14:1-19 (1893-94). Illus., pls.
 Part 7, exhibition at the Champs-de-Mars. Comprehensive sur-
 vey of French decorative arts. Includes the Nancy artists.

1202. Fourcaud, L. de. "Les Arts décoratifs aux salons." *Rev
Arts Dec* 14:340-51; 14:377-86 (1893-94). Illus., pls.
 Parts 1-2, Le Champs-de-Mars, parts 3-6, Le Palais de l'Indus-
 trie.

1203. Fourcaud, L. de. "Les Arts décoratifs aux Salons de 1894."
Rev Arts Dec 15:1-17 (1894). Illus., 4 pls.
 Third article (parts 4, 5). Includes work by Gallé, Lachenal,
 and Dammouse.

1204. Fourcaud, L. de. "Les Arts décoratifs aux salons de 1895."
Rev Arts Dec 15:356-64; 15:385-98; 15:417-28; 15:455-68 (1895).
Illus., pls.
 Parts 1-3, Le Champs-de-Mars. Part 4, Le Palais de l'Industrie.
 Includes the work of many French Art Nouveau artists.

1205. Fourcaud, L. de. "Les Arts décoratifs aux salons de 1897."
Rev Arts Dec 17:289-97 (1897). 7 illus., 1 pl.
 Part 5, Le Champs-de-Mars (1. "Les Arts d'architecture", p.
 290ff.). Work by Art Nouveau artists. Part 6 (2. "Les Arts in-
 times", pp. 339-50, 16 illus., 2 pls.), includes ceramics and book-
 bindings by Art Nouveau artists.

1206. Fourcaud, L. de. "Les Arts décoratifs aux salons de 1898."
Rev Arts Dec 18:129-43; 18:161-71; 18:197-203; 18:232-49
(1898). 58 pls. (scattered through the texts)
Includes many Art Nouveau objets d'art.

1207. "Die Französischen Gewerbekünste auf der Turiner Aus-
stellung." *DKD* 11:169-71 (Ja 1903). 24 illus. (pp. 169-80)

1208. G. "Korrespondenzen: Paris." *Dek K* Jrg. 3 (Bd. 5):126
(D 1899); or *Kunst* Bd. 2:126 (D 1899). 23 illus. (pp. 104-8; 120-1)
Work of Colonna and Prouvé. Also wallpapers designed by A.
Morisset.

1209. Genuys, Ch. "L'Exposition de la Société des Artistes Dé-
corateurs." *Art & Dec* 15:78-92 (Mr 1904). 23 illus.
Art Nouveau decorative work by young artists.

1210. Jacques, G.M. [i.e. J. Meier-Graefe?]. "Les Arts décoratifs."
Art Dec 6:91-3 (Je 1901)
The situation in the decorative arts at the 1900 Exposition and
the salons of 1901.

1211. Jacques, G.M. [i.e. J. Meier-Graefe?]. "Les Objets d'art
aux salons de 1902: 2. Société des Artistes Français." *Art Dec* 8:
144-54 (Jy 1902). 21 illus.
Includes jewelry by Lalique and other French artists.

1212. Jacques, G.M. [i.e. J. Meier-Graefe?]. "Les Objets d'art
aux salons." *Art Dec* 8:209-17 (Ag 1902). 15 illus.
Part 3, dealing with decorative arts at the 1902 salons. Includes
jewelry by Lucien Gaillard.

1213. Jacquot, Albert. "La Décoration des instruments de musi-
que de 1800 à 1899 à l'Exposition de 1900." *Rev Arts Dec* 22:
202-13 (1902). 6 illus.
See p. 208ff. for material on Art Nouveau.

1214. Kahn, Gustave. "Les Objets d'art aux salons." *Art & Dec*
12:24-32 (Jy 1902). 14 illus.; 12:58-64 (1902). 16 illus.; 12:117-
27 (1902). 22 illus.

1215. Karageorgevitch, Prince B. "Les Objets d'art au Salon
(Artistes Français)." *Art Dec* 9:219-24 (Je 1903). 8 illus., 1 pl.;
10:28-33 (Jy 1903). 8 illus.
 Includes jewelry by Lalique and L. Gaillard.

1216. Karageorgevitch, Prince B. "Les Objets d'art au Salon des
Artistes Français." *Art Dec* 16:11-22 (Jy 1906). 24 illus., 1 pl.

1217. Levin, Julius. "Vom Pariser Salon 1899." *Dek K* Jrg. 2
(Bd. 4):92-6 (Je 1899). 43 illus. (pp. 113-27), 1 col. pl. (facing p.
92)
 Primarily French sculpture, decorative arts, and furniture.

1218. Marx, Roger. "La Décoration architecturale et les indus-
tries d'art à l'Exposition Universelle de 1889: conference... au
Congrès des Architectes le mardi 17 juin 1890." *Rev Arts Dec* 10:
372-8 (1889-90); 11:32-41 (1890-91). Illus.
 Includes commentary on Gallé and Tiffany.

1219a. Marx, Roger. *Essais de rénovation ornementale... une
villa moderne: la salle de billard.* [Paris]: Gazette des Beaux-Arts,
1902. 32 pp., pls.
 Folio book reprint of an article appearing in *Art et Décoration*
(1219b).

1219b. Marx, Roger. "Une Salle de billard et une gallerie modernes.
(Salon de la Société Nationale)." *Art & Dec* 12:1-13 (Jy 1902).
15 illus., 2 pls.
 Two interiors. Work by Bracquemond, Charpentier, and Chéret.

1220. Marx, Roger. "Les Maitres décorateurs français." *Art &
Dec* 6:13-22 (Jy 1899). 15 illus.

1221. Mockel, Albert. "Le Salon Français des Industries d'Art
Moderne à l'Exposition de Liège." *Art & Dec* 18:105-14 (O 1905).
16 illus., 1 col. pl.
 A disappointing French exhibit at the 1905 Liège fair.

1222. Musey-Grévin [i.e. J. Meier-Graefe?]. "Un Peu de tout."
Art Dec 7:76-9 (N 1901). 8 illus. (pp. 76-80)

Includes jewelry by P. Cuzin and wallpaper designs by E. Belville and J. Lewis Day.

1223. Musey-Grévin [i.e. J. Meier-Graefe?]. "Un Peu de tout." *Art Dec* 7:122-4 (D 1901). 8 illus.
Jewelry by Falquières and decorative work by Dufrène.

1224. "Our home department: French new art lace." *Cfm* 10: 129-33 (Ap 1906). 6 illus.

1225. "Die Pariser Salons." *Dek K* Jrg. 1, Heft 9 (Bd. 2):110-14 (Je 1898). Illus.

1226. Riotor, Léon. "L'Hygiène et l'habitation: a propos de l'Exposition du Grand Palais." *Art Dec* 12:236-40 (D 1904). 6 illus.
An exhibit of decorative art, in spite of the title.

1227. Riotor, Léon. "Les Objets d'art au Salon (Artistes Français)." *Art Dec* 13:280-8 (Je 1905). 18 illus., 1 pl.

1228. Riotor, Léon. "Les Objets d'art au Salon (Société des Artistes Français)." *Art Dec* 12:15-27 (Jy 1904). 27 illus., 1 pl.
Includes jewelry by the major designers.

1229. Riotor, Léon. "Les Objets d'art au Salon des Artistes Décorateurs." *Art Dec* 11:99-105 (Mr 1904). 15 illus.

1230. Riotor, Léon. "La Société d'Art Décoratif." *Art Dec* 15: 9-15 (Ja 1906). 11 illus.

1231. Sargent, Irene. "A minor French salon." *Cfm* 4:450-9 (Se 1903). 13 illus.
A review of Verneuil's review of a French exhibit in the July 1903 issue of *Art et Décoration* (1255?). Illustrated with examples of French jewelry.

1232. Saunier, Charles. "L'Art décoratif aux salons." *Plume* no. 340:674-82 (Je 15, 1903)

1233a. Saunier, Charles. "Les Arts décoratifs aux salons de 1902."

Rev Arts Dec 22:129-31; 22:161-8; 22:193-201 (1902). 7 illus.
Notably "Les Objets d'art," pp. 196ff.

1233b. Saunier, Charles. "Les Arts décoratifs aux salons de 1902."
Plume no. 318:833-9 (Jy 15, 1902). 7 illus. facing p. 833.

1234. Saunier, Charles. "L'Exposition des Artistes Décorateurs
au Pavillon du Marsan." *Art & Dec* 20:187-212 (D 1906). 39 illus.
Furniture and decorative art, including work by Majorelle and
Dufrène.

1235. Saunier, Charles. "Le Musée de l'Union Centrale des Arts
Décoratifs au Pavillon de Marsan." *Plume* no. 317:803-4 (Jy 1,
1902)

1236. Scheffler, Karl. "Korrespondenzen-Berlin." *Dek K* Jrg. 2
(Bd. 4):134-5 (Jy 1899). 5 illus. (pp. 148-9)
French decorative art at Keller & Reiner gallery, Berlin.

1237. Schmidt, Karl Eugen. "Das Kunstgewerbe in den Pariser
Salons." *Kgwb* N.F. 12:227-32 (1901)

1238. Schopfer, Jean. "The silversmith's art in contemporary
France." *Cfm* 4:433-57 (F 1904). 59 illus.
Late nineteenth-century work, terminating in Art Nouveau de-
sign.

1239. Sedeyn, Emile. "A travers les expositions." *Art Dec* 9:51-
9 (F 1903). 16 illus., 1 pl.
Paintings and Art Nouveau jewelry.

1240. Sedeyn, Emile. "Les Arts décoratifs aux salons de 1902,
1:Société Nationale des Beaux-Arts." *Art Dec* 8:105-17 (Je 1902).
26 illus.
Work by leading Art Nouveau artists.

1241. Sedeyn, Emile. "Les Objets d'art au Salon (Société Na-
tionale)." *Art Dec* 11:217-28 (Je 1904). 24 illus.; 12:35-40 (Jy
1904). 13 illus.

1242. "La Serrurerie." *Art Dec* 8:369-73 (D 1902). 11 illus.
Door handles and hardware designed by Xavier Schoellkopf
and other artists.

1243. Soulier, Gustave. "Les Objets d'art des salons." *Art & Dec*
6:1-12 (Jy 1899). 25 illus.

1244. G.S. [i.e. Gustave Soulier]. "Les Poignées de cannes." *Art
& Dec* 10:87-91 (1901). 9 illus.
Art Nouveau decorations for cane handles.

1245. Soulier, Gustave. "Le Salon." *Art & Dec* 7:170-8 (1900).
11 illus.
Decorative arts and furniture.

1246. Soulier, Gustave. "Les Travaux de l'Ecole des Arts Décora-
tifs." *Art & Dec* 6:115-20 (O 1898). 10 illus.

1247. Testard, Maurice. "Le 5. Salon, Société des Artistes Décora-
teurs." *Art Dec* 23:81-96 (Mr 1910). 20 illus.
Includes late furniture by Majorelle.

1248. Thiébault-Sisson. "L'Art décoratif aux salons: ou en est le
nouveau style?" *Art & Dec* 1:97-104 (Ap 1897). 11 illus.

1249. Thiébault-Sisson. "Un Dernier Mot sur les salons: l'étain,
le cuir, la faience; orfevrerie et bijoux." *Art & Dec* 1:162-72 (Je
1897). 19 illus.
French decorative arts. Includes Gallé and Prouvé. Section on
jewelry (pp. 168-72) written by René Binet.

1250. Thiébault-Sisson. "L'Exposition des travaux d'élèves à
l'Ecole des Arts Décoratifs." *Art & Dec* 2:60-4 (Ag 1897). 11 illus.

1251. Thomas, Albert. "Les Salons de 1901 (suite): les objets
d'art." *Art Dec* 6:179-89 (Ag 1901). 20 illus., 2 pls. (pp. 179-91)

1252. Torquet, Charles. "L'Orfèvrerie et le bronze." *Art Dec* 6:
209-19 (Ag 1901). 20 illus. (pp. 207-18)

1253. Verneuil, M.P. "A propos des expositions des écoles d'art décoratif." *Art & Dec* 16:101-8 (Se 1904). 11 illus., plan

1254. Verneuil, M.P. "The applied arts in the Paris salons of 1904." Transl. from the French by Irene Sargent. *Cfm* 6:431-45 (Ag 1904). 22 illus.
Includes work by Lalique and Lucien Galliard.

1255. Verneuil, M.P. "L'Art décoratif à la Société Nationale." *Art & Dec* 13:173-94 (Je 1903). 34 illus.
Comprehensive exhibition of French Art Nouveau.

1256. Verneuil, M.P. "L'Art décoratif au Salon d'Automne." *Art & Dec* 16:165-76 (N 1904). 15 illus.

1257. Verneuil, M.P. "L'Art décoratif aux salons de 1905." *Art & Dec* 17:193-204 (Je 1905). 23 illus.; 18:1-13 (Jy 1905). 22 illus., plan
A stagnant Art Nouveau style at the 1905 exhibits. The second article is entitled "L'Architecture et l'art décoratif aux salons de 1905."

1258. Verneuil, M.P. "Les Arts appliqués aux salons." *Art & Dec* 15:165-96 (Je 1904) [entire issue]. 60 illus., 1 col. pl.
Comprehensive article, principally on French decorative arts at various exhibitions.

1259. Vitry, Paul. "Essais d'interieurs modernes." *Art & Dec* 5:153-7 (My 1899). 6 illus.

1260. Vitry, Paul. "Le Nouveau Musée des Arts Décoratifs." *Art & Dec* 18:65-104 (Se 1905). 53 illus., 3 pls.
The new museum, a part of the Louvre, the scope of which ranges from the medieval period through Art Nouveau.

ALSO SEE: 143b, 313, 316, 319, 1271-7, 1362

Decorative arts in France (Ceramics)

1261. "Céramique d'art." *Art & Dec* 6:134-9 (N 1899). 12 illus.;

6:181-9 (D 1899). 13 illus.
Ceramics by Lachenal and the firms at Glatigny, Sevrès, and Copenhagen.

1262. "L'Exposition de l'Union Centrale des Arts Décoratifs." *Art & Dec* 8:21-32 (1900). 14 illus., 1 pl.
An exhibition featuring vases by Georges Hoentschel.

1263. Frantz, Henri. "La Céramique française à l'Exposition." *Art Dec* 4:241-7 (Se 1900). 7 illus. (pp. 244-7)
French ceramics at the 1900 Exposition.

1264. Grasset, E. "Concours de service de table en faïence." *Art & Dec* 17:99-104 (Mr 1905). 7 illus.

1265. C.H. [i.e. Charles Holme]. "The renaissance of the potter's art in France." *Studio* 3:180-1 (Se 1894). 3 illus.

1266. Molinier, Emile. "Les Arts du feu." *Art & Dec* 1:109-15 (Ap 1897). 10 illus.

1267. Molinier, Emile. "Les Plus Récents Travaux de la manufacture de porcelaine de Sèvres." *Art & Dec* 14:354-64 (N 1903). 20 illus., 1 col. pl.

1268. Saunier, Ch. "Céramique, verrerie, émail." *Art Dec* 6:147-58 (Jy 1901). 11 illus. (pp. 145-55)
Ceramics, glass, and enamels at the 1901 salons.

1269. Sedeyn, Em. "La Céramique de table." *Art Dec* 6:7-17 (Ap 1901). 25 illus.
Dinner services by artists (De Feure, Colonna) and by French and Swedish firms.

1270. Soulier, Gustave. "A travers les expositions." *Art Dec* 9:33-7 (Ja 1903). 16 illus.
Includes pottery by Lachenal.

1270a. Verneuil, M.P. "L'Émail et les émailleurs." *Art & Dec* 15:37-53 (F 1904); 15:150-64 (My 1904). 21 illus., 1 col. pl.
Part 1 includes work by Feuillatre.

ALSO SEE: 337, 344, 1338, 1452, 1455, 1488-92, 1504, 1513, 1516, 1624-5

Decorative arts in France (Competitions)

1271. Champier, Victor. "Concours pour un miroir à main, organisé par la Société d'Encouragement à l'Art et à l'Industrie." *Rev Arts Dec* 21:266-70 (1901). 12 illus.

1272. "Concours de la Société d'Encouragement à l'Art et à l'Industrie: une lanterne d'antichambre." *Art Dec* 16:117-20 (Se 1906). 6 illus.
 Competition for a chandelier design.

1273. Grasset, E. "Nos concours." *Art & Dec* 2:27-31 (Jy 1897). 14 illus., 1 pl. (pp. 27-32)
 The magazine's competitions for designs for match boxes and the like.

1274. Judex [pseud.?]. "Nos écoles d'art décoratif: concours de fin d'année." *Rev Arts Dec* 21:282-9 (1900). 10 illus.
 Art school competitions, including work by Henri de Waroquier.

1275. Magne, Lucien. "Nos concours: une lanterne d'antichambre." *Art & Dec* 1:125-8 (Ap 1897). 8 illus.

1276. Souza, Robert. "Le Concours d'enseignes." *Art Dec* 9:28-32 (Ja 1903)
 Art Nouveau shop signs.

1277. Verneuil, M.P. "Un Concours de napperon à l'Union Centrale des Arts Décoratifs." *Art & Dec* 13:125-8 (Ap 1903). 6 illus.
 Women's competition in lace design.

Decorative art in France (Lace, Silk, Embroidery)

1278. Félice, Roger de. "Dentelles et broderies au Pavillon de Marsan." *Art Dec* 16:72-80 (Ag 1906). 9 illus.

1279. Fiérens-Gevaert, H. "Tappisseries et broderies." *Art & Dec* 2:85-6 (Se 1897). 4 illus.

1280. Grasset, E. "L'Exposition de soieries au Musée Galliera." *Art & Dec* 20:81-6 (Se 1906). 10 illus., 1 col. pl.
 Exhibition of silk designs.

1281. Karageorgevitch, Prince B. "La Broderie." *Art Dec* 13: 202-8 (My 1905). 13 illus., 1 pl.

1282. Prompt, Jeanne. "Quelques broderies." *Art Dec* 7:139-44 (Ja 1902). 14 illus. (pp. 138-45)

1283. Saunier, Charles. "Broderies et dentelles." *Art Dec* 6:201-5 (Ag 1901). 5 illus. (pp. 199-202)

1284. Sedeyn, Emile. "Exposition de soieries au Musée Galliera." *Art Dec* 16:103-11 (Se 1906). 12 illus.

Decorative art in France (Textile design)

1285. Bramson, J. "Etoffes d'ameublements." *Art Dec* 8:374-80 (D 1902). 14 illus.
 Upholstery designs.

1286. Germain, Alphonse. "Les Tissus de tenture à l'Exposition." *Art Dec* 5:101-15 (D 1900). 25 illus.
 Textile design at the 1900 Exposition, primarily French. Includes Grasset and Aubert.

1287. Sedeyn, Emile. "La Décoration des tissus." *Art Dec* 7:115-22 (D 1901). 17 illus.
 Textile design by De Feure and others.

1288. V. du T. "L'Exposition de Rouen: les arts appliqués à la décoration des tissus." *Rev Arts Dec* 21:329-36 (1901). 8 illus.

1289. Verneuil, M.P. "Les Applications d'étoffes." *Art & Dec* 3:13-21 (Ja 1898). 11 illus., 1 col. pl.

1290. Verneuil, M.P. "La Décoration intérieure et les travaux féminin: la tapisserie." *Art & Dec* 1:73-80 (Mr 1897). 13 illus.
 Fabrics and tapestries by the author and by Ranson and others.

1291. Verneuil, M.P. "Les Étoffes teintes d'Isaac." *Art & Dec* 1:48-56 (F 1897). 13 illus.

1292. Verneuil, M.P. "Etoffes tissés." *Art & Dec* 10:97-107 (1901). 19 illus., 1 col. pl. (facing p. 96)

1293. Verneuil, M.P. "Les Étoffes tissés et les tapisseries à l'Exposition." *Art & Dec* 8:111-25 (1900). 20 illus., 1 pl.
Woven fabrics and tapestries from France and Germany at the 1900 Exposition.

ALSO SEE: 395-7, 1420, 1650, 1789

Decorative art in France (Furniture)

1294. Benn, R. Davis. *Style in furniture.* With illustrations by W.C. Baldock. London, New York: Longmans, Green, 1920. xvi, 338 pp., 102 pls.
See the chapter, "The 'New Art' in France," pp. 278-312 (pls. 88-98).

1295. Lambert, Théodore. *Meubles et ameublement de style moderne.* Paris: C. Schmid, [1904]. 32 pls.
A folio of thirty-two plates, each of which has several photographs. Primarily furniture by the major French designers such as Majorelle and Gallé. Good photographs. No text.

1296. Mannoni, Edith. *Meubles et ensembles, Style 1900.* Paris: Masson, [1968]. 78 pp., illus. (part col.)
Photographs of French Art Nouveau furniture, notably Majorelle and the Nancy school.

1297. *Meubles d'Art Nouveau au Salon du Mobilier de 1902.* Bibliothèque de l'ameublement. Dourdan (Seine-et-Oise): Emile Thézard, [1903]. 43 pls.
Folio of plates, each containing several photographs of furniture by Majorelle and by a number of Parisian firms. The publisher, Thézard, is sometimes identified as the author in bibliographies. No text.

1298. Olmer, Pierre. *La Renaissance du mobilier français (1890-1910)*. Paris: G. Van Oest, 1927. 40 pp., 32 pls., bibl.
A brief survey covering the French artists and expositions of the "Art Nouveau Bing".

1299. Brüning, A. "Neue Erwerbungen: des kgl. Kunstgewerbe-Museums in Berlin." *Br Archw* 1:181-3 (1899). 3 illus.
Exhibit of French furniture in Berlin.

1300. "Concours de l'Art Décoratif." *Art Dec* 2:93-4 (My 1899). 9 illus. (pp. 89-92)
Project for desk and chair design. Prizes won by Georges Lemmen, Dufrène, and H. Sauvage.

1301. Dulong, René. "Les Arts d'ameublement aux salons." *Art & Dec* 6:42-7 (Ag 1898). 6 illus., 1 pl.
French and Belgian furniture.

1302. Félice, R. de. "L'Ameublement au Salon (Société des Artistes Français)." *Art Dec* 12:11-14 (Jy 1904). 4 illus.

1303. Félice, R. de. "L'Ameublement au Salon (Société Nationale)." *Art Dec* 11:210-16 (Je 1904). 8 illus., 1 pl.
Includes work by Majorelle and Dufrène.

1304. Félice, R. de. "L'Ameublement au Salon des Artistes Décorateurs." *Art Dec* 11:91-8 (Mr 1904). 6 illus., 1 pl.

1305. "Französisches Mobiliar auf der Weltausstellung." *Dek K* Jrg. 3 (Bd. 6):409-13 (Jy 1900); or *Kunst* Bd. 2:409-13 (Jy 1900). 20 illus. (pp. 406-16)
Furniture by Majorelle and stained glass windows by De Feure.

1306. Gerdeil, O. "L'Interieur." *Art Dec* 6:125-8 (Je 1901) illus.; 6:158-63 (Jy 1901) 10 illus. (pp. 156-61); 6:189-94 (Ag 1901). 5 illus. (pp. 192-5)
Series of three articles on the salons of 1901. The first includes furniture by Benouville and Serrurier-Bovy, the third, furniture by T. Selmersheim and Majorelle.

1307. Gerdeil, O. "Le Meuble moderne." *Art Dec* 5:214-16 (F 1901). 4 illus. (pp. 212-15)
Furniture by Damon & Colin.

1308. Grasset, E. "Concours d'Avril: un buffet de salle à manger." *Art & Dec* 18:61-4 (Ag 1905). 4 illus.

1309. Grasset, E. "Concours de salle à manger." *Art & Dec* 17: 62-8 (F 1905). 6 illus., 1 col. pl.
Competition for a dining room design.

1310. Jacques, G.M. [i.e. J. Meier-Graefe?]. "Le Meuble." *Art Dec* 8:17-22 (Ap 1902). 8 illus.

1311. Jacques, G.M. [i.e. J. Meier-Graefe?]. "Le Meuble à l'Exposition." *Art Dec* 5:16-20 (O 1900). 7 illus.
Furniture at the 1900 Exposition. Includes work by Plumet & Selmersheim.

1312. Jacques, G.M. [i.e. J. Meier-Graefe?]. "Quelques meubles." *Art Dec* 5:116-17 (D 1900). 5 illus. (pp. 116-19)
Furniture at the 1900 Exposition including work of L. Bénouville.

1313. Jacques, G.M. [i.e. J. Meier-Graefe?]. "Le Salon des Industries du Mobilier." *Art Dec* 8:298-304 (O 1902). 7 illus.
Late Art Nouveau furniture by Majorelle and other designers.

1314. Jourdain, Frantz. "Les Meubles et les tentures murales aux salons de 1901." *Rev Arts Dec* 21:201-12 (1901). 16 illus.
Furniture by "L'Art dans Tout" group and others.

1315. Jourdain, Frantz. "Le Mobilier au Salon des Artistes Français." *Art Dec* 10:60-6 (Ag 1903). 7 illus.

1316. Jourdain, Frantz. "Le Mobilier au Salon National des Beaux-Arts." *Art Dec* 9:209-18 (Je 1903). 11 illus.

1317. Magne, Lucien. "Le Mobilier moderne à l'Exposition Universelle de 1900 (Section Française)." *Rev Arts Dec* 21:6-16 (1901)

13 illus., 2 pl.; 21:41-50 (1901) 13 illus.; 82-90 (1901). 10 illus.
Part 1 and some of part 2 deal with French furniture; foreign
furniture is on p. 47ff. See item 352 for review.

1318. Sarradin, Edouard. "Nouveaux essais d'ameublement: M.
Bellery-Desfontaines; MM. Louis Bigaux et Joseph Le Coeur." *Art
& Dec* 2:56-9 (Ag 1897). 4 illus.

1319. Saunier, Charles. "Les Salons: la céramique, le meuble,
les bibelots." L'Ornement qui passe. *Plume* no. 291:558-62 (Jy
15, 1901)

1320. Sedeyn, Emile. "Les Meubles aux salons." *Art Dec* 13:
255-65 (Je 1905). 10 illus., 1 pl.

1321. Sedeyn, Emile. "Les Meubles aux salons." *Art Dec* 16:23-
32 (Jy 1906). 10 illus.

1322. "Some examples of modern French furniture." *Arch Rec*
10:245 (Ja 1901). 13 illus. (pp. 246-55)
Primarily photographs.

1323. Soulier, Gustave. "L'Ameublement à l'Exposition." *Art
& Dec* 8:33-45 (1900) 21 illus.; 8:137-50 (1900) 13 illus., 2 pl.;
8:177-83 (1900). 10 illus.
Series of three articles on furniture at the 1900 Exposition.
Parts 1 and 2 on French furniture and part 3 on foreign furni-
ture.

1324. Soulier, Gustave. "L'Art dans l'habitation." *Art & Dec* 7:
105-17 (1900). 15 illus., 2 pls.
The furniture and studios of Serrurier-Bovy, Louis Bigaux, and
"L'Art Nouveau".

1325. Soulier, Gustave. "Les Arts de l'ameublement aux salons."
Art & Dec 4:10-21 (Jy 1898). 15 illus., 2 pls.

1326. Soulier, Gustave. "Meubles nouveaux." *Art & Dec* 2:105-9
(O 1897). 5 illus.

1327. Soulier, Gustave. "Le Mobilier." *Art & Dec* 3:65-72 (Mr 1898) 10 illus.; 3:104-14 (Ap 1898). 14 illus.
Part 1 includes furniture from "Art Nouveau Bing", part 2, work of Gallé, Majorelle, and Serrurier-Bovy.

1328. Soulier, Gustave. "Le Mobilier." *Art & Dec* 6:175-80 (D 1899). 6 illus.

1329. Soulier, Gustave. "Le Mobilier." *Art & Dec* 10:113-24 (1901). 17 illus.

1330. Soulier, Gustave. "Le Mobilier aux salons." *Art Dec* 8:166-72 (Jy 1902). 8 illus.

1331. Soulier, Gustave. "Les Sièges." *Art & Dec* 10:155-61 (1901). 11 illus., 1 pl.
Chairs designed by De Feure and by Plumet & Selmersheim.

1332. Vachon, Marius. "Les Industries d'art au Salon: le meuble." *Art & Dec* 2:76-80 (Se 1897). 6 illus.
Exhibition of Art Nouveau furniture.

ALSO SEE: 1083, 1124, 1182-3, 1217, 1234, 1245, 1247, 1381, 1406, 1408-10, 1437, 1439, 1447, 1510, 1523, 1558, 1587, 1592, 1597, 1646-9, 1658-61 (Majorelle), 1699ff. (T. Selmersheim), 1747, 1752

Decorative art in France (Glassware)

1333. Grover, Ray. *Carved and decorated European art glass.* Rutland, Vt.: Tuttle, [1970]. 244 pp., 423 col. pls., bibl.
Brief text. Chiefly color photographs of French Art Nouveau glassware, despite the title of the book. Notably Gallé.

1334. Cuers, René de. "Domestic stained glass in France." *Arch Rec* 9:115-41 (O 1899). 20 illus.
Stained glass windows by Grasset and others.

1335. Germain, Alphonse. "Quelques verriers." *Art Dec* 5:240-49 (Mr 1901). 14 illus. (pp. 238-47)
Glass lamps and vases by Daum Frères, Ledru, and Tiffany.

1336. Kahn, Gustave. "Le Cristal taillé et gravé." *Art & Dec* 11: 57-62 (F 1902). 17 illus.

1337. M.G. et J. [i.e. J. Meier-Graefe?]. "Les Verriers de Nancy." *Art Dec* 1:107-8 (D 1898). 6 illus., 2 col. pls. (pp. 134-8 and facing p. 110)
 Glass by Gallé and Daum.

1338. Molinier, Emile. "Les Arts du feu (Salons de 1898)." *Art & Dec* 3:189-200 (Je 1898). 17 illus.
 Ceramics and glass. Includes Gallé and Tiffany.

ALSO SEE: 1268, 1374, 1525-56 (Gallé), 1632

Decorative art in France (Jewelry)

1339. Amis du Portugal. *Le Bijou 1900: Modern Style-juwelen.* Bruxelles, 1965. 102 pp., 23 col. pls., 35 illus., bibl.
 Exhibit of 128 items of Art Nouveau jewelry, notably by Lalique, Vever, Van de Velde, Wolfers, and Hoffmann. Texts by Y. Oostens-Wittamer, in French and Flemish. Beautiful color and black-and-white photographs. Bibliography, pp. 101-2. See item 375 for review.

1340. Bouilhet, Henri. *L'Orfèvrerie française aux XVIIIe et XIXe siècles.* Tome 3: L'Orfèvrerie française au XIXe siècle, deuxième période (1860-1900). Paris: H. Laurens, 1912. xxxvi, 388 pp., illus.
 Last of three volumes of an extensive study on French goldware. Contents and lists of illustrations, pp. 379-88. See chapter 9, p. 299ff. Numerous illustrations. Limited edition of 1,000 copies.

1341. Follot, Paul. *Documents de bijouterie et orfèvrerie modernes.* Paris: Henri Laurens, [1905]. 24 pls.
 Photographs of French jewelry and goldware. List of plates at rear of book. No text.

1342. Fouquet, Georges, ed. *La Bijouterie, la joaillerie, la bijouterie de fantaisie au XXe siècle.* Paris, 1934. vii, 437 pp.

Texts also by Emile Sedeyn, Jacques Guerin, Lanillier, and
Paul Piel, with a preface by Paul Léon. Limited edition of 200
copies. Index, pp. 419-29. See pp. 44-95, 210-36 (texts by
Emile Sedeyn), which discuss Art Nouveau jewelry in France.

1343. Meusnier, Georges. *La Joaillerie française en 1900: recueil
de 168 pièces.* Paris: Henri Laurens, [1901?]. xii pp., 32 pls., bibl.
 Primarily photographs of French jewelry. Short essay, pp. i-v.
 Brief bibliography, p. vi. List of plates, pp. vii-xii.

1344. Vever, Henri. *La Bijouterie française au XIXe siècle...* Vol.
3: La Troisième République. Paris: H. Floury, 1908. pp. 337-810,
illus.
 Art Nouveau is treated in the second half of the book. Copious-
 ly illustrated. List of illustrations, pp. 795-807. Index, pp. 781-
 93.

1345. "A travers les expositions." *Art Dec* 9:183-9 (My 1903).
11 illus.

1346. Bénédite, Léonce. "Le Bijou à l'Exposition Universelle."
Art & Dec 8:65-82 (1900). 30 illus.
 Notably the work of Vever, Grasset, and Colonna.

1347. Blum, René. "Le Bijou au Musée Galliera." *Art & Dec* 24:
79-88 (Se 1908). 24 illus.
 Late jewelry by leading French artists.

1348. Bouyer, Raymond. "Quelques nouveaux bijoux de MM.
Lalique, Feuillatre et L. Boucher." *Art Dec* 8:54-8 (My 1902).
8 illus., 1 pl. (facing p. 45)

1349. Bouyer, Raymond. "Quelques objets d'art des salons."
Art & Dec 4:22-7 (Jy 1898). 8 illus., 1 pl.
 Gold and silverware.

1350. Bouyer, Raymond. "Les Salons de 1901 (suite): les bijoux."
Art Dec 6:133-42 (Jy 1901) 19 illus. (pp. 133-44); suite et fin 6:
244-52 (Se 1901). 18 illus. (pp. 245-53)
 First article includes jewelry by Wolfers. Second article sub-
 titled "Les bijoux au salon."

1351. Bouyer, Raymond. "La Décoration des montres." *Art &*
Dec 9:37-40 (Ja 1901). 14 illus.
Includes work by Lalique.

1352. C. "Französischer Schmuck." *Dek K* Jrg. 3 (Bd. 6):419-
26 (Ag 1900); or *Kunst* Bd. 2:419-26 (Ag 1900). 18 illus.
Jewelry by Lalique, Colonna, and Marcel Bing.

1353. Calmettes, Pierre. "The 'Modern Style' in jewelry." *Arch
Rec* 14:205-18 (Se 1903). 16 illus.
French Art Nouveau jewelry.

1354. Escholier, Raymond. "L'Exposition de la parure précieuse
de la femme au Musée Galliera." *Art Dec* 20:59-68 (Ag 1908). 16
illus.
Jewelry by the leading French designers.

1355. Geffroy, Gustave. "La Bijouterie et l'orfèvrerie aux salons
de 1901." *Rev Arts Dec* 21:273-81 (1901). 16 illus.

1356. J. "Nos illustrations." *Art Dec* 3:7-8 (O 1899). 36 illus.
(pp. 10-15; 112-13, D 1899)
Jewelry by Van de Velde, Fouquet, and Colonna.

1357. Jacques, G.M. [i.e. J. Meier-Graefe?]. "Bijoux nouveaux."
Art Dec 7:149-54 (Ja 1902). 4 illus.
Jewelry by M. Colin & Co.

1358. Jacques, G.M. [i.e. J. Meier-Graefe?]. "Paradoxes (à pro-
pos d'orfèvrerie)." *Art Dec* 7:252-6 (Mr 1902). 4 illus.
Goldware by Dufrène, Colonna, and Wolfers.

1359. Kahn, Gustave. "Dessins de bijoux: MM. Mucha, De Feure,
Dufrène, Marcel Bing." *Art & Dec* 11:13-17 (Ja 1900). 16 illus.

1360. Kahn, Gustave. "L'Exposition de la miniature et des arts
précieux." *Art & Dec* 11:93-100 (Mr 1902). 13 illus.
Jewelry exhibit. Includes work by Feuillatre and Mucha.

1361. Karageorgevitch, Prince B. "Le Bijou moderne." *Art Dec*
10:150-6 (O 1903). 12 illus.

1362. Molinier, Emile. "Les Objets d'art aux salons." *Art & Dec*
9:185-92 (1901) 12 illus.; 10:21-32 (Jy 1901) 21 illus.; 10:45-
54 (Ag 1901). 12 illus.
 First part on jewelry, notably by Wolfers. Second part on
 French decorative art.

1363. Mourey, Gabriel. "The art of 1899, part 2." *Studio* 17:3-8
(Je 1899). 28 illus. (pp. 4-24)
 Includes Art Nouveau jewelry by René Foy.

1364. Nocq, Henry. "Französischer Schmuck." *Dek K* Jrg. 1,
Heft 8 (Bd. 2):58-65 (My 1898). 10 illus. (pp. 63-4)

1365. Saunier, Charles. "La Bijouterie et la joaillerie à l'Exposi-
tion Universelle." *Rev Arts Dec* 21:17-30 (Ja 1901) 33 illus., 2
pls.; 21:73-81 (F 1901). 17 illus.

1366. Saunier, Charles. "L'Ivoire au Musée Galliéra." *Art Dec*
10:53-9 (Ag 1903). 11 illus., 1 pl.
 Art Nouveau jewelry and sculpture in ivory.

1367. Saunier, Charles. "La Première Exposition des Arts du
Foyer: l'orfèvrerie." *Plume* no. 302:932-3 (N 15, 1901)

1368. Saunier, Charles. "Les Salons." L'Ornement qui passe.
Plume no. 290:349-51 (My 1, 1901)
 Jewelry at the French salons.

1369. Schopfer, Jean. "Modern art (L'Art Nouveau) in jewelry."
Arch Rec 12:67-70 (My 1902). 2 illus.
 Short article on French jewelry, illustrated by the work of
 Colonna.

1370. "Some recent examples of the jewellers' art in France."
Studio 23:25-31 (Je 1901). 20 illus. (pp. 25-33)
 The work of Lalique and Vever.

1371. Soulier, Gustave. "Bijoux: à propos de publications nou-
velles." *Art Dec* 11:72-3 (F 1904). 7 illus.
 Review of two books on jewelry, by Paul Follot and Maurice
 Dufrène.

1372. Valabrègue, Antony. "Nos industries provinciales: les bijoux lorrains." *Rev Arts Dec* 20:9-13 (1900). 10 illus., 1 pl.; 20: 57-60 (1900). 10 illus.
 Jewelry from Nancy.

1373. Verneuil, M.P. "Les Arts décoratifs aux salons de 1906." *Art & Dec* 19:177-208 (Je 1906). 55 illus.
 Includes jewelry by Lalique.

1374. Verneuil, M.P. "Les Objets d'art à la Société des Artistes Français." *Art & Dec* 14:217-36 (Jy 1903). 36 illus., 1 col. pl. (Tiffany)
 Exhibition of jewelry and glass, primarily French. Includes jewelry by Lalique and L. Gaillard.

1375. Vever, Henri. "Les Bijoux aux salons de 1898." *Art & Dec* 3:169-78 (Je 1898). 16 illus., 1 col. pl.
 Notably the work of Lalique.

1376. Vever, Henry. "Dessins de joaillerie." *Art & Dec* 6:83-9 (Se 1899). 9 illus.

ALSO SEE: 368-9, 1183, 1211, 1222-3, 1228, 1231, 1239, 1450, 1496, 1519-22, 1524, 1627-45 (Lalique), 1720, 1729, 1787-9

Decorative art in France (Metalware)

1377. *Ferronnerie de style moderne: motifs exécutés en France et à étranger.* Paris: Ch. Schmid, [190-?]. 45 pls.
 A folio album of forty-five plates, each containing several photographs of iron grillwork for doors and windows by French and Belgian architects. No text.

1378. Aubry, Louis. "La Ferronnerie à l'Exposition Universelle de 1900: Emile Robert." *Rev Arts Dec* 20:177-83 (1900); 20: 211-16 (1900). 5 illus., 1 pl.

1379. Belville, Eugène. "Artisans du métal: à propos de l'exposition du Musée Galliera." *Art Dec* 14:17-23 (Jy 1905). 13 illus.

1380. Bramson, Jacques. "Les Étains." *Art Dec* 8:337-42 (N 1902). 12 illus.
Art Nouveau design in tinware.

1381. R.D. "Le Métal dans le mobilier et la décoration." *Art & Dec* 11:75-84 (Mr 1902). 23 illus.

1382. Magne, Lucien. "La Décoration du fer." *Art Dec* 5:122-33 (D 1900). 14 illus. (pp. 124-32)
Iron grillwork in architecture. Work by E. Robert, Louvet, and Magne.

1383. Magne, Lucien. "Le Fer dans l'art moderne." *Rev Arts Dec* 20:351-8 (1900) 6 illus., 1 pl.; 20:378-82 (1900). 7 illus.
Includes ironwork by Emile Robert.

1384. Molinier, Emile. "Notes sur l'étain." *Art & Dec* 1:81-8 (Mr 1897) 7 illus.; 2:96-104 (O 1897). 10 illus.
The first article includes the work of Raoul Larche, the second, work by Brateau and Baffier.

Book design and typography in France

1385. Zucker, Irving, comp. *A source book of French advertising.* With over 5000 illus. from the turn of the century. New York: Braziller, [1964]. vi pp., 256 pls.
Chiefly black-and-white offset illustrations, with few Art Nouveau motifs despite the promising title. See particularly plates 161-82 (lettering).

1386. Belville, Eugène. "L'Exposition de la relieure moderne au Musée Galliera." *Art Dec* 8:191-9 (Ag 1902). 19 illus.

1387. Beraldi, Henri. "Rapport sur le concours no. 3: relieure." *Rev Arts Dec* 14:170-6 (1893-94). 11 illus., 1 pl.
Competition for bookcover design.

1388. Bosquet, Em. "La Relieure française à l'Exposition." *Art & Dec* 8:46-55 (1900). 14 illus.
French bookbinding at the 1900 Exposition.

1389. Chapon, François. "L'Art graphique et les revues." *Art Fr* 2:306-18 (1962). 15 illus., bibl. footnotes
Magazine illustration in France around 1900. Not specifically Art Nouveau.

1390. Devigne, Roger. "La Lettre et le décor du livre pendant la période 1880-1905." *Arts et Métiers Graphiques* 54:53-6 (Ag 15, 1936). 12 illus.

1391. Garvey, Eleanor N. "Art Nouveau and the French book of the 1890s." *Harvard Library Bulletin* 12:375-91 (Autumn 1958). 8 pls. (15 illus.), bibl., bibl. footnotes
Primarily on book illustration by Toulouse-Lautrec, Bonnard, and Maurice Denis, as well as Grasset and Auriol. List of examples at Harvard College Library.

1392. Grasset, Eugène. "Les Bordures." *Art & Dec* 16:145-54 (N 1904). 44 illus., 1 col. pl.
Decorative borders by French artists.

1393. Grasset, E. "Lettres ornées typographiques: concours du mois d'août." *Art & Dec* 16:135-43 (O 1904). 28 illus.

1394. Henry-Marie. "La Relieure d'art à Nancy." *Plume* no. 157: 487-9 (N 1, 1895). 3 illus.
Bookbindings by the Nancy school. Part of a special issue on Lorraine.

1395. E.L. "Le Relieure aux salons." *Art & Dec* 6:55-9 (Ag 1899). 10 illus.
Work by French bookbinders.

1396. Macht, Hans. "Saint-Andrés Lederplastik." *KKhw* 3:80-2 (F 1900). 4 illus. (pp. 80-4)
Leather bookcovers.

1397. Meier-Graefe, J. "Der gegenwärtige Stand des Buchgewerbes in Paris und Brüssel." *ZfB* 1:42-8 (Ap); 1:77-80 (My 1897)

1398. "Notre concours de couverture." *Art & Dec* 1:26-30 (Ja

1897). 8 illus.
Bookcovers, showing Grasset's influence.

1399. Pudor, Heinrich. "Französische Ledereinbände." *ZfB* 7:
81-2 (My 1903). 3 illus. (pp. 80-2)

1400. Riotor, Léon. "Exposition de relieures au Musée des Arts
Décoratifs." *Art Dec* 15:193-8 (My 1906). 9 illus.
Bookbindings by women artists.

1401. Sedeyn, Emile. "Les Cuirs d'art." *Art Dec* 6:164-73 (Jy
1901). 19 illus.
Bookbindings and objets d'art in leather.

1402. Uzanne, Octave. "La Décoration des livres aux salons de
1898." *Art & Dec* 4:1-9 (Jy 1898). 15 illus.
French Art Nouveau book design by the leading artists.

1403. Uzanne, Octave. "Der moderne französische Bucheinband:
die Künstler des Maroquinleders." *ZfB* 5:409-20 (F 1902). 17 illus.
On French leather bookbindings. Translated from the French
manuscript.

1404. Zur Westen, Walter von. "Der künstlerische Buchumschlag:
Frankreich und Nordamerika." *ZfB* 2:401-16 (Ja 1899). 16 col.
illus., bibl. footnotes
See item 428 for other countries.

ALSO SEE: 406, 1421a-c, 1564, 1781

INDIVIDUAL ARTISTS AND GROUPS

"L'Art dans Tout"
 A group of French designers modeled after the "Art Nou-
veau Bing" group and specializing in furniture and interiors.

1405. Forthuny, Pascal. "L'Art dans Tout." *Rev Arts Dec* 21:
98-112 (1901). 16 illus.

1406. Frantz, Henri. "Le Meuble aux salons de 1902." *Art &*
Dec 11:177-88 (Je 1902). 8 illus., 5 pls.
 Furniture by the "L'Art dans Tout" group.

1407. Jacques, G.M. [i.e. J. Meier-Graefe?]. "L'Art dans Tout."
Art Dec 2:141-5 (Jy 1899). 5 illus. (pp. 160-1)

1408. Jacques, G.M. [i.e. J. Meier-Graefe?]. "L'Art dans Tout."
Art Dec 6:45-68 (My 1901). 32 illus. (pp. 45-65)
 Furniture and decorative work by the French group.

1409. G.S. [i.e. Gustave Soulier]. "L'Ameublement aux salons."
Art & Dec 9:193-9 (1901). 7 illus.; 10:33-40 (Jy 1901). 8 illus.
 Part 1 is on furniture by the "L'Art dans Tout" group; part 2
 is about other French furniture designers.

1410. Soulier, Gustave. "L'Art dans Tout." *Art & Dec* 9:129-40
(1901). 15 illus.
 Furniture by the group, notably by Sauvage and by Plumet &
 Selmersheim.

1411. G.S. [i.e. Gustave Soulier]. "La Société de 'L'Art dans
Tout'." *Art & Dec* 5:82-9 (Mr 1899). 12 illus.
 Art Nouveau firm featuring work by Dampt and Herald.

1412. Vignaud, Jean. "L'Art dans Tout." *Art & Dec* 7:47-50
(1900). 6 illus.

ALSO SEE: 1314

"Les Artistes Réunis"

1413. Sedeyn, Emile. "Les Artistes Réunis." *Art Dec* 11:112-29
(Mr 1904). 14 illus., 1 pl.
 Includes jewelry by Henry Hamm.

Félix Aubert

1414. "Die Spitzen Auberts." *Dek K* Jrg. 2, Heft 4 (Bd. 3):148-9
(Ja 1899). 10 illus. (pp. 172-8)
 Carpets, lacework, and other design work by Aubert.

1415. J. "M. Félix Aubert." *Art Dec* 1:157-61 (Ja 1899). 12 illus. (pp. 168-74)

1416. J. "Nos illustrations." *Art Dec* 3:8 (O 1899). 2 illus. (pp. 26-7)
Lace and fans by Aubert.

1417. "Korrespondenzen: Paris." *Dek K* Jrg. 3 (Bd. 5):167 (Ja 1900) 6 illus. (pp. 156-9); or *Kunst* Bd. 2:167 (Ja 1900). 6 illus. (pp. 156-9)
Interiors and decorative work by Aubert and Charpentier.

1418. "Korrespondenzen, Paris: Félix Aubert... Marie Closset." *Dek K* Jrg. 3 (Bd. 5):8 (O 1899); or *Kunst* Bd. 2:8 (O 1899). 6 illus. (pp. 26-7, 31)

1419. G.M. [i.e. Gabriel Mourey]. "Studio-talk: Paris." *Studio* 12:198-200 (D 1897). 3 illus.
The work of Aubert.

1420. G.M. [i.e. Gabriel Mourey]. "Studio-talk: Paris." *Studio* 17:272-6 (Se 1899)
Includes woven fabrics designed by Aubert.

ALSO SEE: 334, 1118, 1286, 1464, 1763ff.

George Auriol

1421a. Auriol, George. *Le Premier Livre des cachets, marques et monogrammes dessinés par George Auriol.* Paris: Librairie Centrale des Beaux-Arts, 1901. 71 col. pls.
The first of three books of typographical ornaments designed by the artist. Six-page preface by Roger Marx. This first book was issued in a limited edition of 30 copies.

1421b. Auriol, George. *Second livre...* Paris: H. Floury, 1908. 88 pls.
Preface by Anatole France.

1421c. Auriol, George. *Troisième livre.* Paris: H. Floury, 1924.

88 pls.
 Preface is a text by Geoffroy Tory.

1422. Alexandre, Arsène. "George Auriol." *Art & Dec* 5:161-80
(Je 1899). 21 illus., 1 col. pl., 1 pl.

1423. Bouyer, Raymond. "Papiers à lettres." *Art & Dec* 7:51-4
(1900). 13 illus.
 Floral stationery designs by Auriol.

1424. Soulier, Gustave. "Quelques couvertures de George Auriol."
Art & Dec 9:69-76 (F 1901). 19 illus.
 Covers for music scores.

ALSO SEE: 1391, 1781a-b

Edouard Bajot

1425. [Bajot, Edouard]. *L'Art Nouveau: décoration et ameuble-
ment.* [Vol. 1.] Paris: Schmid, [1898]. 24 pls.
 A folio of drawings of interiors designed by Bajot. Only some
 of the plates are properly Art Nouveau. No text.

A. Ballié

1426. Soulier, Gustave. "Interieurs." *Art Dec* 10:211-20 (D 1903).
13 illus., 1 pl.
 The interior of the Grand Hotel, Paris by A. Ballié.

Edmond Becker

1427. Bouyer, Raymond. "Edmond Becker sculpteur." *Art &
Dec* 9:109-19 (1901). 32 illus.
 Sculptured objets d'art by a French artist.

Henri-Jules-Fernand Bellery-Desfontaines

1428. "Au Salon de l'Automobile." *Art Dec* 11:78-80 (F 1904).
3 illus.
 Exhibition stands by Bellery-Desfontaines and Emile Robert at
 the automobile show.

1429. Clément-Janin. "Bellery-Desfontaines." *Art Dec* 22:169-84 (D 1909). 26 illus.
A review of the recently deceased painter's career.

1430. Saunier, Charles. "Bellery-Desfontaines." *Art & Dec* 13:165-72 (My 1903). 8 illus.
Paintings and panels by the artist.

1431. Souza, Robert de. "Un Intérieur de Bellery-Desfontaines." *Art Dec* 14:168-72 (N 1905). 7 illus., 1 pl.

ALSO SEE: 1318

Eugène Belville

1432. Soulier, Gustave. "Eugène Belville." *Art & Dec* 3:148-55 (My 1898). 14 illus.

ALSO SEE: 1222, 1721ff.

Louis Bigaux

1433. Bouyer, Raymond. "La Décoration des restaraunts." *Art & Dec* 4:86-92 (Se 1898). 9 illus., 1 pl.
Art Nouveau work by Louis Bigaux for the Café Voisin.

ALSO SEE: 1318, 1324

René Binet

1434. Geffroy, Gustave. "Esquisses décoratives de René Binet." *Art & Dec* 13:33-7 (Ja 1903)

S. Bing and "Art Nouveau Bing"
S. Bing, a native of Germany, was a veteran art dealer in Paris when he opened a new gallery in 1897 called "L'Art Nouveau", which gave the new art movement the name it was known by in English. Bing's first name is given in various sources as Samuel or Siegfried. Henry Van de Velde was associated with Bing in 1897, and the best known artists working with him subsequently

were Georges de Feure, Eugène Gaillard, E. Colonna, and Marcel
Bing, his son.

1435. Bodenhausen, Eberhard, Freiherr von. "Eine Heimstätte
für Kunst." *Pan* 2:128-30 (1896)
 The significance of S. Bing's "L'Art Nouveau" store and its
 meaning for Germany.

1436. E. "Der Bing'sche Pavillon L'Art Nouveau auf der Weltaus-
stellung." *Dek K* Jrg. 3 (Bd. 6):488-93 (Se 1900); or *Kunst* Bd. 2:
488-93 (Se 1900). 7 illus. (pp. 489-95)
 Illustrated by work of De Feure.

1437. "Französisches Mobiliar." *Dek K* Jrg. 1 (Bd. 1):89-108
(D? 1897). 34 illus.

1438. Gensel, Walther. "Das Kunstgewerbe auf der Pariser Welt-
ausstellung, 3." *Kgwb* N.F. 12:63-9 (1901). 10 illus. (pp. 64-75)

1439. Gerdeil, O. "Le Meuble." *Art Dec* 5:170-5 (Ja 1901). 7
illus. (pp. 169-75)
 Furniture of the "Art Nouveau Bing" group at the 1900 Exposi-
 tion by E. Gaillard and others.

1440. Jacques, G.M. [i.e. J. Meier-Graefe?]. "Exposition Univer-
selle: l'Art Nouveau Bing." *Art Dec* 4:88-97 (Je 1900). 12 illus.
 Includes rugs by De Feure and Colonna and stained glass win-
 dows by De Feure.

1441. Jacques, G.M. [i.e. J. Meier-Graefe?]. "L'Intérieur rénové."
Art Dec 4:217-28 (Se 1900). 15 illus., 2 pls.
 Artists of the "Art Nouveau Bing" group, particularly De Feure.

1442. Koch, Robert. "Art Nouveau Bing." *GBA* sér. 6, vol. 53:
179-90 (Mr 1959). 10 illus., bibl. footnotes
 A review of S. Bing's career, as well as an attempt to define
 Art Nouveau.

1443. "La Maison d'Art 'Bing' à Paris." *Art Mod* 16:22 (Ja 19,
1896)
 On the opening of the "Art Nouveau Bing".

1444. O.M. [i.e. Octave Maus]. "Le Pavillon de l'Art Nouveau à l'Exposition Universelle." *Art Mod* 20:209-10 (Jy 1, 1900)

1445. Mourey, Gabriel. "L'Art Nouveau de M. Bing à l'Exposition Universelle." *Rev Arts Dec* 20:257-68 (1900). 12 illus., 1 pl.; 20:278-84 (1900). 7 illus., 1 pl.
 Work by E. Gaillard, Colonna, and De Feure.

1446. Mourey, Gabriel. "Round the Exhibition, 1: the house of 'Art Nouveau Bing'." *Studio* 20:164-81 (Ag 1900). 27 illus.
 Bing's exhibit is considered the artistic highpoint of the 1900 Exposition. (Part 2 of the article is not on Art Nouveau).

1447. Osborn, Max. "S. Bing's 'Art Nouveau' auf der Weltausstellung." *DKD* 6:550-69 (Se 1900). 46 illus. (pp. 549-94)
 Bing's "Art Nouveau" pavilion at the 1900 Exposition. Copiously illustrated with furniture and interiors by De Feure, Gaillard, and Colonna.

1448. Puaux, René. "L'Art Nouveau Bing, Paris." *DKD* 12:309-12 (Ap 1903)
 Page decorations by Georges de Feure.

1449. R. "Reproductions diverses." *Art Dec* 1:165 (Ja 1899). 1 col. pl. (facing p. 182)
 Art Nouveau Bing.

1450. Riotor, Léon. "Les Bijoutiers modernes à l'Exposition: Lalique, Colonna, Marcel Bing." *Art Dec* 4:173-9 (Ag 1900). 19 illus.
 Jewelry of the Art Nouveau Bing group at the 1900 Exposition.

1451. Townsend, Horace. "American and French applied art at the Grafton Galleries." *Studio* 17:39-44 (Je 1899). 24 illus. (pp. 39-46)
 A London exhibit organized by S. Bing featuring Tiffany glass and jewelry designed by Colonna.

1452. Weisberg, Gabriel P. "Bing porcelain in America." *Conss* 178:200-3 (N 1971). 7 illus., bibl. footnotes

A dinner service designed by E. Colonna, which had been owned
by Gustav Stickley.

1453. Weisberg, Gabriel P. "Samuel Bing, international dealer of
Art Nouveau." *Conss* 176:200-5 (Mr 1971); 176:276-83 (Ap 1971);
177:49-55 (My 1971); 177:211-19 (Jy 1971). 48 illus., bibl. foot-
notes
 Part 1: Contacts with the Musée des Arts Décoratifs, Paris [on
 De Feure and Colonna]; part 2: Contacts with the Victoria &
 Albert Museum; part 3: Contacts with the Kaiser Wilhelm Mu-
 seum, Krefeld and the Finnish Society of Crafts and Design,
 Helsinki [on De Feure and Colonna]; part 4: Contacts with the
 Museum of Decorative Art, Copenhagen [on De Feure and E.
 Gaillard].

1454. Weisberg, Gabriel P. "Samuel Bing: patron of Art Nouveau."
Conss 172:119-25 (O 1969) 13 illus., bibl. footnotes; 172:294-9
(D 1969) 10 illus., bibl. footnotes; 173:61-8 (Ja 1970). 15 illus.,
bibl. footnotes
 Part 1: The appreciation of Japanese art; part 2: Bing's salon
 of Art Nouveau [traces the career of Bing until 1900]; part 3:
 The house of Art Nouveau Bing [on the work of De Feure, Co-
 lonna, E. Gaillard, and Marcel Bing].

ALSO SEE: 97, 100, 104, 166, 318, 336, 1095, 1298, 1324, 1327, 1505,
 1508, 1511

Laurent Bouvier

1455. Moreau-Nélaton, Etienne. "Un Précurseur: Laurent Bou-
vier." *Art & Dec* 9:166-72 (1900). 11 illus.
 On a French ceramicist.

Edgar Brandt

1456. Félice, Roger de. "Quelques oeuvres récentes d'Edgar
Brandt et d'Edouard Schenck." *Art Dec* 15:51-62 (F 1906). 16
illus., 1 pl.

1457. Souza, Robert de. "Oeuvres diverses d'Edgar Brandt." *Art
Dec* 12:145-52 (O 1904). 10 illus.

François Rupert Carabin

1458. Coquiot, Gustave. "Les Figurines de Carabin." *Art Dec* 17:25-30 (Ja 1907). 15 illus.
 The work of a French sculptor.

1459. Schmidt, Karl Eugen. "Ein französischer Kunsthandwerker: François Rupert Carabin." *Kgwb* N.F. 10:69-77 (1899). 6 illus.
 Kitsch sculptured furniture.

Marius Carlier

1460. Leclère, Tristan. "Frises décoratives." *Art Dec* 19:193-6 (My 1908). 6 illus.
 Paintings by Marius Carlier.

Louis Chalon

1461. Forthuny, Pascal. "Louis Chalon." *Rev Arts Dec* 20:97-112 (1900). 20 illus., 2 pls.
 Includes some Loie Fuller style sculpture by a kitsch artist.

Alexandre Charpentier

1462. "Alexandre Charpentier." *Art Mod* 16:334-5 (O 21, 1895)

1463. "Alexandre Charpentier." *Art Mod* 22:318 (Se 21, 1902)

1464. *Art Décoratif.* [Photographs.] *Art Dec* 3:168-71 (Ja 1900). 6 illus.
 Interiors in a home by Aubert and Charpentier. No text.

1465. Mourey, Gabriel. "A decorative modeller: Alexandre Charpentier." *Studio* 10:157-65 (Ap 1897). 15 illus.

1466. Mourey, Gabriel. "An interview on 'L'Art Nouveau' with Alexandre Charpentier." *Arch Rec* 12:121-5 (Je 1902). 19 illus. (pp. 122-53)
 Opinions on Art Nouveau and on the future of art. Illustrated with examples of the artist's work.

1467. Mourey, Gabriel. "Some recent work by Alexandre Charpentier." *Studio* 16:25-30 (F 1899). 8 illus.
Decorative sculpture and relief work in metal.

1468. Pica, Vittorio. "Alexandre Charpentier." Artisti contemporanei. *Emp* 22:242-60 (O 1905). 35 illus., 2 pls., port.

1469. Saunier, Charles. "Les Artistes décorateurs… Alexandre Charpentier." *Rev Arts Dec* 15:549-57 (1895). Illus., 4 pls.

1470. Soulier, Gustave. "Alexandre Charpentier." *Art & Dec* 1: 116-17 (Ap 1897). 4 illus., 1 pl.
Ceramic relief work by the artist.

ALSO SEE: 102, 1219b, 1417, 1763ff.

Georges Chédanne

1471. Marx, Roger. "A propos d'une construction récente de M. Chédanne." *Art & Dec* 16:155-64 (N 1904). 14 illus.

1472. Moisy, Pierre. "Das Palais Lobkowitz als französische Botschaft und das neue Gebäude auf dem Schwartzenbergplatz." *AMK* Jrg. 7 (no. 62-3):17-21 (Se-O 1962). 11 illus.
Two buildings of the French embassy in Vienna, the second of which is a French Art Nouveau structure by Chédanne.

Jules Chéret

1473. Beraldi, Henri. *Les Gravures du XIXe siècle: guide de l'amateur d'estampes modernes.* Vol. 4: Brascassat-Chéret. Paris: L. Conquet, 1886
Volume 4 of this reference work lists 950 posters and other graphic work by Chéret in 60 different categories (includes 504 posters in 31 categories by type of product advertised). See pp. 168-203 of vol. 4, plus the 32-page supplement which follows. Page 1 of the supplement explains the conflict in numbering between vol. 4 and the supplement. Essay on the artist, pp. 168-78. This reference work is too early to list the work of other Art Nouveau poster artists.

1474. Lords, firm, art dealers, London. *Chéret posters 1868-1900.* London: 1970. Unpaged, illus.
 Brochure of sales prices of ninety-four Chéret posters, all illustrated. Includes a short essay.

1475. Mauclair, Camille. *Jules Chéret.* Paris: Le Garrec, 1930. 133 pp., illus., pls., bibl.
 Chapter 2 is on Chéret's posters. Limited edition of 730 copies. Extensive bibliography. Catalog of Chéret items in the Musée Chéret at Nice.

1476. Champier, Victor. "L'Exposition des affiches illustrées de M. Jules Chéret." *Rev Arts Dec* 10:254-8 (1889-90). 2 illus., 1 col. pl.

1477. "Chéret." *Art Mod* 10:252 (Ag 10, 1890)

1478. De Lucio-Meyer, J.J. "Jules Chéret und das künstlerische Plakat. Jules Chéret and the artistic poster. Jules Chéret et l'affiche artistique." *Gebrauchsgraphik* vol. 27, no. 9:24-9 (Se 1970). 17 illus.
 A short, tri-lingual note on Chéret's contribution to poster art.

1479. H.F. [i.e. Henri Frantz]. "Jules Chéret's drawings in sanguine." *Studio* 30:330 (Ja 1904). 9 illus.

1480. Frantz, Henri. "Modern French pastelists: Jules Chéret." *Studio* 32:317-20 (Se 1904). 9 illus., 1 col. pl.

1481. Kahn, Gustave. "Jules Chéret." *Art & Dec* 12:176-92 (1902). 12 illus., 2 col. pls., 5 pls.

1482. Mauclair, Camille. "Jules Chéret." *Art Dec* 9:1-12 (Ja 1903). 12 illus., 2 pls.

1483. Sertot, Raoul. "Quatre panneaux décoratifs par Jules Chéret." *Rev Arts Dec* 12:207-10 (1891-92). 2 illus.

1484. Veth, Cornelis. "Jules Chéret als illustrator." *Maandblad voor Beeldende Kunsten* 7:3-10 (1930). 6 illus., 1 col. pl.
 Text in Dutch.

ALSO SEE: 262, 264, 270, 1092-3, 1118, 1157, 1161-2, 1164, 1169, 1171, 1219b

E. Colonna

1485. Eidelberg, Martin. "Edward Colonna's *Essay on Broom-Corn:* a forgotten book of early Art Nouveau." *Conss* 176:123-30 (F 1971). 13 illus., bibl. footnotes
An interesting article which claims that Colonna was an American, a pioneer of Art Nouveau in the 1880s, and that his first name was Edward.

ALSO SEE: 1208, 1269, 1346, 1352, 1356, 1358, 1369, 1440, 1445, 1447, 1450-4

Albert Dammouse

1486. Garnier, Edouard. "Albert Dammouse." *Dek K* Jrg. 1, Heft 2 (Bd. 1):78-9 (O 1897). 7 illus. (pp. 78-81)

ALSO SEE: 1203, 1721ff.

Daum Frères, Nancy

1487. K.H.O. "Daum Frères, Nancy." *DKD* 13:122-6 (N 1903). 13 illus.

ALSO SEE: 357, 1121, 1125, 1128-9, 1335, 1337

Auguste Delaherche
A noted French ceramicist whose name has been closely associated with Art Nouveau.

*1488. Lecomte, Georges Charles. *A. Delaherche.* Douze hors-texte. L'Art décoratif moderne... Paris: E. Mary, [c1922]. 48 pp., 12 pls.

1489. Félice, Roger de. "August Delaherche." *Art Dec* 18:155-8 (O 1907). 5 illus.

1490. Marx, Roger. "Auguste Delaherche." *Art & Dec* 19:52-63 (F 1906). 15 illus., 1 col. pl.

1491. Mourey, Gabriel. "The potter's art; with especial reference to the work of August Delaherche." *Studio* 12:112-18 (N 1897). 6 illus.

1492. Uzanne, Octave. "Auguste Delaherche." *Art Mod* 12:85-6 (Mr 13, 1892)

ALSO SEE: 1109

1493. This item number not used.

Maurice Denis

Maurice Denis was the leader of the Nabis, a French neo-impressionist school (see 1177). Although mentioned in every book on the movement, he cannot properly be considered as an Art Nouveau artist. Two articles on his applied art are listed below.

1494. "Nos illustrations." *Art Dec* 2:52 (My 1899). 4 illus. (p. 77)
Wallpaper designs by Maurice Denis.

1495. "Papier mural." *Art Mod* 15:237-8 (Jy 28, 1895). 1 illus. Work of Maurice Denis.

ALSO SEE: 1177, 1391

Maurice Dufrène

1496. Dufrène, Maurice. *Les Bijoux.* Paris: Librairie des Arts Décoratifs, [19-?]. 24 pls.
Small folio of loose plates illustrating jewelry designed by the artist. List of plates, but no text.

1497. Musey-Grévin [i.e. J. Meier-Graefe?]. "Art et commerce." *Art Dec* 7:13-16 (O 1901). 5 illus., 1 pl.

1498. Musey-Grévin. "Un Jeune." *Art Dec* 4:237-41 (Se 1900).

6 illus. (pp. 239-43)
Decorative art work by Dufrène.

1499. Sedeyn, Em. "Maroquinerie d'art." *Art Dec* 6:74-80 (My 1901). 14 illus.
Leather work by Dufrène.

1500. Verneuil, M.P. "Maurice Dufrène." *Art & Dec* 19:73-84 (Mr 1906). 21 illus.

ALSO SEE: 350, 388, 1187, 1223, 1234, 1300, 1303, 1358-9, 1371, 1519, 1561, 1700

P.A. Dumas

1501. G.R. "Une Salle à manger." *Art & Dec* 12:167-71 (1902). 6 illus.
Dining room designed by P.A. Dumas.

Francisco Durio

1502. Morice, Charles. "Francisco Durio." *Art Dec* 12:118-20 (Se 1904). 8 illus.

E. Feuillatre

1503. Frantz, Henri. "E. Feuillatre, émailleur." *Art Dec* 5:164-70 (Ja 1901). 11 illus.

1504. H.F. [i.e. Henri Frantz]. "Studio-talk: Paris." *Studio* 40:68-70 (F 1907). 7 illus.
Pottery of Feuillatre.

ALSO SEE: 1270a, 1348, 1360

Georges de Feure

1505. Puaux, René. *Oeuvres de George de Feure.* Paris: L'Art Nouveau Bing, [1902?]. 42 pp., 66 illus., 4 col. pls.
Two articles by Puaux, one on "L'Art Nouveau Bing," pp. 1-4,

with page decorations by de Feure, the second, "George de Feure," pp. 5-12, with illustrations, pp. 5-40. This book may be cataloged under: Art Nouveau Bing. Copy in the Stedelijk Museum, Amsterdam.

1506. "G. de Feure." *Dek K* Jrg. 2 (Bd. 3):47 (N 1898). 1 col. pl. (facing p. 48)

1507. Gerdeil, O. "Un Atelier d'artiste." *Art Dec* 7:144-8 (Ja 1902). 5 illus. (pp. 148-50)
The studio of Georges de Feure.

1508. Jacques, G.M. [i.e. J. Meier-Graefe?]. "Un Petit Salon." *Art Dec* 6:23-30 (Ap 1901). 11 illus.
A salon designed by de Feure for Art Nouveau Bing.

1509. Karageorgevitch, Prince B. "La Toilette féminine comprise par les artistes." *Art Dec* 9:21-7 (Ja 1903). 13 illus., 1 pl.
Includes watercolors by de Feure.

1510. Laran, Jean. "Quelques meubles de G. de Feure au Salon du Mobilier." *Art & Dec* 24:115-32 (O 1908). 22 illus.
Very late furniture designed by the artist.

1511. Mourey, G. "L'Exposition Georges de Feure." *Art & Dec* 13:162-4 (My 1903). 6 illus.
Exhibit by the artist at Art Nouveau Bing.

1512. Mourey, Gabriel. "George de Feure, Paris." *InnDek* 13: 7-16 (Ja 1902). 25 illus. (pp. 7-23)

1513. G.M. [i.e. Gabriel Mourey]. "Studio-talk: Paris." *Studio* 23:64, 69 (Je 1901). 7 illus. (pp. 64, 69-70)
Ceramics by Georges de Feure.

1514. Puaux, René. "George de Feure." *DKD* 12:313-16 (Ap 1903). 66 illus., 3 col. pls. (pp. 313-48)

1515. Riotor, Léon. "Le Salon de *La Plume,* 2: Georges de Feure." *Plume* no. 81:387-8 (Se 1, 1892)

1516. Torquet, Charles. "La Vitrine de G. de Feure." *Art Dec*
6:116-25 (Je 1901). 14 illus.
 Porcelain by the artist.

1517. Uzanne, Octave. "Georges de Feure." *Art & Dec* 9:77-88
(F 1901). 23 illus., 2 col. pls.

1518. Uzanne, Octave. "On the drawings of M. Georges de
Feure." *Studio* 12:95-102 (N 1897). 6 illus., 1 col. pl.
 A generous introduction to the work of the artist.

ALSO SEE: 262, 1269, 1287, 1305, 1331, 1359, 1436, 1440-1, 1445,
 1447-8, 1453-4

Paul Follot

1519. Musey-Grévin [i.e. J. Meier-Graefe?]. "Art et cadeaux."
Art Dec 5:117-22 (D 1900). 6 illus. (pp. 121-3)
 Jewelry and decorative art by Paul Follot and Maurice Dufrène.

ALSO SEE: 1187, 1341, 1371

Georges Fouquet

1520. Jacques, G.M. [i.e. J. Meier-Graefe?]. "Le Bijou qui plait."
Art Dec 8:252-5 (Se 1902). 5 illus.
 Jewelry by Fouquet and Desrosiers.

1521. Sedeyn, Emile. "Les Nouveaux Bijoux de Georges Fou-
quet." *Art Dec* 7:8-13 (O 1901). 5 illus., 1 pl.

1522. Thomas, Albert. "Les Bijouteries modernes à l'Exposition
Universelle: George Fouquet." *Art Dec* 5:1-8 (O 1900). 9 illus.,
2 pls.

ALSO SEE: 1342, 1356

Eugène Gaillard

1523. Soulier, Gustave. "Quelques meubles d'Eugène Gaillard."
Art & Dec 11:20-7 (Ja 1902). 10 illus.

ALSO SEE: 1182, 1186, 1199, 1439, 1445, 1447, 1453-4

Lucien Gaillard

1524. Guillemot, Maurice. "Quelques bijoux de L. Gaillard."
Art & Dec 16:130-4 (O 1904). 8 illus.

ALSO SEE: 1212, 1215, 1254, 1374

Emile Gallé
There is as yet no monograph on Emile Gallé, the leader of
the Ecole de Nancy (Nancy school). Fourcaud's early work (1526)
is a collection of periodical articles. One French art historian,
Françoise-Thérèse Charpentier, has written a number of articles
on Gallé and the Nancy school in both scholarly and non-scholar-
ly French periodicals; some of the latter may be impossible to
obtain outside of France. Gallé is prominently treated in the sec-
tions on the Nancy school and on Art Nouveau glass.

1525. Charpentier, Thérèse. "La Clientèle étrangère de Gallé."
In: *Stil und Ueberlieferung in der Kunst des Abendlandes: Akten
des 21. Internationalen Kongresses für Kunstgeschichte in Bonn,
1964.* Bd. 1:256-65, bibl. footnotes
 The foreign customers of the artist traced through his corre-
 spondence with his Paris dealers, Marcellin and Albert Daigue-
 perce. Cataloged by Library of Congress under: International
 Congresses of the History of Art. Acts (21st).

*1526. Fourcaud, Louis de. *Emile Gallé.* Les Artistes de tous les
temps, série D: le XX siècle. Paris: Librairie de l'Art Ancien et
Moderne, 1903. 69 pp., illus., pls.
 Reprinted from the *Revue de l'Art Ancien et Moderne,* vol. 11:
 34-44, 171-86; vol. 12:281-96, 337-52 (1902). Copy in the
 Bibliothèque Nationale, Paris.

1527. Gallé, Emile. *Ecrits pour l'art: floriculture, art décoratif,
notices d'exposition (1884-1889).* Paris: H. Laurens, 1908. vi,
382 pp., port., bibl.
 Articles by the artist, collected from various journals. Including
 his essays on botany. Bibliography lists Gallé's publications.

1528. Malmö. Museum. *Emile Gallé: en glas konstens mästare...*
Malmö, 1966. 23 pp., illus.
 Text in Swedish. One hundred nineteen items of Gallé glass-
 ware. Four-page appendix on the artist's signatures in glass.

1529. Wohl, Jean Barbara. "Problems in the art of Emile Gallé."
M.A. Thesis, University of California, Berkeley, 1973. 69 pp.,
24 illus., bibl., bibl. footnotes
 Comprehensive monograph on the art of Emile Gallé. Chapter 1
 summarizes previous publication. Extensive bibliography, pp.
 59-67.

1530. Cantelli, Giuseppe. "Emile Gallé." *AV* vol. 6, no. 6:29-37
(N-D 1967). 9 illus. (part col.), bibl. footnotes
 On the glass of Gallé. Text in Italian only. Beautiful photo-
 graphs.

1531. Cantelli, Giuseppe. "Emile Gallé, mobiliere." *AV* vol. 9,
no. 6:50-6 (N-D 1970). 14 illus. (part col.), bibl. footnotes
 On the furniture of Gallé. In Italian, with English, French, and
 German summaries, pp. 66-70.

1532. Charpentier, Thérèse. "L'Art de Gallé: à-t-il été influencé
par Baudelaire?" *GBA* sér. 6, vol. 61:367-74 (My 1963). 5 illus.,
bibl. footnotes
 English summary, pp. 373-4.

1533. Demoriane, Hélène. "Le Cas étrange de Monsieur Gallé..."
Cons des Arts 102:34-41 (Ag 1960). 28 illus., 1 col. pl., port.
 A discussion of Gallé's uneven taste and of the poor quality
 glass manufactured with his signature on it after his death.

1534. Duret-Robert, F. "L'Ecole de Nancy, 2: verres, Gallé." En-
cyclopédie CdA, Ecole de Nancy, leaves 3, 4, 5. *Cons des Arts* no.
232:67-70 (Je 1971); no. 234:19-20 (Ag 1971). 23 illus. in both
sections
 Two-part article on Gallé's glass production. Illustrations are
 small black-and-white photographs. Includes signatures. Leaf 5
 is in August issue.

1535. "Emile Gallé (1846-1904)." *Art & Dec* 16: supplément, pp. 2-3 (O 1904)
 Obituary notice.

1536. Frantz, Henri. "Emile Gallé." *InnDek* 9:86, 88, 91 (Je 1908)

1537. Gallé, Emile. "Au salon du Champs-de-Mars: chemins d'automne, dressoir incrusté de bois polychromes." *Rev Arts Dec* 13:332-5, 383 (1892-93). Pl. facing p. 333.

1538. Gallé, Emile. "Mes envois au Salon..." *Rev Arts Dec* 18: 144-8 (1898). 5 illus.
 Letter to the *Revue des Arts Décoratifs* followed by a note from Victor Champier, pp. 147-8.

1539. Gallé, Emile. "Le Mobilier contemporain orné d'après la nature." *Rev Arts Dec* 20:333-41 (1900). 9 illus., 2 pls; 20:365-77 (1900). 19 illus., 2 pls.
 On the esthetics of furniture design.

1540. Gallé, Emile. "La Table aux herbes potagères." *Rev Arts Dec* 12:381-3 (1891-92). Illus., 1 pl. (facing p. 380)

1541. Gallé, Emile. "Les Verreries de M. Emile Gallé au Salon du Champs-de-Mars (1892)." *Rev Arts Dec* 12:332-5 (1891-92). 1 illus., 1 pl.

1542. M.G. [i.e. Manuel Gasser?]. "Glück mit Glas in Nancy: zwölf Aufnahmen von Franco Cianetti." *Du Atlantis* vol. 26 (no. 304):464, 477 (Je 1966). 12 pls. (part col., pp. 465-77)
 Text consists of two pages of captions for beautiful photographs of Gallé's work in glass.

1543. Gros, Gabriella. "Poetry in glass: the art of Emile Gallé, 1846-1905." *Apollo* 62:134-6, 146 (N 1955). 9 illus.

1544. Hakenjos, Bernd. "Arbeiten von Emile Gallé im Kunstgewerbemuseum, Köln." *Wallraf-Richartz Jahrbuch* 31:259-70 (1969). 8 illus., bibl. footnotes

Comprehensive article on Gallé, which also discusses his work in the Wallraf-Richartz museum.

1545. Henrivaux, Jules. "Emile Gallé." *Art Dec* 13:124-35 (Mr 1905). 14 illus., 1 pl.
Biography of the artist.

1546. Henrivaux, Jules. "La Verrerie à l'Exposition Universelle de 1889." *Rev Arts Dec* 10:169-85 (1889-90). 12 illus.
Part 2 of the article is devoted to Emile Gallé (p. 177ff.).

1547. Hofmann, H.D. "Emile Gallé und Louis Majorelle, unbekannte Arbeiten und stilistische Bemerkungen: ein Beitrag zur 'Ecole de Nancy'." *KHM* 8:65-75 (1968). Schriften der Hessischen Museen. 27 illus., bibl. footnotes

1548. Marx, Roger. "Emile Gallé: psychologie de l'artiste et synthèse de l'oeuvre." *Art & Dec* 11:233-52 (Ag 1911). 24 illus., 1 col. pl., port.
Illustrated with furniture, ceramics, and glass by the artist.

1549. Owsley, David T. "Emile Gallé: poet in glass." *Carnegie Magazine* 45:141-4 (Ap 1971). 6 illus., port.

1550. V.P. [i.e. Vittorio Pica]. "Emile Gallé." *Emp* 20:410 (N 1904). Port.
Obituary.

1551. Polak, Ada. "Gallé glass: luxurious, cheap and imitated." *JGS* 5:105-15 (1963). 26 illus., bibl. footnotes
A study of the artist's mass-produced glass.

1552. Polak, Ada. "Signatures on Gallé glass." *JGS* 8:120-3 (1966). 4 illus., bibl. footnotes
Illustrations reproduce a number of the artist's signatures.

*1553. Rudder, Jean Luc de. "Les Poèmes vitrifiés d'Emile Gallé." *L'Estampille* no. 13:13-38, 62-3 (Se 1970). Illus.

1554. Fr. St. "Emile Gallé, Nancy." *DKD* 15:138 (N 1903).

7 illus., port. (pp. 136-7)
 Obituary.

1555. Varenne, Gaston. "La Pensée et l'art d'Emile Gallé." *Mercure de France* vol. 86 (no. 313):31-44 (Jy 1, 1910)

1556. Weinhold, Reinhold. "Emile Gallé in Nancy." *InnDek* 8: 181-3 (N 1897)

ALSO SEE: 34, 357-8, 361, 365, 1092-3, 1109, 1111, 1115, 1122-6, 1128-9, 1136, 1138, 1203, 1218, 1249, 1333, 1337-8

Tony Garnier
 Garnier is not an Art Nouveau architect, but his name is mentioned in current literature on the subject. The major monograph is listed below.

1557. Wiebenson, Dora. *Tony Garnier: the Cité Industrielle.* London: Studio Vista, [1969]; New York: Braziller, [1970, c1969]. 127 pp., 81 illus., plans, bibl.
 The plans for an urban development project by an early major planner and transitional architect. Comprehensive bibliography.

Ch. Genuys

1558. Champier, Victor. "Une Salle à manger moderne." *Rev Arts Dec* 21:337-50 (1901). 11 illus.
 Dining room designed by Genuys.

Adolphe Giraldon

1559. Verneuil, M.P. "Adolphe Giraldon." *Art & Dec* 21:41-50 (Ja 1907). 30 illus.
 Graphic and decorative art work.

Glatigny

1560. J. "L'Atelier de Glatigny." *Art Dec* 1:50-2 (N 1898). 11 illus. (pp. 77-80)

ALSO SEE: 1261

Eugène Grasset

1561. Grasset, Eugène. *250 [i.e. Deux-cents cinquante] bordures par MM. Albrizio, Bacard,...* Documents ornementaux, publiés sous la direction de M.P. Verneuil. Paris: Librairie Centrale des Beaux-Arts [n.d.]. [7] pp., 33 illus., 60 pls.
 Small folio of plates of decorative borders by French artists, including Verneuil and Dufrène. Introduction by Grasset.

1562. Grasset, Eugène. *Iconographie décorative.* Paris: A. Calavas, [1887]. Illus.
 Folio of twelve allegorical drawings by the artist in a pre-1890 style. No text.

1563. Grasset, Eugène. *Méthode de composition ornementale.* Paris: Librairie Centrale des Beaux-Arts, [1907]. 2 vols., illus., pls.
 Two-volume textbook treatise on the principles of design: vol. 1, "Eléments rectilingues," square elements (xx, 384 pp., illus., 7 col. pls.); vol. 2, "Eléments courbes," curved elements (496 pp., illus., 5 col. pls.).

1564. Grasset, Eugène. *Ornements typographiques: lettres ornés, têtes de pages et fins de chapitres dessinés et publiés en 1880 pour* Les Fêtes chrétiennes *par M. l'Abbé Droux.* Paris: Ed. Sagot, [1880]. xxxvi pp.
 Page illustrations only, no text. Early pre-Art Nouveau work.

*1565. Grasset, Eugène. *La plante et ses applications ornementales.* Paris: Librairie Centrale des Beaux-Arts, [1897-1899]. 2 vols. (144 col. pls. in 2 folios, 47.5 cm.)

1566a. *La Plume* "L'Oeuvre d'Eugène Grasset." *Plume* no. 122: 175-228 (My 15, 1894) [special issue]. Illus., pls.
 Comprehensive issue on Grasset's early decorative and illustrative work. Major articles by Arsène Alexandre, Thiébault-Sisson, Henri Du Cleuziou, and Léon Maillard, with shorter articles reproduced from many journals. Numerous illustrations and page borders by Grasset.

1566b. *La Plume.* "Eugène Grasset et son oeuvre." *Plume* no. 261:

114-79 (Mr 1, 1900) [special issue]. Illus.
Basically a reprint of material from 1566a containing many of
the same articles and illustrations. New lead article by Henry
Eon. Numerous illustrations.

1566c. *Eugène Grasset et son oeuvre.* Texte par Camille Lemmo-
nier, Gustave Kahn, Thiébault-Sisson, Arsène Alexandre, Charles
Saunier, Pol Neveux, Marcel Reja, Henri Du Cleuziou, Fernand
Weyl, Léon Maillard, etc. Paris: Editions de "La Plume", 1900.
68 pp., 70 illus., 2 col. pls.
Reprint of a special issue of *La Plume* (presumably 1566b) in
booklet form. Contents, pp. 65-8.

1567. "L'Art Nouveau." *Art Mod* 17:240-1 (Jy 25, 1897)
A lecture given in Brussels by Grasset on the need for a new art.

1568. Berlepsch, H.E. von. "Bücherschau: *La Plante et ses appli-
cations ornementales...* Eugène Grasset..." *DKD* 1:79-84 (D 1897)
Book review of 1565.

1569. Berlepsch, H.E. von. "Eugène Grasset." *KKbw* 1:129-55
(1898). 23 illus.

1570. Combaz, Gisbert. "Eugène Grasset." *Art Mod* 14:49-50
(F 18, 1894)

1571. "Eugène Grasset." *Art Mod* 15:291-3 (Se 15, 1895)

1572. Genuys, Ch. "Les Ouvrages de ferronnerie d'E. Grasset."
Art & Dec 19:173-6 (My 1906). 4 illus.
Iron grillwork designed by the artist.

1573. Grasset, Eugène. "L'Animal dans la décoration." *Art &
Dec* 4:93-6 (Se 1898). 6 illus.
Illustrated with the work of M.P. Verneuil.

1574. Grasset, Eugène. "L'Art Nouveau: conférence faite à
l'Union Centrale." *Rev Arts Dec* 17:129-44, 182-200 (1897). 49
illus., 1 pl.
Illustrated by examples of Grasset's work.

1575. Grasset, A. [sic]. "The border analyzed as a decorative agent..." Transl. by Irene Sargent. *Cfm* 7:421-30 (Ja 1905). 15 illus.
Decorative page borders from the article in *Art et Décoration*, Nov. 1904.

1576. Grasset, E. "Papier peints." *Art & Dec* 1:118-24 (Ap 1897). 14 illus.
Wallpaper designs.

1577. Monod-Herzen, Edouard. "Méthode de composition ornementale par Eugène Grasset." *Art & Dec* 17:52-7 (F 1905). 11 illus., 1 col. pl.
Review of Grasset's book on the theory of composition (1563).

1578. Mourey, Gabriel. "Eugène Grasset." *Art & Dec* 13:1-25 (Ja 1903). 25 illus., 2 col. pls., 9 pls.
A review of the artist's work.

1579. R. "Reproductions diverses." *Art Dec* 1:164 (Ja 1899). 10 illus. (p. 195)
Students of Grasset at the Ecole Guérin.

1580. Saunier, Charles. "Exposition Eugène Grasset à Paris." *Art Mod* 14:128 (Ap 22, 1894)

1581. Soulier, Gustave. "L'Art moderne: conférence de M. Grasset." *Art & Dec* 2:87-92 (Se 1897). 8 illus.
Review of a lecture given by Grasset on modern decorative art and the use of the term "Art Nouveau".

1582. Thévenin, Léon. "L'Esthétique de Grasset." *Plume* no. 306:81-8 (Ja 15, 1902). 9 illus.

1583. Thiébault-Sisson. "L'Exposition des travaux d'élèves à l'Ecole Guérin." *Art & Dec* 2:155-9 (N 1897). 7 illus.
Art Nouveau work by students of Grasset.

1584. Uzanne, Octave. "Eugène Grasset and decorative art in France." *Studio* 4:37-47 (N 1894). 19 illus. (pp. 37-48)

Survey of the artist's work including stained glass windows, books, and posters.

1585. Uzanne, Octave. "L'Exposition récapitulative d'Eugène Grasset aux Artistes Décorateurs." *Art & Dec* 20:173-86 (D 1906). 13 illus.
 Book illustrations and covers by the artist.

1586. Verneuil, M.P. "Les Vitraux de Grasset." *Art & Dec* 23: 109-24 (Ap 1908). 18 illus., 1 pl.
 Stained glass windows.

ALSO SEE: 1169, 1286, 1334, 1346, 1391, 1398

Jacques Gruber

1587. Lumet, Louis. "Un Décorateur nancéen, Jacques Gruber." *Art Dec* 21:161-7 (My 1909). 6 illus., 1 pl.
 Furniture, interiors, and stained glass windows.

Grün

1588. Soulier, Gustave. "Grün." *Art & Dec* 10:147-54 (1900). 15 illus., 1 pl.
 The work of a poster artist.

Hector Guimard

1589. Culpepper, Ralph. *Bibliographie de Hector Guimard.* Notes et documents, no. 4. Paris: Société des Amis de la Bibliothèque Forney, 1971. v, 94 pp.
 Exhaustive bibliography of the architect Guimard. In alphabetical order. Partly based on holdings of the Bibliothèque Forney. Includes general works on art history which have occasional reference to or illustrations of Guimard's work. Multilithed and sometimes difficult to read. Essay by Roger-H. Guerrand, pp. i-iv. List of periodicals, pp. 90-4. Texts in French.

1590. Guimard, Hector. *Le Castel Béranger.* Paris: Librairie Rouam, [1898]. 3, 3 pp., 65 pls., plans

Folio of colored plates on Guimard's best known building. Introduction by G. d'Hostingue. Rich source book for Guimard's designs.

1591. Guerrand, Roger-H. *Mémoires du Métro.* L'Ordre du jour. Paris: La Table Ronde, [1961]. 243 pp., bibl.
Chapter 3, "Les édicules de l'Apocalypse," pp. 73-99, is on Guimard and the Art Nouveau background of the Paris Metro. No illustrations in the book.

1592. New York. Museum of Modern Art. *Hector Guimard.* New York, [1970]. 36 pp., [37] illus.
Text by F. Lanier Graham. Comprehensive exhibition of architecture, interiors and furniture by the artist. Also see 1607, 1609, 1611, 1620 for reviews of the exhibition.

1593. Putz, Elizabeth Barnes. "Decorative motifs in the architecture of Hector Guimard." M.A. thesis, New York University, New York, 1967. 58 pp., 78 illus., bibl., bibl. footnotes
A review of the architect's career and decorative theory. Extensive bibliography. Footnotes at the end of each chapter.

*1594. Soulier, Gustave. *Etudes sur le Castel Béranger, oeuvre de Hector Guimard...* [Paris]: Rouam, 1899. 44 pp.
Copy at the Bibliothèque Nationale, Paris.

1595. Bans, George. "Les Gares du Métropolitain de Paris." *Art Dec* 5:38-40 (O 1900). 3 illus.
Metro stations designed by Guimard.

1596. Blondel, Alain & Plantin, Yves. "L'Expressionisme naturaliste de Guimard au Castel Béranger." *Oeil* no. 194:2-7, 60 (F 1971). 16 illus. (part col.)
Introductory article on Guimard with emphasis on the Castel Béranger.

*1597. Blondel, Alain & Plantin, Yves. "Guimard, architecte de meubles." *L'Estampille* no. 10:32-40, 61 (My 1970). Illus.

1598. Blondel, Alain & Plantin, Yves. "Hector Guimard: la

Salle Humbert de Romans." *Arch d'Auj* no. 155:xvii-xviii (Ap 1971). 1 illus.

1599. Cantacuzino, Sherbon. "Guimard." *Arch Rev* 147:393-5 (Je 1970). 9 illus.
 A general note on the architect.

1600. Caumont, Jacques. "Revolte gegen den Stil? Structurer un espace intérieur." *Werk* 57:810-18 (D 1970). 10 illus.
 The author's interview with Jean-Pierre Raynaud, a concept artist, who attacks the stylistic dictatorship of Guimard and Mondriaan. Tri-lingual text in German, French, and English.

1601. Champier, Victor. "Le Castel Béranger, Hector Guimard architecte." *Rev Arts Dec* 19:1-10 (1899). 10 illus.

1602. "Chronique: exposition de M.H. Guimard." *Art Dec* 2:41-2 (Ap 1899).

1603. Colombo, Emilio. "Hector Guimard, 1867-1942." *Casabella Continuità* no. 329:36-56 (O 1968). 75 illus. (incl. plans)
 A survey of the artist's career, including his post-Art Nouveau work. Introduction by Giovanni Klaus Koening. Text in Italian, with English summary (p. 36).

1604. Culpepper, Ralph. "Les Premières Oeuvres d'Hector Guimard." Tribune libre. *Arch d'Auj* no. 154:viii-ix (F-Mr 1971). 5 illus., bibl. footnotes

1605. Dali, Salvador. "Cylindrical monarchy of Guimard." *Arts Mag* vol. 44, no. 5:42-3 (Mr 1970). 7 illus.
 A short manifesto in favor of fantastical architecture.

1606. Eon, Henry. "Notes d'art: l'architecture de M. Guimard." *Plume* no. 204:647 (N 1, 1897)

1607. J.R.G. [i.e. J. Roger Guilfoyle?]. "Style Guimard: an exhibit of Hector Guimard's work ..." *Industrial Design* vol. 17, no. 2:49 (Mr 1970). 6 illus. (pp. 48-51)
 The exhibit at the Museum of Modern Art, New York (1592). A short discussion of Guimard's modernism.

1608. Grady, James. "Hector Guimard, an overlooked master of Art Nouveau." *Apollo* 89:284-95 (Ap 1969). 23 illus., bibl. footnotes
 A review of buildings designed by the architect.

1609. F.L.G. [i.e. F. Lanier Graham]. "Le Style Guimard..." *Intr* vol. 129, no. 8:98-105 (Mr 1970). 15 illus.
 On the Guimard exhibit at the Museum of Modern Art, New York (1592).

1610. Guimard, Hector. "An architect's opinion of Art Nouveau." *Arch Rec* 12:127, 131, 133 (Je 1902). Port. (p. 126)
 Guimard's principles of architecture.

1611. Haber, Francine. "F. Lanier Graham, Hector Guimard." Society of Architectural Historians. *Journal* 29:354-6 (D 1970)
 Detailed critique of the Guimard exhibition and its catalog (1592).

1612. Haber, Francine. "Hector Guimard, surviving works: map guide..." *Architectural Design* 41:31-4 (Ja 1971). 2 illus., map
 A list of thirty-seven Guimard structures in Paris (p. 34) with locational map (pp. 32-3).

1613. Mannoni, Edith. "Hector Guimard." *GBA* sér. 6, vol. 77: 159-76 (Mr 1971). 22 illus., bibl. footnotes
 A general article on the architect. English summary, p. 176.

1614. Mazade, Fernande. "An Art Nouveau edifice in Paris: the Humbert de Romans building, Hector Guimard, architect." *Arch Rec* 12:50-66 (My 1902). 12 illus., plan
 Well-illustrated article on a striking, short-lived building by Guimard.

1615. Molinier, Emile. "Le Castel Béranger." *Art & Dec* 5:76-81 (Mr 1899). 7 illus.

1616. G.M. [i.e. Gabriel Mourey]. "Studio-talk: Paris." *Studio* 17:49-50 (Je 1899)
 Short, unfavorable review of Guimard's architecture.

1617. Muret, Luciana Miotto, and Pallucchini-Pelzel, Vittoria. "Une Maison de Guimard." *Revue d'Art* no. 3:75-9 (1969). 12 illus. (incl. plans), bibl. footnotes
 On the Maison Coilliot in Lille, a major edifice by the architect.

1618. Peignot, Jérôme. "Guimard: 'Son graphisme est du grand art'." *Cons des Arts* no. 217:72-9, 132-3, 135 (Mr 1970). 14 illus. (part col.), map
 On p. 132ff. is a guide to Guimard's architecture with map and addresses.

1619. Poupée, Henri. "Actualité de Guimard." *Construction Moderne* 1970, no. 4:41-57 (Jy-Ag 1970). 59 illus., plan, port.
 A review of the architect's career, illustrated with many small black-and-white photographs. Map of Guimard's edifices in the sixteenth arrondissement, Paris (p. 57).

1620. "Le style Guimard." *Intr* vol. 129, no. 8:98-105 (Mr 1970). 15 illus.
 Well-illustrated introductory article on the occasion of the exhibition at the Museum of Modern Art, New York (1592). Long excerpt by F. Lanier Graham from the exhibition's catalog.

ALSO SEE: 102, 227, 839-43, 1111, 1115, 1140-1, 1147

Hurtré

1621. Weyl, Fernand. "Décoration d'un restaraunt." *Art & Dec* 5:16-21 (Ja 1899). 8 illus., 1 col. pl.
 A hotel dining room by the architect Hurtré and the painter Jules Wielhorski.

Jossot

1622. "Jossot." *Dek K* Jrg. 1 (Bd. 3):47 (N 1898). 4 illus. (p. 60)

ALSO SEE: 262

Kalas

1623. Darc, Jean. "L'Art dans la rue: la façade de la Maison
Jules Mümm, à Reims." *Art & Dec* 6:90-2 (Se 1898). 4 illus.
 By a local architect, Kalas.

Edmond Lachenal

1624. Enault, Louis. "L'Exposition Lachenal." *Rev Arts Dec*
18:335-8 (1898). 7 illus.

1625. Minkus, Fritz. "Edmond Lachenal." *KKhw* 4:390ff. (1901).
13 illus. (pp. 386-95)
 Statuary and ceramics.

ALSO SEE: 1102, 1121, 1203, 1261, 1270

Jean Lahor (pseudonym of Henry Cazalis)

1626. Walton, Thomas. "A French disciple of William Morris,
'Jean Lahor'." *Revue de Littérature Comparée* 15:524-35 (1935).
Bibl. footnotes
 Lahor's role in spreading Morris' social and esthetic ideals in
 France.

ALSO SEE: 33

René Lalique

1627. Geffroy, Gustave. *René Lalique.* L'Art décoratif moderne.
Paris: E. Mary, [1922]. 43 pp., 12 pls.
 A review of the artist's career and his influence on jewelry de-
 sign.

1628. Bayle, Paule. "Chez Lalique." *Art Dec* 13:217-24 (My
1905). 10 illus.

1629. Beaunier, André. "Les Bijoux de Lalique au Salon." *Art &
Dec* 12:33-9 (1902). 9 illus.

1630. Bénédite, Léonce. "La Bijouterie et la joaillerie à l'Exposition Universelle de 1900: René Lalique." *Rev Arts Dec* 20:201-10 (1900) 11 illus., 2 pls; 20:237-44 (1900). 11 illus., 2 pls.

1631. Binet, René. "Orfèvrerie et bijoux: les bijoux de M. Lalique." *Art & Dec* 2:66-71 (Se 1899). 8 illus.

1632. Demoriane, Hélène. "Verres signés Lalique." *Cons des Arts* no. 218:112-17, 164 (Ap 1970). 6 col. illus.
On the present-day family of the artist.

1633a. Destève, Tristan. "The workshops and residence of M. René Lalique." *Cfm* 4:1-8 (Ap 1903). 7 illus., 1 pl.
The artist's home, designed by himself in collaboration with the architect Feine.

1633b. Destève, Tristan. "La Maison de René Lalique." *Art & Dec* 12:161-6 (1902). Illus.

1634. "The exhibition of jewelry by René Lalique." *Studio* 35:127-34 (Jy 1905). 12 illus.
Exhibition in Agnew's Gallery, London.

1635. Fourcaud, L. de. "Les Arts décoratifs aux salons, 3: bijouterie." *Rev Arts Dec* 17:172-4 (1897). 4 illus.
Jewelry by Lalique.

1636. Geffroy, Gustave. "Des bijoux: à propos de M. René Lalique." *Art & Dec* 18:177-88 (D 1905). 15 illus. (part col.), 2 col. pls.

1637. Geffroy, Gustave. "Les Salons de 1901: René Lalique." *Art Dec* 6:89-91 (Je 1901). 4 illus. (pp. 89-92), 1 pl.

1638. Gomes Ferreira, Maria Teresa. "René Lalique at the Calouste Gulbenkian Museum, Lisbon." *Conss* 177:241-9 (Ag 1971). 17 illus. (part col.), bibl.

1639. Graul, Richard. "René Lalique." *Kgwb* N.F. 12:122-5 (1901). 5 illus.

1640. "Lalique: the art jewel." *Art News* vol. 70, no. 3:69-71
(My 1971)
 Short biography of the artist. No illustrations.

1641. Neveux, Pol. "René Lalique." *Art & Dec* 8:129-36 (1900).
12 illus., 1 pl. (facing p. 160)

1642. Pudor, Heinrich. "René Lalique." *Cfm* 5:619-20 (My
1904). Port.
 Translation of an article in *Dokumente des modernen Kunstge-
werbes,* ed. by Pudor (5 vols. Berlin: Steglitz, [1903-1908]).

1643. Sargent, Irene. "René Lalique; his rank among contempo-
rary artists." *Cfm* 3:65-73 (N 1902). 2 pls.

1644. G.S. [i.e. Gustave Soulier]. "Les Bijoux de M. Lalique."
Art & Dec 2:160 (N 1897). 1 illus., 1 col. pl.

1645. Vollmer, H. "René Lalique, Paris." *DKD* 13:153-73 (D
1903). 22 illus., 1 col. pl., port.

ALSO SEE: 34, 166, 365, 382, 1092, 1211, 1215, 1254, 1339, 1348,
 1351-2, 1370, 1373-5, 1450, 1700

Abel Landry

1646. Gerdeil, O. "Meubles nouveaux." *Art Dec* 6:36-40 (Ap
1901). 6 illus.
 Furniture by Landry for "La Maison Moderne" (see 1653-7).

1647. Jacques, G.M. [i.e. J. Meier-Graefe?]. "Intérieurs mo-
dernes." *Art Dec* 5:70-2 (N 1900). 8 illus. (pp. 67-71)
 Furniture for "La Maison Moderne" by A. Landry.

1648. Leclère, Tristan. "Abel Landry, architecte et décorateur."
Art Dec 17:49-60 (F 1907). 14 illus., 2 pls.

1649. Sedeyn, Emile. "Intérieurs." *Art Dec* 9:13-20 (Ja 1903).
13 illus.
 Furniture and interiors by Landry.

ALSO SEE: 1199, 1752

Gaston de Latenay

1650. Vignaud, Jean. "Gaston de Latenay." *Art & Dec* 7:119-23 (1900). 9 illus.
 Textile designs by the artist.

A. Laverrière

1651. Mourey, Gabriel. "Une Maison de compagne: projet de MM. A. Laverrière et E. Monod." *Art & Dec* 14:316-21 (O 1903). 4 illus., 1 col. pl., plans
 Country home showing the influence of Voysey.

Lavirotte

1652. Sergent, René. "Une Maison de rapport." *Art & Dec* 10:140-6 (1900). 10 illus.
 An apartment building by Lavirotte.

ALSO SEE: 1147

"La Maison Moderne"

 This was the Paris boutique which Julius Meier-Graefe opened in 1899, modelled along the lines of S. Bing's "L'Art Nouveau".

1653a. Gerdeil, O. "A la 'Maison Moderne'." *Art Dec* 3:213-16, 218 (F 1900). 5 illus.

1653b. G. "Einiges aus 'La Maison Moderne'." *Dek K* Jrg. 3 (Bd. 5):209-12 (F 1900) 5 illus.; or *Kunst* Bd. 2:209-12 (F 1900). 5 illus.

1654. "Korrespondenzen, Paris: ein neues Kunsthaus." *Dek K* Jrg. 2, Heft 12 (Bd. 4):215-16 (Se 1899)

1655. Osborn, Max. "La Maison Moderne in Paris." *DKD* 7:99-103 (N 1900). 11 illus. (pp. 99-109)
 Furnishings designed by Van de Velde.

1656. Puaux, René. "La Maison Moderne in Paris." *DKD* 12: 551-4 (Se 1903). 15 illus. (pp. 551-60)

1657. R. "La 'Maison Moderne'." Chroniques de l'Art Décoratif. *Art Dec* 2:277 (Se 1899)
 The opening of the new gallery.

ALSO SEE: 1646-7

Louis Majorelle

1658. Gerdeil, O. "Les Meubles de Majorelle." *Art Dec* 7:16-25 (O 1901). 12 illus.

1659a. J. "L'Art au restaurant." *Art Dec* 1:161 (Ja 1899). 3 illus. (pp. 165-7)
 Restaurant furniture by Majorelle in the Café de Paris.

1659b. J. "Moderne Restaurants in Paris." *Dek K* Jrg. 2 (Bd. 3): 147-8 (Ja 1899). 3 illus. (pp. 169-71)

1660. Jacques, G.M. [i.e. J. Meier-Graefe?]. "Le Meuble français à l'Exposition." *Art Dec* 4:142-9 (Je 1900). 14 illus.
 The furniture of Louis Majorelle at the 1900 Exposition.

1661. "Majorelle trouve preneur." *Cons des Arts* no. 195:108-9 (Je 1968). 2 col. illus.
 Two pieces of furniture in a Paris office.

ALSO SEE: 1121, 1124-5, 1129, 1133, 1150, 1190, 1199, 1234, 1247, 1295-7, 1303, 1305-6, 1313, 1327, 1547, 1746

Louis Marnez

1662. Bouyer, Raymond. "La Décoration d'un restaurant." *Art & Dec* 6:151-5 (N 1899). 5 illus.
 Maxim's Restaurant, designed by the architect Louis Marnez, with paintings by Léon Sonnier.

Roger Marx

Roger Marx was an important art historian and critic in France at the turn of the century who championed the ideals of Art Nouveau in France.

1663. Bernard, Emile. "Roger Marx." *Plume* no. 352:642-6 (D 15, 1903)

1664. Bouyer, Raymond. "La Renaissance des arts décoratifs et son initiateur en France." *Art Dec* 7:196-204 (F 1906). 9 illus., 2 pls.

On Roger Marx's critical role in introducing English decorative ideals into France.

1665. Jourdain, Frantz. "... Roger Marx." *Rev Arts Dec* 22:219-21 (1902)

A review of Marx's work and accomplishment.

1666. Saunier, Charles. "M. Roger Marx et l'art décoratif du temps présent." *Plume* no. 310:402-5 (Mr 15, 1902). 5 illus.

Fix Masseau

1667. C. "Fix Masseau." *Dek K* Jrg. 3 (Bd. 5):223 (Mr 1900); or *Kunst* Bd. 2:223 (Mr 1900). 9 illus. (pp. 217-22)

The work of a French sculptor.

Henri Matisse

1668. Trapp, Frank Anderson. "Art Nouveau aspects of early Matisse." *Art J* 26:2-8 (Fall, 1966). 11 illus.

1669. Trapp, Frank Anderson. "Matisse and the spirit of Art Nouveau." *Yale Literary Magazine* vol. 123 [no. 8?]:28-34 (Fall, 1955)

Traces Art Nouveau influence in Matisse's painting. Part of a special issue, "Hommage to Matisse."

Lucien Métivet

1670. Bouyer, Raymond. "La Musique illustrée: Lucien Métivet."
Art Dec 6:18-23 (Ap 1901). 12 illus., 2 pls.
 Covers for sheet music.

Robert de Montesquiou

*1671. Jullian, Philippe. "Ce que l'Art Nouveau doit à la curiosité
fantasque de Robert de Montesquiou." *Cons des Arts* no. 161:
60-7 (Jy 1965). 14 illus. (part col.)

André Morisset

1672. Reboux, Paul. "André Morisset." *Art Dec* 3:102-4 (D
1899). 6 illus. (pp. 104, 128-9)

ALSO SEE: 1208

Alphonse Mucha
 This bibliography concentrates on Mucha's earlier career as
an Art Nouveau poster artist and book illustrator in France and
ignores his later work in his native Czechoslovakia where he spe-
cialized in paintings portraying heroic scenes from Slavic history.
The major works on Mucha are the four books authored by his
son Jiri (1676-79).

1673. Galleria del Levante, München. *Alphonse Mucha.* Katalog
n. 22. München, 1967. [14] pp., [17] illus.
 Short texts in French and German by Maurice Rheims and Jiri
Mucha.

1674. Grosvenor Gallery, London. *Alphonse Mucha: Art Nou-
veau, 1890-1913.* London, 1963. Unpaged [circa 30 illus.]
 Exhibition catalog of 165 items. Two-page text by James La-
ver, "Mucha and Art Nouveau." Also exhibited in the Arthur
Jeffress Gallery, London. Chronology at rear of book.

*1675. Mucha, Alphonse. *Documents décoratifs: panneaux déco-
ratifs, étude des applications de fleurs, papiers peints, frises, vitraux,*

orfèvrerie, etc.... Paris: E. Lévy, [1903]. 6 pp., 72 pls. (part col.), folio
 Copy at the Bibliothèque Forney, Paris.

1676. Mucha, Jiri; Henderson, Marina; and Scharf, Aaron. *Alphonse Mucha, posters and photographs.* London: Academy Editions; New York: St. Martins Press, [1971]. 136 pp., 157 illus. (part col.), port., bibl.
 A collection of three essays, two of which deal with Mucha and photography. Numerous full-page illustrations.

1677. Mucha, Jiri. *Alphonse Mucha, his life and art.* London: Heinemann, [1966]; New York: Humanities Press, 1967. 391 pp., illus., bibl.
 A comprehensive biography of the artist by his son. Few illustrations. Extensive bibliography.

1678. Mucha, Jiri. *Alphonse Mucha, the master of Art Nouveau.* [Prague: Artia, 1966]. 291 pp., 299 illus.
 Numerous illustrations and photographs. A shorter text than in the same author's biography (1677).

1679. Mucha, Jiri, ed. *The graphic work of Alphonse Mucha.* London: Academy Editions; New York: St. Martins Press, [1973]. 143 pp., 174 illus., 40 col. pls., bibl.
 Includes a catalogue raisonné of Mucha's graphic work including posters, books, and calendars, pp. 109-133. Primarily illustrations. Introduction, "Women and flowers: the life and work of Alphonse Mucha," by Marina Henderson, pp. 7-16. Mucha signatures, p. 135. Bibliography of Mucha, pp. 137-8.

*1680. Paris, Bibliothèque Forney. *Un Maître de l'Art Nouveau, Alphonse Mucha...* [Catalogue: Andrée David, Roger-H. Guerrand]. Paris: Société des Amis de la Bibliothèque Forney, [1966]. 64 pp., illus., pls.
 Cataloged by the Library of Congress under: David, Andrée.

1681. *La Plume.* "Numéro consacré à Alphonse Mucha." *Plume* no. 197:393-488 (Jy 1, 1897). 126 illus.
 Includes articles by Sarah Bernhardt and numerous French art

critics, both original contributions and reprints from various newspapers. Illustrations are in black and white. Indexed, pp. 486-7.

1682. California. University, Los Angeles (UCLA). College Library. *Mucha: an exhibition of books and periodicals illustrated by Alphonse Mucha...* Los Angeles, 1972. 18 pp.
An exhibition of thirty-eight books designed by Mucha, plus book covers, periodical covers, and ephemera. Introduction by James Davis, p. 2.

1683. Reade, Brian. *Art Nouveau and Alphonse Mucha.* 2nd ed. London: H.M.S.O., 1967. 34 pp., 36 pls.
Comprehensive short essay on Mucha, pp. 1-29. Based on the 1963 exhibition held at the Victoria and Albert Museum, London. Black-and-white plates, primarily posters.

1684. Zurich. Kunstgewerbemuseum. *Alphonse Mucha (1860-1939): Plakate und Druckgraphik.* Zürich, 1967. Unpaged, 57 illus.
Text by Erika Billeter. Black-and-white illustrations. Bibliographic citation with each illustration.

1685. Amaya, Mario. "Mucha's fantasy." *Apollo* 77:475-7 (Je 1963). 3 illus., 1 col. pl., bibl. footnotes
A reappraisal of the then-forgotten artist.

1686. S.C. "Mucha." *Plume* no. 168:242-3 (Ap 15, 1896). 3 illus. (incl. issue cover, p. 237).
Brief notice on the new artist.

1687. Champier, Victor. "L'Exposition de R. [sic] Mucha à La Bodinière." *Rev Arts Dec* 17:58-60 (1897). 3 illus.

1688. "Documents décoratifs par A.M. Mucha." *Art & Dec* 14: 302-4 (Se 1903). 6 illus.
Review of Mucha's 1903 publication (1675).

1689. Heppenstall, Rayner. "Mucha's stamp design." *Apollo* 87: 209 (Mr 1968). 6 illus., port.
Czech postage stamps designed by the artist.

1690. Hofmann, Albert. "Alphons Maria Mucha." *Kgwb* N.F.
11:1-5 (1900). 13 illus., port. (pp. 1-14)

1691. Lancelot [pseud.?]. "Figures décoratives de A. Mucha."
Art & Dec 17:33-6 (Ja 1905). 8 illus.

1692. Masson, Charles. "Mucha." *Art & Dec* 7:129-38 (1900).
15 illus., 4 pls. (following pp. 128, 144)

1693. R. "Nos illustrations." *Art Dec* 2:147 (Jy 1899). 6 illus.
(pp. 168-9)
Unpublished chalk drawings.

1694. Sheldon-Williams, P.M.T. "L'Art Nouveau and Alphonse
Mucha." *Contemporary Review* 203:265-70, 316-20 (My, Je
1963)
An introductory sketch of Mucha's life in two installments. No
illustrations.

1695. Soulier, Gustave. *"Ilsée, Princesse de Tripoli."* *Art & Dec*
2:23-6 (Jy 1897). 4 illus.
Designs by Mucha for a book by Robert de Flers.

ALSO SEE: 143a, 257, 262, 1359-60, 1781a-b

E. Mulier

1696. Mulier, E. *Peinture d'Art Nouveau.* Doudon (Seine-et-Oise):
Juliot, [1904]. 2 vols., 31, 40 col. pls.
Chiefly illustrations. Decorative schemes of a French designer
in Art Nouveau motifs.

Henry Nocq

1697. Saunier, Charles. "Les Artistes décorateurs: Henry Nocq."
Rev Arts Dec 17:7-11 (1897). 6 illus., 1 pl.

ALSO SEE: Index (for articles written by Henry Nocq)

Auguste Perret
 Perret is a transitional architect between the styles of the
nineteenth and twentieth centuries and is often mentioned in the
literature on Art Nouveau. A few of his early works show some
Art Nouveau motifs, but he cannot properly be considered a part
of the movement. He was in charge of rebuilding Le Havre after
World War II. One article is listed below.

1698. Uhry, Edmond. "Une Maison à Paris." *Art Dec* 12:51-60
(Ag 1904). 9 illus., 1 pl., plans
 The apartment house in the Rue Franklin, by Auguste Perret.

ALSO SEE: 1054, 1140

Plumet & Selmersheim
 Charles Plumet, architect, and Tony Selmersheim, interior
designer, were a prominent team in French Art Nouveau work.
Also listed here are Pierre, the brother of Tony Selmersheim with
whom he sometimes worked, and Pierre's wife, Jeanne.

1699. *Art Décoratif.* [Illustrations.] *Art Dec* 3:39 (O 1899). 2
illus.
 No text.

1700. Belville, Eugène. "Un Hôtel particulier à Paris." *Art Dec*
20:41-58 (Ag 1908). 20 illus.
 A building by Barberis and Saint-Maur, architects, with inte-
riors by Dufrène, Lalique, and Tony and Pierre Selmersheim.

1701. Commichau, Felix. "Plumet's Pariser Neubau auf der
Avenue Malakoff." *InnDek* 12:50-2 (Mr 1901). 5 illus. (pp. 52-6),
plan, p. 92 (My 1901)

1702. Esquié, Pierre. "Les Essais de mobilier et de décoration
intérieure." *Art & Dec* 1:105-8 (Ap 1897). 6 illus.
 The work of Plumet & Selmersheim.

1703. Forthuny, Pascal. "Un Maître d'oeuvre, Charles Plumet."
Rev Arts Dec 19:179-91 (1899). 12 illus.

1704. "Französische Architektur." *Dek K* Jrg. 2 (Bd. 3):186-7 (F 1899). 23 illus. (pp. 201-8, 210-13)
 Architecture by Plumet and interiors by T. Selmersheim, L. Bonnier, and Jean Dampt.

1705. G. "Ein moderner Laden." *Dek K* Jrg. 3 (Bd. 5):53-6 (N 1899); or *Kunst* Bd. 2:53-6 (N 1899). 14 illus. (pp. 58-66)
 Store façades by Plumet & Selmersheim.

1706. Gardelle, Camille. "Charles Plumet, architecte." *Art Dec* 1:201-3 (F 1899). 11 illus., plan (pp. 217-24)

1707. Gerdeil, O. "Croquis d'intérieur." *Art Dec* 7:104-10 (D 1901) 9 illus. (pp. 103-9); 7:190-6 (F 1902). 12 illus. (pp. 189-95)
 The first article features interiors and furniture by Plumet & Selmersheim. The second article is by Gustave Soulier.

1708. J. "M. Tony Selmersheim." *Art Dec* 1:203-4 (F 1899). 6 illus. (pp. 223-4)

1709. J. [Nos illustrations: Plumet et Selmersheim.] *Art Dec* 3:89-90 (N 1899). 14 illus. (pp. 62-70)

1710. Jacques, G.M. [i.e. J. Meier-Graefe?]. "Rue et boutiques." *Art Dec* 7:36-40 (O 1901). 5 illus.
 Store fronts and stores by Plumet.

1711. Jourdain, Frantz. "Tony Selmersheim." *Art & Dec* 16:189-98 (D 1904). 12 illus.

1712. Jourdain, Frantz. "Une Maison, un mobilier moderne." *Art & Dec* 13:149-61 (My 1903). 16 illus.
 A Parisian residence by Plumet with furniture by Plumet & Selmersheim.

1713. Riotor, Léon. "Un Intéreur moderne." *Art Dec* 11:194-200 (My 1904). 6 illus.
 An interior for a M. Deniau designed by Tony Selmersheim.

1714. Saunier, Charles. "Une Nouvelle Construction de Ch. Plumet." *Art Dec* 5:154-64 (Ja 1901). 7 illus.

1715. Soulier, Gustave. "Les Aménagements de magasins." *Art & Dec* 7:32-8 (1900). 8 illus.
Store designs and facades by Plumet & Selmersheim and others.

1716. Soulier, Gustave. "Charles Plumet et Tony Selmersheim." *Art & Dec* 7:11-21 (Ja 1900). 14 illus.

1717. Soulier, Gustave. "Un Intérieur." *Art Dec* 8:381-90 (D 1902). 13 illus.
Furniture for a home designed by Pierre Selmersheim.

1718. Soulier, Gustave. "Maison de ville et maison des champs." *Art Dec* 9:60-9 (F 1903). 13 illus., 1 pl., plans
A city and a country residence by Plumet.

1719. Thiébault-Sisson. "A propos d'une décoration d'intérieure: pourquoi l'Art Nouveau chez nous est en retard; un mobilier de salle à manger, nouveau style, par les architectes Plumet et Selmersheim." *Art & Dec* 1:25-9 (?) (My 1897). 3 illus.

1720. Thomas, Albert. "Trois [sic] femmes artistes." *Art Dec* 6:69-74 (My 1901). 16 illus. (pp. 66-74)
Includes sculpture by Mme. A. de Frumerie, jewelry by Mme. Jeanne Selmersheim, and decorative art by her husband Pierre.

ALSO SEE: 111, 1109, 1306, 1311, 1331, 1410, 1763-5

"La Poignée"
"La Poignée" was an interior designers group whose name means "a fistful" in French. The ten artists included Emile Robert, Victor Prouvé, Eugène Belville, Maurice P. Verneuil, and Albert Dammouse.

1721. Calmettes, Pierre. "La Poignée: a new artistic society in Paris." *Arch Rec* 13:535-47 (Je 1903). 11 illus.

1722. Calmettes, Pierre. " 'La Poignée': sa deuxième exposition." *Art & Dec* 15:54-62 (F 1904). 15 illus.

1723. "Deuxième exposition de 'La Poignée'." *Art Dec* 11:48-55 (F 1904). 15 illus.

1724. Leclère, Tristan. "La Poignée." *Art Dec* 9:70-7 (F 1903). 13 illus.

1725. Mourey, Gabriel. "L'Exposition de 'La Poignée'." *Art & Dec* 13:65-72 (F 1903). 11 illus.

1726. Saunier, Charles. "L'Art décoratif: La Poignée, Léon Benouville." *Plume* no. 355:157-60 (F 1, 1904)

1727. Saunier, Charles. "Les Arts décoratifs: exposition de 'La Poignée'." *Plume* no. 329:54-6 (Ja 1, 1903)

Victor Prouvé

1728. Ducrocq, Georges. "Quelques oeuvres de Victor Prouvé." *Art & Dec* 1:1-11 [sic] (My 1897). 10 illus., 1 pl.
 Bookbindings and statuary by the Nancy artist.

1729. Frantz, Henry. "Quelques bijoux de Victor Prouvé." *Art Dec* 3:100-1 (D 1899). 10 illus. (pp. 114-16)

1730. Rais, Jules. "Victor Prouvé et ses plus récentes inspirations." *Rev Arts Dec* 21:297-314 (1901). 9 illus.; 21:351-6 (1901). 4 illus.
 The first article is about drawings and bookbindings of the artist. The second is about Prouvé's decorative art.

ALSO SEE: 1208, 1249, 1721ff.

Paul Ranson

1731. R. "Nos illustrations." *Art Dec* 2:192 (Ag 1899). 9 illus. (pp. 202-5)
 Work by Paul Ranson.

1732. "Ranson at Munich." *Apollo* 85: suppl. p. 14 (Je 1967). 3 illus.

Announcement for an exhibition at the Galleria de Levante in Munich.

ALSO SEE: 262, 1290

Augustin Rey

1733. Frantz, H. "The Rothschild artizan' [sic] dwellings in Paris, designed by Augustin Rey." *Studio* 37:115-28 (Mr 1906). 5 illus., 13 plans
A projected development with Secession design motifs.

Théodore Rivière

1733a. Thomas, Albert. "Théodore-Rivière." *Art Dec* 7:129-38 (Ja 1902). 10 illus., 2 pls.
Includes a figurine of Loïe Fuller (p. 137) by the sculptor.

Pierre Roche
Roche was a sculptor best known for his statuettes of the American dancer Loïe Fuller.

*1734. Marx, Roger. *La Loïe Fuller.* [Paris: Les Cents Bibliophiles, 1904]. 24 pp.
Work of Pierre Roche.

1735. Clément-Janin. "Un Artiste inventeur, Pierre Roche." *Rev Arts Dec* 20:383-7 (1900). 7 illus.

1736. Clément-Janin. "Un Tombeau." *Rev Arts Dec* 22:97-102 (1902). 2 illus.
An Art Nouveau tomb in Nancy designed by Roche.

1737. Honson, J.M.P. "Pierre Roche, a prominent sculptor of the New School." *Arch Rec* 13:34-41 (Ja 1903). 6 illus.

1738. "Pierre Roche." *Art & Dec* 15:117-27 (Ap 1904). 21 illus.

1739. Roche, Pierre. "Un Artiste décorateur: la Loïe Fuller." *Art Dec* 19:167-74 (N 1908). 8 illus.

Statuettes and plaques depicting Loïe Fuller, executed by Pierre Roche. Article written by the artist.

1740. Saunier, Charles. "Pierre Roche." *Art Dec* 6:1-7 (Ap 1901). 11 illus. (pp. 1-8)

ALSO SEE: 1102

Roy

1741. Félice, Roger de. "Un Hôtel particulier à Paris." *Art Dec* 13:136-44 (Mr 1905). 9 illus.
Residence by the architect Roy with ironwork by E. Robert.

Henri Sauvage
Only the earlier work of the architect in the Art Nouveau style is included in this bibliography.

1742. G. "Henri Sauvage." *Dek K* Jrg. 3 (Bd. 5):232-5 (Mr 1900); or *Kunst* Bd. 2:232-5 (Mr 1900). 6 illus. (pp. 232-7)

1743. "Intérieurs." *Art Dec* 9:148-52 (Ap 1903). 5 illus.
Interesting interiors in a project by Sauvage and Sarazin.

1744. Jacques, G.M. [i.e. J. Meier-Graefe?]. "Deux salons de restaurant par M.H. Sauvage." *Art Dec* 3:244-9 (Mr 1900). 6 illus.
Restaurant interiors.

1745. Jourdain, Frantz. "Hôtel et café modernes." *Rev Arts Dec* 20:33-40 (1900). 6 illus.
Includes the Café de Paris interior by Sauvage.

1746. Jourdain, Frantz. "La Villa Majorelle à Nancy." *Art Dec* 8:202-8 (Ag 1902). 7 illus., plans
The home of the artist Majorelle. Correction for this article on p. 220.

1747. G.M. [i.e. Gabriel Mourey]. "Studio-talk: Paris." *Studio* 22:51-2 (F 1901). 2 illus. (pp. 49-50)
Furniture by Henri Sauvage.

1748. Mourey, Gabriel. "Une Villa en Bretagne par MM. Sauvage et Sarazin." *Art & Dec* 15:63-8 (F 1904). 6 illus., 2 plans, 1 col. pl.
> A country home. Not Art Nouveau.

1749. Soulier, Gustave. "Henri Sauvage." *Art & Dec* 5:65-75 (Mr 1899). 23 illus.

1750. Uhry, Edmond. "Logements hygéniques à bon marché et maison de rapport." *Art Dec* 12:128-36 (O 1904). 10 illus., plans, 1 pl.
> Apartment house designed by Sauvage and Sarazin. Some Art Nouveau decorative motifs.

ALSO SEE: 350, 1117, 1150, 1300, 1410

Ed. Schenck

1751. Uhry, Edmond. "Un Intérieur moderne." *Art Dec* 15:178-84 (My 1906). 8 illus.
> Apartment interior by Ed. Schenck and Francis Jourdain.

ALSO SEE: 1456

Xavier Schoellkopf

1752. Levin, Julius. "Neue Pariser Architektur und Möbel." *Inn-Dek* 12:77-86 (My 1901). 18 illus. and 2 pls. (pp. 78-92)
> The house of Yvette Guilbert. Furniture and interiors by Abel Landry.

1753a. J. "Neues in der Architektur." *Dek K* Jrg. 2 (Bd. 4):41-3 (My 1899). 19 illus. (pp. 49-57)
> Architecture by Schoellkopf in the Avenue d'Jena.

1753b. J. "Le Modernisme dans l'architecture." *Art Dec* 2:45-8 (My 1899). 19 illus. (pp. 53-61)

1754. "No. 4 Avenue d'Jena, Paris." *Arch Rec* 9:65-76 (Jy-Se 1899). 16 illus.
> By Xavier Schoellkopf, architect. Photographs only, no text.

1755. Saunier, Charles. "L'Hôtel de Mme. Yvette Guilbert." *Art Dec* 5:190-7 (F 1901). 5 illus.
 A noted building by the architect.

1756. Soulier, Gustave. "Une Maison de rapport." *Art & Dec* 8: 319-26 (N 1902). 10 illus.
 An apartment house by Schoellkopf.

ALSO SEE: 1242

Carlos Schwabe

1757. Soulier, Gustave. "Artisti contemporanei: Carlos Schwabe." *Emp* 11:173-97 (Mr 1900). 23 illus., 2 pls., port.

1758. Soulier, Gustave. "Carlos Schwabe." *Art & Dec* 5:129-46 (My 1899). 24 illus., 1 col. pl.

1759. G.S. [i.e. Gustave Soulier]. "Oeuvres récentes de Carlos Schwabe." *Art & Dec* 9:127-8 (1901). 2 illus., 1 col. pl. (following p. 110)

Sèvres Porcelain Factory

1760. Gensel, Walther. "Die Porzellan-Manufaktur zu Sèvres." *DKD* 7:177-83 (Ja 1901). 18 illus. (pp. 177-93)
 Includes figurines by A. Léonard.

E.M. Simas

1761. Guillemot, Maurice. "Un Cabinet de toilette par M.E.M. Simas." *Art & Dec* 14:399-400 (D 1903). 2 illus., 2 col. pls.
 An elaborate tiled bathroom.

1762. "A modern bathroom designed by E.M. Simas." *Studio* 17:32-6 (Je 1899). 5 illus., 1 col. pl.

"Les Six"
 An artists' group which included Félix Aubert, Alexandre Charpentier, Jean Dampt, and Plumet & Selmersheim, among others.

1763. J. "Chronique." *Art Dec* 1:197-8 (Ja 1899)
 On the artists' group "Les Six".

1764. Mourey, Gabriel. "Decorative art in Paris: the exhibition
of 'The Six'." *Studio* 13:83-91 (Mr 1898). 15 illus., 1 col. pl. (pp.
81-8)

1765. Mourey, Gabriel. "The decorative art movement in Paris."
Studio 10:119-24 (Mr 1897). 11 illus. (pp. 119-26)

Société d'Art Moderne, Bordeaux

1766. Soulier, Gustave. "La 'Société d'Art Moderne' à Bordeaux."
Art & Dec 7:83-9 (1900). 9 illus.
 Report on an Art Nouveau group in the provinces.

1767. This item number not used.

Henri de Toulouse-Lautrec
 Toulouse-Lautrec was a major post-impressionist painter as
well as an important poster artist. For this last reason he is pro-
minently featured in the literature on Art Nouveau. However it
is difficult to consider him an Art Nouveau artist on stylistic
grounds. Only some major works on Toulouse-Lautrec are listed
below. Attention should be called to Dortu (1772), which is a
six-volume catalogue raisonné of the artist's work.

1768. Bern. Kunsthalle. *Die Maler der* Revue Blanche: *Toulouse-
Lautrec und die Nabis.* Bern, 1951. Unpaged, illus., 4 col. pls.,
bibl.
 Texts by Fritz Hermann and Arnold Rüdlinger. Exhibition of
 255 items.

1769. Cooper, Douglas. *Henri de Toulouse-Lautrec.* The Library
of great painters. London: Thames & Hudson; New York: Abrams,
[1956]. 152 pp. (incl. 54 col. pls.), illus., bibl.
 Text, pp. 9-47, plus text with each plate. Cataloged by the Li-
 brary of Congress under Toulouse-Lautrec.

*1770. Copenhagen. Danske Kunstindustrimuseum. *Toulouse-*

Lautrec's posters. Catalogue and comments by Merete Bodelsen. Copenhagen: Museum of Decorative Arts, 1964. 28 pp., illus., bibl.
 Bibliography, pp. 27-8.

1771. Dortu, M.-G.; Grillaert, Madeleine; and Adhémar, Jean. *Toulouse-Lautrec en Belgique.* Paris: Quatre Chemins-Editart, 1955. 45 pp., 32 pls. (part col.)
 Includes a list of Toulouse-Lautrec's Belgian exhibitions (Salon de "XX", La Libre Esthétique, and others), pp. 29-41.

1772. Dortu, M.-G. *Toulouse-Lautrec et son oeuvre.* New York: Collectors Editions, 1971. 6 vols., illus.
 Comprehensive documentation on the artist and his work. Contents for the six volumes are found at the end of vol. 1 (pp. 180-1). Vols. 2 and 3 are a catalogue raisonné of the paintings, vols. 4, 5, and 6, of the drawings. Vol. 1 contains much documentary material including self-portraits and photographs of the artist, lists of exhibitions, index of persons in the paintings, index of museums and collectors, photographs of the artist's signatures. Limited edition of 1,500.

*1773a. Huisman, Philippe, and Dortu, M.G. *Lautrec par Lautrec.* Lausanne: Edita; Paris: Bibliothèque des Arts, [1964]. 274 pp., illus. (part col.), col. pls.

1773b. Huisman, Philippe, and Dortu, M.G. *Lautrec by Lautrec.* London: Macmillan; New York: Viking, A Studio Book, [1964]. 274 pp. (incl. col. pls.), illus., bibl.
 Richly illustrated book with numerous color plates. Comprehensive in scope. "Catalogue of graphic works," pp. 252-71. Map of Toulouse-Lautrec's Paris, pp. 248-9.

1774. Joyant, Maurice. *Henri de Toulouse-Lautrec, 1864-1901 ... dessins, estampes, affiches.* Paris: H. Floury, 1927. 281 pp., illus., pls., bibl.
 Companion volume to 1775. Includes the artist's poster work. Bibliography, pp. 265-73.

1775. Joyant, Maurice. *Henri de Toulouse-Lautrec, 1864-1901,*

peintre. Paris: H. Floury, 1926. 307 pp., illus., pls.
The major biographical source on Toulouse-Lautrec, written by
a close friend of the artist. Both of the Joyant volumes (1774-5)
were reprinted by Arno Reprints, New York, in 1968.

*1776a. Julien, Edouard. *Les Affiches de Toulouse-Lautrec.*
[Monte-Carlo]: Editions du Livre A. Weber, [1950]. 101 pp., illus.

1776b. Julien, Edouard. *The posters of Toulouse-Lautrec.* Monte-
Carlo: André Sauret, Editions du Livre, [1951]. 101 pp., [38] col.
pls.
Primarily large color reproductions of the posters. Text, pp. 7-
20, 83-4, 93-101. Cataloged by Library of Congress under Tou-
louse-Lautrec.

1777a. Keller, Horst. *Henri de Toulouse-Lautrec.* DuMont's Neue
Kunst-Reihe. Köln: Verlag M. DuMont Schauberg, [1968]. 108
pp., illus., 17 col. pls., 24 pls., port.

1777b. Keller, Horst. *Toulouse-Lautrec: painter of Paris.* New
York: Abrams, [1968]. 108 pp., illus., 17 col. pls., 24 pls., port.

1778. Mack, Gerstle. *Toulouse-Lautrec.* New York: Knopf,
1953 [c1938]. 371, xxiv pp., 58 illus., bibl.

1779a. Perruchot, Henri. *La Vie de Toulouse-Lautrec.* [Paris]:
Hachette, [1958]. 367 pp., bibl.
Biography of the artist. No illustrations. Lengthy bibliography
of books written in French.

1779b. Perruchot, Henri. *Toulouse-Lautrec.* [London]: Perpetua
Books, [1960]; Cleveland: World, [1961]. 317 pp., [47] illus.,
bibl.
Biography of the artist. Illustrated with photographs. Lengthy
bibliography of books written in French.

*1780a. Toulouse-Lautrec, Henri de. *Toulouse-Lautrec, lithogra-
phies, pointes sèches, oeuvre complet.* [Ed. par] Jean Adhémar.
[Paris]: Arts et Métiers Graphiques, 1965. 55 pp., 370 pls. (part
col.)

1780b. Toulouse-Lautrec, Henri de. *Toulouse-Lautrec: his complete lithographs and drypoints.* [Ed. by] Jean Adhémar. London: Thames & Hudson; New York: Abrams, [1965]. xxxviii pp., 370 pls. (part col.), bibl.

Catalogue raisonné of the artist's posters and drawings. Primarily illustrations. Descriptions of plates at the end of the book.

ALSO SEE: 53, 262, 1179, 1391

Maurice Pillard Verneuil

1781a. Verneuil, M.P.; Auriol, G.; and Mucha, [A.]. *Combinaisons ornementales se multipliant à l'infini à l'aide du miroir.* Paris: Librairie Centrale des Beaux-Arts, [1901?]. 60 col. pls.

Two-page text by Verneuil, "De l'emploi du miroir." Small folio of loose plates of typographical ornaments by the three artists.

1781b. "Combinaisons ornementales par MM. M.P. Verneuil, G. Auriol et Mucha." *Art & Dec* 9:204-8 (Je 1901). 5 col. illus.

Typographical ornaments by the three artists.

1782a. Verneuil, M.P. "Adaptation du décor à la forme." *Art & Dec* 14:364-82 (D 1903). 28 col. illus.

Article on composition illustrated with drawings from French artists.

1782b. Verneuil, M.P. "The adaptation of ornament to space." *Cfm* 5:470-84 (F 1904). 30 illus.

1783. Verneuil, M.P. "Enamel and enamelers." Translated by Irene Sargent. *Cfm* 6:14-29 (Ap 1904). 19 illus.

1784. Verneuil, M.P. "Fish forms in decorative art..." *Cfm* 8:68-77 (Ap 1905). 11 illus.

1785a. Verneuil, M.P. "L'Insecte." *Art & Dec* 15:1-21 (Ja 1904). 38 illus. (part col.), 1 pl.

The insect as decorative motif in French Art Nouveau.

1785b. Verneuil, M.P. "The Insect in decoration." *Cfm* 5:563-74 (Mr 1904). 12 illus.

1786. Verneuil, M.P. "Le Pochoir." *Art & Dec* 10:65-75 (1901). 25 illus., 1 col. pl.
Designs for stencils

ALSO SEE: 1231, 1290, 1500, 1561, 1573, 1721ff.

Henri Vever

1787. Germain, Alphonse. "Les Bijoux de Vever." *Art Dec* 5: 137-46 (Ja 1901). 20 illus. (pp. 137-47)

1788. Plantagenet, Ralph. "Des bijoux nouveaux." *Art Dec* 18: 37-40 (Jy 1907). 10 illus.
Jewelry by Vever.

ALSO SEE: 1339, 1346, 1370

Henry de Waroquier

1789. Vitry, Paul. "Henry de Waroquier." *Art Dec* 21:82-91 (Mr 1909). 14 illus.
Jewelry and fabric designs.

ALSO SEE: 1274

L. Woog

1790. Uhry, Edmond. "Un Théâtre-concert à Paris (La Cigale)." *Art Dec* 15:129-35 (Ap 1906). 5 illus., plans, 1 pl. (facing p. 136)
Theater designed by L. Woog.

INDEX

Book and periodical titles are in *italics*. The major
sections on certain topics and individuals are
indicated by item numbers in **bold-face**.

The Abbreviations and List of Periodicals will be found on pages xxiii-xxvi, immediately following the Introduction and preceding the Bibliography.